Lone Stars III

CHARLES N. PROTHRO TEXANA SERIES

LONE S

A Legacy of Texas Quilts, 1986–2011

TARS III

By KAROLINE PATTERSON BRESENHAN
and NANCY O'BRYANT PUENTES

UNIVERSITY OF TEXAS PRESS *Austin*

Requests for permission to reproduce material from this work
should be sent to:
Permissions
University of Texas Press
P.O. Box 7819
Austin, TX 78713-7819
www.utexas.edu/utpress/about/bpermission.html

∞ The paper used in this book meets the minimum requirements of
ANSI/NISO Z39.48-1992 (R1997) (Permanence of Paper).

LIBRARY OF CONGRESS CATALOGING-IN-PUBLICATION DATA
Lone stars III : Texas quilts today / by Karoline Patterson Bresenhan and
Nancy O'Bryant Puentes. — 1st ed.
 p. cm. — (Charles N. Prothro Texana series)
 Includes bibliographical references and index.
 Summary: This volume, which covers 1986–2011, completes the land-
mark documentation of 175 years of Texas quilt history that the authors
began in Lone Stars I and II.
 ISBN 978-0-292-72699-4 (cloth : alk. paper) — ISBN 978-0-292-72940-7
(pbk. : alk. paper) — ISBN 978-0-292-73556-9 (E-book)
 1. Quilts—Texas—History—20th century—Catalogs. 2. Quilts—Texas—
History—21st century—Catalogs. I. Puentes, Nancy O'Bryant. II. Bresen-
han, Karey, Lone stars. III. Title. IV. Title: Lone stars 3 : Texas quilts
today.
 NK9112.B685 2011
 746.4609764'074—dc22 2011009407

To the men in our lives, who inspired us to believe we could do anything we wanted to do:

Our fathers, the late C. C. "Pat" Patterson and the late Hollis Vernon O'Bryant;

Our cousin and brother, Hollis Pearce O'Bryant;

And our husbands, Maurice Lee Bresenhan, Jr., and Carlos Daniel Puentes

Contents

Acknowledgments

exas-sized thanks to the staff of Quilts, Inc., who helped make this book a reality, with Wilma Hart, Pamela Kersh, Amanda Schlatre, and Carmen Valls leading the list. Also, Margaret Bavousett, Teresa Duggan, Ann Graf, Vicki Mangum, Judy Murrah, Marvin Paz, Bob Ruggiero, J. R. Villanueva, Dora Ramirez, and Rhianna White deserve mention.

Special thanks go to Crystal Battarbee, coordinator of the International Quilt Association, who provided information on IQA Judged Show finalists and winners from Texas; quilt artist Barbara Oliver Hartman and numerous members of the Studio Art Quilt Associates and the online discussion group, QuiltArt, who tirelessly helped to track down many Texas quiltmakers; Kay Marburger and Mary Margaret Read of the Colorado Valley Quilt Guild; Whitney Rainer of Systemas, our computer expert; and quilt guilds, quilting bees, and quilters throughout the State of Texas.

Principal photography by

Jim and Judy Lincoln, Jim Lincoln Photography, Austin, Texas

Additional photography by

Gary Bankhead
Deloye Burrell
Korday Studio
Mellisa Karlin Mahoney
Kathy York

Authors' Note

All of the quilts you will see in this book are Texas quilts, made in or completed in Texas by Texans. According to an old Texas tradition, even if you are so unlucky as to move away from our state, we still claim you, as we know you're still Texans in your heart!

And we owe an immense debt of gratitude to Jim and Judy Lincoln, of Jim Lincoln Photography, whose talent portrays the quilts as the art they are.

Lone Stars III

A Quarter Century of Change

1986

The anti-smoking movement gained traction when both Surgeon General C. Everett Koop and the National Academy of Sciences reported that breathing secondhand smoke could cause cancer.

The first woman to win a United States Senate seat, Congresswoman Barbara Mikulski, had the political and financial support of women contributors to Emily's List, who gave $150,000 to her campaign.

The Statue of Liberty got a face-lift for her 100th birthday.

Five and a half million Americans joined Hands Across America on May 25, paying $10 each for a place in a human chain reaching across the continental United States. Proceeds were donated to local charities to fight hunger, homelessness, and poverty.

The Chernobyl nuclear disaster in the U.S.S.R. set off widespread speculation about potential fallout from a radioactive cloud.

Dr. Martin Luther King, Jr.'s birthday was celebrated as a national holiday for the first time.

The first American woman died of AIDS.

1987

Americans watched televised coverage of the rescue of "Baby Jessica" McClure, who fell into a well.

The population of the world hit five billion.

"Black Monday" on October 19 saw the steepest drop in Wall Street history, far surpassing the 1929 stock market crash that led to the Great Depression. The drop of 508.32 points represented a 22.6% loss of total stock value.

The Starbucks coffee empire, featuring coffee bars staffed by "baristas," began to build.

1988

NASA launched its first manned flight since the *Challenger* disaster two years earlier, when seven astronauts were killed in an explosion that occurred less than two minutes after takeoff.

The number of microwave products introduced in the United States soared as microwave ovens became ubiquitous in households.

1989

The Chinese army massacred student protesters at Tiananmen Square in Beijing.

The *Exxon Valdez* ran aground, releasing 240,000 barrels of crude oil into Prince William Sound, Alaska, killing or endangering otters, whales, porpoises, fish, and seafowl.

On August 25, America's *Voyager* space probe confirmed the rings of Neptune, and discovered six new moons circling the planet.

On November 9, the Berlin Wall came down.

1990

The popularity of "rap" music spread through all socioeconomic groups.

Iraq invaded Kuwait on August 2.

On October 3, after forty-three years of separation, East and West Germany were reunified.

1991

Operation Desert Storm started on February 24; on February 28, one hundred hours later, Iraq agreed to a ceasefire.

Texan Red Adair came out of retirement to fight Kuwaiti oil well fires set by withdrawing Iraqi forces.

Martha Stewart Living was launched.

The World Wide Web allowed image as well as message exchanges across the Internet.

IBM ceased typewriter production.

Eastman Kodak introduced its first digital camera.

Salsa outsold ketchup by $40 million.

Scarlett, the sequel to *Gone with the Wind*, became the fastest-selling novel in history; 2.5 million copies were purchased between September 25 and December 31.

1992

Civil war began in the former Yugoslavia, as Serbia attempted to gain control of Bosnia-Herzegovina, Macedonia, Croatia, and Slovenia.

The United Nations Security Council sanctioned Libya for failing to surrender two suspects in the bombing of a Pan Am flight over Lockerbie, Scotland.

The Americans with Disabilities Act became effective.

Jury selection began in Los Angeles in the case of the beating of Rodney King by Los Angeles police.

At sixteen, Tiger Woods became the youngest Professional Golf Association (PGA) golfer in thirty-five years.

The Soviet newspaper *Pravda* suspended publication.

Disneyland Paris opened.

Rosa Parks's autobiography, *Rosa Parks: My Story*, was published, recounting the civil rights icon's life up to her historic refusal to give up her seat on a Montgomery, Alabama, bus.

Bill Clinton, the Democratic governor of Arkansas, was elected president of the United States, defeating the Republican incumbent, President George H. W. Bush, and independent candidate H. Ross Perot of Texas.

1993

The Branch Davidians had a standoff with U.S. Bureau of Alcohol, Tobacco, and Firearms agents at Mount Carmel, near Waco.

A U.S. Black Hawk helicopter was shot down in Mogadishu, Somalia.

Agents of al-Qaeda carried out the first bombing of the World Trade Center in New York City.

1994

Jacqueline Kennedy Onassis died and was buried next to her first husband, President John F. Kennedy.

The Hubble Telescope revealed proof of the existence of black holes.

Nelson Mandela was elected president of South Africa.

The oldest human ancestor, believed to be 4.4 million years old, was discovered in Kenya.

Nicole Brown Simpson and Ronald Goldman were murdered, and the O. J. Simpson trial began.

The Channel Tunnel, or "Chunnel," between England and France opened, allowing underwater travel from one shore to the other in only thirty-five minutes.

1995

Timothy McVeigh and Terry Nichols bombed the Alfred P. Murrah Federal Building in Oklahoma City, killing 168 people, including eight federal marshals.

The Ebola virus hit in Zaire, killing 244 people.

The first planet, a gas giant, was found outside our solar system.

1996

The Unabomber, Theodore "Ted" Kaczynski, was arrested in Montana.

Prince Charles and Princess Diana divorced.

NASA scientists described the presence of possible microbe fossils on a meteorite from Mars, indicating the possibility of life having existed on another planet.

1997

Madeleine Albright was the first woman sworn in as the U.S. Secretary of State.

Princess Diana died in an August car crash in Paris; one week later, Mother Teresa of Calcutta died.

Scottish scientists introduced Dolly, the cloned sheep.

Timothy McVeigh was found guilty and sentenced to death for the Oklahoma City bombing.

After 156 years, the British returned the colony of Hong Kong to China.

Pathfinder, the remote-controlled robot, landed on Mars, took pictures, and sampled its surface.

Hale-Bopp, considered the greatest comet of the twentieth century, was visible to 80% of Americans without need of a telescope.

Titanic became the biggest box-office hit in film history, earning more than $1 billion and winning thirteen Academy Awards.

The first Harry Potter book by J. K. Rowling was published.

1998

Google began operations.

President Bill Clinton was impeached.

A heat wave in Texas saw temperatures reach nearly 120 degrees, the hottest temperature on record.

Former astronaut John Glenn returned to space on the shuttle *Discovery*, becoming the oldest person ever in space.

1999

Fears that the millennium changeover known as Y2K would cause major problems with computer software were unwarranted.

NATO, the North Atlantic Treaty Organization, celebrated its fiftieth anniversary.

Two students killed twelve classmates, a teacher, and themselves in the Columbine High School tragedy.

America's women's soccer team won the World Cup.

Refugee Elián González survived while others in his boat, including his mother, drowned en route between Cuba and Florida. González's Miami relatives wanted to keep him in the United States, but Fidel Castro demanded his return to Cuba.

The Texas A&M University bonfire tragedy killed twelve Aggies and injured twenty-seven others. The Bonfire tradition, in place since 1909, was cancelled.

The euro was accepted as the monetary unit of the European Union by members Austria, Belgium, Finland, France, Germany, Greece, Ireland, Italy, Luxembourg, the Netherlands, Portugal, and Spain.

2000

The Women's Museum opened in Dallas.

Two rival groups of scientists announced they had each created a map detailing the secrets of human genetic structure—the sequencing of the human genome—which was expected to change medicine.

2001

The USS *Cole* was bombed in the port of Yemen by al-Qaeda.

U.S. and British military forces invaded Afghanistan.

The U.S. Department of Justice began an investigation of Enron.

2002

Queen Elizabeth, the Queen Mother, died; her funeral was held in Westminster Abbey.

2003

The Iraq War began.

Mad cow disease caused human deaths and resulted in thousands of cows being slaughtered, primarily in the United Kingdom.

Sky marshals were placed on U.S. planes to prevent hijackings.

The space shuttle *Columbia* disintegrated upon reentry over Texas, killing all seven astronauts.

A major earthquake killed a reported 40,000 people in southeastern Iran.

Martha Stewart and her stockbroker were indicted for using illegal investment information; she resigned from *Martha Stewart Living*.

Saddam Hussein was captured.

2004

The social networking site Facebook was introduced.

The Mars Exploration Rovers *Spirit* and *Opportunity* reached Mars, sending back data and clear images. Evidence indicated part of Mars once had water.

The Boxing Day tsunami hit Southeast Asia, following an earthquake measuring 9.3 on the Richter scale. An estimated 230,000 people were reported dead or missing.

60 Minutes reported on the Abu Ghraib prison scandal.

The National World War II Memorial was dedicated in Washington, D.C.

2005

On August 29, Hurricane Katrina hit Louisiana and other Gulf Coast states, creating an unprecedented disaster.

On September 22, the Texas coast was evacuated as Hurricane Rita headed for Texas. Hundreds of thousands were involved in an evacuation that created a nightmare traffic jam and several deaths.

Pope John Paul II died; four million people traveled to Vatican City for his funeral.

YouTube went online.

W. Mark Felt was revealed as Watergate's Deep Throat.

2006

A Jackson Pollock painting sold for $140 million, becoming the world's most expensive painting.

NASA's Stardust mission returned dust from a comet.

Warren Buffett donated more than $30 billion to the Bill & Melinda Gates Foundation.

Google bought YouTube for $1.65 billion.

Nancy Pelosi became the first female Speaker of the House of Representatives.

Former Texas governor Ann Richards died.

2007

A Virginia Tech student shot and killed thirty-two other students and faculty members, then killed himself in the worst mass shooting in United States history.

2008

The mortgage and financial collapse occurred, raising fears of an economic meltdown.

More than 146,000 were killed by a cyclone in Myanmar, formerly Burma.

Barack Obama became the first African American presidential candidate by winning the Democratic nomination for president.

The government took control of the two largest mortgage financing companies in the United States: Fannie Mae and Freddie Mac.

Barack Obama was elected the forty-fourth president of the United States, the first African American president-elect.

2009

The H1N1 flu pandemic killed nearly 12,000 people.

A U.S. Airways flight lost power after takeoff from La Guardia airport. The pilot, Chesley "Sully" Sullenberger, landed the aircraft in the Hudson River, and all passengers and crew were rescued with no injuries.

Giant insurance company AIG lost billions of dollars.

Michael Jackson died. Huge numbers of people seeking information about his death derailed several major websites as Internet traffic rose to record-setting levels.

Sonia Sotomayor became the first Hispanic and third woman to serve on the U.S. Supreme Court.

Fort Hood was the site of the worst mass shooting at a U.S. military base when Major Nidal Malik Hasan shot and killed thirteen people and wounded dozens more.

Congress approved a $787 billion economic stimulus plan, the largest since President Eisenhower's term.

2010

The Boy Scouts celebrated their 100th anniversary.

A BP (British Petroleum) offshore oil well blew up in the Gulf of Mexico, killing eleven workers and creating a massive oil spill in Gulf waters that became an ecological disaster.

The U.S. government announced that the BP oil leak, which dumped 200 million gallons of crude oil into the Gulf and onto the coastline of Gulf states, was completely sealed.

*Searching for Texas Quilts
in the Digital Age*

othing illustrates the changes in quilting in Texas today better than the differences in how we conducted the first Texas Quilt Search in the early 1980s and how we searched for Texas quilts at the end of the first decade of the twenty-first century.

Back then we traveled the vast Lone Star State for two years, conducting Quilt Days in twenty-seven cities and towns, after spending three previous years on planning and logistics. We traveled by car or plane, including puddle jumpers, to get to locations that we felt would fairly cover Texas, so that we could give Texans the chance to learn about our quilt documentation project and bring their quilts for examination and documentation.

We were recording the quilts, still held in private hands, that were made in or came to Texas between the years of 1836, the year the Republic of Texas was founded, and 1936, the year of the Centennial celebration of Texan independence. Our book was to be published as an integral part of the Texas Sesquicentennial Quilt Association's statewide program and to serve as the catalogue for the traveling exhibit of quilts that would tour Texas museums. The Association's effort was aimed at seeing that the cultural and artistic contributions of Texas women to our state, through the uniquely female art of quiltmaking, were not forgotten during the state's Sesquicentennial, its 150th birthday celebration.

Because the quilts selected for the first *Lone Stars* book were old, and some fragile, we organized a Quilt Conservation Seminar, the first such event in the nation to bring together professional textile conservators, museum textile curators and staff, and quilt artists for a dialogue about the need for the preservation of quilt and textile art. The seminar was followed by an intensive hands-on laboratory led by a professional conservator and attended by expert quilters, who were instructed in museum mounting methods for quilts. These expert quilters then stabilized, backed, and prepared for exhibit the quilts that were to debut in the rotunda of the State Capitol as part of the Texas Sesquicentennial Quilt Association's celebration. Several supplemental lab sessions were also held a month later to complete the process. On San Jacinto Weekend 1986, the quilts premiered in Austin at the Capitol, kicking off a traveling exhibition that toured Texas museums during 1986 and 1987.

So that first Texas quilt search was labor intensive indeed, as were the research and writing methods used in the book itself, which served as the catalogue for the traveling exhibition.

After the two years spent searching for and documenting Texas quilts, we began the book. We corresponded with the quilters, their families, or the current owners of the quilts by mail and conversed with them by telephone. We wrote the draft manuscript on two electric typewriters at either end of a dining table, each with our research materials arranged behind us on chairs and benches for easy consultation. Each morning a courier would pick up the draft pages that we'd written overnight and deliver them to a skilled secretary who deciphered our typed pages, filled with corrections and handwritten addenda, and turned them into something presentable that we could then review, edit, and rewrite.

Photography, too, was logistically and physically challenging. We loaded all the quilts for the

book into a van and arranged for two trusted individuals to drive them to our photographer in San Francisco, one of the few photographers at the time who was expert in photographing individual quilts in their entirety, from an overhead perch. The two of us then flew to the West Coast, and each night worked to mark the details we wanted the photographer to capture the following day, after she took a full overhead shot of each quilt. Each was shot in two 4" x 5" transparencies and two sets of 35mm slides. When the photo shoot was completed, the quilts went back into the van for the return trip to Texas, where they were returned to their owners. They were never left unattended. When the drivers stopped for food, one stayed in the van. When they stopped at night, the quilts were taken in with them.

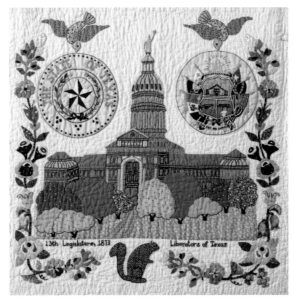

As it is with all writers, our manuscript went through several editing and proofing processes, and several additional laboriously typed drafts before it was ready for our publisher to put it into final form. It was completed at the Shamrock Hilton Hotel, where we moved for the very last rewrite, in order not to be disturbed.

Lone Stars: A Legacy of Texas Quilts, 1836–1936, marked the first time a major university press had published a comprehensive book on quilts. It opened the doors to many other such books throughout the country, as other states embarked on similar quilt documentation projects. They found an easier path to publication because of our publisher's trailblazing. Further, *Lone Stars: A Legacy of Texas Quilts, 1836–1936*, received an award for book design for the University of Texas Press from the American Institute of Graphic Arts. It also received an award from the San Antonio Conservation Society, the oldest such organization in our state, and one of the oldest in the nation, for preserving Texas history through a hundred-year record of quilt art masterpieces and the stories of their makers.

The second book, *Lone Stars II: A Legacy of Texas Quilts, 1936–1986*, was written to update our state's quilt heritage and document quilts made between the Centennial in 1936 and the 1986 Sesquicentennial celebration. It was published in 1990, and not only was the search for quilts much different, so was our research and writing.

During our initial travels, we had identified many quilts that were made after our 1936 cut-off date. So we had the advantage of many documentation forms in the Texas Quilt Archives to peruse in locating great quilts made after 1936. We also had the many contacts we had made throughout the state who sent us possible quilts, or quilters to interview, or names of individuals who might own great Texas quilts. Further, we had the advantage of knowing of many quilts that had been made especially for that 1986 celebration, and we were able to invite individual quilters to be a part of our research.

The second time, the research and writing were also quite different: we had upgraded to two Apple computers ensconced on individual six-foot office tables, set facing each other to allow easy discussion, in a separate room that held our ever-increasing research materials. For this book, we input our own manuscript and made our own corrections. By this time, use of the fax machine had become so commonplace that we found it invaluable for verifying information with quilters and other sources.

The photography process for that book was different also. For it, we brought the photographer to Houston for the shoot, locating a studio that again allowed the photographer to shoot from high above the quilts to capture them in their entirety, again on 4" x 5" and 35mm transparencies.

Our final book in the *Lone Stars* Texas quilt trilogy covers the last quarter century from 1986 to 2011, a period that bridges two millennia, and

also a world of change . . . not only for quilters, but for writers and publishers.

We had access to many images and documents in the archives of the International Quilt Association from its annual judged shows, which featured many Texas entrants and winners during that period. In addition, we also had access to the data files of Quilts, Inc.'s special exhibits unit, with its many hundreds of quilt exhibits documenting thousands of quilts.

We were able to locate great quilts, too, by contacting quilt guilds, quilting bees, and individual quilters via the Internet. Guild and individual quilter websites, online discussion groups, and quilting blogs expanded our search possibilities. In addition, we were able to track down some quilts and quilters using search engines and social media such as Facebook and YouTube. Our search this time was, for the most part, essentially a virtual one, done electronically.

Initial selection was made from digital submissions or invitations. Photo file management and electronic databases allowed all research to be kept and shared electronically with each other. Almost all of our contact with quilters throughout the state was done by email, although we did encounter a very small number who were not part of the digital community. Those we reached by fax, mail, or telephone.

In addition, for this book we had quilt check-in and documentation photography done by staff members of Quilts, Inc. The quilt selection process was conducted at the Great Expectations Creativity Center in La Grange, where we also had help from Quilts, Inc. staff.

Professional photography of the majority of the two hundred selected quilts was done digi-tally, quilt photography was viewed online on the photographer's image-sharing website, detail shots were selected online, and almost all the images were supplied to the publisher on very high-resolution compact disks, along with match prints to verify colors. A very small number of quilt images were submitted to our publisher via existing 4" x 5" or 2¼" x 2¼" transparencies. In addition, instead of only a typed or input and printed manuscript, the manuscript for this book also went to the publisher on a CD.

So in a way, just as the quilts featured in the *Lone Stars* trilogy mark the changes in quilting in Texas over 175 years, the books themselves mark the changes in publishing over the more than a quarter century that we have been writing about our state's quilts, still an almost uniquely female art form . . . in spite of the fact that there are five quilts in this book made by men.

Now there is a more technologically aware group of quilters and more means of disseminating information and learning techniques to a public not only within Texas, but worldwide via YouTube, Facebook, Twitter, and similar sites, blogs, websites, and email. Much of what we have done in this book has been made easier because of such widespread access, as well as by the added recognition for and acceptance of quilts as art. One thing that has not changed through the years, however, is the generosity of quilters in sharing their quilts and information about them.

Author's Note: This book completes a trilogy covering 175 years of quiltmaking in Texas. More than 6,500 Texas quilts have been documented in the extended Texas Quilt Search, and have become part of the Texas Quilt Archives.

Texas Quilts

BRIDGING THE MILLENNIUM

I t was the best of times, it was the worst of times . . .

What was said of late eighteenth-century France and England could also be said of late twentieth- and early twenty-first- century America.

The AIDS epidemic, the World Trade Center tragedy on September 11, 2001, the first and second Gulf Wars, the wars in Iraq and Afghanistan, the Oklahoma City bombing, the eighteen years of Unabomber scares, the drowning of New Orleans and ravaging of the Mississippi and Alabama coasts by Hurricane Katrina, the evacuation nightmare on Texas highways as the fourth-largest city emptied in fear of Hurricane Rita and its coming blow to the Texas coast, all balanced by the good that took place alongside those events . . .

America elected its first black president, as had South Africa; women rose to Secretary of State and Speaker of the U.S. House of Representatives; a former astronaut reclaimed his place in space; a symbol of oppression was destroyed and two halves of one country were reunited; the Internet, the World Wide Web, and social media brought people all over the globe together; the first Hispanic woman joined the U.S. Supreme Court; children everywhere learned to love reading through the Harry Potter books; we moved from the twentieth to the twenty-first century without a hitch; women got their own museum—in Texas; we went to Mars, saw new moons for Neptune, and discovered the first planet outside our solar system, a gas giant.

At the very least, "May you live in interesting times," whether an ancient Chinese curse or a familiar saying of 1930s American origin, is a good way to characterize the roller coaster of the past quarter century's high and low points.

How to make sense of it all? For quilters, making sense meant making quilts. When the Twin Towers fell in 2001, quilters made quilts. When the AIDS epidemic hit and the first American woman died of AIDS in 1986, quilters made quilts. When Katrina drowned New Orleans, quilters made quilts. When the first Gulf War broke out, quilters made quilts. Wherever there was a need . . . a cause . . . a catastrophe, quilters made quilts.

Quilters saw ways in which quilts could be used to counterbalance some of the puzzling and disturbing events that were occurring in the world as it hurtled toward the millennium, and ways in which they could help and heal. And they set about making those things happen.

They established nonprofit quilt organizations that spearheaded the making of fundraising quilts for those causes and other worthwhile goals, and worked to further the art of quilting and see it recognized. They embarked on statewide efforts to document America's quilt history and heritage, ensuring that the roots of traditional quiltmaking were not forgotten. They took quilting and an appreciation for quilts as art from the New World back to the Old World where it began, planting seeds that have grown into national quilt organizations and American-style quilt shows. They changed the perception of quilts as utilitarian bed covers to quilts as a means of expressing the universal creative urge, creating the art quilt that broadened horizons and options for all quilters. And they established

quilt museums to showcase both traditional and contemporary quilt art to inspire viewers with quilting's Cinderella story: the story of a utilitarian craft transformed into an art . . . a transformative story, a story for a new millennium.

Quilts for Causes

On September 11, 2001, quilters, like other Americans, watched in disbelief and growing horror as events in New York City, at the Pentagon in Washington, D.C., and on an airliner over Pennsylvania played out before their eyes on television and the Internet. The feelings of helplessness and anger engendered an overwhelming desire in quilters to "do something." And the something they did was to create quilts.

International Quilt Festival founder, Karey Bresenhan, monitored websites, online forums, and email messages from quilters who were turning to their art to channel their emotions and to distract their minds from the images that had been seared there. The Festival and its companion trade show, International Quilt Market, were scheduled for just six weeks following the tragic events. Many involved with the shows were unsure if the thousands who had already pre-enrolled would be willing to travel, some of them from other countries. But the decision was made to proceed as planned, although with some changes. In less than six weeks, the two shows' entire decorating scheme, which had been set for months, was changed to a patriotic red, white, and blue. New patriotic covers for two show magazines were chosen at the last minute before going to press.

Fundraising efforts were quickly organized to benefit survivors and their families. Show exhibitors such as Dallas-based United Notions/Moda stepped forward to donate two old-fashioned "Stars and Stripes" patriotic signature quilts, one for the Festival, another for the Market. Show attendees paid $5 to sign their names, leave an inspiring message, or to honor someone. Matching funds from generous industry sponsors helped each signature grow to $30 in value. The two quilts were donated to a New York City firehouse.

And those quilts the quilters everywhere were making? The Festival had issued an offer to display ANY quilt made after September 11 on a September 11 theme. Nearly 300 quilts arrived from all over the world for the "AMERICA: From the Heart" exhibit . . . with no remaining space in the show to display them. Finally, a decision was made to mount them in a display down the middle of "Main Street," the wide center aisle that is the most prominent spot in both shows.

Ranging from large to small, realistic to abstract, and using a wide variety of styles and techniques, the quilts moved all who viewed them. They pictured American flags, eagles, the Twin Towers, the Pentagon, and so much more. The exhibit was the most stunning and emotionally charged ever shown at the Festival and the Market, causing attendees to weep openly in the aisles. Because the exhibit had come together at the last minute, no information was available about it in advance. People walking down cross-aisles encountered it unexpectedly; many stopped in their tracks, tears streaming down their faces. Strategically placed boxes of tissue were replenished frequently during the shows. Some of the quilts had been donated to sell for fundraising purposes; others were part of an online auction, proceeds from which also went into the show's fundraising efforts. In all, more than $100,000 was raised for victims of the September 11 attacks, and was given to the American Red Cross Liberty Disaster Relief Fund and the Families of Freedom Scholarship Fund set up by former President Bill Clinton and former U.S. Senator Bob Dole, and administered by Harvard University, to help meet the educational needs of spouses and children of September 11 victims.

Later, due to demand, a smaller traveling show toured selected locations in the U.S. and abroad, including Barcelona, Spain. The impact of the exhibit and the desire to continue raising funds for the victims of the September 11 attacks and their families led C & T Publishing to publish a book based on the exhibit, also called *America from the Heart: Quilters Remember September 11, 2001*, with all profits also going to the Families of Freedom Scholarship Fund.

An earlier, and also moving, quilt-related cause was the AIDS Memorial Quilt, founded in 1987. Organizers at the NAMES Project Foun-

dation, which maintains the quilt, say it is the "largest ongoing community arts project in the world." Many of the panels have been made by people who had never sewn before. A typical "quilt block" is about twelve feet square, made up of eight three-foot-by-six-foot panels sewn together. Each of the more than 40,000 panels represents a person lost to AIDS. The panels were first displayed together on the National Mall in Washington, D.C., in 1987, resulting in a colorful, moving, and diverse exhibit. The quilt was last displayed in full in 1996, again on the National Mall.

Virginia Spiegel, a fiber artist and quilt-maker, had planned to make just a few fiber art postcards and offer them online for a dona-tion to the American Cancer Society through the Society's Relay for Life, which her sister chaired in her home-town of Forest Lake, Minnesota. Their father is a survivor of colon cancer. Virginia's hope was to have three of her seven postcards acquired by patrons and raise $90 for the cause. Another artist, Karen Stiehl Osborne, offered to help make postcard quilts in memory of her own father. Soon artists and patrons all over the world, including many members of the online group QuiltArt, began making—and purchasing—the postcard-sized quilts themselves to help. Fiber art postcards were donated and acquired quickly, raising more than $10,000 for the American Cancer Society in only four months. Fiberart for a Cause and its Postcard Project were underway!

International Quilt Festival organizers invited the project to Houston in November 2005, giv-ing it a large and prominent location on the main aisle of the huge quilt event and billing it as the Great Wall of Postcards. There, in just four days, an additional $20,000 was raised. The Festival supported the effort at its Chicago show the following spring also. The Postcard

Project, which ended in 2006, raised more than $100,000 altogether for the fight against can-cer. Fiberart for a Cause continued other fiber-related fundraising efforts, eventually donating more than $205,000 to the American Cancer Society.

While International Quilt Festival supports many worthy causes, it often creates projects itself, when the need is great. Quilters Com-fort America was one such project, born from the desire to help assuage the grief, despair, and hopelessness residents of New Orleans and Louisiana felt follow-ing the brutal fury of Hurricane Katrina in September 2005.

Just three weeks after Katrina, coastal Texans had had their own hurricane-related nightmare to contend with, although not on the scale or the gravity of Katrina. Hurricane Rita, apparently tar-geting Houston, had caused a mass evacu-ation of the nation's fourth-largest city. Estimates of the number of evacuees surging onto the arteries leading out of the city and encountering a massive traffic jam, gas scar-city, accidents, and deaths ranged from several hundred thousand to more than a million. In one case it took twenty-six hours to reach La Grange from Houston, a distance of no more than eighty-five miles. Rita missed Houston but caused widespread destruction in several coastal areas. The feeling of shared disaster increased the already-strong bond between the two cities.

Texans in general, and Houstonians in partic-ular, did not sit on the sidelines wringing their hands after images and reports of Katrina's dev-astation and the plight of New Orleans's citizens were broadcast over television and radio and published in newspapers and on the Internet. They opened their doors and their hearts, offer-ing temporary housing, meals, clothing, and other supplies—including jobs, cash,

The Elissa
1877

whatever they could manage—as individuals and as communities. Texas cities provided apartments for short periods, often at low, or sometimes no, cost.

More than 250,000 evacuees from Katrina arrived in Houston with nothing . . . no money, no food, no shelter or warm bedding. Shelters were set up with little more than a cot and sometimes a blanket. The idea that uprooted citizens from a beloved "next-door" neighbor city had arrived in Houston with nothing to comfort them resonated with the staff of Quilts, Inc. They spearheaded an effort from quilters around the world to get quilts and soft bedding to those who needed them in a project called Quilters Comfort America. It was created for quilters to channel their wish to help in some way to ease the misery they saw etched on the faces of Katrina's victims. The plan was for the Festival to provide a central shipping address for homemade quilts to distribute to those who had lost everything . . . their homes, their belongings, sometimes their pets, and even, in some cases, their relatives . . . those who were oftentimes even separated from close family members who had been evacuated to a different location. Organizers urged quilters to send financial donations to the Red Cross as well, offering to match the first $10,000 that came in.

The project asked quilters to send any kind of quilt, ranging from baby-quilt size to large bed size. One worker urged quilters to "get those unfinished projects out of your closets. Tie them, machine quilt them, work in a group with your friends on an assembly line, but finish them now." Another noted, "These quilts are not meant to be heirlooms, although they will probably be treasured for many years as a symbol of the kindness of strangers."

Expecting perhaps a few hundred quilts, staff members were at first thrilled when that goal was met . . . and then some! In the first week, more than 2,000 quilts arrived at company headquarters, many accompanied with heartfelt notes attached to them. In addition, blankets, bedding, linens, throws, towels, and fabric for pet bedding began to arrive several times a day. Federal Express and UPS added multiple deliveries a day. All packages were opened, inspected, laun-

dered if necessary, and consolidated. Boxes were stacked up to the ceiling in extra offices provided by building management.

Staff members who were preparing for the upcoming show just weeks away were drafted to help instead with the unpacking of boxes. Distribution as well as storage had to be worked out. Where to send things to be sure they would reach needy recipients? The destinations turned out to be a military base in Louisiana being converted into evacuee housing, a combination of church shelters in Mississippi, the Salvation Army, and several Houston-area churches and ministries. Donations were also sent to the City of Houston's official hurricane relief center, where evacuees went to "shop" for free goods to furnish their new housing, and the Red Cross shelter at Reliant Center, where the three biggest Houston shelters combined forces.

Quilts, Inc.'s building management finally insisted the quilts be moved to another location due to concern over fire safety from the huge number of boxes, now also stacked on both sides of the corridors, waiting to be opened, inspected, and consolidated. An appeal to the company's convention decorator, AEX Convention Services, brought an offer to store the quilts in its huge warehouse while they were being dispersed . . . especially welcome because the 18-wheelers needed to transport all the quilts could more easily be loaded from that facility. A volunteer noted at the time, "We placed over 1,000 yesterday, the first truck for Mississippi left with another 1,500 today, and Monday we should make the first delivery to the City of Houston center. So we are placing quilts right and left."

Quilts, Inc., the Festival's parent company, also challenged quilters to donate money for evacuee aid to the Red Cross, with its promise to match the first $10,000 in donations. While the Festival and Quilts, Inc. accepted the quilts and other items, quilters were instructed to donate any money directly to the Red Cross, sending a receipt or other record to the company to tally on behalf of quilters.

The final count of quilts donated was 15,000, plus many thousands more sheets, blankets, and other bedding items, not to mention countless items donated for the pets that had been left

behind. The money donated by quilters to the Red Cross topped $1 million, according to the Red Cross's own website.

Quilters from Camp Foster, Okinawa, were typical of quilt groups who wanted to help. Members of the Pacific Patchwork Guild sent "quillows" (small quilts that could be folded into thirds and tucked into an attached pocket to become a pillow when not needed as cover). "Like many others stationed on Okinawa, our members followed the news and wondered what they could do to help," said Laura Aquiar. They also made baby blankets for younger victims. Club members found out about Quilters Comfort America from quilt groups sharing information on the Internet.

The George R. Brown Convention Center in Houston became a major destination for busloads of New Orleanians sent out of the devastated area, and thousands were housed there. When provisions had been made and accommodations found for those displaced individuals and families and the convention center returned to its usual role, it was time for International Quilt Festival's fall event there. Festival enrollees from all over the world had seen the news coverage and wondered if the show would go on . . . would the convention center be available? Would there be room for the show if some people were still there, waiting and hoping for permanent housing, or a job?

As it turned out, Houston's business and community leaders working together were successful in solving the logistical problems of finding more permanent and more suitable housing for those sheltering at the convention center. By the time for the Festival, the center had returned to its usual role of hosting conventions, and the Festival brought a totally different feeling to downtown Houston . . . one full of brightly colored quilts, happy quilters, and interesting and exciting events. But Festival organizers had not forgotten the earlier occupants of the space they now filled. A special quilt exhibit called "Do You Know What It Means to Miss New Orleans?" was quickly organized in the short time between the events. Quilters created new works expressing their feelings over Katrina's destruction and the plight of so many helpless victims left in its wake.

They also made or found quilts in their collections that recalled happy times in the Big Easy, quilts depicting musicians, Mardi Gras, and mansions in the Garden District, and brought them to share. Quilts in the exhibit expressed the joy that had been experienced in New Orleans, the sadness the Crescent City's misery evoked, and the horror at what had happened to fellow Americans.

Organizers also scoured improvised databases established to keep track of displaced Louisiana musicians and found famed clarinetist Dr. Michael White. They offered him an unusual gig . . . putting together a combo from among the musicians temporarily in residence in Houston and playing in the quilt exhibit during the Festival's show hours. There he and his group attracted an admiring audience, many of whom kicked off their shoes and danced to the jazz beat, while others reminisced about mudbugs and maque choux at much-loved French Quarter restaurants. Dr. White's CDs were a daily sell-out.

Another cause that has touched many quilters' hearts is the Alzheimer's Art Quilt Initiative. The national grassroots charity aims to raise awareness of the disease and to fund research through the auction and sale of donated quilts, and through a national touring exhibit of quilts about Alzheimer's. The effort was founded and is directed by Ami Simms, whose own mother suffered from the disease. The first traveling exhibition in 2006 contained fifty-two quilts, each interpreting Alzheimer's in some fashion. Called "Alzheimer's: Forgetting Piece by Piece," the exhibit has been seen by more than 220,000 people during its tour. A book and CD commemorate the exhibit. A new exhibit called "Alzheimer's Illustrated: From Heartbreak to Hope" will replace "Alzheimer's: Forgetting Piece by Piece" in 2011. In addition, "Priority: Alzheimer's Quilts" is a monthly online auction of donated quilts small enough to fit the flat rate cardboard priority U.S. Postal Service mailers, which is how they are shipped to winning bidders. "There are an estimated 5.3 million Americans with Alzheimer's disease," said Simms. "We believe we can make a difference, one quilt at a time."

The Quilts of Valor Foundation was begun in 2003 by Catherine Roberts of Delaware, when her son was deployed from Germany to Iraq. The mission of this foundation is to present all service members and vets touched by war, primarily the war in Iraq and the war in Afghanistan, with a quilt called a "Quilt of Valor." Many thousands of quilts have been presented to service members who suffer either physical or psychological wounds of war.

Heart-2-Heart brought mini-quilts to service men and women. Recuperating soldiers at eight U.S. military hospitals in Texas, Virginia, Washington, D.C., Germany, and other locations were sent fabric postcards the size of a 4" x 6" postcard. The postcards were covered in fabric, decorated with painting, stamping, designs, embellishment, and quilting, and many came with personal notes. Each was specially made by individuals and groups ranging from Brownie troops to professional quilt artists as a way of expressing thanks and good wishes to recuperating U.S. soldiers.

The project was begun by International Quilt Festival with a call to quilters and fabric artists to send fabric postcards for distribution at Walter Reed Army Medical Center in Washington, D.C., for Valentine's Day, 2007. Within a few weeks, more than 4,200 cards arrived at the offices of Quilts, Inc., the parent company of the Festival. So many cards arrived that the original destination was expanded to include the Landstuhl Regional Medical Center in Germany, the largest U.S. military hospital outside the States; Brooke Army Medical Center and William Beaumont Army Medical Center in Texas; Eisenhower Army Medical Center in Georgia; Madigan Army Medical Center in Washington; Womack Army Medical Center in North Carolina; and Portsmouth Naval Medical Center in Virginia. Distribution of the cards at all facilities was spearheaded and handled by the American Red Cross.

Joe Moffat, Executive Director of the American Red Cross Armed Forces Emergency Services, said, "We are so pleased that the Red Cross could assist . . . in these compassionate efforts to bring comfort to the wounded soldiers. Our Red Cross volunteers at these military installations were delighted to hand deliver the special Valentines to our brothers and sisters in arms."

Though most of the cards came from individuals, many of whom sent up to fifty unique art cards each, some enterprising schoolteachers, such as Barbara Lyons, Brownie and Girl Scout co-leader at the Providence Academy in Plymouth, Minnesota, made it a group project for their students. "I wanted our girls to participate because it is something that they, even as young as they are, can do to lift the spirits of our wounded veterans. They had fun making cards," said Lyons. "The Brownies were told to make one card each, but when they completed that, they asked us if there was time for them to make another!"

Lyons added that one of the older girls asked how she could fit the phrase "Thank you for choosing to go into the service, and for going overseas, and suffering for our country" on one little card. "I told her that a simple 'Thank you' would suffice, but that gives an idea of how seriously they took this activity," she added.

"We always knew that quilters were generous with their hearts and their time," organizers from Quilts, Inc. summed up, noting that participation was far greater than originally planned or expected. "That's why we had to expand the project."

The overwhelming success of Heart-2-Heart caused Quilts, Inc. staff members to ponder what else could be done for wounded service personnel recovering in military hospitals. "Obviously, injured veterans couldn't go out to buy a card for their mothers on Mother's Day," Karey Bresenhan pointed out. "So we decided that more fabric postcards should be given to them so they could

actually mail both a combination greeting and a tiny gift quilt to their mothers."

Since the little quilts were regulation postcard sized, quilters were asked to leave space for a message and signature on the back side of their new designs, as well as room for an address. All service personnel had to do was sign and address the card. The Red Cross provided postage, which enabled the quilted cards to go first class to service moms all over the country.

And quilters support women everywhere, as shown by the Iraqi Bundles of Love project begun by one man, U.S. Army Major Art La Flamme. With a wife who quilts, Maj. La Flamme knew that quilters always have more fabric in their stash than they can ever hope to use. The "IBOL" project started in 2009 and was repeated in 2010; La Flamme hopes to make it an annual event. Its simple goal was to get women to donate their extra fabric, thread, and any other sewing supplies to Iraqi women and have them delivered to coincide with Ramadan, the major Muslim religious holiday. The idea was to help the women establish a means of earning money for their families, individually or through local sewing cooperatives. La Flamme, whose last tour of duty in Iraq ended in fall 2010, had no idea quilters could be so generous. He noted that the "IBOLs" are being distributed in Salah ad Din, in northern Iraq, including the area around Tikrit.

Subscribers to QuiltArt online mailing list and other online quilters made fifty Child Abuse Quilts from April to October 1998 on the subject of child abuse, and prevention of child abuse and violence against children. Quiltmakers were able to explore the subject by conversing through email, even though they were scattered in distant parts of the country.

Project Linus is another ongoing nonprofit effort supported by quilters who provide local children in crisis or in need a handmade quilt of their own. There are 405 chapters of Project Linus throughout the country. Many quilt guilds are perennial supporters of the project, with their members making quilts for local children.

International Quilt Festival has donated free booths and publicity for a number of charitable causes or organizations to be able to reach the public with their message, solicit support or donations, or otherwise further the causes with which they are associated. They include The Congenital Heart Defect Awareness Quilt Project, the Hope and Dreams Quilt Challenge for ALS, Houston Hospice (end of life care), KN Quilt for a Cause (breast cancer), M. D. Anderson Cancer Center Ovarian Cancer Awareness Project, Patchwork Promise (breast cancer cause of the Girl Scouts), Project Linus (quilts and blankets for children), The Quilt: A Celebration of Survivors (Canadian breast cancer awareness), Susan G. Komen Quilt for the Cure, The Rose (Houston-based Komen affiliate providing free mammograms for low-income women), SEARCH (program assisting the homeless), St. Jude Quilt of Hope, Susan G. Komen Quilt Project (breast cancer), Wrap Yourself in a Rainbow (crisis therapy). Also the Ethiopian Orphans Quilt Project/ Quilts Beyond Borders, Mary Fisher: Abataka (AIDS), the Million Pillowcase Challenge (children's charities), the LoveQuilt Connection, and Rowenta's Iron-a-Thon (breast cancer).

Quilters are by no means the only generous segment of quilting. Quilt industry suppliers themselves support many worthy causes. For example, Kaye Wood's LoveQuilt Connection began in 1993, with a coordinator working with volunteers at quilt and sewing shows to make quilts on site for a local charity, which in turn distributes them to the needy. Thousands of quilts have been made and distributed through the LoveQuilt Connection.

On several occasions, when notified of a need, industry suppliers have donated fabric, notions,

thread, batting, needles, scissors, books, patterns, and many other related goods left over at their International Quilt Market display booths instead of shipping them back to warehouses after the show. On one such occasion, a quilt retailer was totally wiped out by a severe tornado. The donated goods, shipped free by the Market's long-time commercial decorator, made it possible for that retailer to reopen her business . . . and begin to put one part of her life back together at least. Another time, supplies from Market exhibitors were shipped to Russian quilters who wanted to make quilts but had no access to the items needed to do so. And, in 1990, at a Patchwork and Quilt Expo in Odense, Denmark, just after the Berlin Wall came down and Germany was soon to be reunified, American suppliers at the event donated money to help feed East Berlin quilters who had arrived at the show but whose currency was no longer accepted. West German quilters pitched in to help also, doubling up to provide free rooms for their East German counterparts, and Danish restaurants devised low, fixed-price menus in exchange for vouchers purchased by the suppliers' funds.

Rise of Quilt Organizations

Many of the cause quilts detailed above were undertaken or popularized and publicized by or through quilt organizations, many of them nonprofit. These organizations began as early as the 1970s and as late as the 1990s, some focusing on scholarship; others on setting standards for the quilting, judging, and appraising of quilts; others on fostering the spread of quilting worldwide; and still others on documenting oral histories, quilt archives, and honoring leaders in the quilt renaissance. These organizations are major forces in the quilt world and can marshal significant support for worthy causes and projects.

The National Quilting Association, begun by seven Washington, D.C.–area women in 1970, was chartered as a nonprofit (501c3) in 1972. Now based in Columbus, Ohio, the NQA has 5,500 members, and two hundred affiliated guilds in thirty-three states. It was established "to create, stimulate, maintain, and record an interest in all matters pertaining to making, collecting, and preserving of quilts, and to establish and promote educational and philanthropic endeavors through quilts." It offers members a teaching certification program and a judging certification program, recognizes master quilters whose work meets certain standards, gives grants and scholarships, and holds an annual show that travels to different locations.

The Quilters Hall of Fame, founded by Hazel Carter in 1979, is a nonprofit (501c3) entity dedicated to honoring those who have made outstanding contributions to quilting. It is located in the Marie Webster House in Marion, Indiana, the home in which Marie Webster designed quilts and ran her successful pattern company from 1902 to 1942. The Webster House has been placed on the National Register of Historic Places, designated a Landmark of Women's History, and declared a National Historic Landmark by the National Park Service, "the only one which honors a quiltmaker," according to Hall of Fame literature.

The International Quilt Association (IQA) was founded by the authors and their mothers, Jewel Pearce Patterson and Helen Pearce O'Bryant, and incorporated as a nonprofit (501c3) organization in 1979 in Houston, where it is based. IQA is dedicated to preserving the art of quilting and to advancing the state of the art throughout the world, and its nearly 6,200 members come from thirty-seven countries. It offers members a quarterly journal, *Quilts: A World of Beauty*, a grant program, and a teachers' registry. In addition, it holds a judged show of members' works, the largest in the U.S., also called "Quilts: A World of Beauty," each fall in conjunction with International Quilt Festival in Houston. It also has a judged show of members' quilts each spring on the theme "Celebrate Spring!" in conjunction with the Festival's spring show, previously in Chicago for eight years, and in Cincinnati from 2011 forward. Together, the two judged shows offer more than $100,000 in prizes donated by industry suppliers. The largest individual award is the Handi-Quilter Best of Show $10,000 prize. In addition, IQA sponsored the biennial Patchwork and Quilt Expo in Europe for many years in Salzburg, Austria;

Odense, Denmark; The Hague, the Netherlands (twice); Karlsruhe, Germany; Lyon, France (twice); Innsbruck, Austria; Strasbourg, France; and Barcelona, Spain.

In 1993 four founders, including the authors, established another nonprofit (501c3) organization, the Alliance for American Quilts. Its aim is to document, preserve, and share America's quilt heritage by collecting the stories of historic and contemporary quilts and their makers, which tell about our nation's diverse people and their communities. The Alliance has formal partnerships with two academic institutions: the Great Lakes Quilt Center at Michigan State University Museum in East Lansing, Michigan, and Winedale, a division of the Briscoe Center for American History at the University of Texas at Austin. These centers implement Alliance projects within their geographic regions and take leadership roles in coordinating one or more Alliance projects at the national level. Both also maintain extensive quilt and quilt history collections, offer public programs on quilts, and facilitate quilt research.

Alliance programs are Quilters' S.O.S.—Save Our Stories, a national grassroots oral history project capturing the stories and culture of today's quiltmakers. The project includes transcribed interviews and photographs, which are archived and available for research at the Library of Congress American Folklife Center. Quilt Treasures is an additional oral and video history project documenting the lives, work, and influence of leaders of the American quilt revival of the 1960s and 1970s.

The Quilt Index provides online access to documentation and images of quilts in public and private collections. Approximately 50,000 quilts can be accessed. The Index is a joint project of the Alliance and Michigan State University through MATRIX and the MSU Museum. It has received funding from the National Endowment for the Humanities and the Institute for Museum and Library Sciences.

Boxes Under the Bed educates the public about identifying, preserving, and making accessible archives and ephemera of quilt history. Winedale, the Briscoe Center for American History, the University of Texas at Austin, and

Michigan State University are partners with the Alliance in developing the project, which will include making quilt history documentation available for research in an institutional setting; offering digital examples of quilt history in a browsing gallery on the Alliance website; and training local researchers to identify and rescue quilt-related documentation in need of preservation.

H-Quilts is an online, moderated discussion list that makes possible the sharing of information among individuals involved in quilting research and documentation. It provides a forum for raising issues and reporting findings about exhibitions, collections, publications, research projects, and other topics within a virtual worldwide community of subscribers. This network, part of H-Net: Humanities and Social Sciences Online, was developed by the Alliance with the American Quilt Study Group and Michigan State University.

The American Quilt Study Group is another nonprofit (501c3) organization which began in California in 1980, and is now located in Lincoln, Nebraska. It is a leader in quilt scholarship, publishing *Uncoverings*, the journal of papers presented at its annual seminar. Topics include essays that represent advances in quilt and related research in such areas as cultural roles of quilting and quilters, period analysis of quilting, and studies of quilt media. AQSG also publishes a quarterly newsletter called *Blanket Statements*, containing research articles and information for members, along with technical guides providing information on a range of topics.

The American Quilter's Society (AQS), a membership organization located in Paducah, Kentucky, began in 1984. It publishes the bimonthly *American Quilter* magazine, an online newsletter, and conducts quilt shows that have been held in Paducah since 1985. In 2009, it added a magazine called *The Quilt Life*. It also holds shows in Des Moines, Iowa; Knoxville, Tennessee; and Lancaster, Pennsylvania. In addition, the founders of AQS established a quilt museum in Paducah in 1991 to house a quilt collection that includes some of the winners of AQS shows. AQS also publishes and distributes books and offers a quilt appraiser certification program.

The State Quilt Documentation Projects

Realizing that historic quilts were disappearing without a trace, quilters began a major push to document the quilts in their states. A movement that began in Kentucky in 1981 and was further developed in Texas in 1983–1985 spread to virtually every state in the nation, and in addition, incorporated a number of regional quilt documentation efforts. These grassroots efforts involved documenting and photographing quilts; recording their family history, their age, and how they were made; noting physical information such as their size, fabrics, pattern, stitching, and any other pertinent details; and detailing to some degree oral histories associated with the quilts. Individuals and groups such as quilt guilds, historical associations, arts groups, and other organizations participated, both in the conducting of and the participation in quilt search efforts. A true grassroots phenomenon, the state quilt documentation projects were an enormous success. The information they amassed provided detailed records on tens of thousands of quilts. Participation in the projects, whether as an organizer or as an individual who brought a quilt to be documented, created a newfound respect for quilts as cultural and historical records. In fact, the documentation projects were such a success that efforts to duplicate them abroad have been studied and undertaken.

Growth of the Art Quilt

By the end of 1986, the year of the Texas Sesquicentennial, quilts had already begun to change. Many quilts grew smaller because they were being made for the wall, to be displayed as art . . . even being called "wall quilts" because they were never destined for the bed. Circular quilts were tried, as were quilts of other shapes. There was also a move toward miniaturization. Of course, quilts had always been made for babies, and crib quilts are a recognized genre of quilt collecting. Doll quilts the size of doll beds had also been made for generations of little girls and their dolls. But quilt blocks themselves, the basic building blocks of full-sized quilts, began to be displayed at quilt shows. Later, in shows of tours de force, quilters began miniaturizing whole quilts.

Quilters also began pushing the envelope of the expected, and the accepted. In 1982, at the judged show of the American International Quilt Association (now the International Quilt Association), held in Houston, the Best of Show designation went to Katie Pasquini (now Pasquini Masopust) for *Threshhold of a Dream*, the first art quilt to win a major award. That a renowned traditional quilter, Jinny Beyer, awarded the prize created almost as much of a stir. Six years later, in 1988, the first machine-quilted quilt to win the IQA show was Lois Tornquist Smith's *Golden Memories of Christmas*.

And while quilters were experimenting with and challenging ideas about traditional quilt sizes and construction, they also began to experiment with materials. From traditional cottons, wools, and the silks, velvets, and other luxurious fabrics used in crazy quilts, quilters branched out to batiks, synthetics, and upholstery fabrics; from tiny chintzes to large-scale designs; from traditional conversation prints such as horseshoes and riding crops to novelty prints featuring tools from a man's workbench and kitchen utensils. They also began dyeing and marbleizing fabric for their quilts.

Some quilters began to construct quilts to tell stories, create landscapes, record events, and depict people. Quilters began to transfer photo-

graphs to fabric to be incorporated into quilts. They began to embellish with buttons, beads, lace, ribbon, and other typical decorations found among sewing supplies, but then moved from that to shisha mirrors, metal pop-tops, doll hair made of roving, shells, tiny charms or milagros, or anything else that caught their fancy.

A formerly very traditional quilter, Ted Storm-van Weelden of the Netherlands, won Best of Show in 2001 at IQA's judged show for *Noctural Garden*, a quilt embellished with beading and handmade mirrors. In 2004, at another IQA show in Houston, Best of Show went to a painted-surface quilt for the first time: *Precious Water* by Hollis Chatelain, who also heavily embellished the quilt with threadwork. Machine quilted quilts, frowned upon until Smith's earlier win in 1988, were accepted routinely into shows and began to win alongside their hand-quilted sisters. The next barrier to fall came in 2005, with the first longarm-quilted quilt to win IQA's Best of Show, Sharon Schamber's *Scarlet Serenade*.

With the rise of the art quilt has come the ignoring of, or rewriting of, traditional tenets of quiltmaking, an acceptance of machine quilting, longarm quilting, quilt embellishing, quilt deconstruction, painting, dyeing, printing, distressing, fusing, searing, and many other means of treating cloth and other materials used in art quilts. And along with all that have come shows and organizations created specifically for the art quilter. While art quilts can now be found at all major quilt competitions in the U.S., in 1979, Quilt National was the first exhibition to be created *for* the art quilt. As noted in its history, Quilt National spotlights "the transformations taking place in the world of quilting. Its purpose is to carry the definition of quilting far beyond its traditional parameters and to promote quilt-making as what it always has been—an art form." Held biennially in Athens, Ohio, at the Dairy Barn Cultural Arts Center, Quilt National takes place in what was originally part of a 1914 functioning dairy barn, now on the National Register of Historic Places.

In 1989, Yvonne Porcella founded the Studio Art Quilt Associates, which incorporated as a nonprofit (501c3) organization in early 1990. The aim of SAQA is to promote art quilts, educate the public about art quilts, serve as a forum for the development of quilt artists, and act as a resource for curators, dealers, consultants, teachers, students, and collectors.

Art to Wear

While quilted vests have been on the quilt scene since the 1970s, it wasn't until a major showcase for wearable art was established at International Quilt Festival/Houston that art garments found their niche. Quilted wearable art hit the runway at the Festival in 1979 with the Concord-Fairfield Fashion Show, which continued as the Fairfield Fashion Show until 2000, and was taken up by Bernina of America as the Bernina Fashion Show until 2008. During that time, the bar was set high for wearable art. The fashion show was an invitational event that designers vied to be chosen for, submitting portfolios of their designs a year or more in advance to a jury for selection. It was a major runway production, staged with professional models, set, lighting, music, and commentary, and when the Festival moved to the George R. Brown Convention Center in 1987, the fashion show was held in the Center's theater. While there is no flagship fashion event such as that at present, International Quilt Festival continues to feature art garments at the Stitch in Time fashion event and in periodic special exhibits, and wearable quilt art can be found in the aisles of any quilt show, as attendees sport their latest styles. Books, too, were devoted to wearable art from the 1990s forward. Judy Murrah's *Jacket Jazz* series of five books, published between 1993 and 2003, were bestsellers for That Patchwork Place, and created a trend of art jackets among quilters.

The Twentieth Century's Best Quilts

On the cusp of the millennium, lists of the "100 best" in many categories were publicized. Nowhere was there a list of the best quilts. Karey Bresenhan decided that was unacceptable for a century that had seen the phenomenon of the quilt renaissance in America. She enlisted the

help of the major nonprofit quilting organizations, who named representatives of their organizations to a committee that nominated 1,720 quilts worthy of being recognized. Many ballots later, when the final one hundred had been selected, International Quilt Festival/Houston created an art gallery at its fall 1999 show, with a special entrance, subdued lighting, and hard walls, where the quilts chosen were hung as art. Each member of the committee was assigned quilts to write about for a special publication, *The Twentieth Century's Best American Quilts: Celebrating 100 Years of the Art of Quiltmaking*, introduced at the show by Primedia. The book sold out several times during the Festival, and the exhibit remains a treasured memory, both for the quilt artists whose works hung there, and for the attendees who saw those quilts displayed as the art they are.

Texas As Quilt Nexus

Texas—home to the International Quilt Festival, the International Quilt Market, the world's only trade show for the quilting and soft crafts industry, and the (501c3) nonprofit International Quilt Association—is a major center of quilting. All come together each fall in Houston, where the Market trade show precedes the Festival consumer show at which the IQA's judged show winners are announced and awarded close to $100,000 in prizes. This confluence of events makes Houston, and Texas, Quilt Central each fall. It's where new products are introduced, designers and authors make contacts with suppliers and publishers, product makers find distributors, thousands of students take hundreds of classes with a faculty of experts over the course of a week, and the general public and media converge to find out what's new in quilts and quilting, as well as to shop in 1000 to 1500 booths, all in more than a half-million square feet, or a hall big enough to hold nearly nine football fields. And that's just on one floor . . . there are two others occupied by the shows. It's no exaggeration to say that Houston, Texas, is where networking in the quilt world takes place.

To illustrate how important these events are, not only for the quilting industry but for the city of Houston, the annual International Quilt Festival, the largest quilt event in the United States and one of the largest in the world, annually brings in approximately $20 million to the city's coffers, and is perennially one of its largest conventions. It draws in excess of 60,150 attendees, and hosts its own electronic event, Quilt Festival@Home, for those who cannot attend in person, as well as its own show magazine, *The Quintessential Quilt*. In addition, it has spun off its own spring and summer festivals in other cities. Making an annual pilgrimage to the Festival in Houston to attend classes, however, is still a rite of passage that marks the serious quilter.

When you add International Quilt Market to the Festival, the financial benefit to the city is even greater: the total amount is more than $52.8 million, according to city figures based on a formula devised by Destination Marketing Association International.

So quilting is big business. But until fairly recently, the size of that business throughout the United States had never been measured.

Measuring Quilting

For twenty years, between the early 1970s and 1990s, estimates of the increasing interest in quilting were anecdotal and apocryphal. Beginning in 1994, however, *Quilters Newsletter*, the first major consumer quilt magazine, and Houston's International Quilt Festival embarked on a project to quantify the growing phenomenon of the post-Bicentennial renaissance in quilting and the buying power quilting represents in the U.S. The 2010 survey is the sixth Quilting in America survey since 1994 to measure the amount of time and money quilters spend on their pastime.

The statistical methodology has remained the same in all surveys. A first phase measures 20,000 U.S. households to determine how many quilters there are in the country and how much they spend on quilting. A second phase surveys 2,500 "Dedicated Quilters" to learn more about them, their quilting habits, and their buying behaviors.

The survey also measures what techniques of quilting devotees enjoy; what quilting-related products and supplies they own; their preferences in books, magazines, and online sites; and

their quilting skill level. Quilting in America is remarkable for the consistently high response rates it generates—63% and 60% for phases I and II, respectively, in 2010.

At present, the sixth such survey, released in spring 2010, reveals that quilting enthusiasts spend almost $3.6 billion annually on their passion. Spending increased nine percent since the previous survey in 2006. Currently, 16.38 million U.S. households are home to at least one active quilter, and the total number of quilters in the United States now exceeds twenty-one million. The average yearly expenditure among all quilting households was up 27% over the previous survey.

We know much more than anecdotal information about quilters now. We know there's a subgroup, the dedicated quilter, which is affluent ($91,602 annual household income), well educated (72% attended college), and technologically savvy (91% own a computer and access it regularly). She's older (sixty-two years old), has quilted about sixteen years, and may spend anywhere from twenty-five to sixty-four hours per month on quilting. She likes both traditional and contemporary quilts and quilting almost equally. She generally has a room set aside for quilting and sewing, and she may own four or more sewing machines. She continues to spend money on what she likes: on average she has $8,542 worth of quilting tools and supplies and owns $3,677 worth of fabric. Nearly 20% reported spending on a new sewing machine during 2009.

So all indications are that quilting is healthy for the foreseeable future. The main challenge for the industry is to expand its appeal to younger quilters, an effort that is gathering force.

Quilt Museums Established

In the conference room of Quilts, Inc., home of International Quilt Festival and Market, there's a framed quote from Hannibal, the military commander of ancient Carthage, to his generals when they declared it impossible to cross the Alps with elephants: "We will either find a way or we will make one." For many years, quilters

struggled to gain the respect of the art world for their work. Finding the way almost universally blocked as far as seeing quilts represented in major art museums, quilters and quilt organizations could be said to have adopted Hannibal's mindset. They made their own way, founding museums that showcased fine quilt art.

The San José Museum of Quilts and Textiles began in 1977 with mainly late nineteenth- and early twentieth-century quilts from its founders' collections when the Santa Clara Valley Quilt Association opened what was then known as the American Museum of Quilts and Related Arts. It was the first museum to focus completely on quilts and other textiles. The museum has expanded its objectives from recognizing the role of San Francisco Bay Area artists in quilting and other textile arts in the late twentieth century to enlarging its historical quilts and ethnic textiles collections. It was housed in a storefront in Los Altos and in various other locations before purchasing an historic 1923 facility in 2003 and relocating there in 2005. Its collection consists of approximately 550 items and a library of more than 500 items on the history and making of quilts and textiles. One aspect of its programming, Kids Create, is aimed at providing children five to ten years old a hands-on art project on one Sunday each month.

The Rocky Mountain Quilt Museum was the dream of Eugenia Mitchell, who worked diligently to create a home for the quilts she had made and collected. In 1981, others joined with her to incorporate and begin fundraising, but it wasn't until 1990 that the museum was opened in Golden, Colorado, in one room that housed an exhibit, a gift shop, and collection storage. In 2009, the museum and gift shop moved into one building and the 3,000-volume Sandra Dallas Library and administrative office moved to a separate location. The museum now houses more than 600 quilts in its permanent and its educational collections. It offers educational outreach via traveling trunk shows for area groups and organizations.

The New England Quilt Museum in Lowell, Massachusetts, a historic textile-producing city, is housed in an 1845 Greek Revival brick building that is on the National Register of Historic

Places. The museum opened in 1987, and contains more than 300 antique and contemporary quilts and quilt tops, plus related textile and sewing items representing the history of American quiltmaking. Its 18,000-square-foot building contains galleries, a library, classrooms, and a museum store. In 1991, the museum received a donation of antique quilts from the Binney family that now numbers 60 and which is augmented annually by an additional donated quilt. A nonprofit (501c3) institution, the museum has strong ties to the 150 quilt guilds in six New England states, 100 of which help support it financially.

The People's Place Museum opened in 1988 in Intercourse, Lancaster County, Pennsylvania, in a gallery above the historic Old Country Store. Begun by Merle and Phyllis Pellman Good, who serve as curators and directors, the museum mounts an annual exhibition which has featured antique Amish and Mennonite quilts, as well as contemporary quiltworks.

The building housing the Museum of the American Quilter's Society, now called the National Quilt Museum, was constructed in 1991 especially for the museum, which is located in Paducah, Kentucky. It includes three galleries totaling 13,400 square feet, with moveable walls that allow flexible exhibition space in the galleries. There are also classrooms, a conference room, a museum shop, offices, storage, and work areas. The museum's lobby features stained glass windows based on quilt designs which were the work of a Kentucky artist, and which were a gift from Meredith and Bill Schroeder, co-founders of the nonprofit (501c3) museum, who also donated five bronze sculptures entitled *On the Trail of Discovery*. The sculptures, which celebrate the link between Paducah, home of the museum, and Meriwether Lewis of Lewis and Clark Expedition fame, are located on the museum's front lawn.

The International Quilt Study Center and Museum (IQSC), located at the University of Nebraska-Lincoln, in Lincoln, Nebraska, houses one of the largest known public quilt collections. Founded in 1997 with a donation by Ardis and Robert James of their more than 900 quilts, the IQSC now houses some 3,000 quilts, along with research and storage space and galleries, in a specially designed building opened in 2008. A lead gift from the Jameses, supported by private funds from the University of Nebraska Foundation, made possible the construction of the new building. Quilts in the IQSC collection range from early American quilts to contemporary art quilts, and include examples from twenty-four countries, dating from the early eighteenth century to the present.

In March 2004, the Lancaster Quilt and Textile Museum opened, and it reopened after extensive renovation and expansion, in November 2007. It is located in a 1912 Beaux Arts former bank building that had been empty for some years. The nucleus of the museum's collection is the former Esprit Collection begun by Doug Tompkins, consisting of quilts made by Amish women in Lancaster County, Pennsylvania, between the 1870s and the 1940s. The museum is part of the Heritage Center of Lancaster County, a nonprofit (501c3) entity.

July 2004 saw the Quilters Hall of Fame move its headquarters into the restored Marie Webster House in Marion, Indiana. A museum is maintained there, and exhibits, workshops, seminars, and an annual quilt celebration take place. It is also the location for the induction of new honorees into the Hall of Fame.

The newest quilt museum, the Texas Quilt Museum, opens in fall 2011, in the historic town

of La Grange in Central Texas. It occupies two 1890s buildings that are part of the town square, which is dominated by a historic restored courthouse. Recently restored as well, the museum buildings occupy a treasured place in the town's history. A nonprofit (501c3) institution, the museum will have approximately 10,000 square feet of exhibit space, a research library that will eventually house the Texas Quilt Archives, a material culture collection, a museum shop, and offices. A non-collecting museum, it will offer unique traveling exhibitions. One unusual characteristic of the museum will be a specially commissioned mural featuring quilts and quilting on the museum's outer brick wall. The mural will be the focal point of a period dyeing and kitchen garden typical of nineteenth-century Texas farms and ranches that is planned for adjacent museum property.

Art Museums Accept Quilts

Traditional art museums have occasionally nodded in the direction of quilts. As far back as 1929, the Museum of Fine Arts Houston (MFA/H) mounted a quilt exhibit, noted only as "An Exhibition of Quilts." From November 1980 to January 1981, the MFA/H showed "Baltimore Album Quilts," although the very fine and very large quilts were consigned to a small lower gallery where it was somewhat difficult to get a perspective on them.

In 2001, however, the Museum participated with the Blaffer Gallery, the Art Museum of the University of Houston; the Holocaust Museum Houston; and International Quilt Festival in "Quilts Blanket Houston," a joint project, jointly publicized, involving three major exhibitions of quilts, in addition to the Festival's annual fall show. "American Traditions: Quilts and Coverlets, 1760–1900" ran from October 28, 2001, until February 17, 2002, then was extended until April 7, 2002, at MFA/H. Bus tours and shuttle buses from the Festival deposited hundreds of attendees at the exhibit . . . and at the museum's gift shop, which registered tremendous sales, according to all accounts. Thousands more made their own way to it and to the two other museums, where the Blaffer Gal-

lery mounted "Spirits of the Cloth: Contemporary Quilts by African American Artists" and the Holocaust Museum Houston showcased "Cover Them: A Quilt Installation by Rachel Brumer."

Since then, MFA/H has initiated two more exhibitions of quilts, both of which had extended touring schedules to other museums. "The Quilts of Gee's Bend" was originated by the museum and its curator, Alvia Wardlaw, along with Anthony Gerard Thibodeaux. It ran from September 8, 2002, to November 11, 2002, then started an extended tour to the Whitney Museum of Art, the Mobile Museum of Art, the Milwaukee Art Museum, the Corcoran Gallery, the Cleveland Museum of Art, the Chrysler Museum of Art, the Memphis Brooks Museum of Art, the Museum of Fine Art–Boston, the Jule Collins Smith Museum of Art at Auburn University, the High Museum of Art, the Fine Arts Museums of San Francisco (the Legion of Honor Museum and the M. H. de Young Memorial Museum).

A second exhibition called "Gee's Bend: The Architecture of the Quilt" was another success for the museum and Wardlaw. Following its run at MFA/H, from June 4, 2006 to September 4, 2006, it toured the Indianapolis Museum of Art, the Orlando Museum of Art, the Walters Art Museum in Baltimore, the Tacoma Museum of Art, the Speed Art Museum in Louisville, the Denver Museum of Art, and the Philadelphia Museum of Art.

The Virtual Quilt World

The Internet, the World Wide Web, and social networking are extending the reach of quilters all over the world, and changing the way they work. Quiltmakers everywhere are prodigious users of the Internet and of social media, networking with each other by email; providing their guild members with information digitally; searching suppliers' websites for products; downloading patterns; creating quilts using special software; purchasing computerized sewing machines; accessing show websites for information and to enroll online for classes; receiving electronic magazines (e-zines); receiving their local quilt shop's newsletter via email; blogging

about their quilts and their quilt-related travel; joining H-Net's H-Quilts listserv, the electronic newsletter linking scholars, historians, and others; corresponding with quilters all over the world via email, Facebook, and Twitter; taking online classes; reading quilt books on Kindle or Nook; getting email "blasts" about special offers for goods and services related to quilting; buying and selling quilts online; and much more. It's a wired, wired world, where quilters are concerned.

As change takes place in that world at a faster pace than ever before, quilters are staying up with it. Women are busier? Now you can make a quick quilt in twenty-four hours! Want to decorate with quilts but live in a tiny apartment?

Collect miniature quilts. Like the tactile appeal of quilts but prefer a clean, modern look? Take up contemporary quiltmaking and produce abstract art. Love your computer job at a dot. com, work late hours, and miss the warmth of connecting with friends? Join one of the countless chat rooms devoted to quilting . . . your odd hours won't be a problem with quilting friends in Indonesia or Australia. Or get an electronic pen pal who loves quilts as much as you do and design a quilt together via email.

Once considered a dying craft, quilting is now a vibrant art form, winning new converts who are building on past traditions but making new ones as well. It's a new millennium for quilting.

The Quilts

Captain Tom, A Tall Texan

1986

SIZE IN INCHES: 72 X 72

TEXAS LOCATION: Dallas

MADE BY: Shirley Fowlkes
Stevenson

STYLE OF QUILT: Traditional

SOURCE OF DESIGN: Original
design

MATERIALS USED: Cotton

PRIMARY TECHNIQUES: Hand
appliqué and embroidery,
hand quilting with stippling

This quilt was made to commemorate the life and times of Shirley's pioneer great-grandfather, Captain John Files Tom, and his contributions to Texas history. The Tom family came to Texas from Tennessee when he was seventeen, a 6'5" barefoot boy; they traveled by ships and oxcart to Washington-on-the-Brazos. He fought in three key battles of the Texas Revolution—Mission Concepcion, San Antonio, and San Jacinto. Because he had no shoes and socks, his mother would not at first give permission for him to leave for San Antonio, but a girl gave him her new pink wool stockings. Teased as "The Boy Who Went to War in a Girl's Stockings," he's shown on the quilt wearing those pink stockings. He and his father were part of the company of about one hundred men left to guard the Alamo after the Texians captured it, but they left in February 1836 to protect a friend. "I would not be here to tell this story had they stayed at the Alamo," says Shirley, referring to the massacre of March 6, the Battle of the Alamo. Captain Tom was wounded at the Battle of San Jacinto (when the Texians routed the Mexican army to assure independence for the republic). He later was elected sheriff of Guadalupe County, became a Texas Ranger and fought in the Indian wars, and served in the thirteenth Texas Legislature. All of these events and activities are illustrated on this quilt, a true masterpiece of pictorial appliqué. The quilt has won several Best of Show awards, and other work by this quilt artist appeared in *Lone Stars II: A Legacy of Texas Quilts, 1936–1986.*

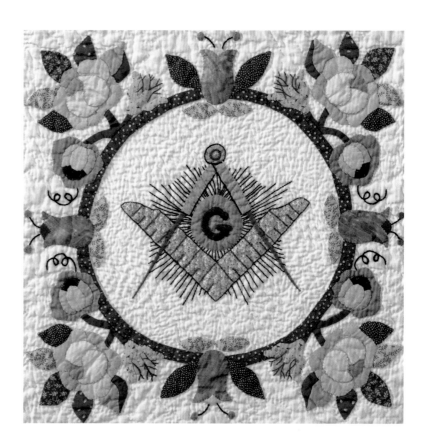

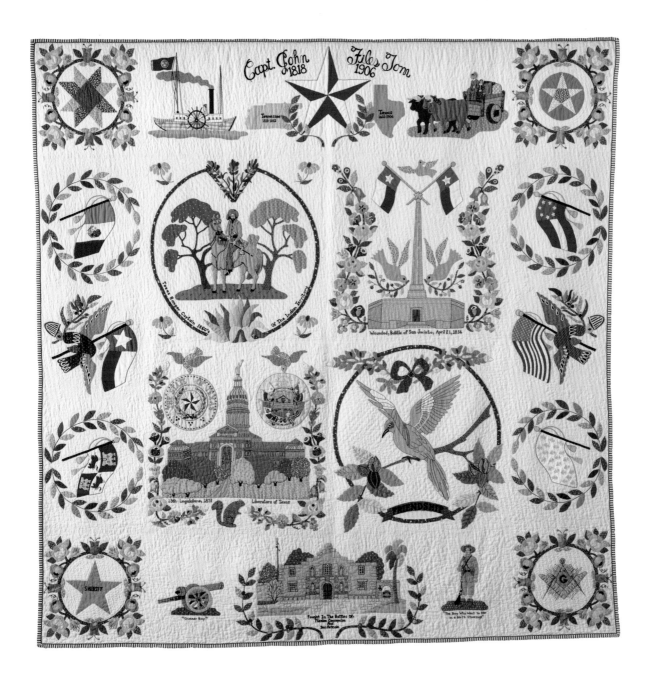

Reflections at Sunset

1987

SIZE IN INCHES: 67 x 87

TEXAS LOCATION: Houston

MADE BY: Janet Steadman

STYLE OF QUILT: Traditional

SOURCE OF DESIGN: Based on
 Tumbling Block design

MATERIALS USED: Cotton

PRIMARY TECHNIQUES: Hand
 piecing, hand quilting

An early art quilt, this optical illusion design was based on a pattern that can be used to great effect in architectural quilts, where the coloration of the blocks can create the mental picture of buildings and cities. Here, Janet's placement of color not only conveys the light at sunset but also resembles the choppy surface of a body of water. The quilt artist lived in Houston when this award-winning quilt was made, but she subsequently moved out of state.

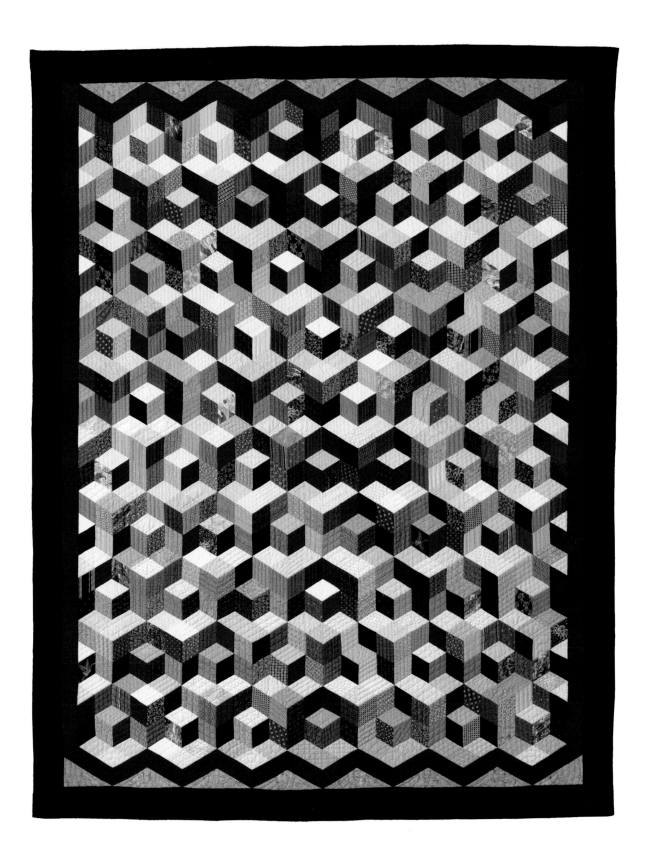

Spiral Progression

SIZE IN INCHES: 120" round

TEXAS LOCATION: Houston

MADE BY: Janet Steadman

STYLE OF QUILT: Art

SOURCE OF DESIGN: Needed quilt for round bed

MATERIALS USED: Cotton

PRIMARY TECHNIQUES: Machine piecing, machine quilting

Experimenting in gradations of blue, red, and brown, the quilt artist often used a dozen different hues of each color to create this unusual spiral effect. The quilt was made for a round bed, which was quite the rage in the 1980s. Janet lived in Texas when this quilt was made.

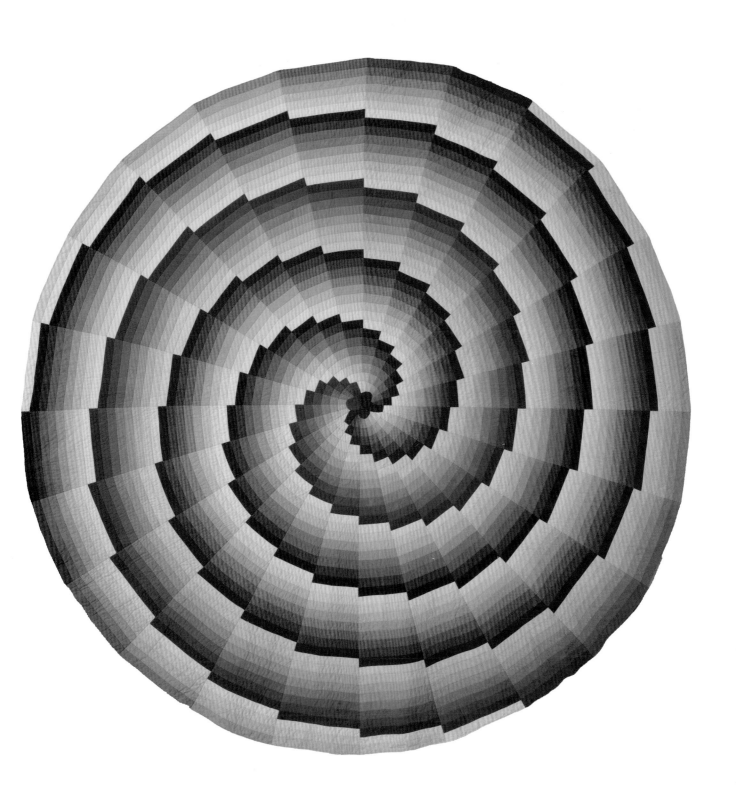

Pulse Star

1988

SIZE IN INCHES: 84 x 84

TEXAS LOCATION: Dallas

MADE BY: Shirley Fowlkes
Stevenson

STYLE OF QUILT: Traditional

SOURCE OF DESIGN: Antique
quilts

MATERIALS USED: Cotton

PRIMARY TECHNIQUES:
Machine piecing, hand
quilting

Placing light and dark fabrics differently in each point of the star causes the star to appear to pulsate. "The small stars in the background give the feeling of a galaxy," states the artist. This piece was inspired by antique quilts and has won multiple awards in Texas and Pennsylvania. Work by this quilt artist was also shown in *Lone Stars II: A Legacy of Texas Quilts, 1936–1986.*

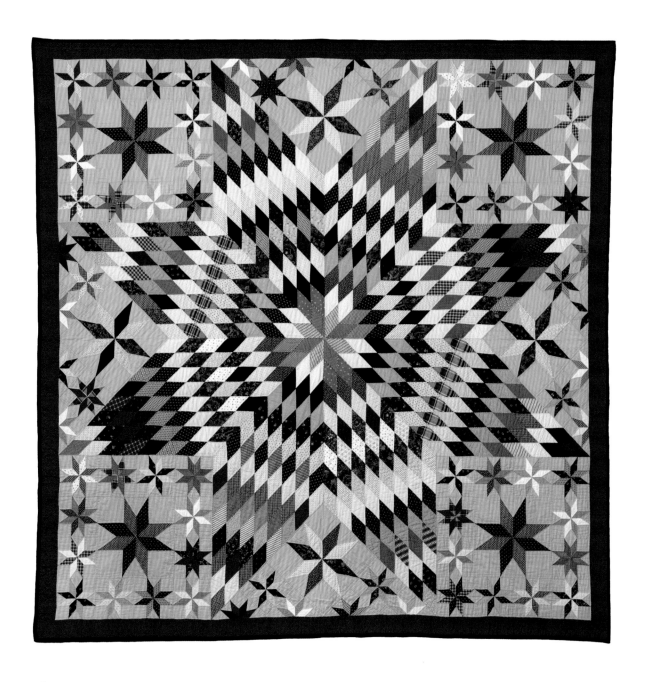

Princess Feather and Rose of Sharon

SIZE IN INCHES: 84 x 84

TEXAS LOCATION: Dallas

MADE BY: Dana Greenberg Klein

STYLE OF QUILT: Traditional

SOURCE OF DESIGN: 1860s Vermont quilt

MATERIALS USED: Cotton

PRIMARY TECHNIQUES: Appliqué, reverse appliqué, hand quilting

Fine traditional quilts will always be loved and respected. This distinguished example was inspired by a quilt made by Lutheria Babbitt Johnson in Vermont in the 1860s and is quite accurate in its duplication, even to the elaborate hand quilting. Dana entered the quilt in its first competition with "incomplete" quilting; "more complete" quilting for its second appearance; and "complete" quilting by the time of its final entry. "I used each show's entry deadline as motivation to complete the quilting!" she said.

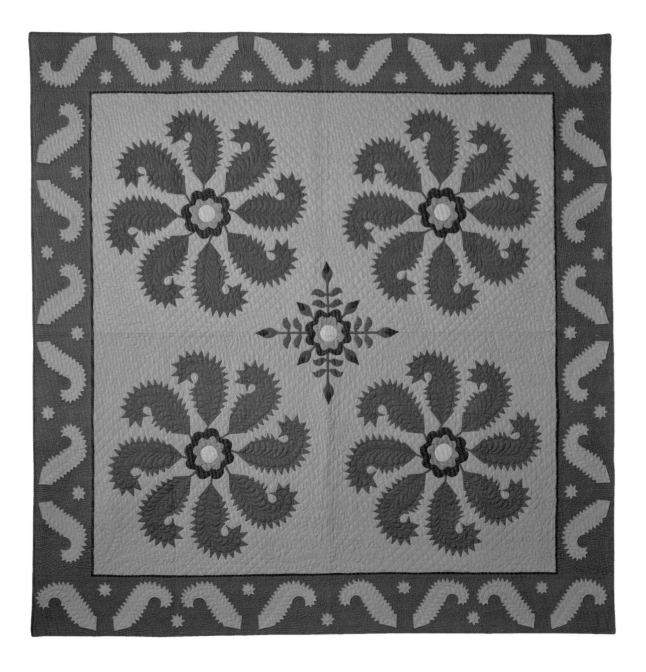

6 x 6 Comes Up Roses

1990

SIZE IN INCHES: 87 X 101

TEXAS LOCATION: Austin

MADE BY: Kathleen Holland
McCrady

STYLE OF QUILT: Traditional

SOURCE OF DESIGN: Center
based on museum quilt

MATERIALS USED: Cotton

PRIMARY TECHNIQUES: Hand
piecing and appliqué, hand
quilting

After seeing a photograph of a nineteenth-century quilt in the collection of the Long Island Historical Society, this prolific quiltmaker, a master of traditional quilts, duplicated the center design of six-pointed stars and based the multiple borders on other period patterns. Kathleen admits that it was only after she started this quilt that she realized how challenging it would be. The star and grid pattern is intricate, with up to ten points coming together. "Anyone who quilts knows it's tedious to get that many pieces to come together right," she says. Kathleen also led the way in what has come to be a national trend, that of creating a completely different design for the reverse side of the quilt. The maker of this award-winning quilt was one of the artists featured in *Lone Stars II: A Legacy of Texas Quilts, 1936–1986*.

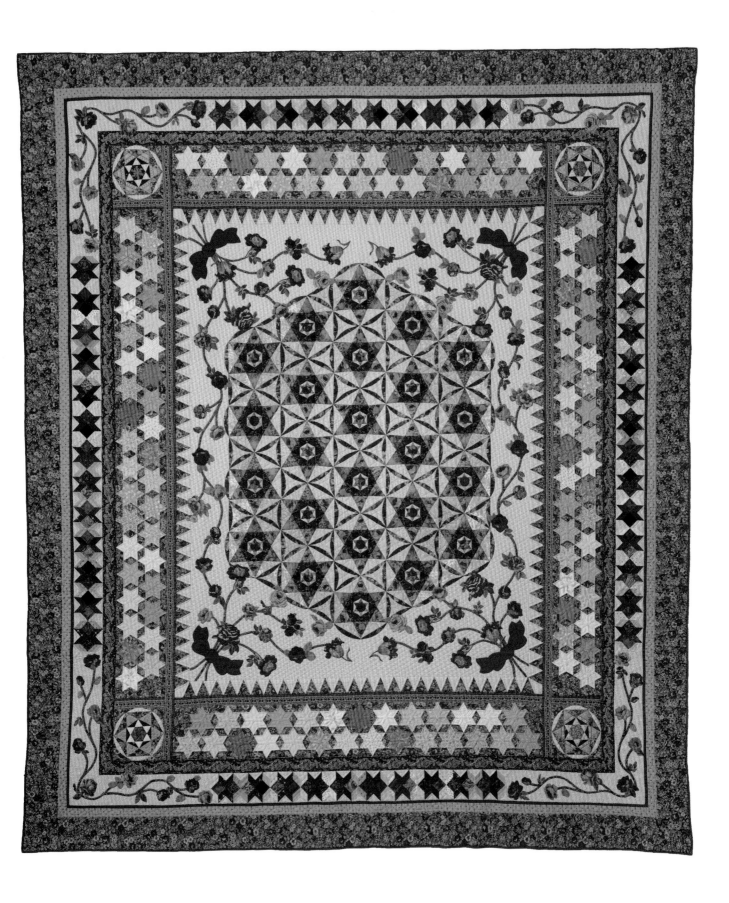

Expectations #4: Mixed Emotions

SIZE IN INCHES: 72 X 72

TEXAS LOCATION: Dallas

MADE BY: Sue Benner

STYLE OF QUILT: Art

SOURCE OF DESIGN: Based on Railroad Crossing design

MATERIALS USED: Cotton and blends

PRIMARY TECHNIQUES: Dyeing, painting, machine piecing, machine quilting

Double-sided quilts are a Texas tradition, going back to the nineteenth century. Texas-Germans often had Sunday houses they used only when their large families came to town for the weekend. Double-sided quilts allowed one side to take the wear and tear of the weekends, while the other side was kept nice during the week. Sue made her brilliantly colored reversible quilt as the fourth and last in a series; it was made while she was pregnant with her first child. Although it draws on several traditional patterns, the artist's use of painting and dyeing and her creative placement of the designs firmly identifies this quilt as an art piece.

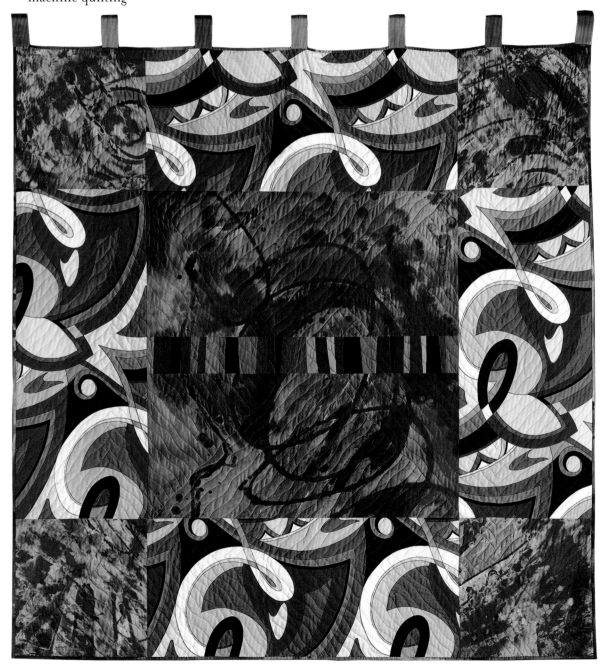

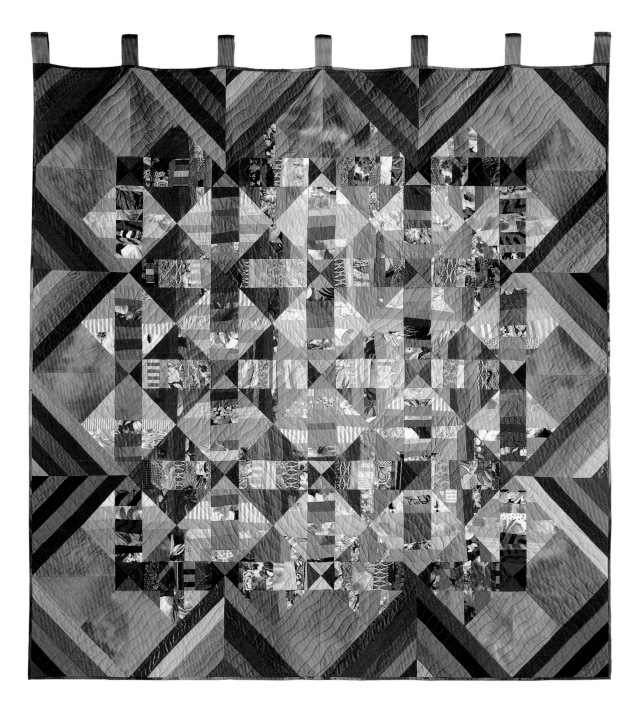

FRONT

Elizabethan Woods

1991

SIZE IN INCHES: 68 × 80

TEXAS LOCATION: Dallas

MADE BY: Patricia B. Campbell

QUILTED BY: Thekla Schnitker

STYLE OF QUILT: Traditional

SOURCE OF DESIGN: Fantasy
 botanicals of Jacobean origin

MATERIALS USED: Cotton

PRIMARY TECHNIQUES: Hand
 appliqué, hand quilting

Pat is known for her passion for Jacobean designs, her line of Fossil Fern fabrics, her teaching, and her enthusiasm for appliqué. This quilt, one of her Jacobean masterpieces, features an oval of Elizabethan vines holding a fascinating variety of appliquéd fantasy flowers and leaves adapted from the inspirational motifs found in Jacobean crewel embroidery of the sixteenth and seventeenth centuries. It has won Best of Show.

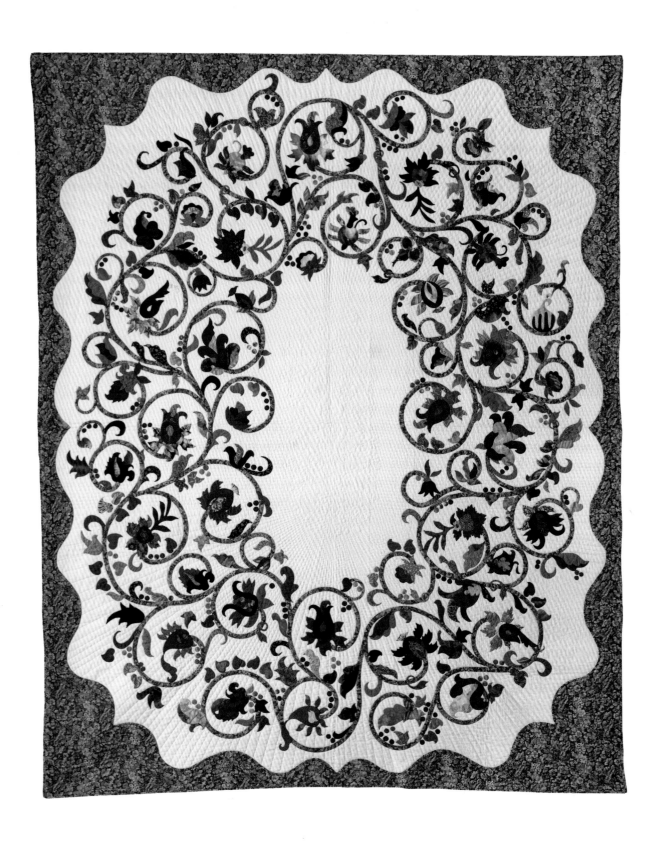

43

Storm Warning

SIZE IN INCHES: 54 X 44

TEXAS LOCATION: Houston

MADE BY: Paulie Carlson

STYLE OF QUILT: Art

SOURCE OF DESIGN: House blocks

MATERIALS USED: Cotton

PRIMARY TECHNIQUES: Strip piecing, machine quilting

Texas is known for spectacular storms that can often bring a drastic change in the weather in only a few minutes. This quilt shows vividly the changes in the sky and scenery that portend the arrival of a big storm. Hunker down and stay safe is the message of Paulie's quilt.

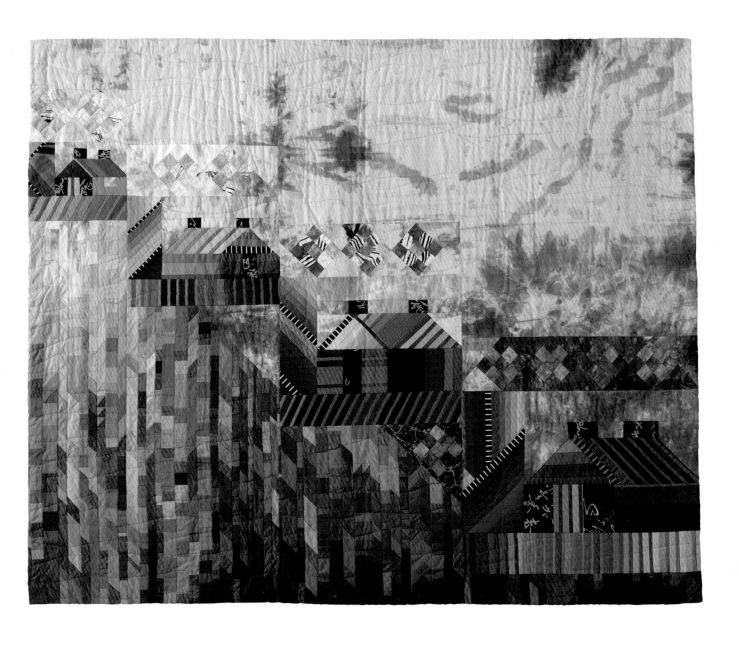

I See the Moon

SIZE IN INCHES: 57 X 64

TEXAS LOCATION: Austin

MADE BY: Joy Rose Baaklini

STYLE OF QUILT: Art

SOURCE OF DESIGN: Original

MATERIALS USED: Hand-dyed cotton

PRIMARY TECHNIQUES: Piecing, appliqué, machine quilting

FROM THE COLLECTION OF: Sharron Carr Bank

A groundbreaking quilt, this piece presents a fascinating construction of the reclining female figure with its mummy-like wrappings. In the background, Joy has used carefully planned color and shape changes and lots of "goddess graffiti" for extra mystery. This quilt won a Judge's Choice award. The quiltmaker was featured in *Lone Stars II: A Legacy of Texas Quilts, 1936–1986*.

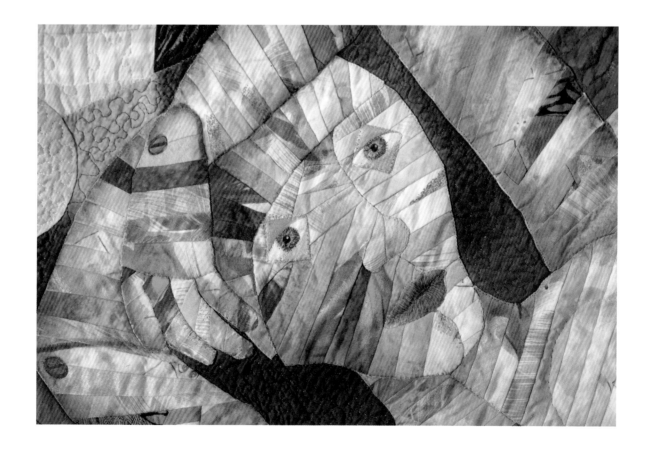

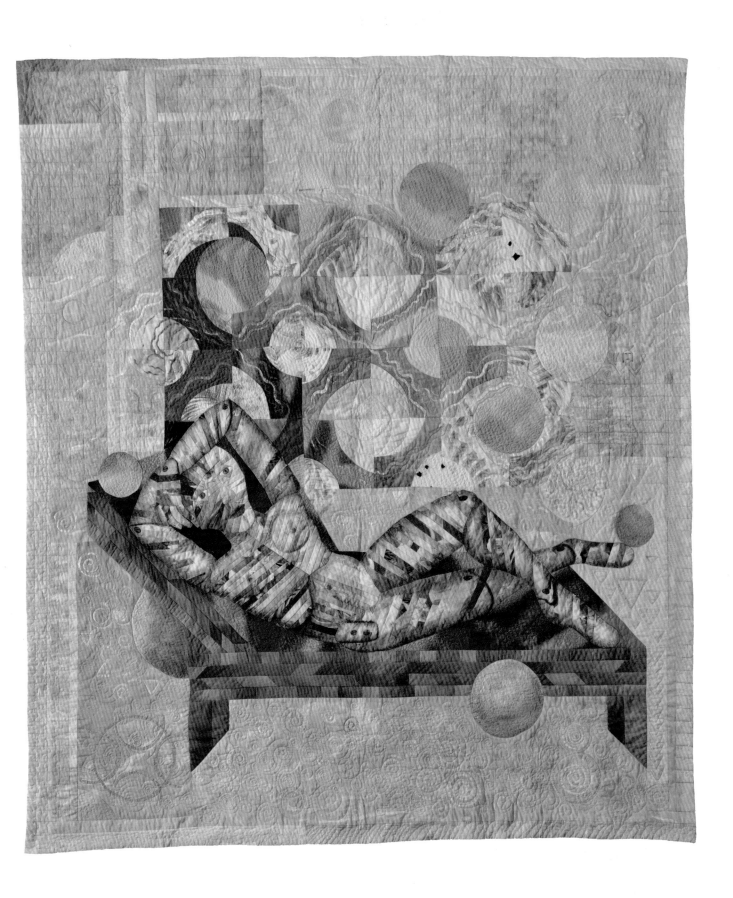

47

1991

SIZE IN INCHES: 51 X 75

TEXAS LOCATION: Austin

MADE BY: Lisa Beaman

STYLE OF QUILT: Art

SOURCE OF DESIGN: Original
design, self-portrait

MATERIALS USED: Cotton

PRIMARY TECHNIQUES:
Machine piecing, hand
appliqué, machine quilting

One of a series of sixteen quilts explaining the quilt artist's emotional development, this piece can convey frustration, impatience, shock, uncertainty, fear, anger, even excitement, depending on what the viewer reads into it. Lisa conveys the sense of shaky ground quite well—is she standing over a crevasse created by an earthquake? Or is she dancing in fury, pounding the earth so hard that it shatters beneath her? Another piece in this series was juried into Quilt National.

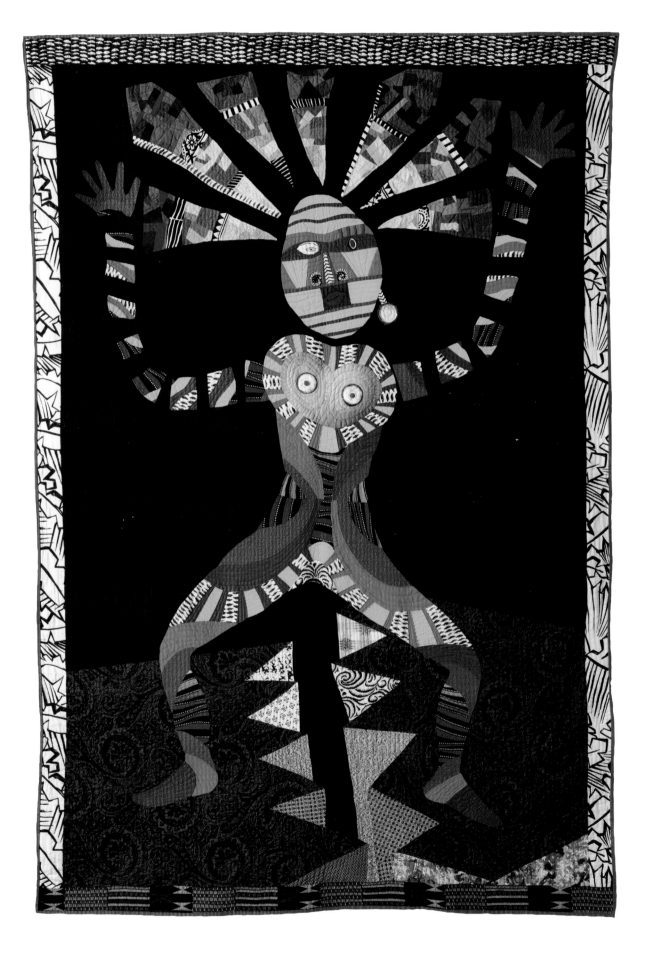

49

Enchanted Garden

1991

SIZE IN INCHES: 72 × 96

TEXAS LOCATION: Mesquite

MADE BY: Sharon Chambers

STYLE OF QUILT: Traditional

SOURCE OF DESIGN: Jacobean
 appliqué

MATERIALS USED: Cotton

PRIMARY TECHNIQUES: Hand
 appliqué, hand quilting

Sharon remembers that the class where she learned how to make quilts in the Elizabethan style was held in the teacher's restaurant, so she knows she was one of Pat Campbell's first students in her first class on Jacobean appliqué. In addition to the elaborate vines and entwined flowers, all the work of a true appliqué artist, the entire border was appliquéd as well. The quilt took two years to complete and has won awards.

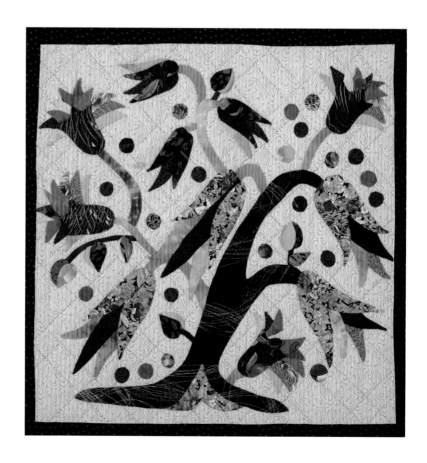

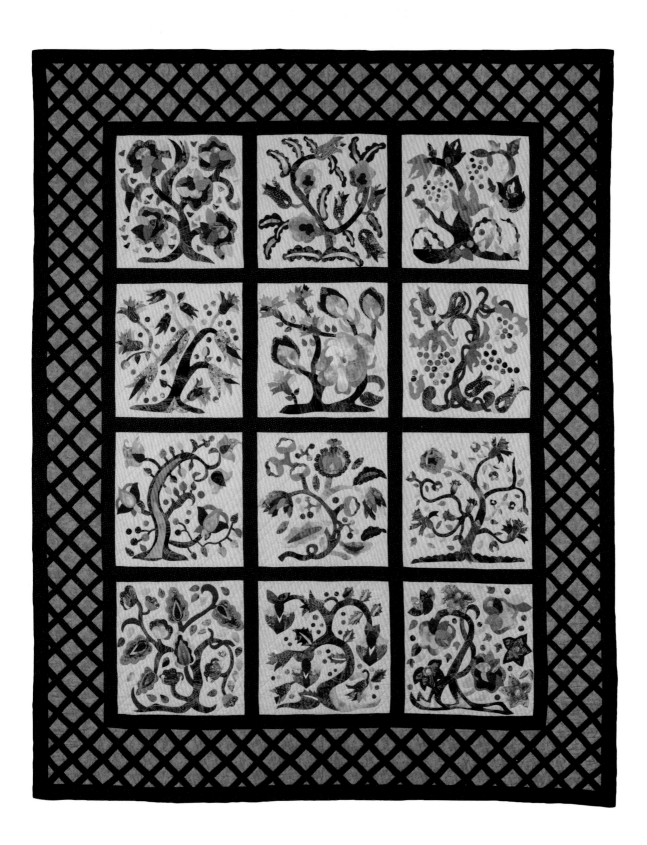

King of Hearts

1991

SIZE IN INCHES: 60 X 96

TEXAS LOCATION: Lubbock

MADE BY: Elizabeth Shotts
Beach

STYLE OF QUILT: Art

SOURCE OF DESIGN: Playing
cards

MATERIALS USED: Cotton

PRIMARY TECHNIQUES:
Appliqué, piecing, hand
quilting

FROM THE COLLECTION OF:
Amanda Shotts

While Elizabeth was playing bridge one day and consistently getting poor hands, she began to daydream of quilting, specifically about the King of Hearts playing card by Congress and what an elegant quilt it would make. This was her first art quilt, and it is a remarkable depiction of all the details that create this image, from the curled hair under his crown to the somewhat pained look on the royal visage and the ermine that trims his robes. The quilter now lives in Virginia.

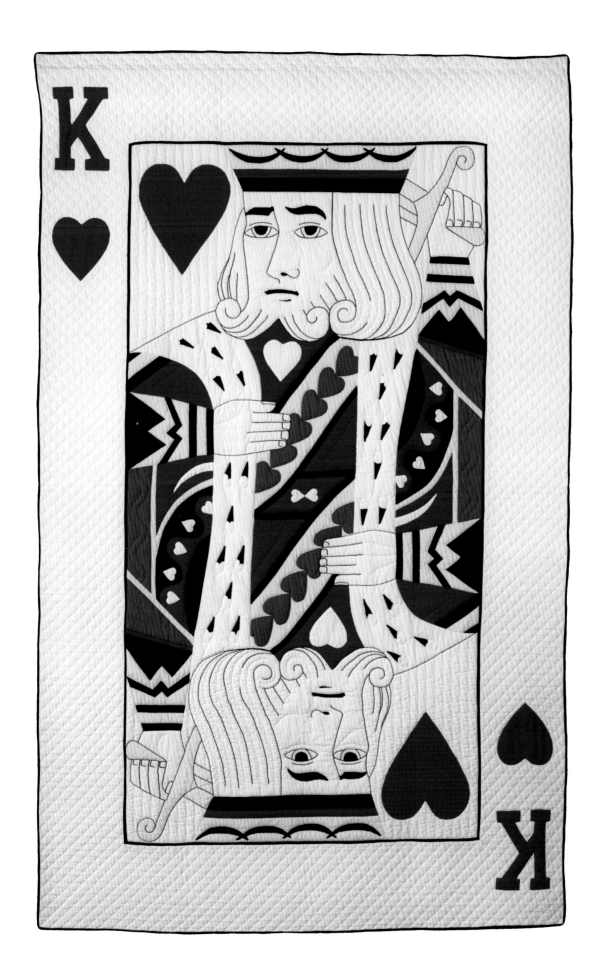

Legacy

1991

SIZE IN INCHES: 81 x 81

TEXAS LOCATION: Flower Mound

MADE BY: Barbara Oliver Hartman

STYLE OF QUILT: Art

SOURCE OF DESIGN: Original design

MATERIALS USED: Cotton

PRIMARY TECHNIQUES: Piecing, some painting on borders, hand quilting

This quilt, a strong environmental statement, was created to show what could happen if the occupants of Earth do not mend their ways. Using no color, Barbara, an artist whose work has been juried into Quilt National, wanted to depict "the world we may be leaving future generations." One 12" block is repeated sixteen times in this quilt, with the block turned different ways to form secondary patterns. The quilt has won multiple awards.

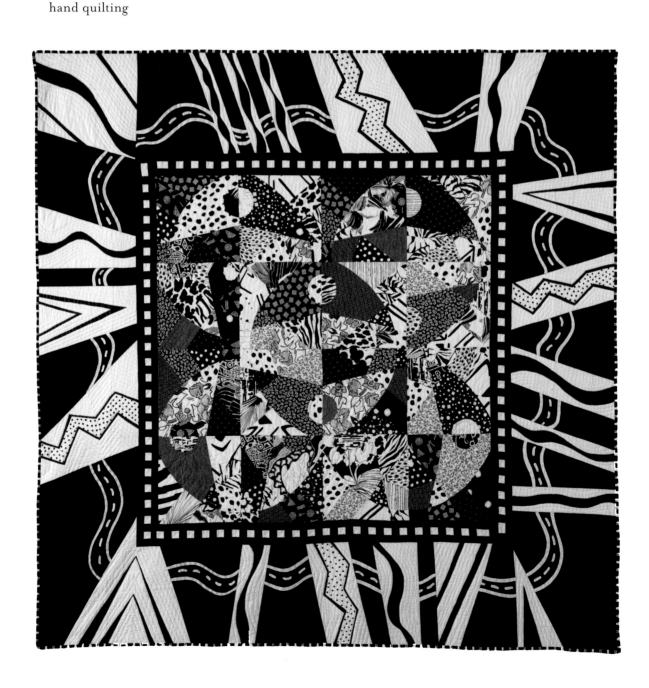

Botanica

SIZE IN INCHES: 80 x 80

TEXAS LOCATION: Houston

MADE BY: Mary Ann Jackson Herndon

STYLE OF QUILT: Art

SOURCE OF DESIGN: Antique book

MATERIALS USED: Hand-dyed cotton

PRIMARY TECHNIQUES: Appliqué, piecing, hand quilting

Mary Ann's family once lived in Galveston in a house that withstood the 1900 storm that inundated the city; that storm is known even today as the hurricane that caused the greatest loss of life ever in the U.S. In the attic of that house were old books that survived, including one with original watercolors of plants, which inspired this quilt and the artist's earlier quilt that appeared in *Lone Stars II: A Legacy of Texas Quilts, 1936–1986*. The quilt artist collects botanical prints.

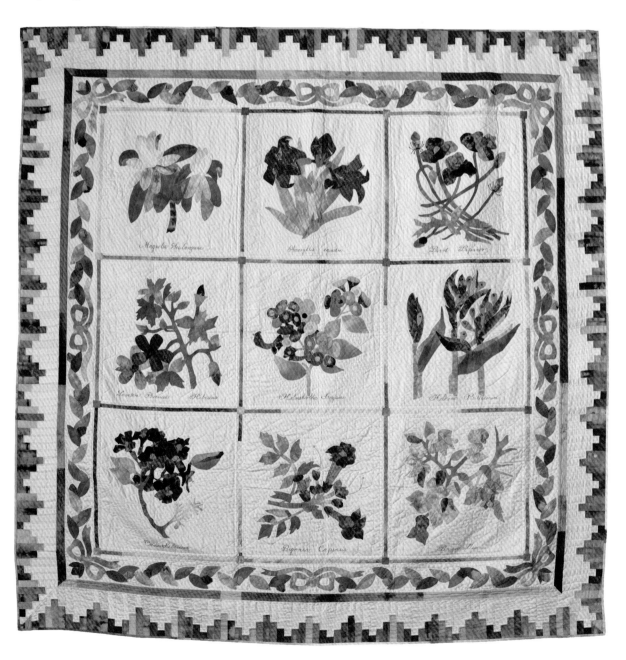

Contour of My Heart (Joe's Quilt)

1992

SIZE IN INCHES: 84 x 84

TEXAS LOCATION: Austin

MADE BY: Lisa Beaman

STYLE OF QUILT: Traditional

SOURCE OF DESIGN: Original design

MATERIALS USED: Cotton

PRIMARY TECHNIQUES: Piecing, hand appliqué, hand quilting

Made to honor her husband, this quilt is a remarkable combination of appliqué, piecing, and quilting, with each technique adding dimension and depth to the design. Lisa drew on the traditions of nineteenth-century crewel work for both her design and coloration. The tiny Sawtooth used for the inner and outer borders are the perfect choice to set off the many curves in the rest of the quilt.

Contour of My Heart (Joe's Quilt)

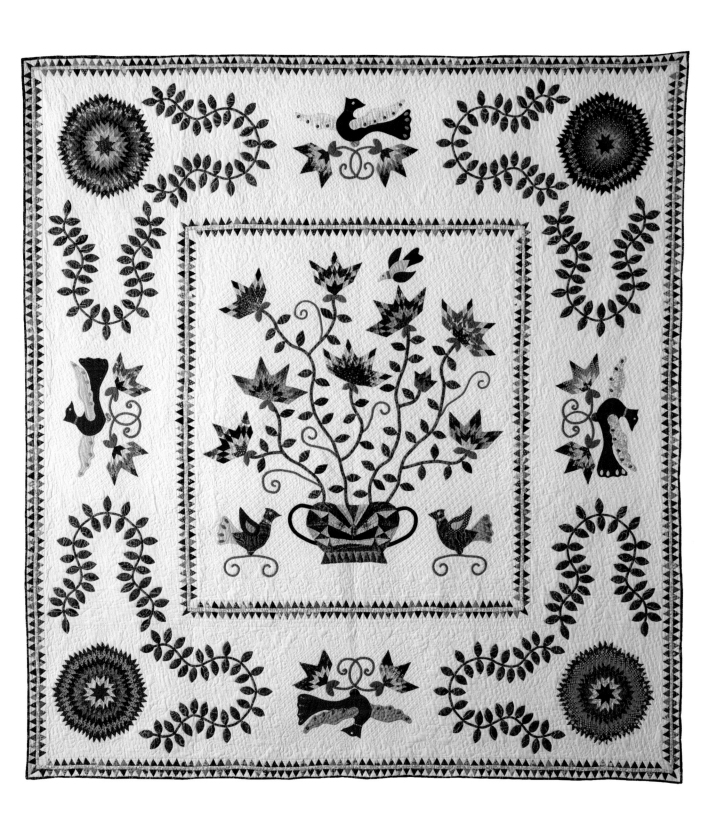

In God We Trust

SIZE IN INCHES: 42 X 43

TEXAS LOCATION: Houston

MADE BY: EuJane Taylor

STYLE OF QUILT: Traditional

SOURCE OF DESIGN: Original design

MATERIALS USED: Cotton

PRIMARY TECHNIQUES: Hand needle-turn appliqué, freehand sketching, dimensional appliqué, inking, embroidery, hand quilting

Many scenes of American exploration are depicted in this quilt, ranging from inked drawings of Columbus to the Wright Brothers and their airplane to space flights, an adventure in which Texas, through Houston-based NASA, has played a large role. The magnificent bald eagle in the center is based on EuJane's observation of eagles in their natural habitat when she lived in Canada. For this quilt, she tea-dyed the background fabric and did all of the inking freehand. Her quilt won the grand prize in a national competition.

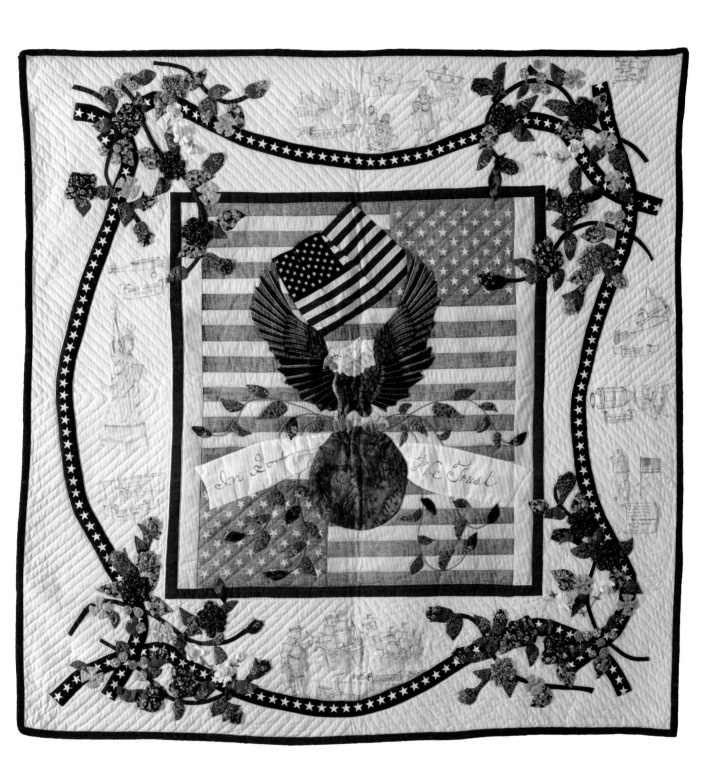

Les Amis (Friends)

SIZE IN INCHES: 44 X 35

TEXAS LOCATION: Austin

MADE BY: Beth T. Kennedy

STYLE OF QUILT: Art

SOURCE OF DESIGN: Original design adapted from postcard

MATERIALS USED: Cotton, hand-dyed and hand-painted

PRIMARY TECHNIQUES: Machine appliqué and embroidery, machine quilting

In Egyptian mythology, the hippopotamus is known as the protector of women. The award-winning quilt was fifth in a series of eight devoted to the celebration of women in different cultures. The artist first saw this image on a postcard sent from France. Beth, whose work was included in *Lone Stars II: A Legacy of Texas Quilts, 1936–1986*, was one of the first art quilters in the state and has been juried into Quilt National in the past.

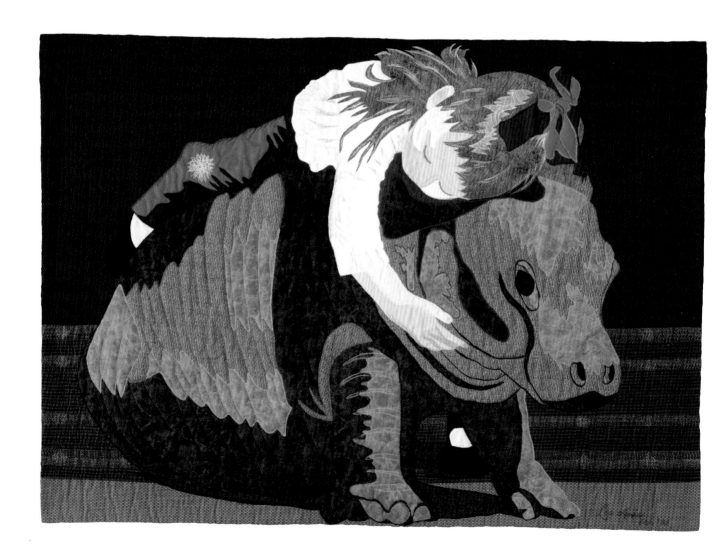

Seasons in Silhouette

1992

SIZE IN INCHES: 47" round

TEXAS LOCATION: Austin

MADE BY: Gail Valentine

STYLE OF QUILT: Art

SOURCE OF DESIGN: Original design

MATERIALS USED: Cotton

PRIMARY TECHNIQUES: Strip piecing, reverse hand appliqué, hand quilting

Gail has superimposed a design of reverse appliqué portraying the four seasons with the appropriate colors and symbols on a background of wedges. Trees represent spring and fall, ocean waves with sailboats signify summer, and snowflakes hail winter. An unusual, almost mysterious, round art quilt, this piece was started in Utah but finished in Texas and has won an award. The quilt-maker has since moved out of state.

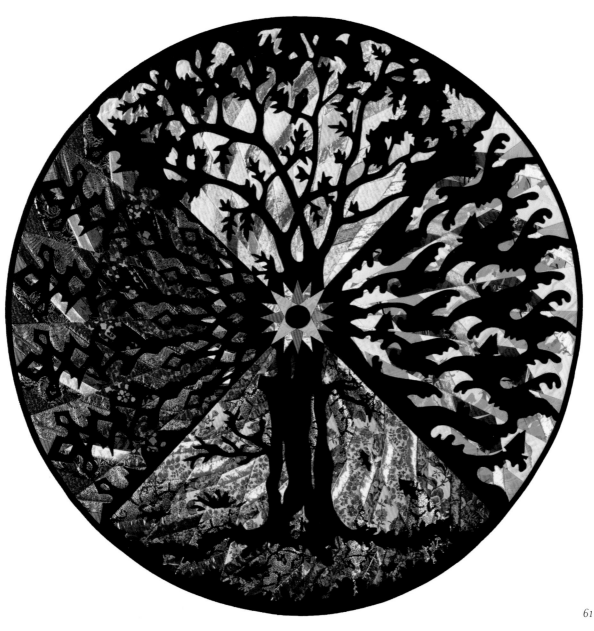

1992

SIZE IN INCHES: 91 X 91

TEXAS LOCATION: Port Neches

MADE BY: Blockhead Bee of Southeast Texas

GROUP MEMBERS: Robin Campbell, Norma Clubb, Dot Collins, Renella Deloney, Jessie Dickerson, Betty Johnson, Jerry Kelley, Mavis Luquette, Laverne Noble Mathews, Linda Mathews, Carolyn Slack, Linda Taliaferro

STYLE OF QUILT: Traditional

SOURCE OF DESIGN: Baltimore Album quilts

MATERIALS USED: Cotton

PRIMARY TECHNIQUES: Appliqué, piecing, hand quilting

FROM THE COLLECTION OF: Devra Cormier

This guild quilt was made to be given away in a raffle benefitting the International Quilt Association. The blocks are based on traditional Baltimore Album blocks, with multi-layer appliqué; realistic and fanciful flowers and fruit; a painterly approach to color, shading, and balance; and beautifully executed feather quilting.

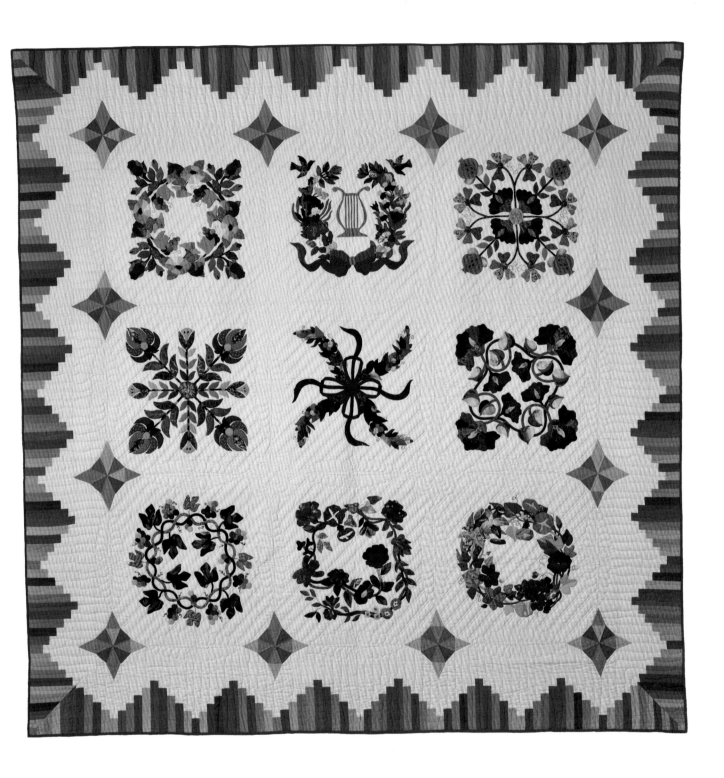

Texas Triumph

1992

SIZE IN INCHES: 97 X 106

TEXAS LOCATION: Plano

MADE BY: Lynn B. Welsch

STYLE OF QUILT: Traditional

SOURCE OF DESIGN: Original design inspired by antique quilt

MATERIALS USED: Cotton

PRIMARY TECHNIQUES: Machine piecing, machine quilting

"I was inspired by a late nineteenth-century quilt from Pennsylvania and by the stories of early settlers. This is a tribute to those who triumphed over many hardships to successfully settle Texas," says the quilt artist. The repetition of many squares and triangles in the pattern and the use of fabrics that appear to be vintage add interest and complexity to this dramatic quilt. Lynn's piece is an award winner and was also selected for a contest that drew over 4,500 entries. She has since moved out of state.

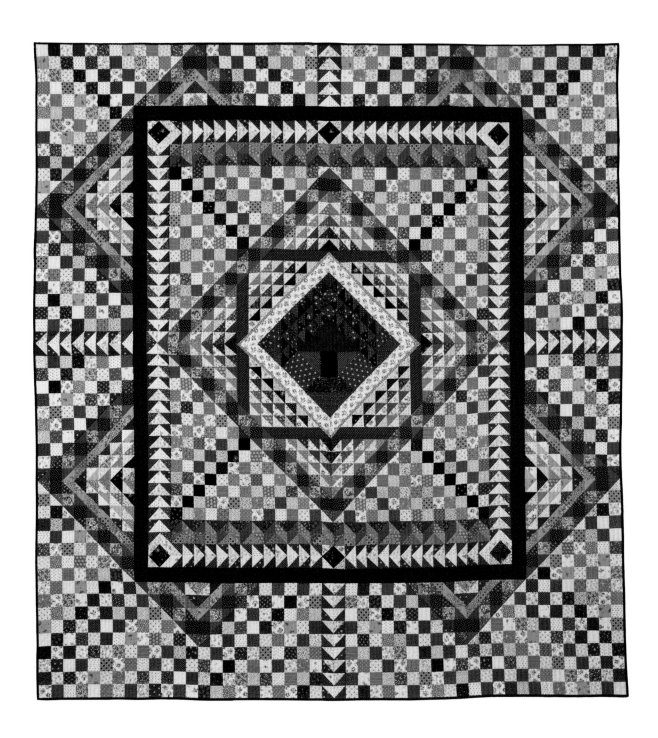

SIZE IN INCHES: 87 x 87

TEXAS LOCATION: Orange

MADE BY: Laverne Noble Mathews

GROUP: Blockhead Bee of Southeast Texas

GROUP MEMBERS: Robin Campbell, Dot Collins, Renella Deloney, Jessie Dickerson, Gloria Gaar, Betty Johnson, Jerry Kelly, Betty Mathews, Laverne Noble Mathews, Linda Mathews, Mary Ray, Linda Taliaferro, Bobbie Thompson

STYLE OF QUILT: Traditional

SOURCE OF DESIGN: Baltimore Album style

MATERIALS USED: Cotton

PRIMARY TECHNIQUES: Appliqué, reverse appliqué, hand quilting

Laverne, a former teacher, often shares her artistic talents with the Blockhead Bee, and many beautiful group quilts have come out of that collaboration. This outstanding example, created in an album style with a vining border and stipple quilting in the center, features original design blocks made by group members to depict their favorite books. *Anne of Green Gables* is here, and so are *Old Yeller*, *A Girl of the Limberlost*, *Gone with the Wind*, and *Lonesome Dove*—look closely and you may find your own cherished book. The quilt artist also had her work included in *Lone Stars II: A Legacy of Texas Quilts, 1936–1986*. This quilt has won Best of Show.

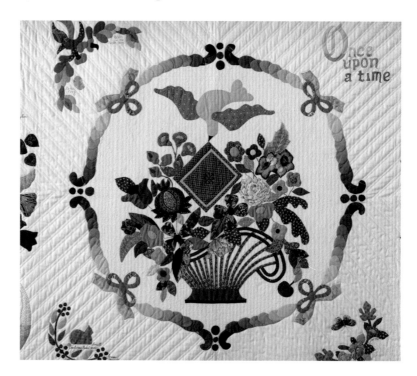

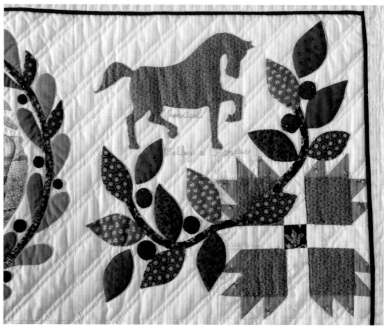

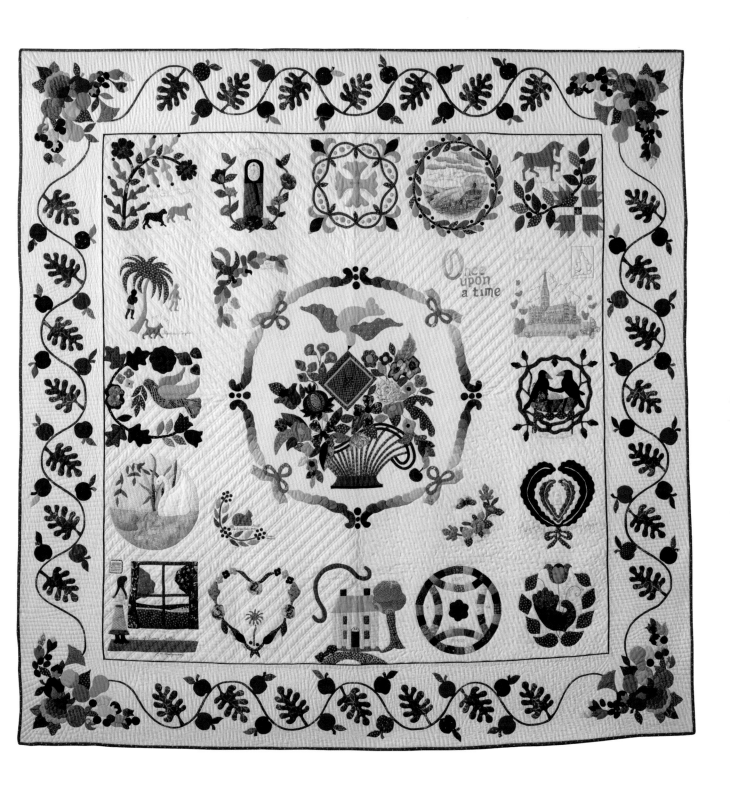

The Pheasant

1993

SIZE IN INCHES: 41 X 56

TEXAS LOCATION: Texarkana

MADE BY: Dee Shaffer

STYLE OF QUILT: Art

SOURCE OF DESIGN: Original
design based on tapestries

MATERIALS USED: Cotton

PRIMARY TECHNIQUES:
Appliqué, embroidery,
beading, hand quilting

Flemish tapestries, c. 1450, with their highly detailed flora and fauna and their rich period colors, inspired this quilt. Just as the weavers of those ancient tapestries did, the quilt artist has almost hidden the subject of the quilt—the pheasant—among the lush foliage and flowers. Dee's detailed work on the body and tail is particularly impressive, and the beadwork and hand quilting add distinction to the quilt, an award-winning design in several states.

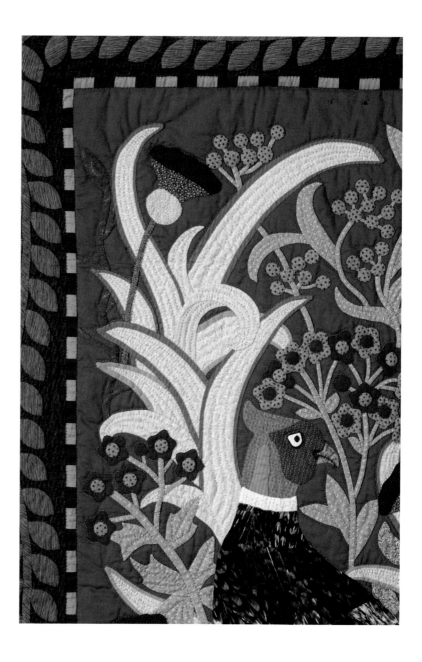

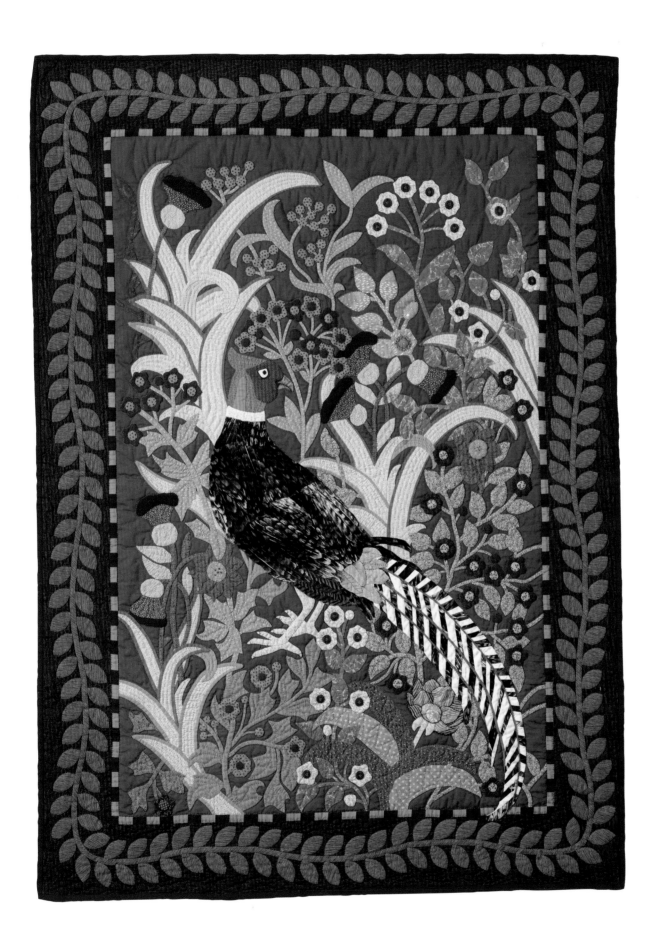

Piece & Quiet

SIZE IN INCHES: 80 x 64

TEXAS LOCATION: Dickinson

MADE BY: Cynthia Law England

STYLE OF QUILT: Art

SOURCE OF DESIGN: Original design based on photograph

MATERIALS USED: Cotton

PRIMARY TECHNIQUES: Picture piecing, some appliqué, machine quilting

This extraordinary quilt was named one of the twentieth century's 100 best American quilts. The prestigious designation led to so much attention for Cynthia's unique new picture-piecing method that it opened the door to a seventeen-year career as an international teacher and lecturer. The quilt took about six months to make and has more than 8,000 pieces. The majority of the quilt was made at night when her three children were asleep—hence the name! This show-stopper of a quilt has won several Best of Show and Viewer's Choice awards.

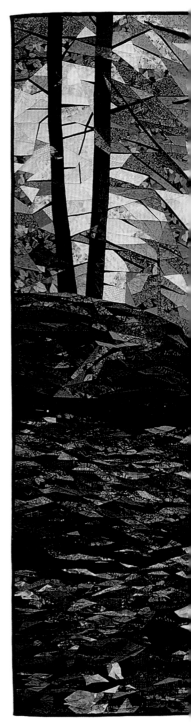

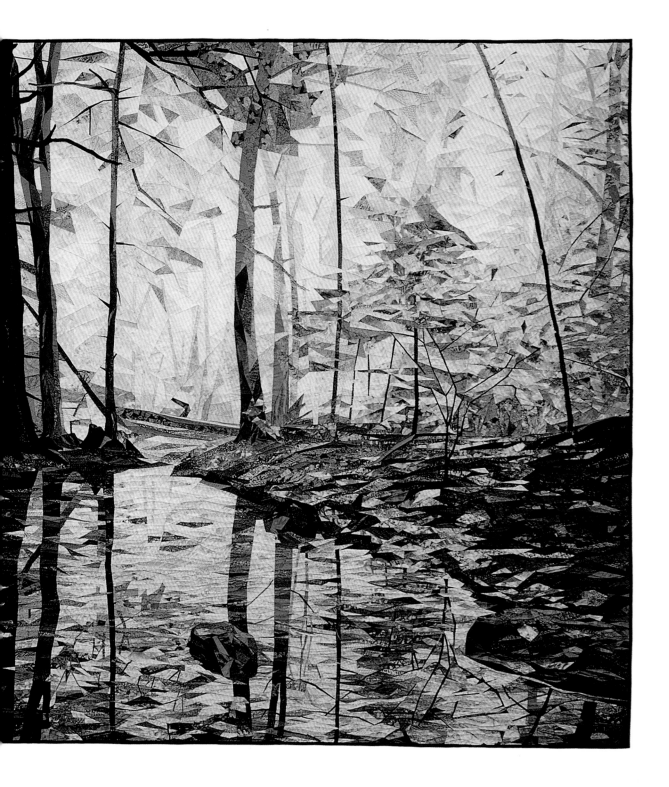

Germination

1993

SIZE IN INCHES: 63 × 63

TEXAS LOCATION: Katy

MADE BY: Jo Sweet

STYLE OF QUILT: Art

SOURCE OF DESIGN: Original
design based on painting

MATERIALS USED: Cotton

PRIMARY TECHNIQUES:
Machine piecing, appliqué,
embroidery, couching and
beading, machine quilting

In attempting to get out of her "comfort zone," Jo left her realistic quilts behind and set off into the new territory of abstraction, creating a series of four abstract pieces inspired by one realistic painting. There is little agreement about the meaning of this quilt. Viewers see various subtexts in the block designs—some see them as a series of petri dishes with different cultures growing in them. The block designs remind the artist of "seeds and seedpods."

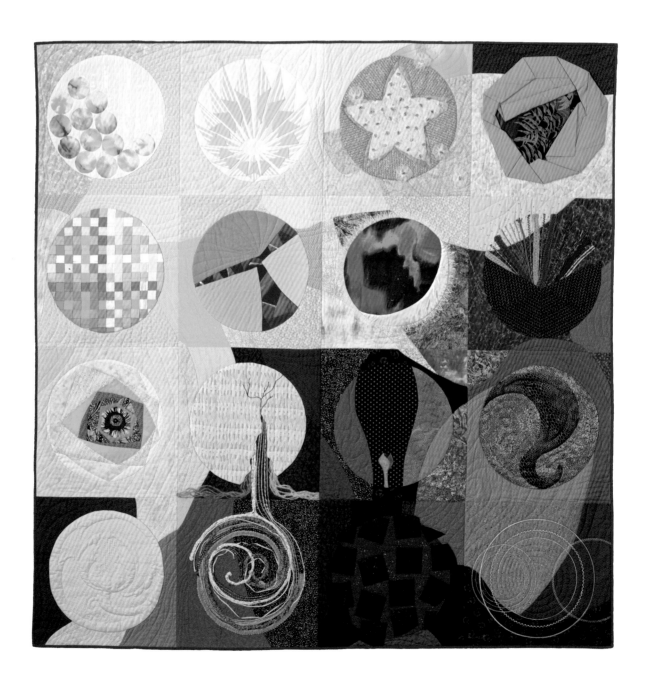

Penelope's Garden

SIZE IN INCHES: 62 x 62

TEXAS LOCATION: Austin

MADE BY: Joy Rose Baaklini

STYLE OF QUILT: Art

SOURCE OF DESIGN: Greek
mythology

MATERIALS USED: Cotton

PRIMARY TECHNIQUES:
Machine piecing, hand
painting, hand dyeing,
hand and machine appliqué
and embroidery, machine
quilting

Mythical Penelope waited faithfully for her husband, who was away almost two decades fighting the Trojan War, but many suitors pursued her so they could take over the wealthy kingdom. She agreed to choose one when she finished weaving a special cloth, but every night she tore out the weaving done that day. Joy says that is exactly how this quilt, her third in a series about goddesses in the real world, evolved, as she constantly did work and then took it out. This complex, charming piece has won several awards. Other work by this quilt artist was included in *Lone Stars II: A Legacy of Texas Quilts, 1936–1986*.

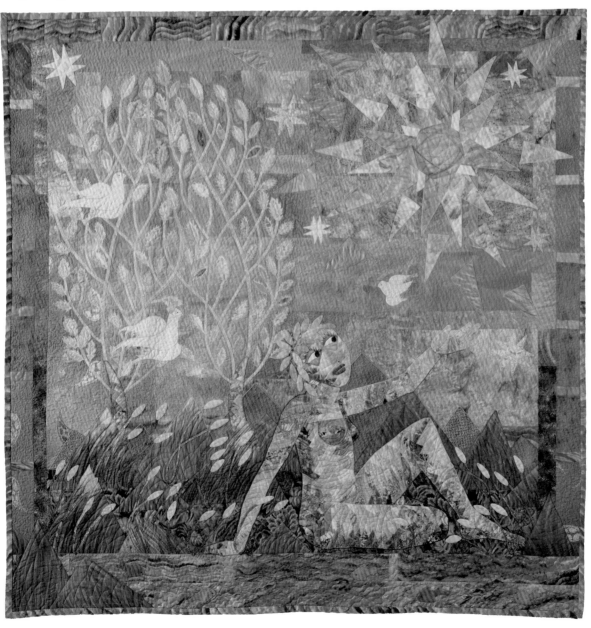

Summer Flowers

SIZE IN INCHES: 80 x 100

TEXAS LOCATION: Houston

MADE BY: Hazel Canny

STYLE OF QUILT: Traditional

SOURCE OF DESIGN: Her mother's garden

MATERIALS USED: Cotton

PRIMARY TECHNIQUES: Hand piecing and appliqué, hand quilting

Fine hand stitching, often combined with trapunto, is this quilter's claim to fame. In this piece, she has added beautiful appliquéd flowers as a tribute to her mother's garden. Hazel spent seven months making this quilt and worked about four hours a day on it. Her close cross-hatching makes the stuffed work stand up in relief and adds dimension and richness to the finished quilt.

1994

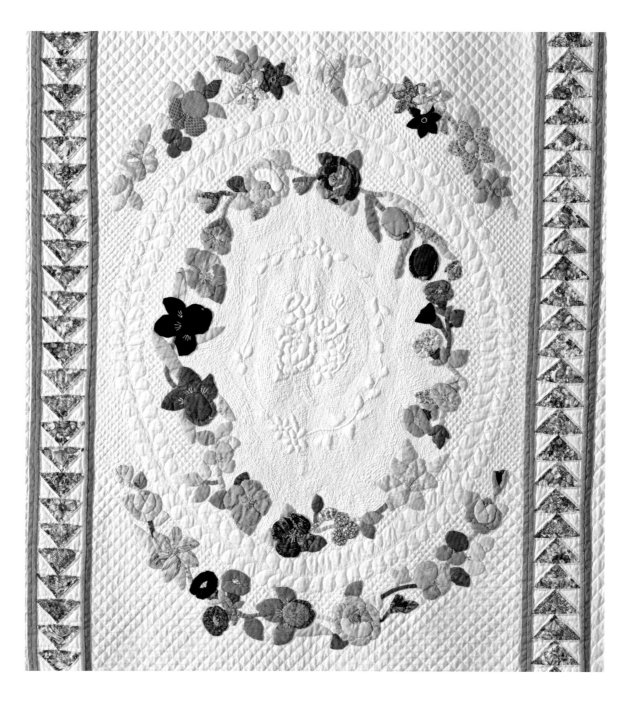

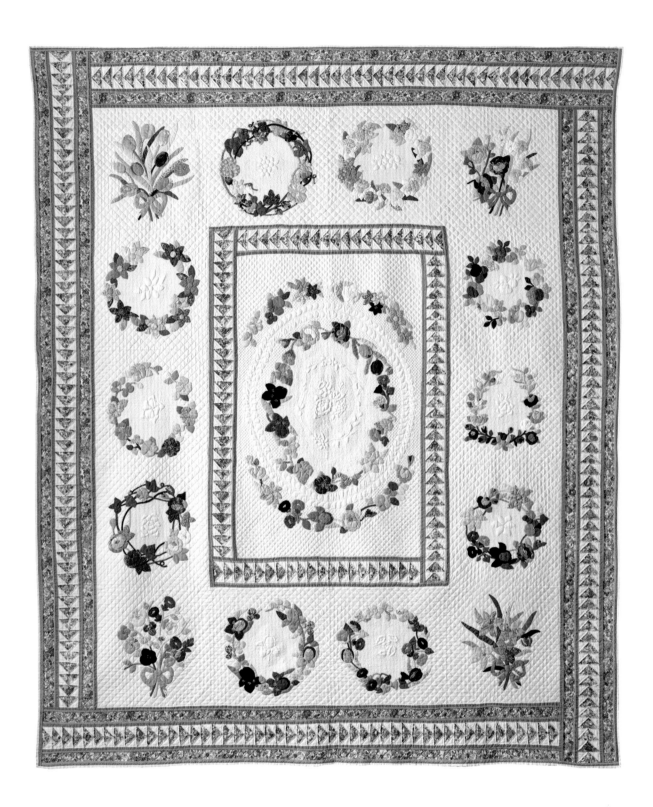

Academic Laurels

1994

SIZE IN INCHES: 65 x 65

TEXAS LOCATION: Houston

MADE BY: Volunteers from University of Houston–Clear Lake; designed by Judy Cloninger

GROUP MEMBERS: Judy Chapmon, Judy Cloninger, Naomi Dunaway, Janice Fisher, Diane Johnson, Jan Just, Elizabeth Leibfried, Anna Lowery, Pat Pate, Loretta Poston, Mary Ann Shallberg, Darlene Staples

STYLE OF QUILT: Art

SOURCE OF DESIGN: Original design based on classical decorative arts

MATERIALS USED: Cotton

PRIMARY TECHNIQUES: Hand appliqué, piecing, trapunto, calligraphy, hand quilting, stippling

FROM THE COLLECTION OF: University of Houston–Clear Lake

This elegant quilt, made by twelve volunteers to celebrate the twentieth anniversary of the University of Houston–Clear Lake, now hangs in the president's office. Judy, whose work was also featured in *Lone Stars II: A Legacy of Texas Quilts, 1936–1986,* designed the intricate piece and drew her inspiration from historic commemorative quilts, Baltimore Album quilts, and classical decorative arts such as Aubusson carpets and marquetry. The center medallion's laurel wreath represents the university itself, and the four corner wreaths each represent one of the four schools. The quilt was quilted in the anteroom of the president's office and took more than 1,000 hours to complete. It has won several awards.

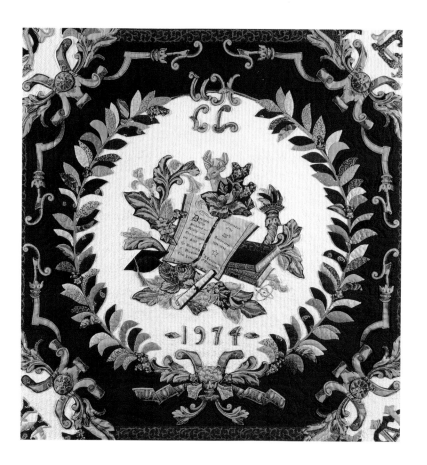

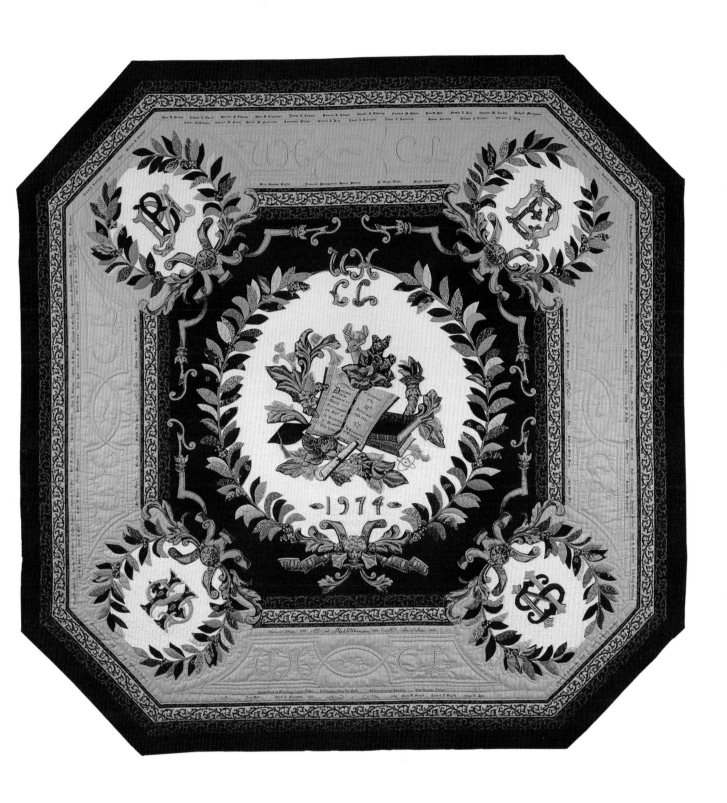

Rosehurst

1994

SIZE IN INCHES: 82 x 99

TEXAS LOCATION: Irving

MADE BY: Ruth Cattles Cottrell

STYLE OF QUILT: Art

SOURCE OF DESIGN: Based on
appliqué flower book

MATERIALS USED: Hand-dyed,
marbleized cotton

PRIMARY TECHNIQUES:
Machine piecing, hand
appliqué, and hand quilting

Twelve framed floral appliqué blocks, each more stunning than the last, make this quilt an eternal garden that will never depend on the seasons for its beauty. Roses, tulips, peonies, iris, painted daisies—all appear in this splendid design, which was based on a book of appliqué blossoms. Ruth worked with fabric she marbleized herself to create the quilt's saturated colors and complex appliqué. This quilt has won several awards in the U.S. and three awards in the U.K.

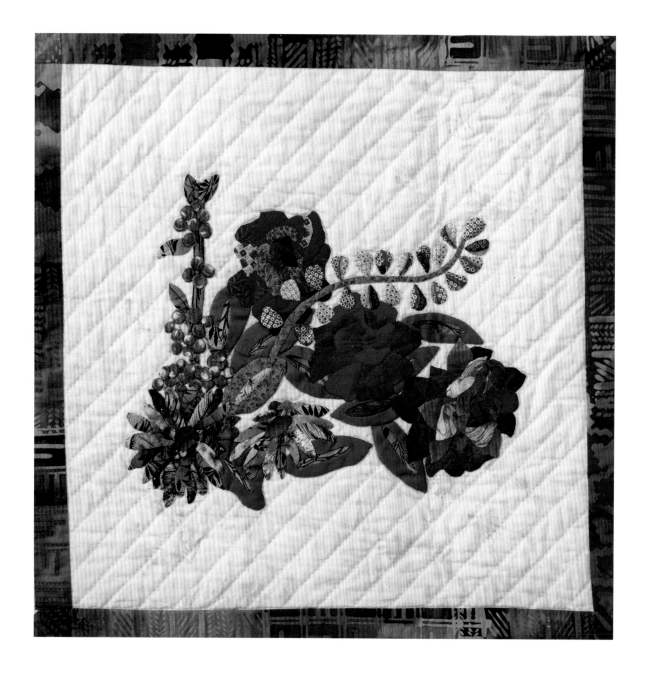

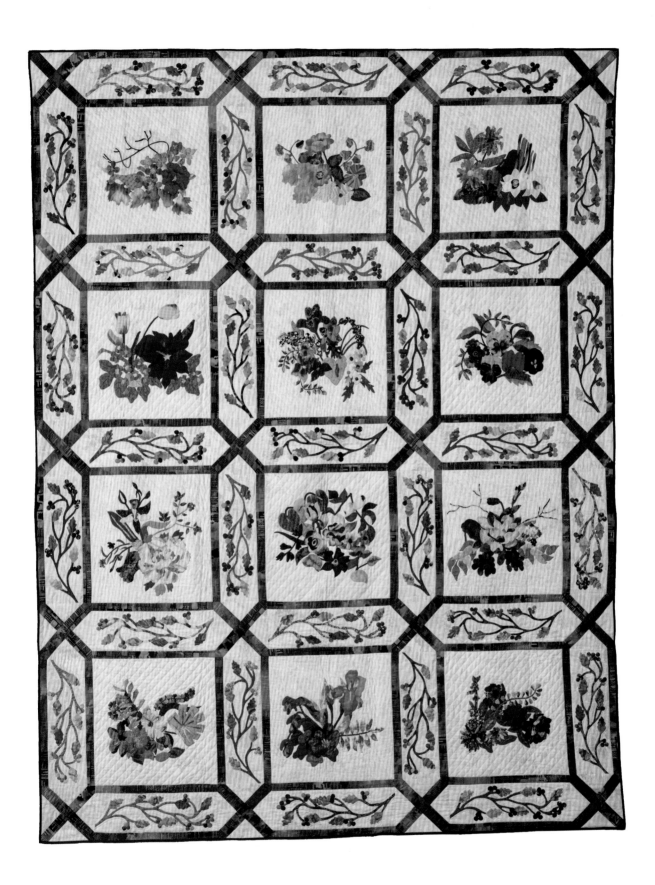

Companions

1994

SIZE IN INCHES: 87 × 79

TEXAS LOCATION: Kingwood

MADE BY: Linda Wilson

STYLE OF QUILT: Art

SOURCE OF DESIGN: Original design based on her uncle's love of American Indian life

MATERIALS USED: Cotton

PRIMARY TECHNIQUES: Machine piecing, hand appliqué, machine quilting

"This quilt portrays two long-time friends who have spent the night into morning pondering the universe and is a celebration of the commitment of lifelong companionship between individuals," says the quilt artist. The pictorial piece was designed for her uncle, who was "going through his American Indian stage of his life," Linda added. "He loved their way of life and the respect they had for the land and wildlife."

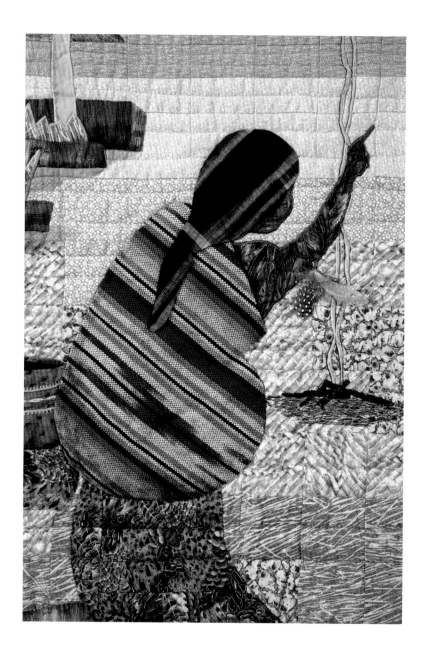

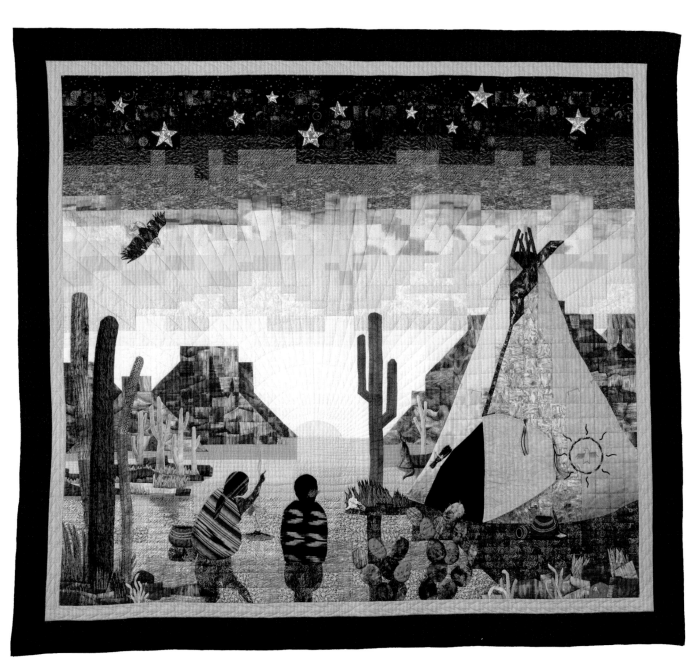

Mumbo Jumbo III

1995

SIZE IN INCHES: 77 × 49

TEXAS LOCATION: Houston

MADE BY: Liz Axford

STYLE OF QUILT: Art

SOURCE OF DESIGN: Based partially on Broken Dishes pattern

MATERIALS USED: Hand-dyed cottons

PRIMARY TECHNIQUES: Improvisational piecing, machine piecing, machine quilting

Improvisational piecing involves piecing rectangular units from mostly scrap triangles and can involve using compensating strips to make all the units fit, as the artist has done here. The art quilt technique can involve the quiltmaker in an ongoing mystery, since the overall look of the quilt doesn't usually show up until much of the piecing is complete and the quilt begins to assume its own personality. It is at that point that the artist begins to make more deliberate choices that influence the final design. Liz, an architect by training, is also a gifted colorist. Her work was featured in *Lone Stars II: A Legacy of Texas Quilts, 1936–1986,* and has been juried into Quilt National four times.

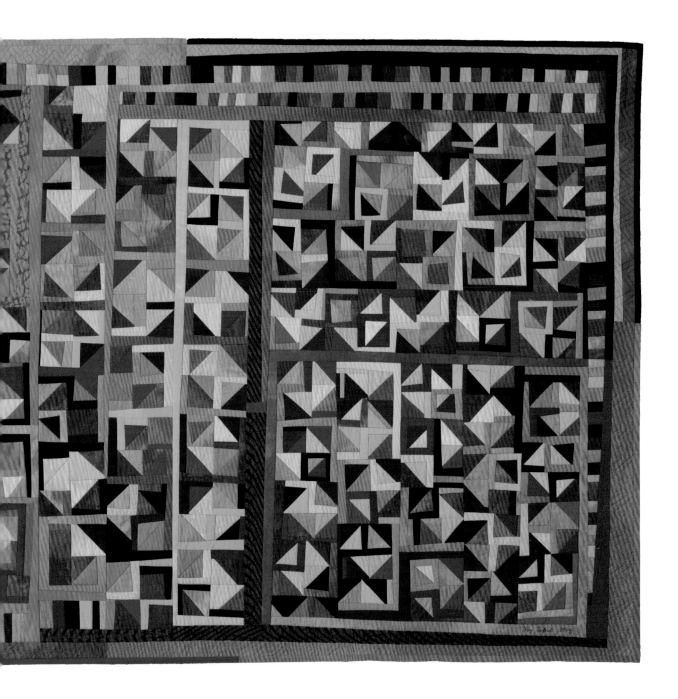

Rod 'n' Reel

1995

SIZE IN INCHES: 48 x 48

TEXAS LOCATION: Austin

MADE BY: Gail Valentine

STYLE OF QUILT: Traditional

SOURCE OF DESIGN: Original design based on Unnamed Star pattern

MATERIALS USED: Cotton

PRIMARY TECHNIQUES: Mirror manipulation, machine piecing, machine and hand quilting

Any fishing enthusiast would love this quilt with its mirror-image depictions of leaping fish, reels, and fishing paraphernalia. The pattern the quiltmaker has used is known as Unnamed Star, but the overall piece is an original design. Gail reports that it won an award at a large show.

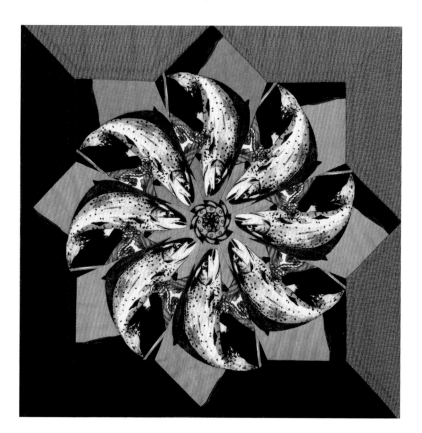

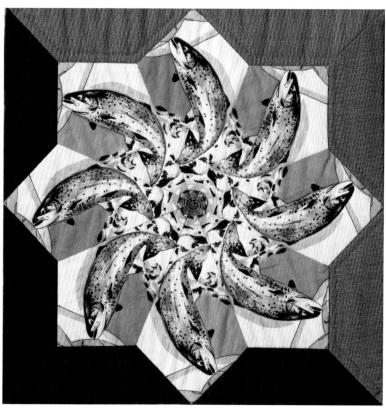

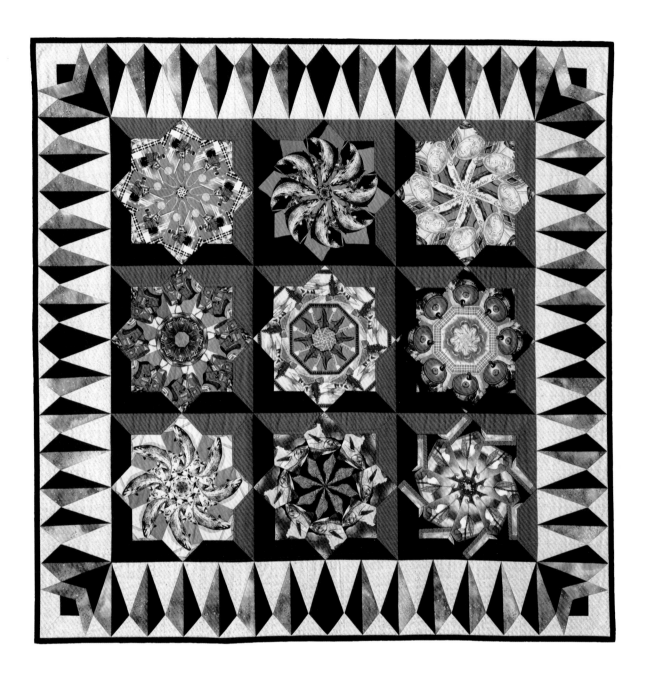

Hot Pink Bird's Nest

1995

SIZE IN INCHES: 88 x 88

TEXAS LOCATION: Katy

MADE BY: Vicki Coody Mangum

STYLE OF QUILT: Traditional

SOURCE OF DESIGN: Patterns

MATERIALS USED: Cotton, silk

PRIMARY TECHNIQUES: Hand appliqué, hand trapunto, hand and machine quilting

A completely handmade quilt is unusual today, but this quilt artist wanted to continue the traditions of earlier centuries. All of the appliqué, trapunto, embellishment, and quilting was done by hand, except for the last small border, which she machine quilted. Vicki was the manager of special exhibits for Houston's International Quilt Festival until her early retirement.

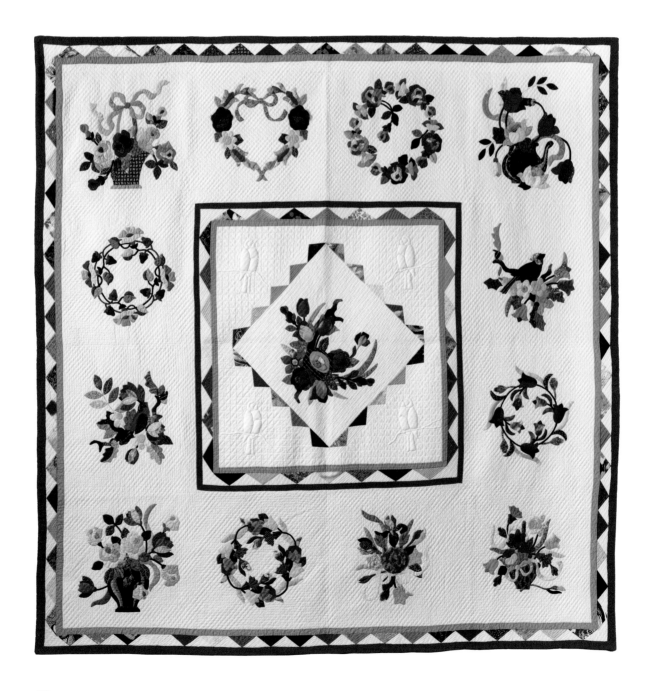

Crewel Whirl

1996

SIZE IN INCHES: 88 × 88

TEXAS LOCATION: Austin

MADE BY: Patrice Perkins
Creswell

STYLE OF QUILT: Art

SOURCE OF DESIGN: Original
design based on Mariner's
Compass pattern

MATERIALS USED: Cotton

PRIMARY TECHNIQUES:
Appliqué, hand quilting

This exceptional quilt, based on the traditional Mariner's Compass pattern, is a dramatic contemporary piece that leads the eye through a series of complex designs. Patrice is an imaginative, talented quilt artist whose work tends to be not only technically superior, but unusual and sometimes even whimsical. This quilt has won a Judge's Choice and several other awards.

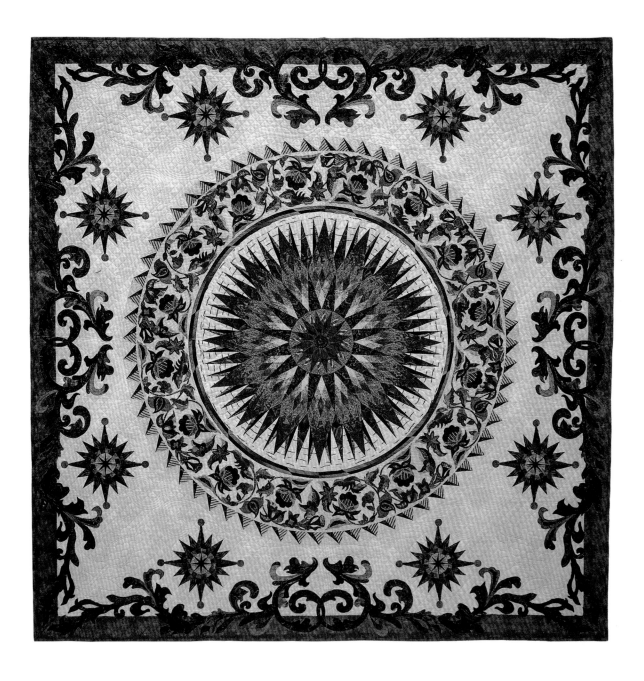

The Dream

1996

SIZE IN INCHES: 62 x 54

TEXAS LOCATION: Austin

MADE BY: Joy Rose Baaklini

STYLE OF QUILT: Art

SOURCE OF DESIGN: A dream
about creativity

MATERIALS USED: Cotton

PRIMARY TECHNIQUES:
Machine piecing and
appliqué, machine quilting

Creativity can be both electrifying and intimidating, as Joy acknowledges in this stunning work. The outsize curls in the woman's hair and the long eyelashes belie her sad expression, and the soaring doves leave the impression of a happy dream with no boundaries to the imagination. Her choices of color and fabric convey the image of a tightly bound creative spirit flying free in a dream world.

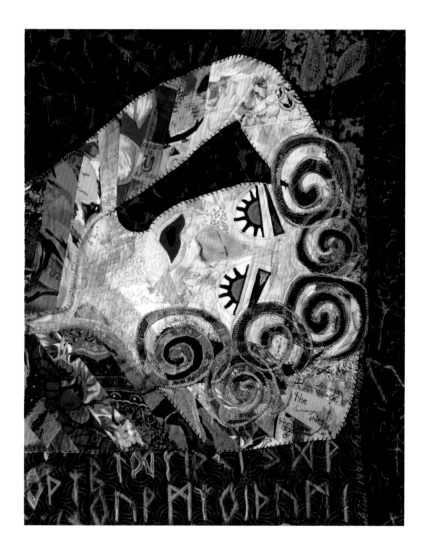

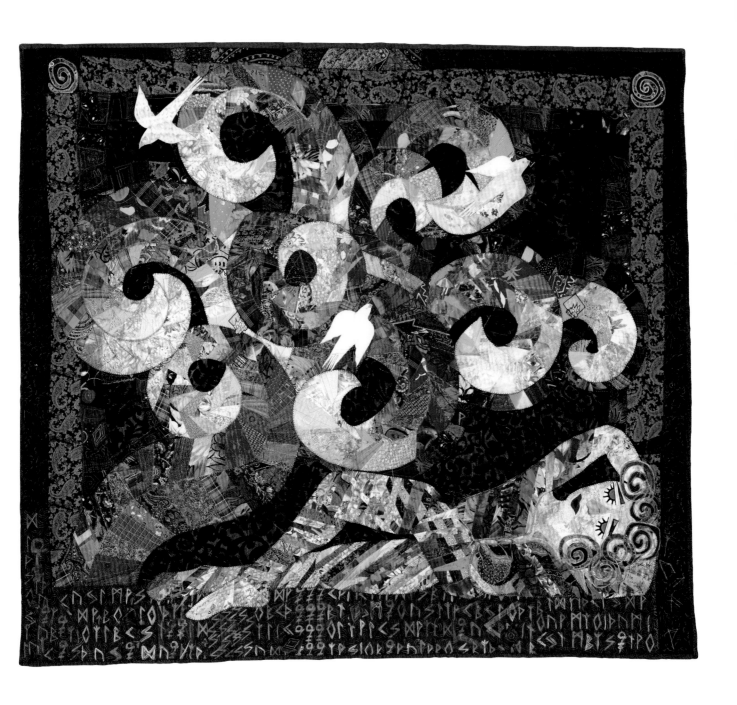

1996

SIZE IN INCHES: 76 x 76

TEXAS LOCATION: Irving

MADE BY: Ruth Cattles Cottrell

STYLE OF QUILT: Traditional

SOURCE OF DESIGN: Antique
quilt

MATERIALS USED: Cotton

PRIMARY TECHNIQUES:
Machine piecing, hand
appliqué, hand quilting

Any quilter knows the challenge of piecing the many needle points of these Mariner Compass blocks, but Ruth has obviously mastered the art of precision piecing. Her goal was to duplicate an 1830s quilt by Emeline Barker, now in the collection of the New York City Museum, that combines both piecing and appliqué. This impressive quilt has won awards and been seen in museum exhibitions.

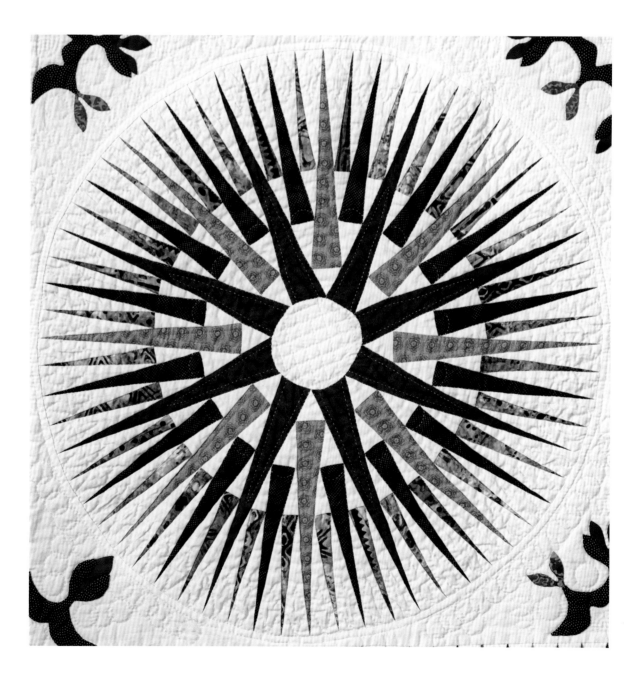

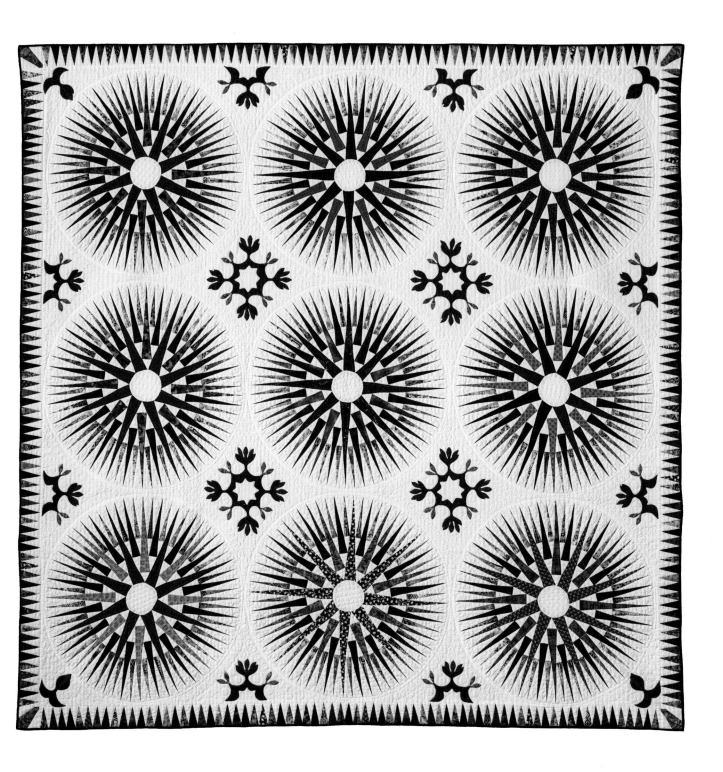

Variations on Jacobean

1996

SIZE IN INCHES: 88 x 107

TEXAS LOCATION: Dallas

MADE BY: Monna Kornman

STYLE OF QUILT: Art

SOURCE OF DESIGN: Jacobean
 patterns, wallpaper print

MATERIALS USED: Cotton

PRIMARY TECHNIQUES:
 Appliqué, hand quilting

Once quilters discovered the detailed fantasy flowers, trees, and vines seen in Jacobean embroidery on early tapestries and bed hangings, many extraordinary quilts were born. Here, Monna adapted published floral patterns for her central blocks, created original designs for the top and bottom panels, and adapted the side borders from a wallpaper print. Tree of Life designs appear on all four sides of this award-winning quilt, with exotic animals on the bottom.

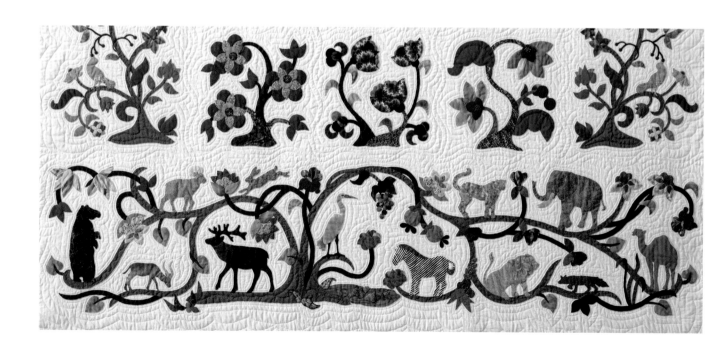

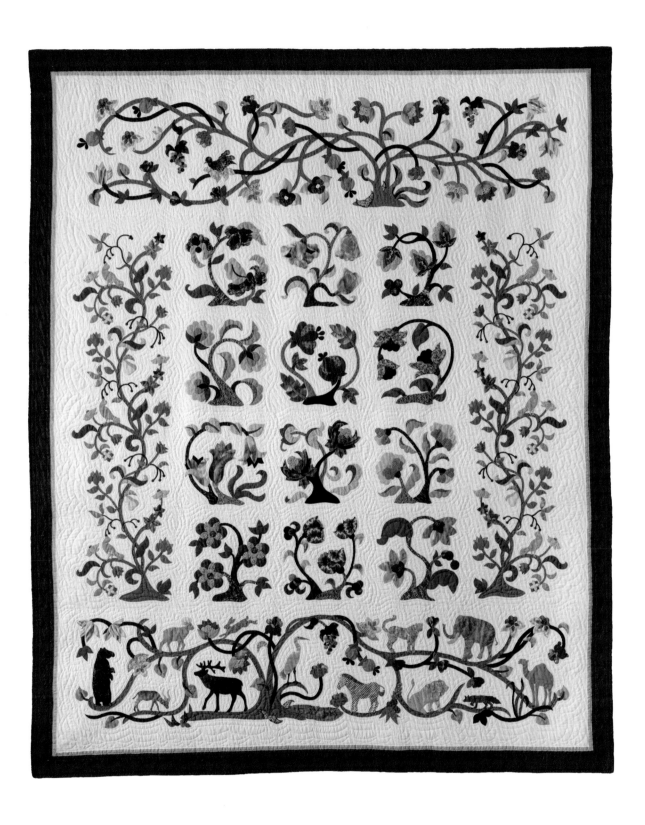

Joy Ride

1996

SIZE IN INCHES: 80 X 80

TEXAS LOCATION: Houston

MADE BY: Libby Lehman

STYLE OF QUILT: Art

SOURCE OF DESIGN: Original
design using circular
embroidery attachment

MATERIALS USED: Cotton

PRIMARY TECHNIQUES:
Machine piecing,
embellishing, quilting

A groundbreaking work that opened quiltmakers' minds to the
unlimited possibilities of machine stitching with specialty threads,
Libby's quilt is celebratory and exuberant. It has a strong struc-
tural form underneath the transparency of the free-form and
imaginative surface stitching. Writing about this quilt, Jean Ray
Laury, an icon in the quiltmaking world, said: "Her dazzling and
remarkably detailed work changed our ideas of what is possible
with machine stitching." This award-winning quilt was chosen
as one of the twentieth century's 100 best American quilts. The
quiltmaker also had other work included in *Lone Stars II: A Legacy of
Texas Quilts, 1936–1986*.

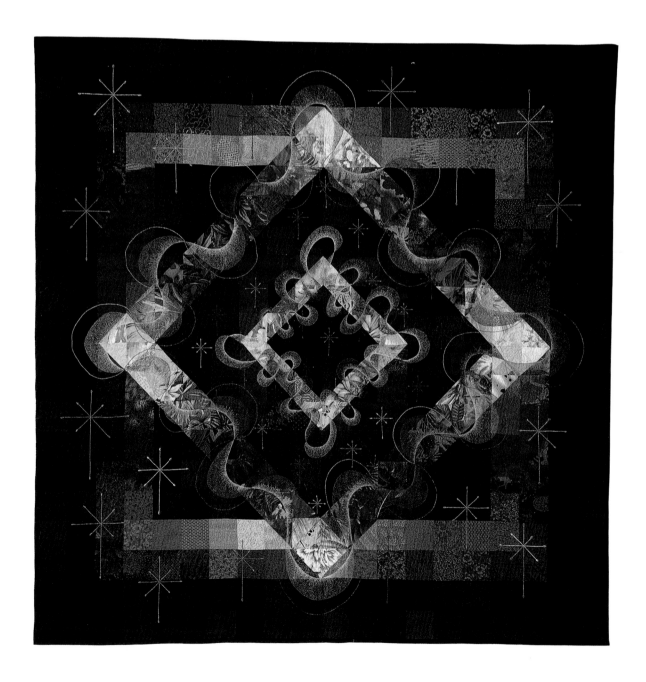

Simple Gifts

SIZE IN INCHES: 88 x 88

TEXAS LOCATION: Wichita Falls

MADE BY: Ricky Tims

STYLE OF QUILT: Art

SOURCE OF DESIGN: Original design based on Diamond in a Square pattern

MATERIALS USED: Cotton

PRIMARY TECHNIQUES: Machine piecing using foundation paper piecing, free-motion machine quilting

Texan by birth, Ricky lived in the state thirty-two years, and while he did not start this quilt in Texas, he quilted it here. So in the words of Texas musician Lyle Lovett, "That's right, you're not from Texas, but Texas wants you anyway!" Often described as a Renaissance man, this quilt artist also composes, conducts, and records music and co-hosts a popular show on the Internet. This vividly colored, joyous quilt with its extravagant machine quilting reflects the artist's attitude toward life. "The design is original but based on a traditional Diamond in a Square, and the colors represent Amish traditions, even if the quilt is contemporary," he says.

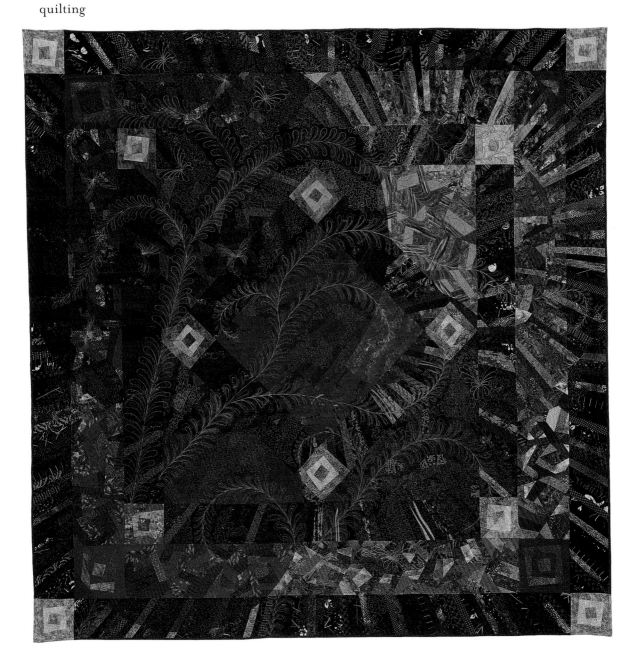

The Right One for Me

1997

SIZE IN INCHES: 30 X 30

TEXAS LOCATION: Austin

MADE BY: Melissa Grooms
Sullivan (deceased)

STYLE OF QUILT: Art

SOURCE OF DESIGN: Original
design

MATERIALS USED: Unknown

PRIMARY TECHNIQUES:
Machine quilting

FROM THE COLLECTION OF:
Mike Sullivan

The quiltmaker's talent lives on in this very personal art quilt. In it, she pays tribute to her husband and his music. Before her death, she wrote: "Much of my inspiration springs from the sense of harmony and security my husband creates. We're each blessed with talents and often express ourselves through them—Mike's music and my quilting. Using mixed techniques, this original design acknowledges the vitality of Mike and his music. Mike's own musical talents, his artistic ability, his gentle nature, his unwavering encouragement, and his infinite patience are just some of the reasons he's 'The Right One for Me'!"

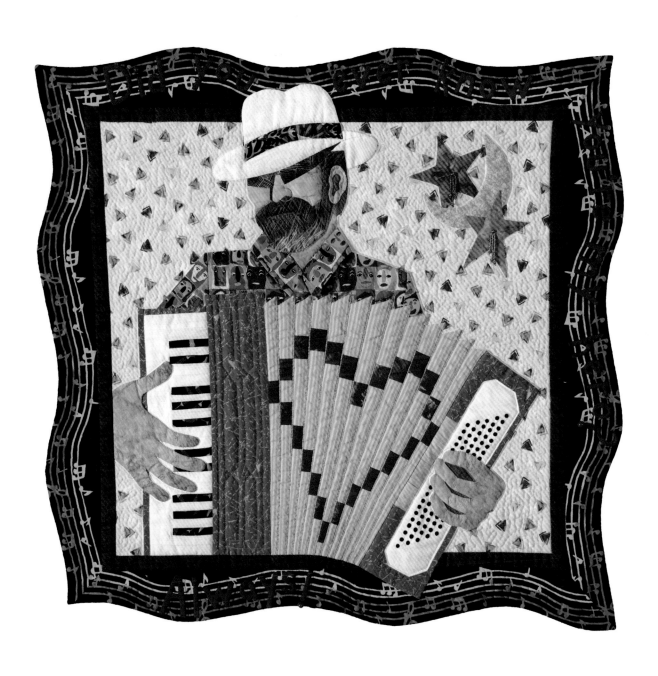

Hannah's Garden

SIZE IN INCHES: 82 x 82

TEXAS LOCATION: Rockport

MADE BY: Jo Ann Hannah

STYLE OF QUILT: Traditional

SOURCE OF DESIGN: Original design inspired by 1930s quilt

MATERIALS USED: Cotton

PRIMARY TECHNIQUES: hand appliqué, trapunto, hand quilting

After seeing a 1938 quilt *The Garden* in a magazine, Jo Ann created her own pattern and adapted others to capture the beauty of the Depression-era quilt masterpiece. Flowers, fruit, birds, and insects, such as butterflies and dragonflies, are all featured in this amazing quilt, which has won Best of Show and other awards.

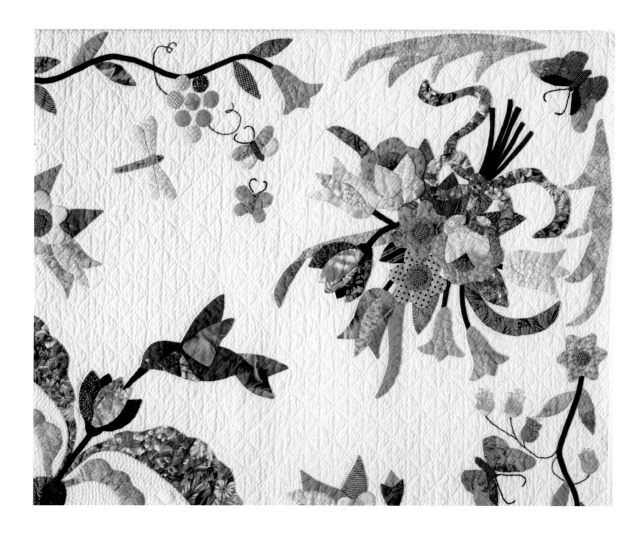

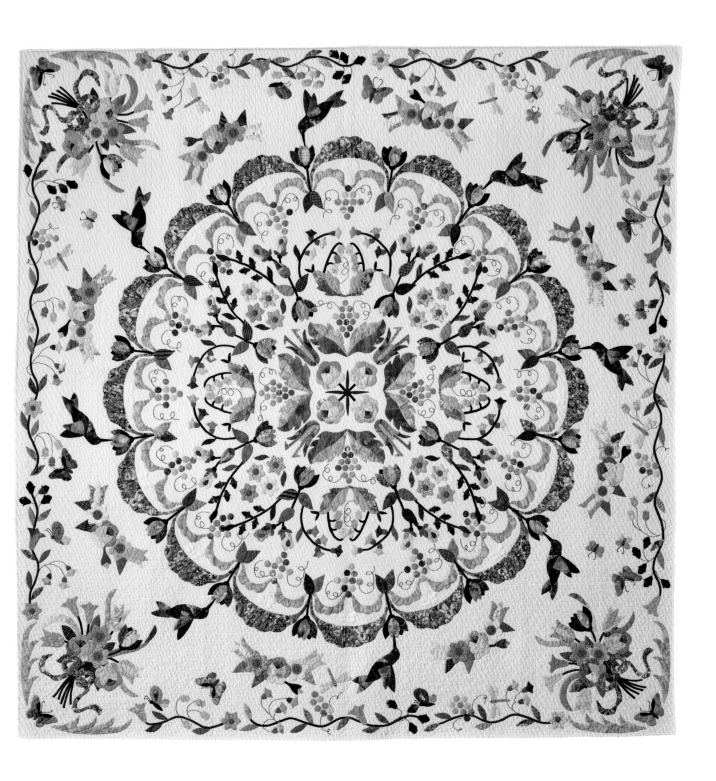

Forest Fire Spirits

SIZE IN INCHES: 57 X 51

TEXAS LOCATION: El Paso

MADE BY: Sherrie Spangler

STYLE OF QUILT: Art

SOURCE OF DESIGN: Original design inspired by summer heat

MATERIALS USED: Hand-painted cotton, tulle

PRIMARY TECHNIQUES: Raw-edge appliqué, painting, machine quilting

Sherrie hand painted strips of fabric in these vibrant colors and then noticed that in some areas, "the paint had migrated to form designs that reminded me of spirit dancers and fire. It was summer in Texas, and I had heat on my mind!" According to the artist, the fabrics had a three-dimensional quality that reminded her of relief maps, so she added clouds of tulle and feathers. "Gold quilting lines began as wind and then became fire spirits," she adds. A resident of El Paso at the time, the artist has since moved out of state.

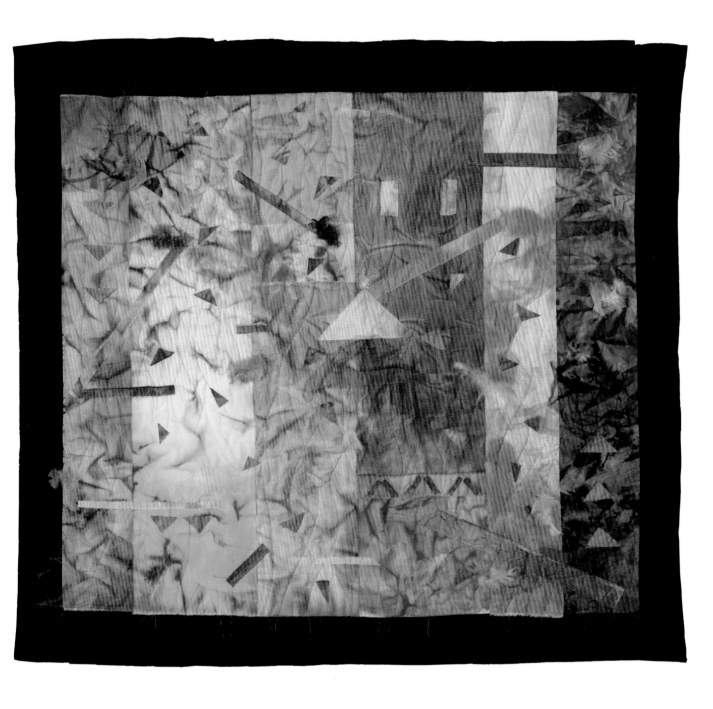

Guiding Light

1997

SIZE IN INCHES: 77 X 88

TEXAS LOCATION: Midland

MADE BY: Joyce Goodson

STYLE OF QUILT: Traditional

SOURCE OF DESIGN: Stained glass designs

MATERIALS USED: Cotton, 200 yards of black bias tape

PRIMARY TECHNIQUES: Needle-turn hand appliqué, hand quilting

Using the dramatic method that allows the replication of the colorful windows that have graced so many churches through so many centuries, Joyce created this quilt to include religious symbols and floral designs. The quilt is centered around the spiritual image of the soaring Dove of Peace in the center. Making stained glass quilts was very popular in the 1980s and 1990s.

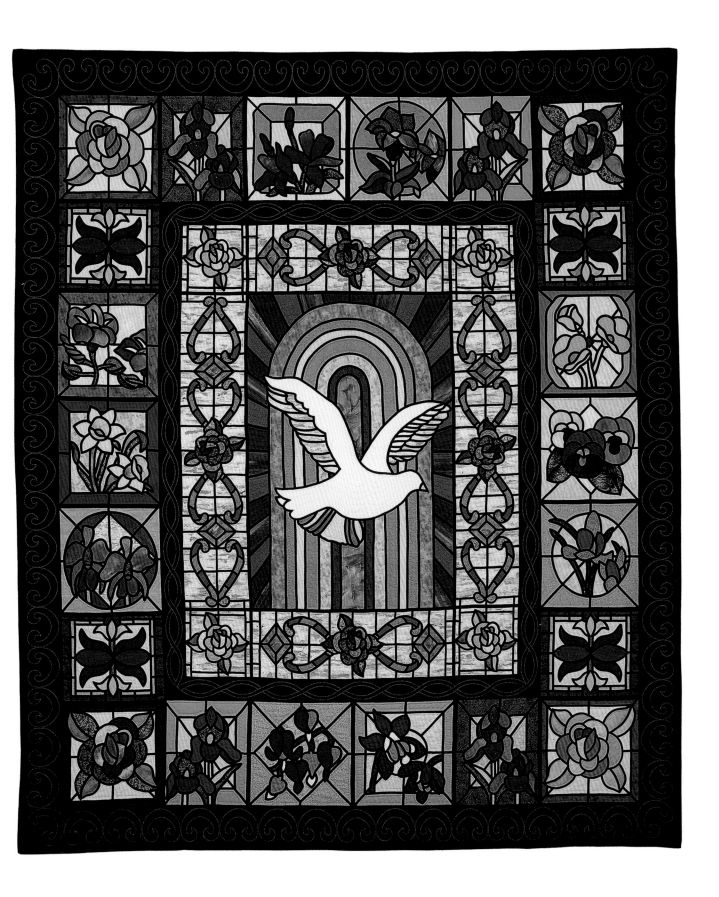

Reminiscence

1997

SIZE IN INCHES: 80 x 80

TEXAS LOCATION: Orange

MADE BY: Laverne Noble
Mathews

STYLE OF QUILT: Traditional

SOURCE OF DESIGN: Original
design inspired by antique
quilt

MATERIALS USED: Cotton

PRIMARY TECHNIQUES: Piecing,
appliqué, hand quilting

Inspired by memories of a Mary "Betsy" Totten quilt from the nineteenth century now in the collection of the Smithsonian's National Museum of American History, the quilt artist has drawn upon the traditional Sunburst pattern for this piece. The pieced Sunburst in muted colors, with its complex tangle of appliquéd flowers, leaves, and vines, is an original design by Laverne. Her quilt has won several awards, including two Best of Show designations. The quilt artist also had her work included in *Lone Stars II: A Legacy of Texas Quilts, 1936–1986.*

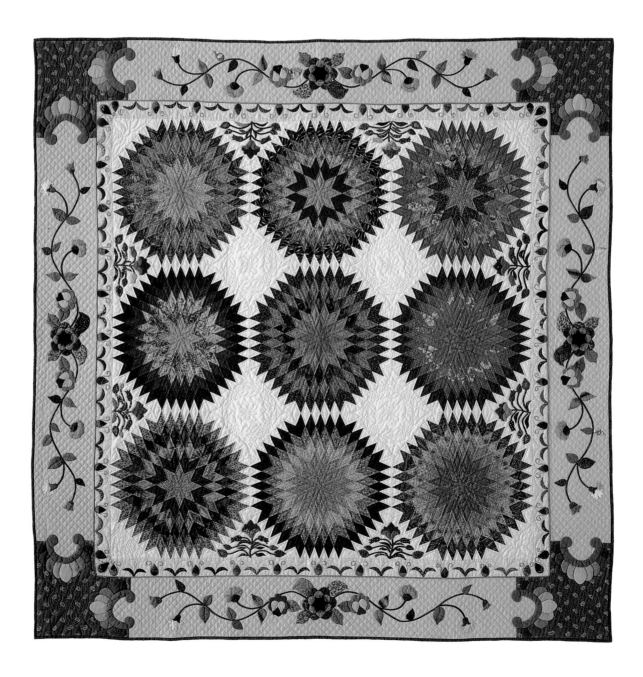

Feathered Rose

SIZE IN INCHES: 76 x 76

TEXAS LOCATION: Mesquite

MADE BY: Sharon Chambers

STYLE OF QUILT: Traditional

SOURCE OF DESIGN: Antique quilts

MATERIALS USED: Cotton

PRIMARY TECHNIQUES: Hand appliqué, hand quilting

A love of red and green quilts coupled with a love of Princess Feather designs combined to produce Sharon's beautiful replica of an antique four-block quilt. Graceful yet free spirited, the design is both formal and lively, a combination that is not easy to achieve. It has won a Best of Show award.

1998

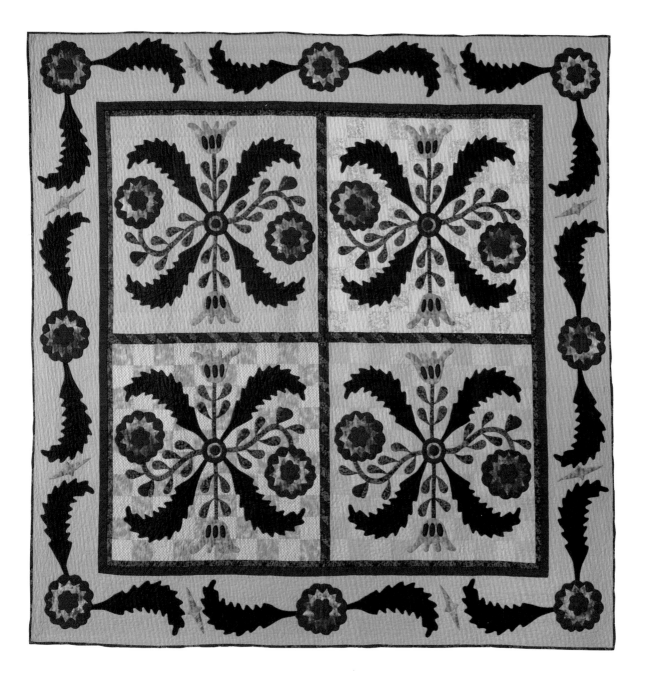

The Rising Sun

1998

SIZE IN INCHES: 100 x 100

TEXAS LOCATION: Gruver

MADE BY: Gerry O'Brien Davis

QUILTED BY: Susie Miller

STYLE OF QUILT: Traditional

SOURCE OF DESIGN: 1835 quilt

MATERIALS USED: Cotton

PRIMARY TECHNIQUES: Piecing,
 appliquéing, hand quilting

Using reproduction fabrics that became available at the end of the twentieth century, Gerry created a duplicate of Betsy Totten's complex and visually stunning quilt, made in 1835 and now in the collection of the Staten Island Historical Society. She saw the quilt in a book, fell in love with it, and decided to make it as a wedding gift for her granddaughter. She worked on the hand-appliquéd quilt four hours a day for two years and she reports that during that time "my husband learned to cook!" The quilt has won a Best of Show award.

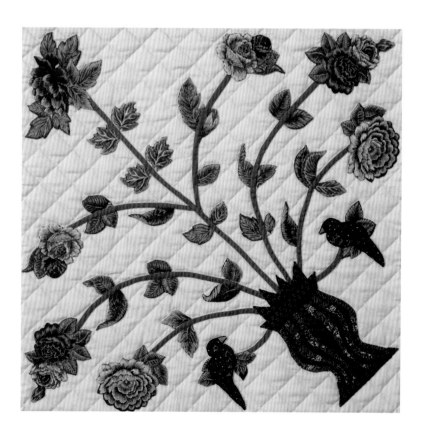

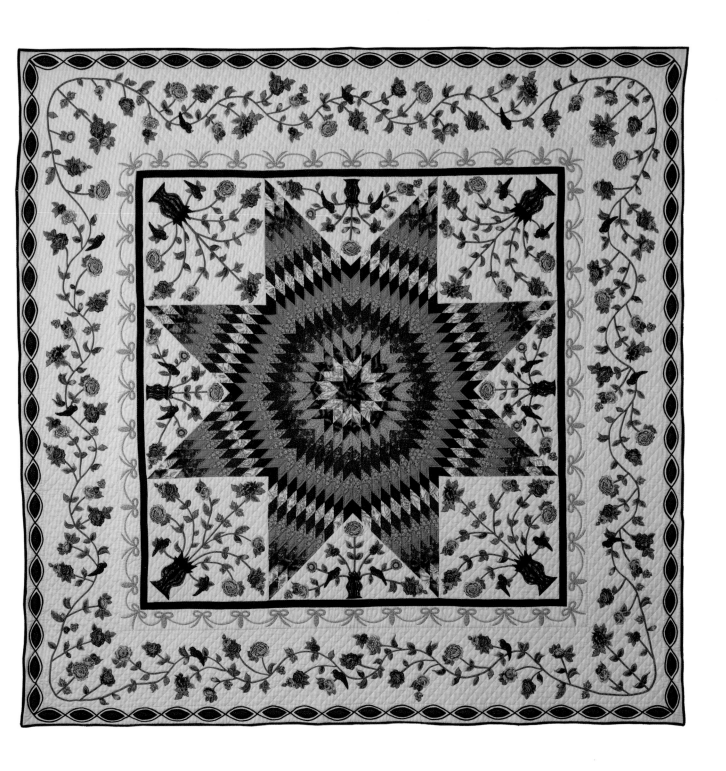

Floral Phantasma

SIZE IN INCHES: 96 x 96

TEXAS LOCATION: Spring

MADE BY: Margaret (Peggy) Fetterhoff

STYLE OF QUILT: Traditional

SOURCE OF DESIGN: Original design

MATERIALS USED: Cotton

PRIMARY TECHNIQUES: Piecing, hand quilting

The viewer's eye travels through and around this quilt in a sinuous, serpentine fashion, constantly curving. This effect was deliberately created by the quiltmaker, who wanted the viewer to join her in her love of both fabric and color. Peggy's quilt contains 1200 different fabrics, with the pattern created by 4,049 two-inch squares. This award-winning piece has also been selected for a Viewer's Choice award.

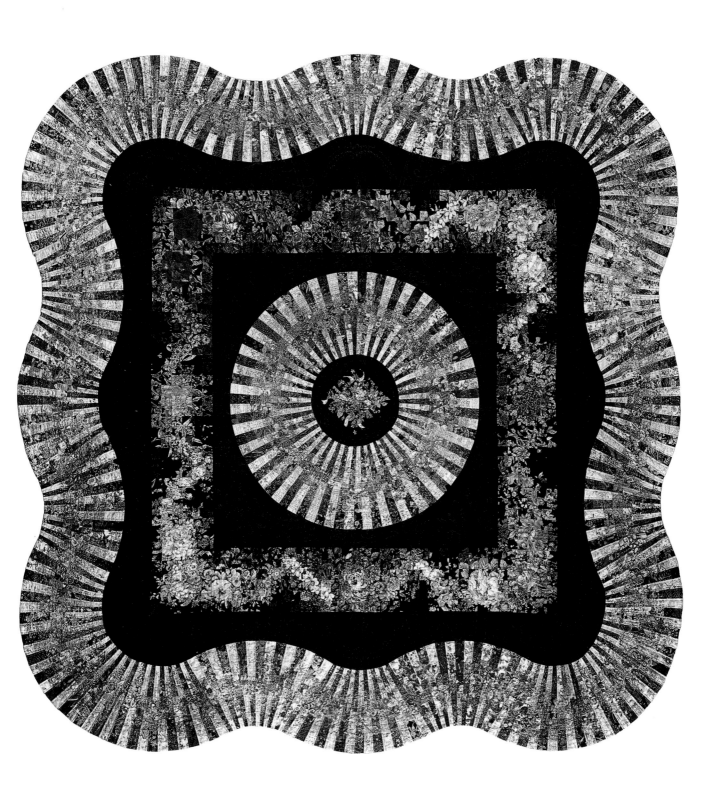

1998

SIZE IN INCHES: 89 x 109

TEXAS LOCATION: Dimmitt

MADE BY: Friendship Quilter's Guild

GROUP MEMBERS: Karen Alair, Amelia Barrera, Ina Cleavinger, Darlene Collins, Bonnie Davis, Joyce Davis, Janice Duke, Winona Franks, Cenci Hardee, Yvonna Hays, Claudine Langford, Doris Lust, Cassa McCormick, Annie McCurry, Tommie Sue Nisbett, Jean Robb, Tara Wales, Twila West

STYLE OF QUILT: Traditional

SOURCE OF DESIGN: Many Album designs

MATERIALS USED: Cotton

PRIMARY TECHNIQUES: Machine and hand appliqué, machine piecing, embroidery, various fabric manipulations, hand quilting

FROM THE COLLECTION OF: Jean Grisham Gilles Dean

A guild dedicated to meticulous workmanship, the Friendship Quilter's Guild makes outstanding raffle quilts each year. This piece draws extensively from appliqué patterns of four top American appliqué designers. The attention to detail is excellent, and the choice of a strong outer and inner border does an admirable job of containing the exciting blocks and flowing border.

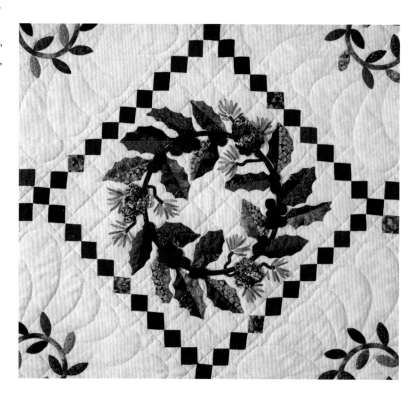

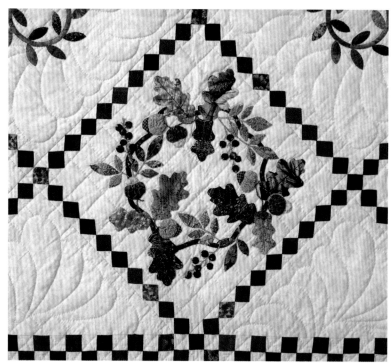

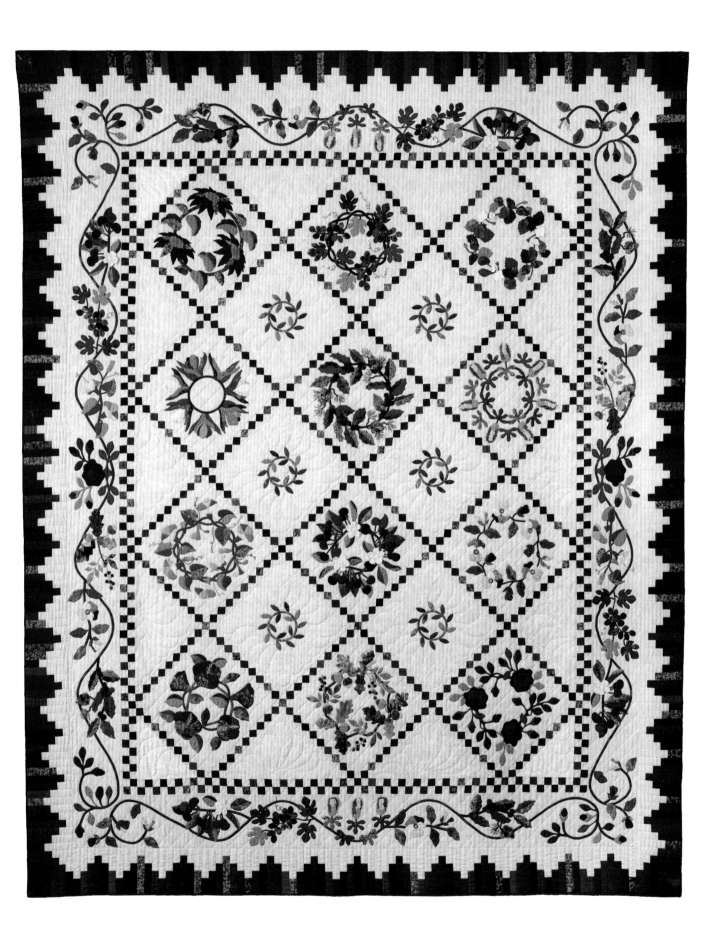

SIZE IN INCHES: 50 x 66

TEXAS LOCATION: Pipe Creek

MADE BY: Pamela Studstill

STYLE OF QUILT: Art

SOURCE OF DESIGN: Original design incorporating geometric piecework

MATERIALS USED: Cotton

PRIMARY TECHNIQUES: Machine piecing, painting, machine quilting

A Texas artist whose work is frequently seen in and represented by the Connell Gallery in Atlanta, Pamela combines traditional quiltmaking techniques with contemporary aesthetic concerns to create sumptuous geometric and patterned piecework. Known for her focus on painting to embellish the surface of her pieced art, she states: "By painting on my fabrics, I achieve a greater range of color and pattern than would be possible by using just solid-colored fabrics." She goes on to say: "Each of my quilts is a study in light. I am inspired by the Hill Country views and vistas, fields, and changes in my local landscape." Her work has been seen in Quilt National and was included in *Lone Stars II: A Legacy of Texas Quilts, 1936–1986*.

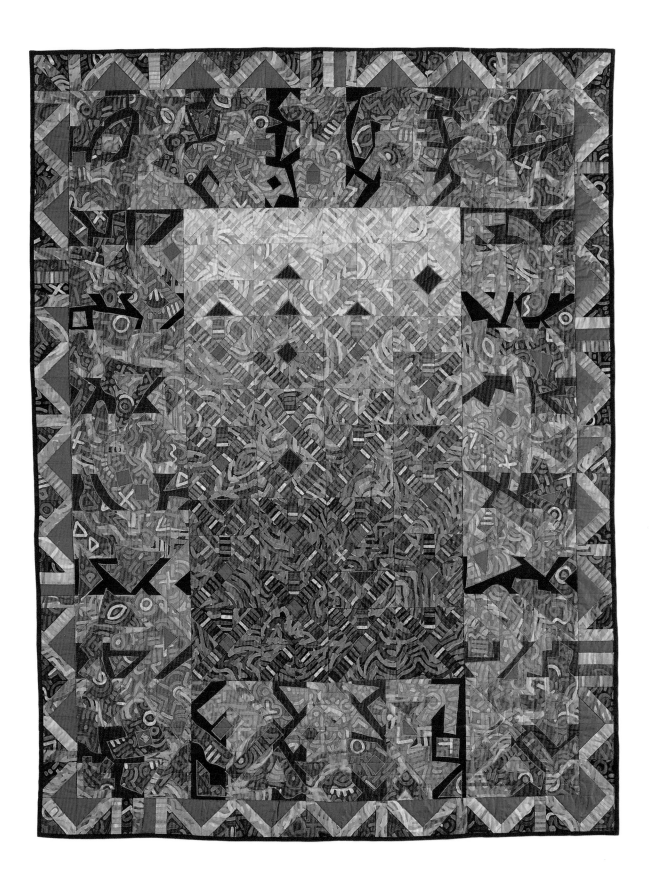

1998

SIZE IN INCHES: 104 × 104

TEXAS LOCATION: Kingwood

MADE BY: Nellie Showen Switzer

STYLE OF QUILT: Traditional

SOURCE OF DESIGN: Patterns

MATERIALS USED: Cotton

PRIMARY TECHNIQUES: Hand appliqué, hand quilting

Beautiful floral appliqué designs, all executed perfectly and presented with the elegance of hand appliqué and hand quilting—what could be more the essence of a fine traditional quilt? Nellie has taken her album quilt to another level with the obvious attention she has paid to the detail in her flowers, the many layers to create realism, the fabric and colors carefully chosen to enhance the design, the juxtaposition of cross-hatch quilting with elaborate floral quilting. "I decided that someday I would have to make a wall hanging of these flower designs. That wall hanging just kept growing. What a joy to see each bloom come to life!" says the artist, whose great aunt, Lillie Henderson, was included in *Lone Stars II: A Legacy of Texas Quilts, 1936–1986*. This quilt has won Best of Show and other awards.

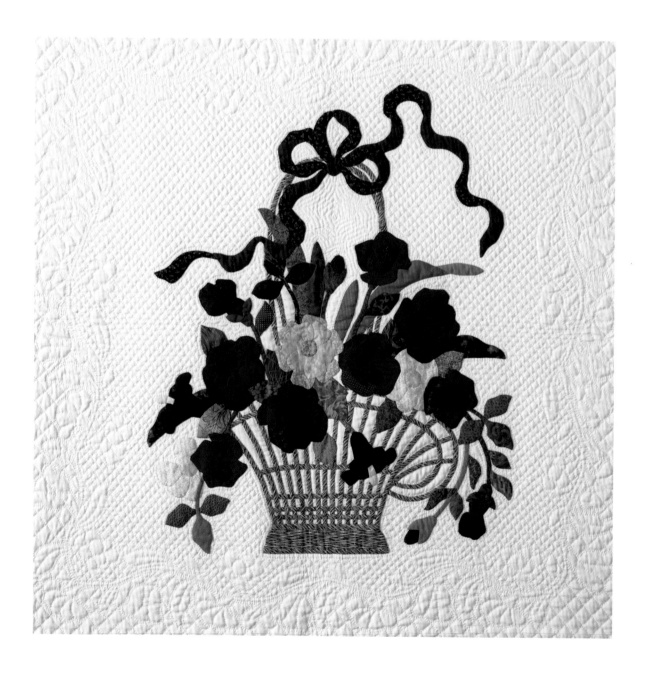

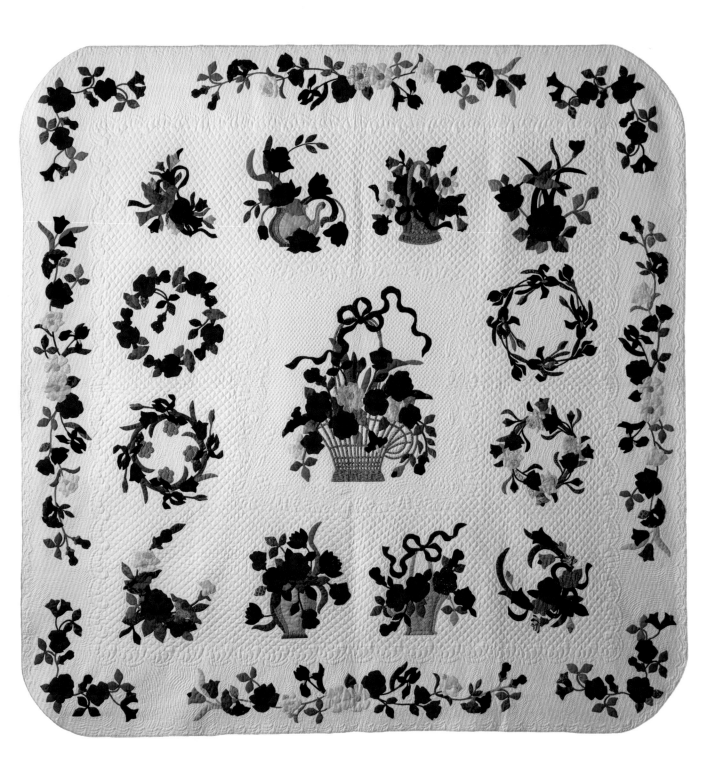

Shirley Was Right!

1998

SIZE IN INCHES: 74 x 75

TEXAS LOCATION: Austin

MADE BY: Sharon Haner

STYLE OF QUILT: Traditional

SOURCE OF DESIGN: Center
 original design

MATERIALS USED: Cotton

PRIMARY TECHNIQUES: Hand
 appliqué, trapunto, machine
 quilting

The quiltmaker's friend Shirley always told her that appliqué was relaxing, so she gave it a try with this quilt and discovered that Shirley was indeed right! Now Sharon teaches appliqué after enjoying her success with this quilt. Although the blocks are from published patterns, the center is an original pattern based on Rose of Sharon and Baltimore Album designs. The lush, blended colors used here make for a very approachable, painterly quilt, which has won awards.

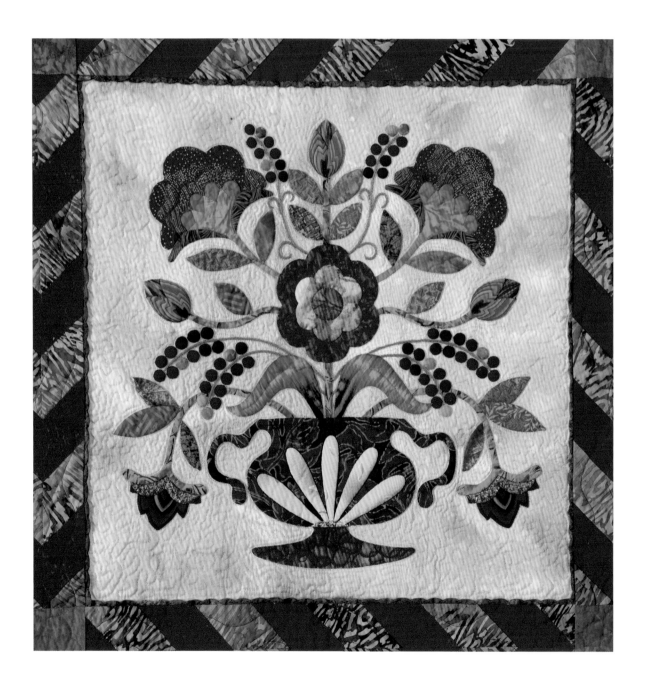

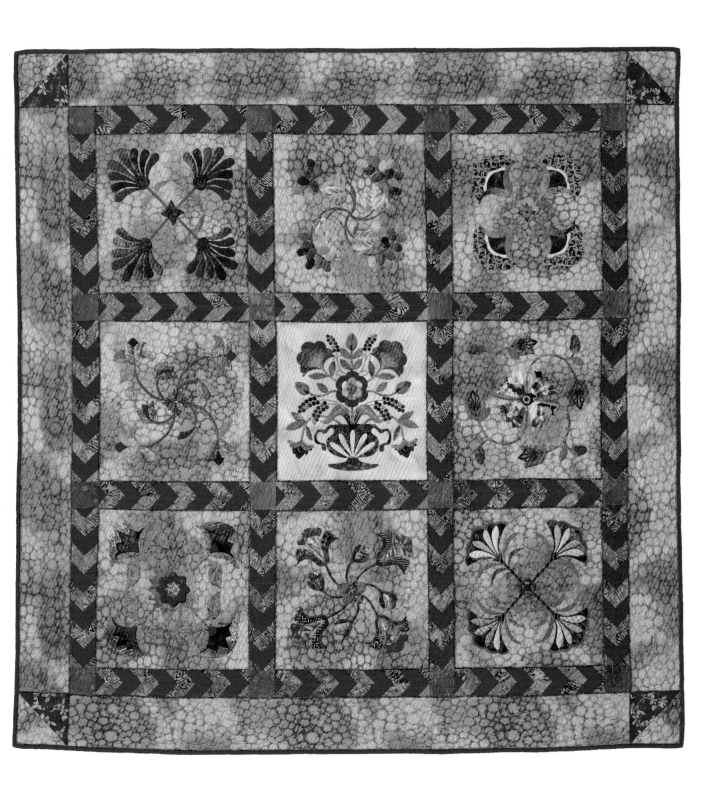

Baltimore Cutwork Appliqué

1998

SIZE IN INCHES: 104 X 103

TEXAS LOCATION: Katy

MADE BY: Charlotte McFadin

STYLE OF QUILT: Traditional

SOURCE OF DESIGN: Inspired by book on papercut appliqué

MATERIALS USED: Cotton

PRIMARY TECHNIQUES: Hand appliqué, hand quilting

An excellent quiltmaker who loves a challenge, Charlotte uses her talents to create many different types of quilts. Here, a cut paper appliqué design reflects both her color sense and her fine workmanship. It is dated on the front of the quilt, an unusual step that will be appreciated by future quilt scholars working on identifying quilts made in the twentieth century. This piece draws from the tradition of the Baltimore Album quilts with each block being different and contained within elaborate borders.

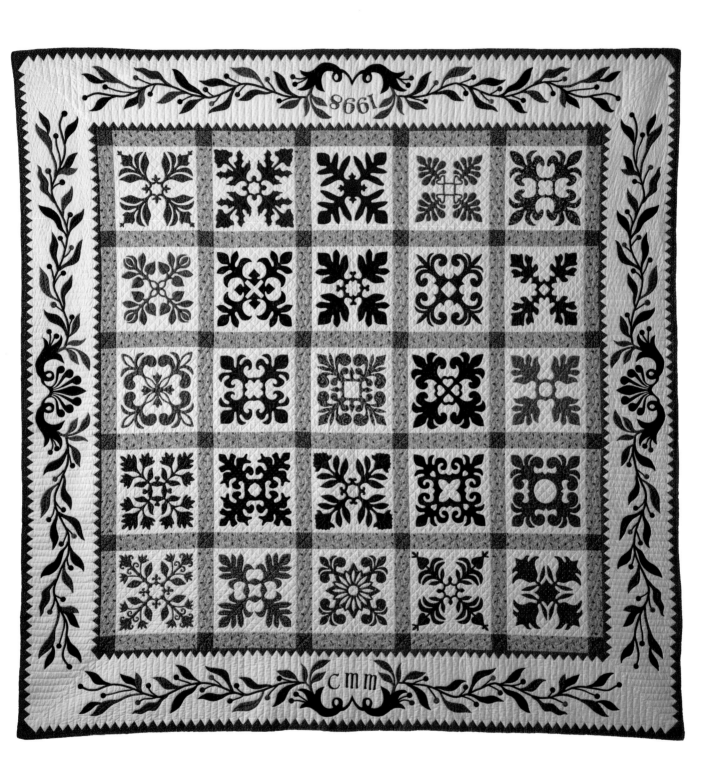

Untitled

1998

SIZE IN INCHES: 78 x 78

TEXAS LOCATION: San Antonio

MADE BY: Sarah Abright
Dickson

STYLE OF QUILT: Traditional

SOURCE OF DESIGN: Antique
red and white quilt

MATERIALS USED: Cotton

PRIMARY TECHNIQUES:
Machine piecing, hand
quilting

Using black solids, black on black prints, and many hand-dyed fabrics, Sarah created a dramatic contemporary rendition of an antique red and white quilt from Iowa. Not a common pattern, the quilt's design is both precise and lively, with the color placement determining the abstract effect.

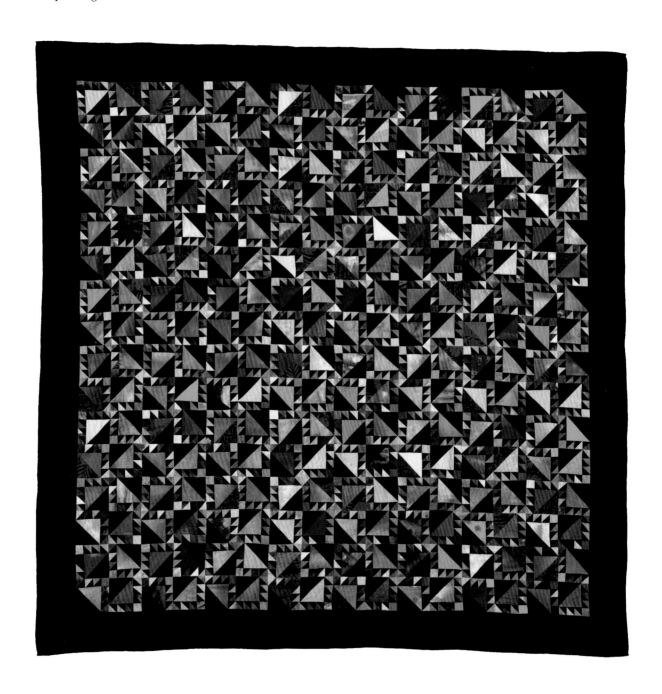

Pineapple Stretch

SIZE IN INCHES: 80 x 80

TEXAS LOCATION: Houston

MADE BY: Mary Ann Jackson Herndon

STYLE OF QUILT: Art

SOURCE OF DESIGN: Original design based on off-center Pineapple Log Cabin pattern

MATERIALS USED: Cotton

PRIMARY TECHNIQUES: Piecing, hand quilting

The quilt artist states that most of her Pineapple quilts end up as surprise designs even though she makes black and white mockups of the complete quilt before she starts work. "It never ceases to amaze me how altering the basic Pineapple pattern and arranging the colors to radiate from a central point combine to create an unanticipated whole," she explains. Ombre and gradated fabrics play a big role in Mary Ann's designs. This quilt has won awards, and two previous quilts by this artist appeared in *Lone Stars II: A Legacy of Texas Quilts, 1936–1986.*

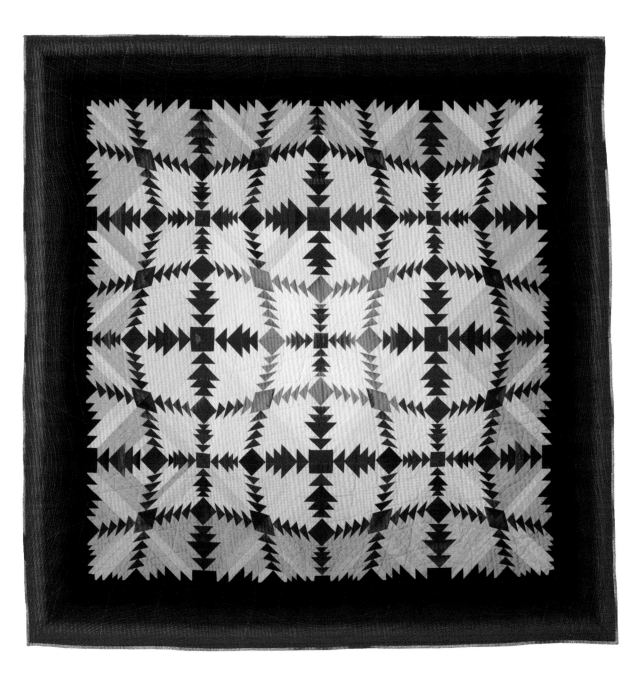

Cherry Basket

SIZE IN INCHES: 72 X 72

TEXAS LOCATION: Rockport

MADE BY: Jo Ann Hannah

STYLE OF QUILT: Traditional

SOURCE OF DESIGN: Book on feathers and flowers

MATERIALS USED: Cotton

PRIMARY TECHNIQUES: Hand appliqué, hand quilting, trapunto

The quiltmaker reduced the size of the four large squares to create this quilt, which she had first seen in a book. The border and trapunto designs are original creations of this artist. Jo Ann's quilt has been shown internationally and has won awards.

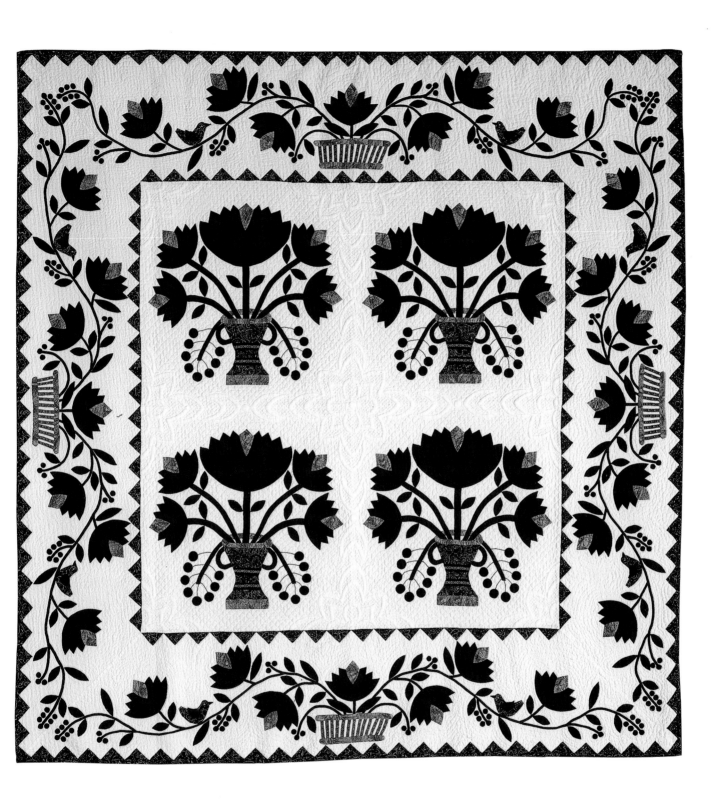

The Supper

1999

SIZE IN INCHES: 183 X 67

TEXAS LOCATION: Waxahachie

MADE BY: Don Locke, DDS

QUILTED BY: Linda V. Taylor

STYLE OF QUILT: Art

SOURCE OF DESIGN: Leonardo da Vinci's *The Last Supper*

MATERIALS USED: Cotton (some hand-dyed)

PRIMARY TECHNIQUES: Machine piecing, machine quilting

After successfully using a small pixilated image to create his first quilt, Don immediately thought of the ambitious idea for his second: Leonardo da Vinci's famous mural, *The Last Supper*. He worked on this huge quilt for almost two-and-a-half years (1200 working hours) and used 400 fabrics, many hand-dyed. These were cut to size, then organized and filed by colors. Working on his studio's flannel wall, he arranged the 51,816 half-inch squares into fifteen large areas of the quilt, then numbered columns of squares, took them down, and pieced them together on a Singer Featherweight machine. As the artist says, "God was involved in this project."

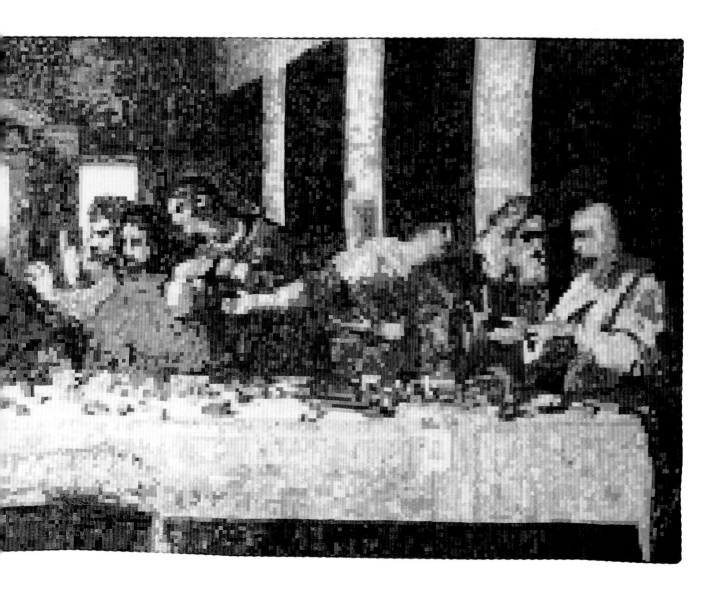

Sphere

SIZE IN INCHES: 92 × 92

TEXAS LOCATION: Spring

MADE BY: Margaret (Peggy) Fetterhoff

STYLE OF QUILT: Traditional

SOURCE OF DESIGN: Original design

MATERIALS USED: Cotton

PRIMARY TECHNIQUES: Piecing, hand quilting

1999

An original design loosely based on the old-fashioned Clamshell design or the Charm quilts of the past, this striking quilt makes use of hundreds of printed fabrics blended as an artist might blend oil paints or watercolors. Together they create the feeling of flowers in motion, of gardens spinning through realms of light and shadow. Peggy's mastery of value, shape, color, and light is obvious in this fascinating piece. It has won Best of Show and Viewer's Choice awards when exhibited.

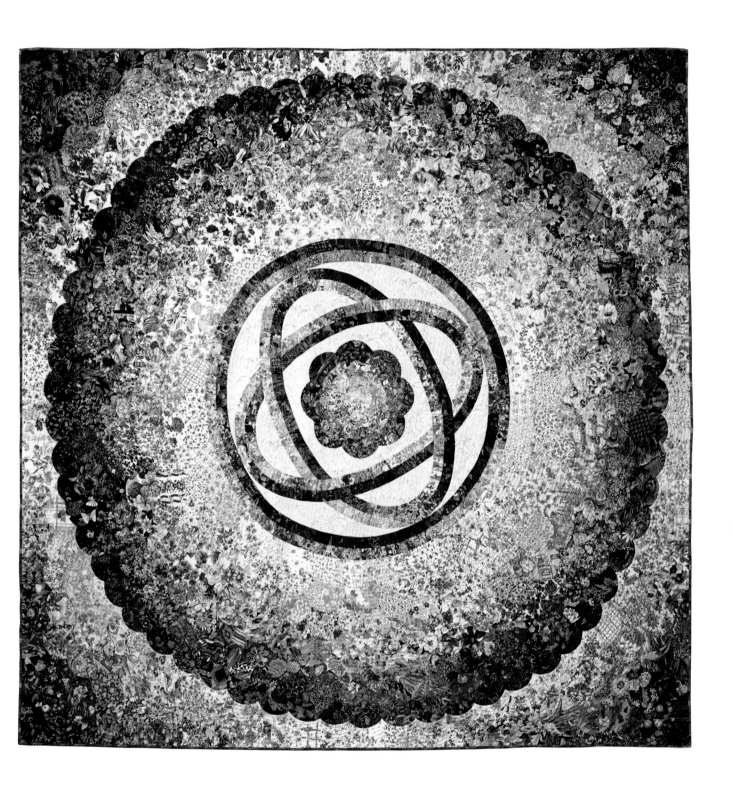

Mama Said

1999

SIZE IN INCHES: 73 x 87

TEXAS LOCATION: Houston

MADE BY: Susan H. Garman

STYLE OF QUILT: Traditional

SOURCE OF DESIGN: Primary
 values of life

MATERIALS USED: Cotton

PRIMARY TECHNIQUES:
 Appliqué, hand quilting

Most mothers hope to instill special virtues in their daughters—
that's why the sentiments in this quilt resonate so strongly.
"Share, trust, learn, play, love, hope, believe, dream, and
laugh"—add "work" to that list, and what more is there to a suc-
cessful life? Family is very important to Susan, a pattern designer,
and she wanted to make a quilt that celebrated the guiding prin-
ciples of life—the living verbs—that her parents taught her. She
also embroidered in the sashing the many other "rules" she heard
growing up. This quilt has won a Best of Show award.

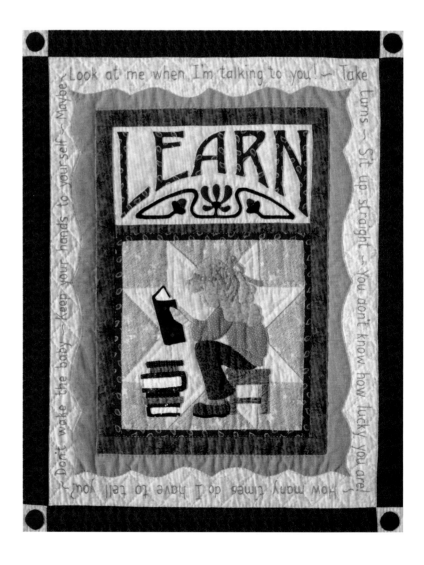

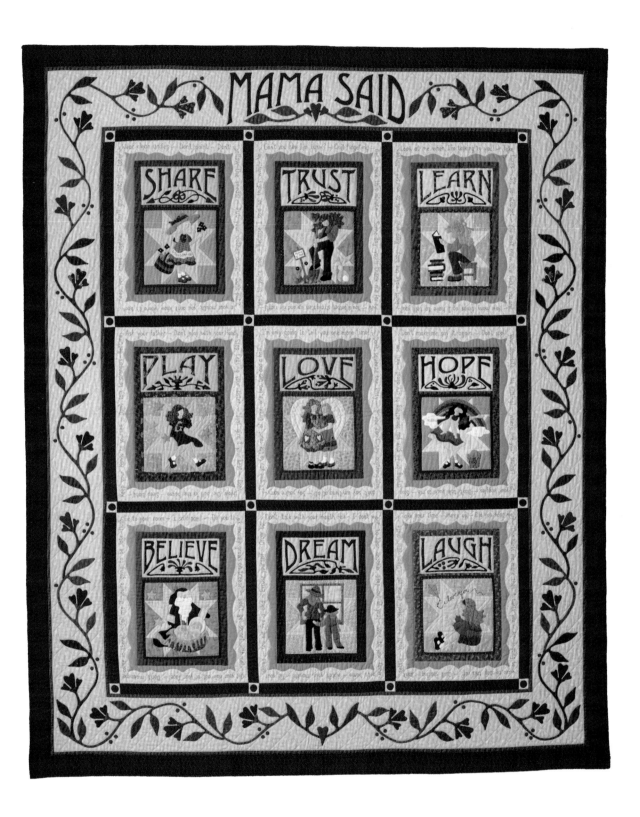

Midnight on the Oasis

1999

SIZE IN INCHES: 38 X 35

TEXAS LOCATION: Bryan

MADE BY: Connie Hester

STYLE OF QUILT: Art

SOURCE OF DESIGN:
Improvisational piecing

MATERIALS USED: Cotton and
blends (some hand-dyed),
rayon

PRIMARY TECHNIQUES:
Machine piecing, machine
quilting

Improvisational placement of her original dark pattern blocks created the suggestion of a pale moon, and this unexpected shape inspired Connie's fantasy oasis. Sparkling water, flowers, and flying fish make a somewhat surrealistic transition between the water and the sky. Another quilt by this artist appeared in *Lone Stars II: A Legacy of Texas Quilts, 1936–1986*.

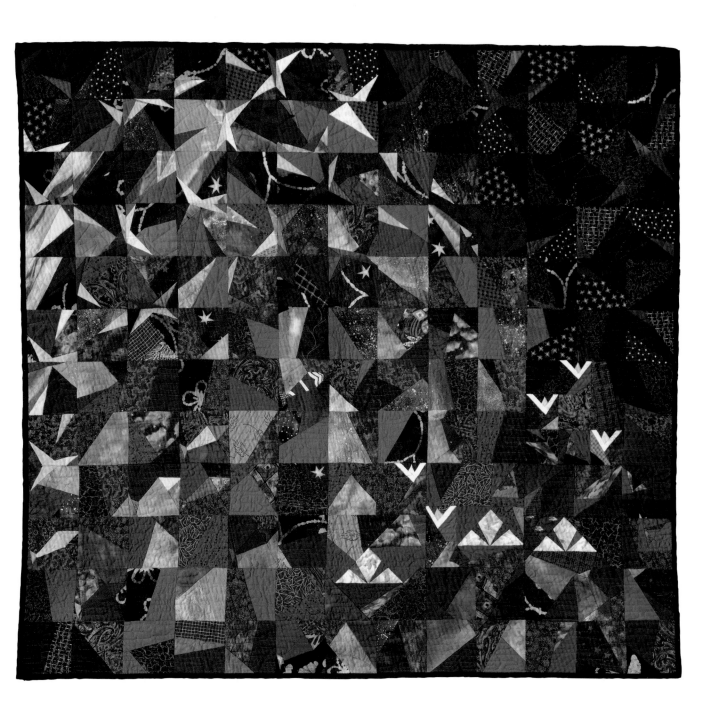

131

There's a Dandelion in Our Garden

1999

SIZE IN INCHES: 86 x 102

TEXAS LOCATION: Dimmitt

MADE BY: Friendship Quilter's Guild

GROUP MEMBERS: Amelia Barrera, Darlene Collins, Ina Cleavinger, Bonnie Davis, Joyce Davis, Winona Franks, Cenci Hardee, Yvonna Hays, Claudine Langford, Doris Lust, Cassa McCormick, Annie McCurry, Tommie Sue Nisbett, Jean Robb, Donita Vernon, Tara Wales, Twila West

STYLE OF QUILT: Traditional

SOURCE OF DESIGN: Patterns

MATERIALS USED: Cotton

PRIMARY TECHNIQUES: Machine and hand appliqué, machine piecing, hand embroidery, hand quilting

FROM THE COLLECTION OF: Gerry O'Brien Davis

A simple repeated star pattern is emphasized by the elaborate border design of flowers, fruit, birds, and insects, much of which is original. Note the dandelion in the lower left corner and the garden gloves in the center top border. Fabrics were chosen to illuminate and give visual texture. This quilt has won a Best of Show award. It was a raffle quilt for the guild and is now owned by the winner, who is also a guild member.

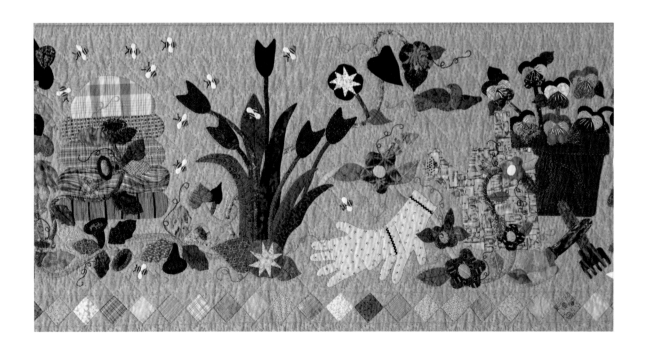

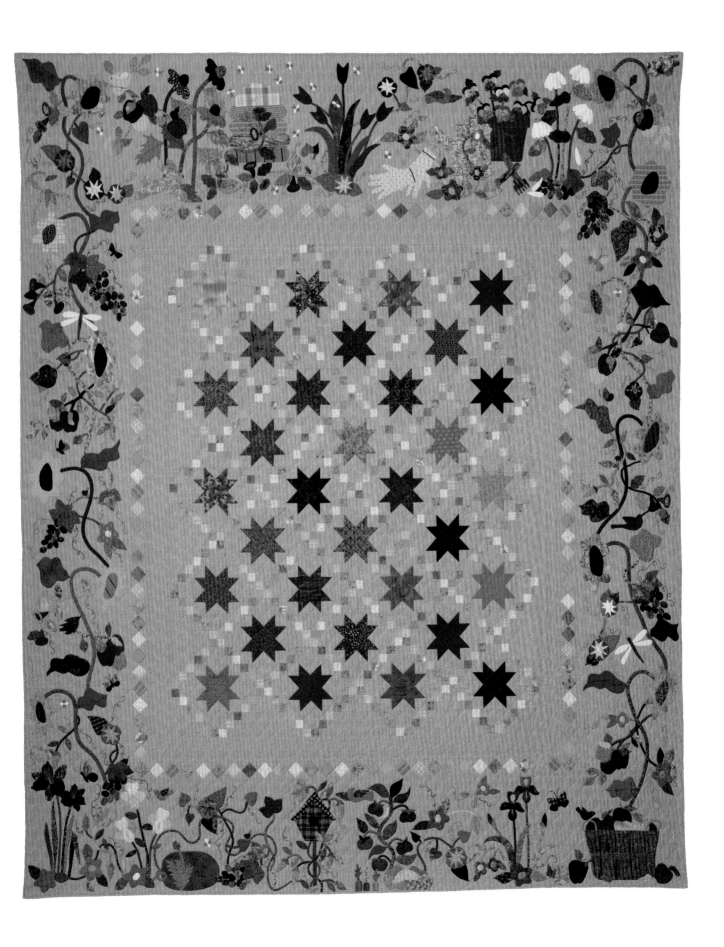

Gaillardia

SIZE IN INCHES: 70 x 50

TEXAS LOCATION: Carrollton

MADE BY: Carol Morrissey

STYLE OF QUILT: Art

SOURCE OF DESIGN: Personal photographs of Texas wildflowers

MATERIALS USED: Hand-dyed cotton

PRIMARY TECHNIQUES: Machine piecing, machine quilting

1999

After the bluebonnets fade, fields of Gaillardia or Fire Wheel blanket Texas with their brilliant color. When the sun hits a field of this indomitable flower, it looks as though the land is on fire with the flower some still call Mexican blanket or Indian blanket. Carol's original design art quilt is quite unusual in its construction—although it looks like appliqué, it is entirely pieced, even the rounded centers of the flowers. "It was a little tricky," she says, "but I managed to make it fit together." The quilt has won awards and been part of a solo museum exhibition.

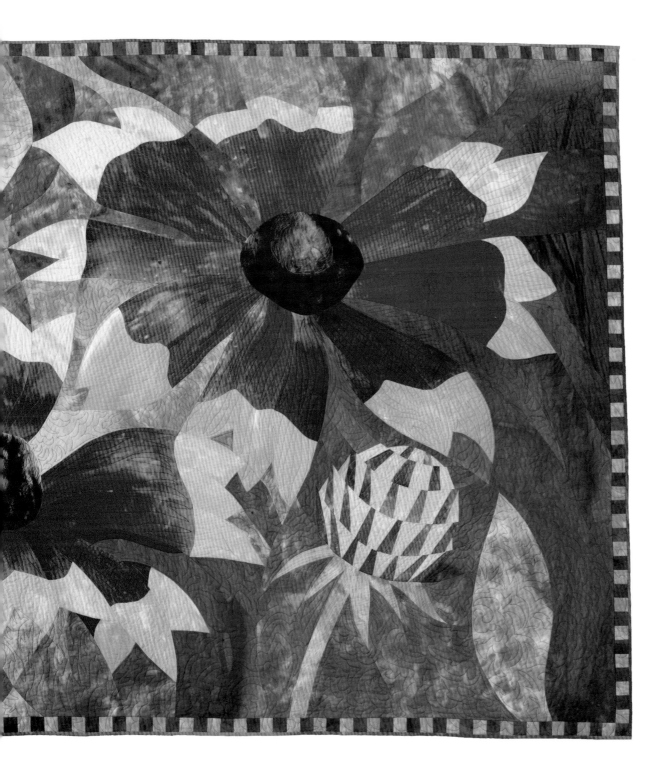

135

1999

SIZE IN INCHES: 30 x 28

TEXAS LOCATION: Austin

MADE BY: Vickie Hallmark

STYLE OF QUILT: Art

SOURCE OF DESIGN:
Photograph of a scientific experiment

MATERIALS USED: Cotton, silk organza

PRIMARY TECHNIQUES:
Piecing, appliqué, machine embroidery, machine quilting

Inspired by a simple grid of rectangles with beautiful metal oxide colors that "haunted my imagination," Vickie created this unusual and appealing art quilt. Here the quilt artist used the grid format to explore juxtapositions of color and texture.

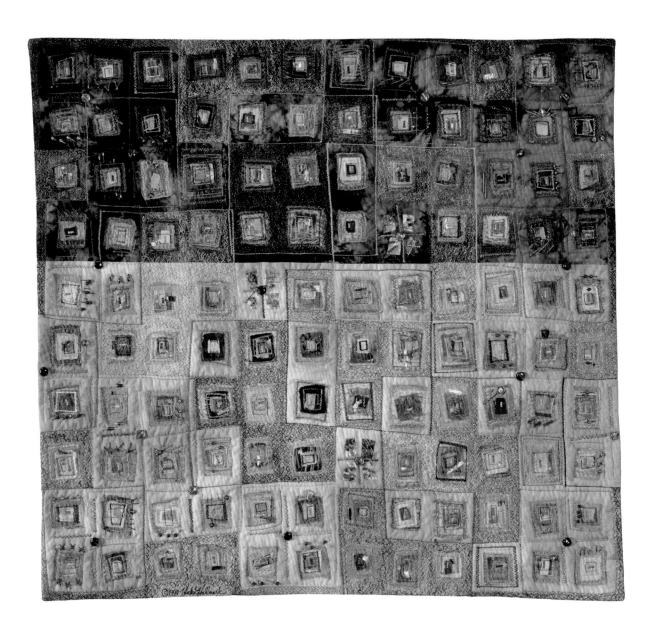

Quilt Works #2339

SIZE IN INCHES: 18 X 18

YEAR MADE: 2000

TEXAS LOCATION: Houston

MADE BY: Moira Cannata (deceased)

STYLE OF QUILT: Traditional

SOURCE OF DESIGN: Miniature patterns

MATERIALS USED: Cotton

PRIMARY TECHNIQUES: Piecing, hand quilting

FROM THE COLLECTION OF: Fred Cannata

Moira, who, sadly, died during the research phase of this book, was well known for the astonishing number of pieces she used in her quilts. This miniature quilt, based on the Log Cabin design and on early Medallion-style quilts, contains 2,339 tiny pieces and was the first in a series planned to use up baskets of scraps left over from other projects.

Rose

SIZE IN INCHES: 19 X 19

YEAR MADE: 2004

TEXAS LOCATION: Houston

MADE BY: Marie Moore

STYLE OF QUILT: Traditional

SOURCE OF DESIGN: Pattern from book

MATERIALS USED: Cotton

PRIMARY TECHNIQUES: Needle-turn hand appliqué with some embroidery, hand quilting

Miniature quilts are truly a challenge to make. Size requirements vary from show to show and often change, which means that the quilt artist may suddenly have a quilt that is eligible for only one show instead of the several she had planned to enter. It takes dedication to focus on these small pieces. Marie has never lost that focus. Her miniature quilts are often prizewinners and always crowd-pleasers, especially when the viewers realize her quilts are all handmade. Here, her small square quilt presents rose centers surrounded by clusters of grapes on the vine with feather quilting.

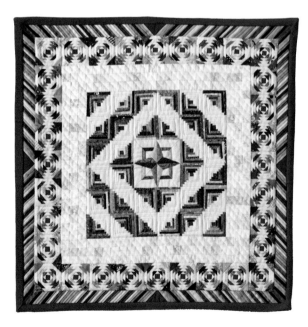

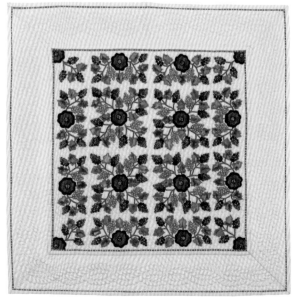

Pineapple Paintball

SIZE IN INCHES: 23 X 23

YEAR MADE: 2004

TEXAS LOCATION: Houston

MADE BY: Michelle Settle

STYLE OF QUILT: Art

SOURCE OF DESIGN: Original design based on foundation quilt book

MATERIALS USED: Cotton

PRIMARY TECHNIQUES: Machine piecing using foundation paper piecing, machine quilting

The Pineapple block, a traditional Log Cabin variation, can be manipulated to create many contemporary designs. Here, the artist was inspired by a miniaturized design seen in a book on foundation quilts. She used 6,300 pieces in the 140 paper-pieced blocks in this quilt and created her own border design and vivid color scheme. "I love quilts that are challenging and unconventional," says Michelle. "Black in the background makes the colors 'burst' like a paint-ball. The more color the better, I say!"

Rainbow Refraction

SIZE IN INCHES: 18 X 18

YEAR MADE: 2005

TEXAS LOCATION: Splendora

MADE BY: Sara Avers

STYLE OF QUILT: Traditional

SOURCE OF DESIGN: Magazine picture

MATERIALS USED: Batiks

PRIMARY TECHNIQUES: Foundation piecing, hand and machine quilting

The blocks in this quilt create a color wheel, and Sara has created dimension by changing the value of the colors within each block. A miniature quilt, this design was based on a large quilt, *Peacock Window*, seen in a magazine and then adapted to miniature size by the quiltmaker. The quilt has won Best of Show and Viewer's Choice awards.

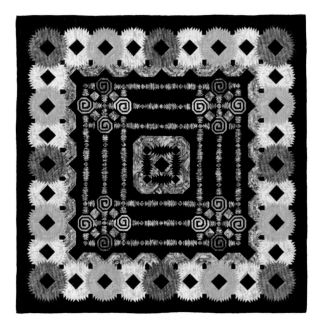

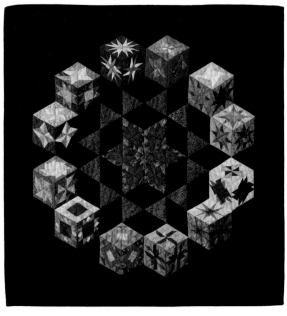

Nightcruise on the River Thames

SIZE IN INCHES: 21 X 21

YEAR MADE: 2006

TEXAS LOCATION: Houston

MADE BY: Kumiko Abe Frydl

STYLE OF QUILT: Traditional

SOURCE OF DESIGN: Pineapple and Flying Geese patterns

MATERIALS USED: Cotton

PRIMARY TECHNIQUES: Paper foundation piecing, machine piecing, hand quilting

Precision paper piecing is what makes this miniature quilt possible. It is based on the Pineapple and Flying Geese patterns and traveled with the quiltmaker to six different countries before being finished. Kumiko, Japanese by birth and married to a Czech-Canadian, was inspired by the River Thames at night, when "the murky waters glisten in the moonlight and cast shimmering white rays across the surface." London's bright lights also reflect in the river, and this quilt reflects their sparkle.

Little Boy Blue

SIZE IN INCHES: 18 X 24

YEAR MADE: 2007

TEXAS LOCATION: Austin

MADE BY: Barb Forrister

STYLE OF QUILT: Art

SOURCE OF DESIGN: Original design

MATERIALS USED: Cotton (some hand-dyed), Tyvek

PRIMARY TECHNIQUES: Inking, painting, heat distressing, hand embroidery, machine appliqué and quilting

Detailed and realistic in an impressionistic style, this charming little quilt focuses on depth and texture in nature. The artist took the picture on which this quilt is based while on vacation in Colorado. Bluebirds migrate north to the Colorado Rockies for the summer. By painting and heat distressing Tyvek, Barb has carefully created the texture of the bark of the Ponderosa Pine which shelters the bluebird.

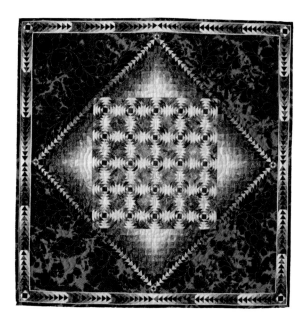

Mission: Impossible?

SIZE IN INCHES: 21 X 21

YEAR MADE: 2008

TEXAS LOCATION: Houston

MADE BY: Kumiko Abe Frydl

STYLE OF QUILT: Traditional

SOURCE OF DESIGN: Miniature version of pattern

MATERIALS USED: Cotton, silk ribbon

PRIMARY TECHNIQUES: Paper foundation piecing, silk ribbon embroidery, reverse appliqué, and free-motion quilting

The quiltmaker's goal seemed impossible at first as she tried to adapt a full-size pattern to a miniature quilt only one-twentieth the size of the original piece. However, when she changed the original appliqué on the border and sashing to ribbon embroidery, the impossible became possible. The ribbon embroidery enhances the precision of the sixty-four pieced points of the Mariner's Compass, each 5.25" in diameter, and adds richness and dimension to the quilt. The artist uses very fine paper for the foundation and dense but fine fabrics. She won Best of Show for a similar quilt, which had 128 points to each compass.

Rios

SIZE IN INCHES: 24" round

YEAR MADE: 2009

TEXAS LOCATION: Montell

MADE BY: Jill Clark Frazior

STYLE OF QUILT: Art

SOURCE OF DESIGN: Original design

MATERIALS USED: Cotton, silk

PRIMARY TECHNIQUES: Free-motion quilting, colored pencil work

Fancy cowboy boots are a Texas icon, and the boots captured in this round quilt are fancy enough for any cowboy's big night out. Jill has used cotton and silk fabric with colored pencils to create this symbolic quilt. She found her inspiration in a book on cowboy boots.

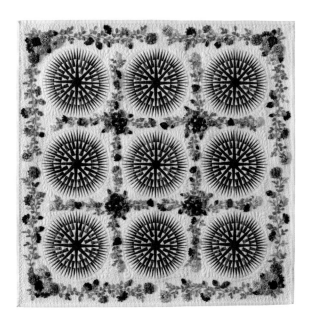

Mission: Impossible?

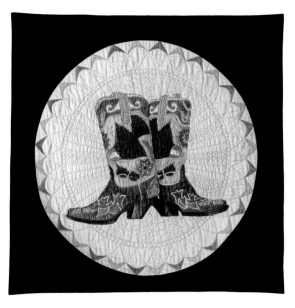

Moonglow Madness

2000

SIZE IN INCHES: 81 x 83

TEXAS LOCATION: Kingwood

MADE BY: Linda Wilson

STYLE OF QUILT: Traditional

SOURCE OF DESIGN: Challenge
with friends

MATERIALS USED: Cotton

PRIMARY TECHNIQUES:
Machine piecing, quilting

A group of friends worked together to create individual quilts based on the same pattern and fabrics. "The challenge was to make our quilts just a little different," says Linda. "We laughed, we cried, some didn't finish, and one never got started. Mine got jeweled. It was such fun!" Using what are sometimes considered Amish colors, or jewel-tone colors, the quiltmaker has added crystals to highlight the points in each of the blocks and add sparkle to the finished piece.

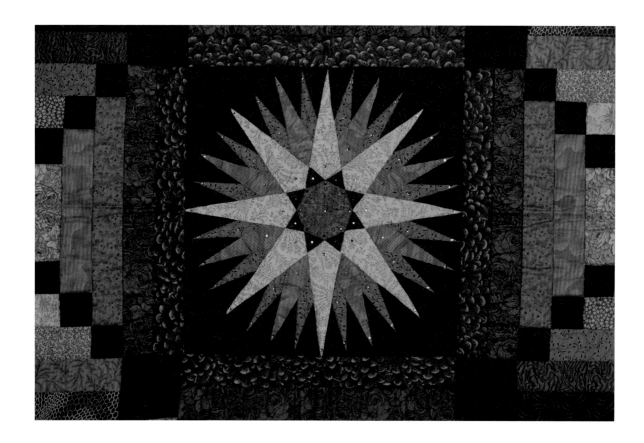

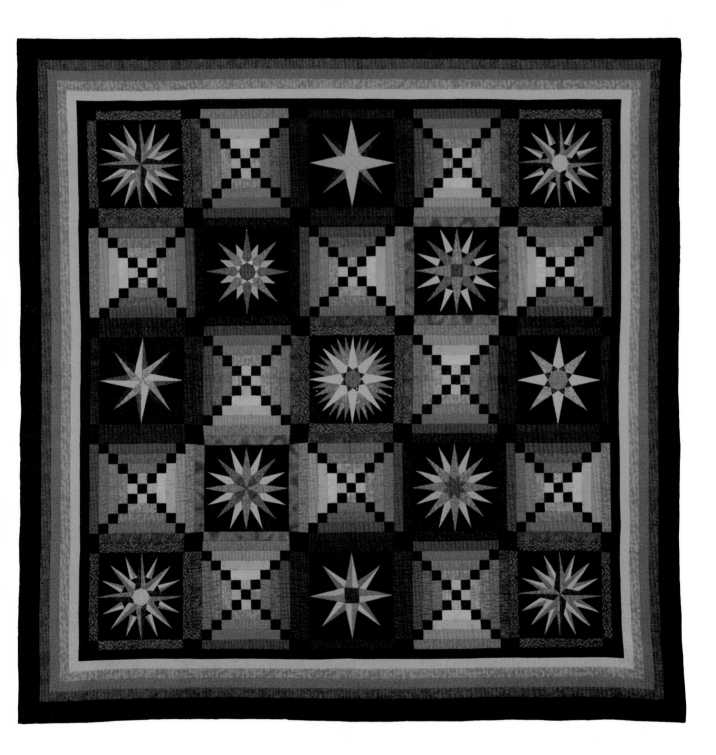

Power of Houston

2000

SIZE IN INCHES: 120 X 108

TEXAS LOCATION: Houston

MADE BY: Cynthia Law
England, Libby Lehman,
and Vicki Mangum

STYLE OF QUILT: Art

SOURCE OF DESIGN: Based on
a photograph

MATERIALS USED: Cotton

PRIMARY TECHNIQUES:
Picture piecing, appliqué,
threadwork, machine
quilting

FROM THE COLLECTION OF:
City of Houston

This huge quilt depicts the Houston skyline at night and was created by a trio of quilt artists commissioned by Houston's International Quilt Festival to celebrate its "Quilt Show of the Century" in 2000. The three artists collaborated to create this spectacular quilt, now donated to the city and on permanent exhibit. Working from a photograph, Cynthia picture pieced the buildings, Libby threadpainted the fireworks, and Vicki machine quilted the piece in metallic thread.

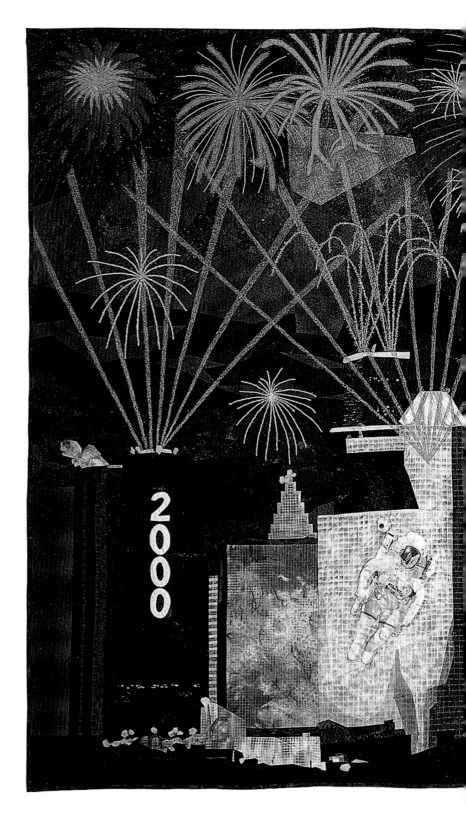

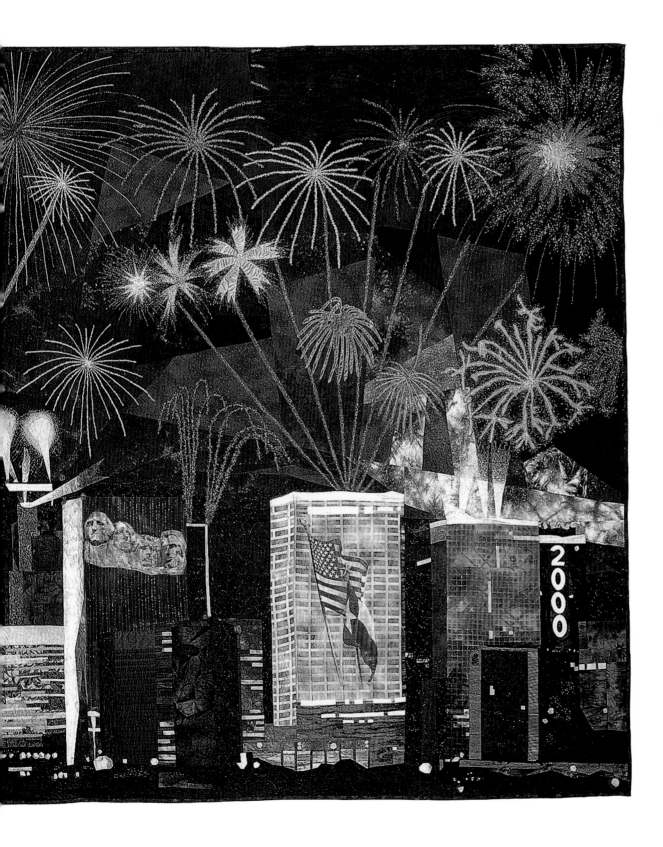

Twylite Zone (Storm at Sea)

SIZE IN INCHES: 72 X 91

TEXAS LOCATION: Burleson

MADE BY: Frances McNatt Snay

QUILTED BY: Linda V. Taylor

STYLE OF QUILT: Traditional

SOURCE OF DESIGN: Original layout design based on Storm at Sea pattern

MATERIALS USED: Cotton

PRIMARY TECHNIQUES: Piecing, machine quilting

Storm at Sea, a traditional pattern with nineteenth-century maritime origins when many a fisherman's wife sat home waiting and praying for his safe return, is an ideal design for using a wide variety of printed fabrics and multiple colors. The design "gave me a feeling of outer space invention," says Fran. The quilt has won multiple awards in two states.

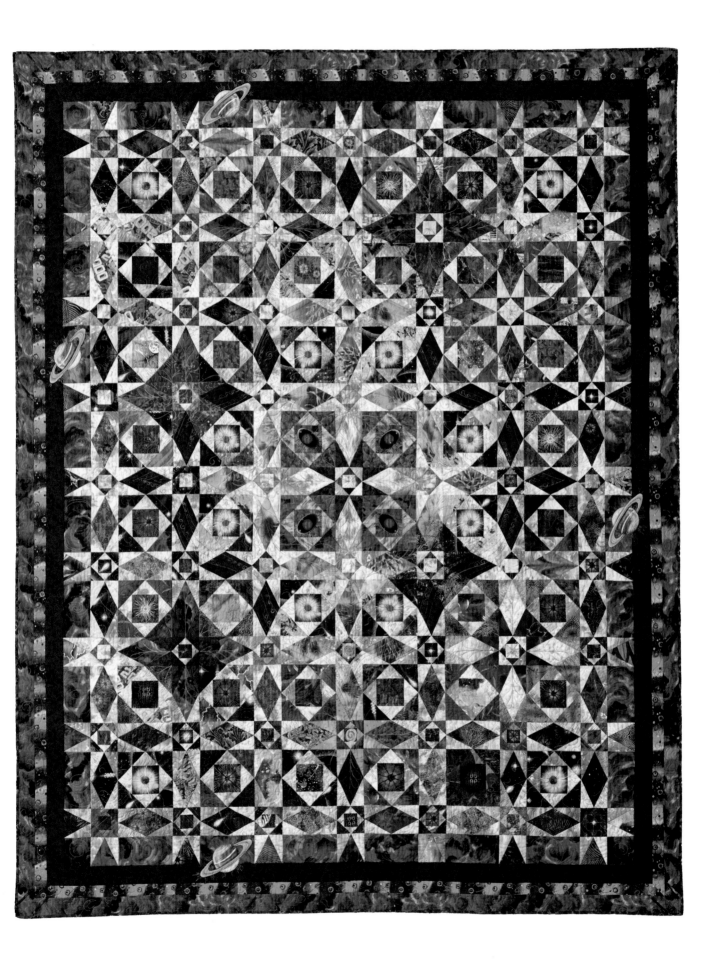

Open Season

2000

SIZE IN INCHES: 87 x 90
TEXAS LOCATION: Houston
MADE BY: Cynthia Law England
STYLE OF QUILT: Art
SOURCE OF DESIGN: Based
on a photograph by Leroy
Williamson
MATERIALS USED: Cotton,
organza, satins
PRIMARY TECHNIQUES: Picture
piecing, machine quilting

Cynthia, whose work frequently wins awards, has said that she considers this to be her best quilt. A winter scene, it captures the peace and tranqillity of a creekside vignette in the snow, complete with a silent, still rabbit keeping watch. Created over six years, the quilt has more than 21,000 individual pieces of 280 different fabrics. Cynthia used her inventive picture piecing technique and based the quilt on a *Texas Highways* photograph, which she used with permission. This quilt has won five Best of Show awards and several Viewer's Choice awards.

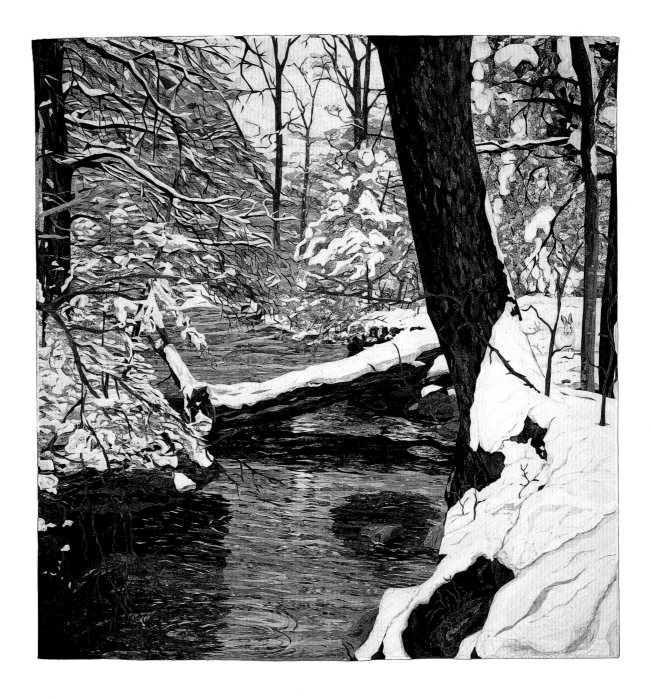

On the Fourth Day

SIZE IN INCHES: 71 X 76

TEXAS LOCATION: Houston

MADE BY: Sandra Greve Thompson

QUILTED BY: Carol Thelen

STYLE OF QUILT: Art

SOURCE OF DESIGN: Original design

MATERIALS USED: Cotton

PRIMARY TECHNIQUES: Piecing, appliqué, machine quilting

Stars, planets, the sun and the moon are all appliquéd onto the pieced background of this quilt, which clearly references a specific Bible verse. "And God said, 'Let there be lights in the firmament of the heaven . . . to divide the day from the night . . . and to give light upon the earth': and it was so. And God made two great lights, the greater light to rule the day, and the lesser light to rule the night: He made the stars also . . . and God saw that it was good. And the evening and the morning were the fourth day." Sandra made her award-winning quilt for a quilt show with the theme "To the Stars and Beyond."

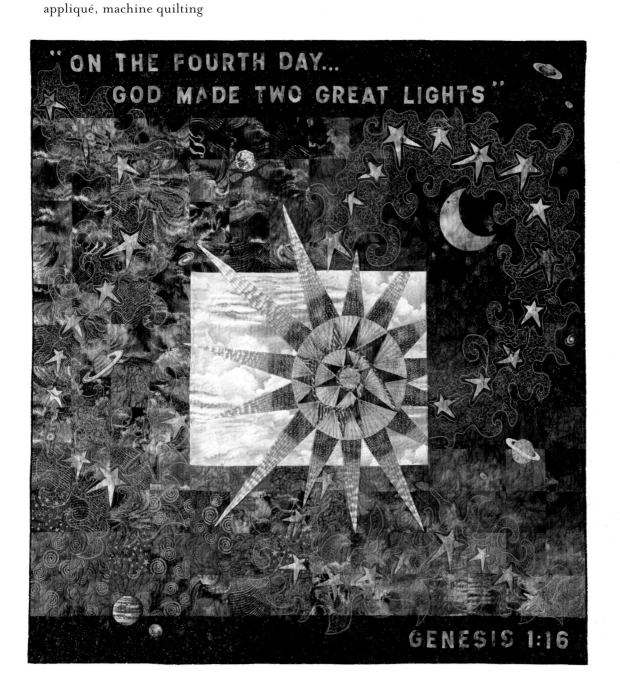

149

2000

SIZE IN INCHES: 44 x 66

TEXAS LOCATION: Pipe Creek

MADE BY: Pamela Studstill

STYLE OF QUILT: Art

SOURCE OF DESIGN: Original
design

MATERIALS USED: Cotton

PRIMARY TECHNIQUES:
Machine piecing, painting,
machine quilting

FROM THE COLLECTION OF:
Martha and Pat Connell

Shimmering color-filled surfaces activated by dazzling stripes, dots, and intricate painted markings are the hallmark of this artist's work. "I like all that pattern," says Pamela. "I like the way it moves. That shimmering quality is the mark of a successful quilt for me." No matter how abstract her compositions may seem, there is always what appears to be an allusion to landscape. The sky can be seen as a lighter area appearing at the top, then the suggestion of a horizon, and finally, the ground is represented by darker sections near the bottom. The artist always numbers her quilts rather than naming them, because she doesn't want people to think of "things" when they look at her work. Earlier work by this artist was included in *Lone Stars II: A Legacy of Texas Quilts, 1936–1986*.

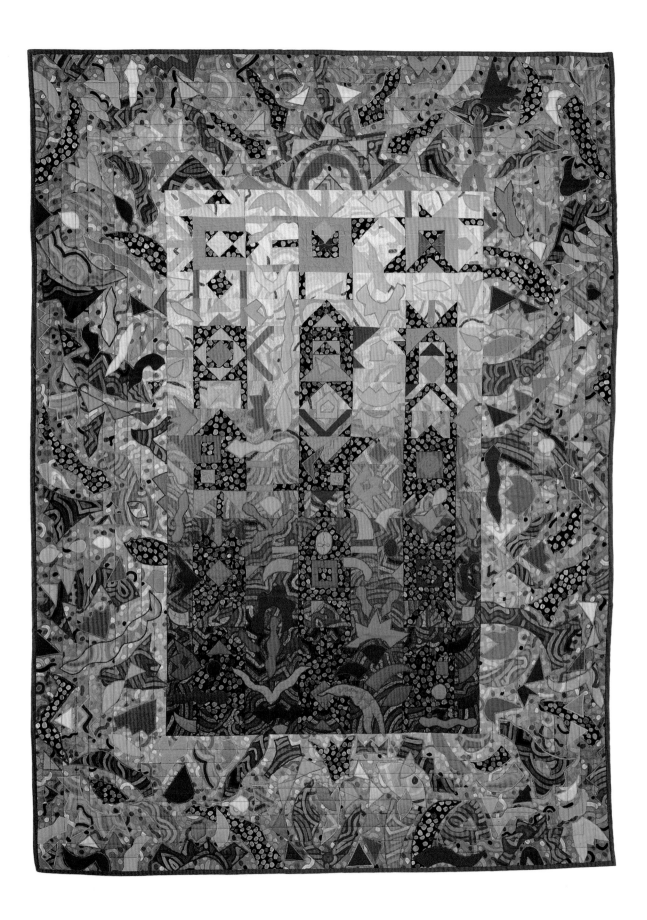

Carmen's Veranda

2000

SIZE IN INCHES: 74 X 90

TEXAS LOCATION: Austin

MADE BY: Patrice Perkins
Creswell

STYLE OF QUILT: Art

SOURCE OF DESIGN: Original
design

MATERIALS USED: Cotton

PRIMARY TECHNIQUES: Hand
appliqué, machine piecing,
machine and hand quilting

Exuberance exemplified, this art quilt radiates the fun that comes
to mind with the name of movie star and singer Carmen Miranda.
Trying to convey the flamboyance of the star who always wore
exotic headpieces decorated with towering arrangements of fruit,
Patrice designed her quilt to place Carmen in Austin, the city with
the unofficial slogan "Keep Austin Weird." With a rooster, fla-
mingo, scorpion, bat, parrot, and two snakes, Carmen's veranda
is a lively place! It has won a Best of Show award.

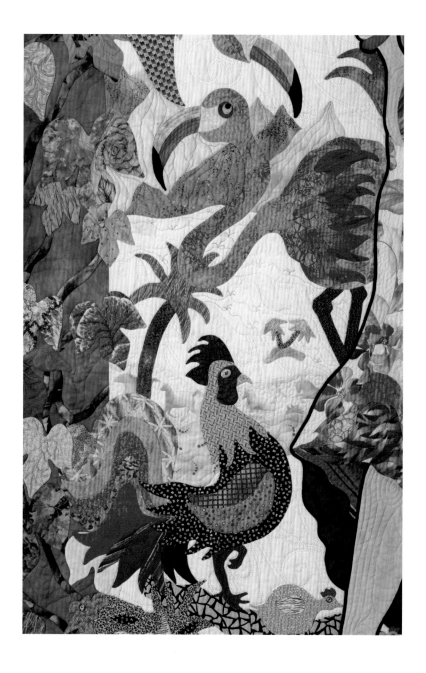

Carmen's Veranda

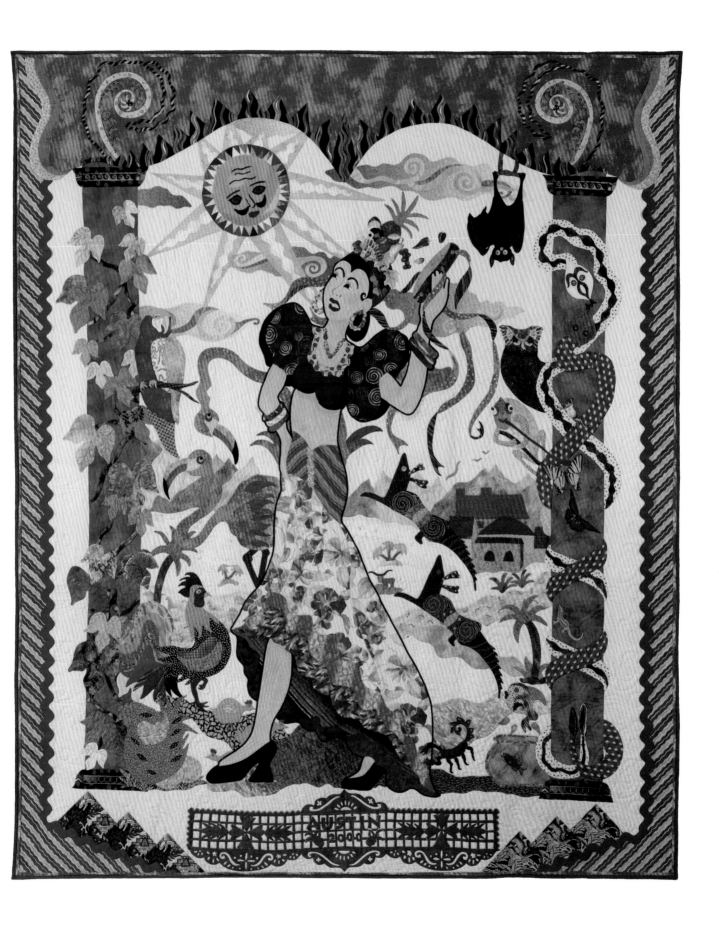

153

Magic Carpet

2000

SIZE IN INCHES: 78 x 83

TEXAS LOCATION: Irving

MADE BY: Cheri Meineke-Johnson and Linda V. Taylor

QUILTED BY: Linda V. Taylor

STYLE OF QUILT: Combination art and traditional

SOURCE OF DESIGN: Original design

MATERIALS USED: Cotton

PRIMARY TECHNIQUES: Hand appliqué, embellishing, longarm machine quilting

More than 9100 Austrian-made Swarovski crystals were heat applied to this remarkable quilt. All of the pieces were fussy cut from one fabric (also used for the back) and were hand appliquéd to a separate solid background. Machine trapunto and original longarm quilting designs created specifically for this quilt make this a joint masterpiece. Cheri and Linda often work together to create their beautiful, award-winning quilts. This piece has won Best of Show at two venues.

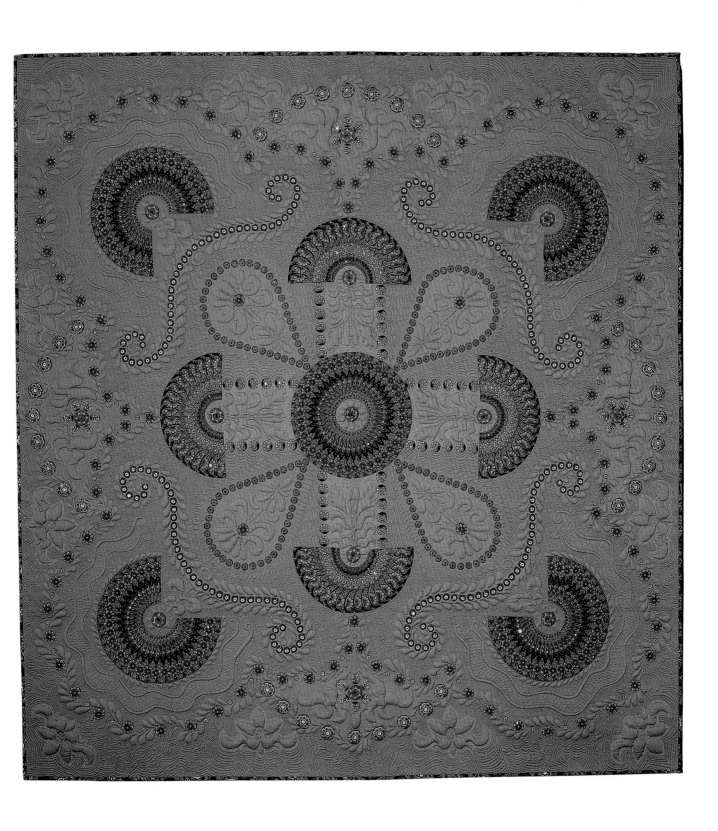

Bluebonnets & Indian Paintbrushes

2000

SIZE IN INCHES: 52 × 52

TEXAS LOCATION: Austin

MADE BY: Sue Laurent

STYLE OF QUILT: Traditional

SOURCE OF DESIGN: Inspired
by Hawaiian quilts

MATERIALS USED: Cotton

PRIMARY TECHNIQUES: Hand
appliqué, machine piecing,
machine quilting

Devising a Texas take on the Hawaiian quilt style was the inspiration for this award-winning quilt, which depicts popular Texas wildflowers in appliqué. It was loosely based on a traditional pattern. The Indian paintbrushes, in particular, are very realistic.

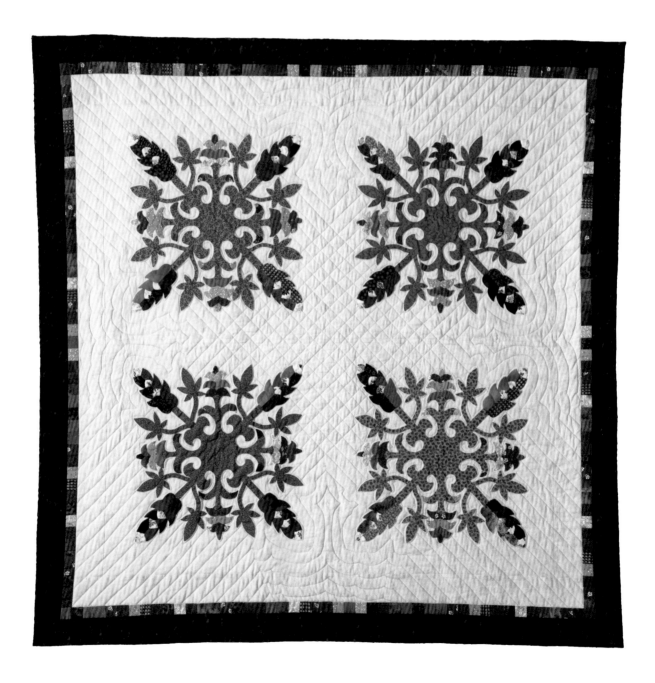

Tobacco Leaf + Tulip

SIZE IN INCHES: 85 X 85

TEXAS LOCATION: New Braunfels

MADE BY: Susan Cummins Derkacz

STYLE OF QUILT: Traditional

SOURCE OF DESIGN: Original design adapted from antique quilt

MATERIALS USED: Cotton

PRIMARY TECHNIQUES: Machine piecing, hand appliqué, hand quilting

Strong contrasting colors, a vigorous, assertive design, and a delicate border, all confined within tiny Sawtooth inner and outer borders, make this quilt a visual treat with a certain tension to it. Susan adapted this four-block design from an antique Kentucky quilt, c. 1850, that she saw in a book. A strong proponent of hand work on quilts, she has won several awards for her work.

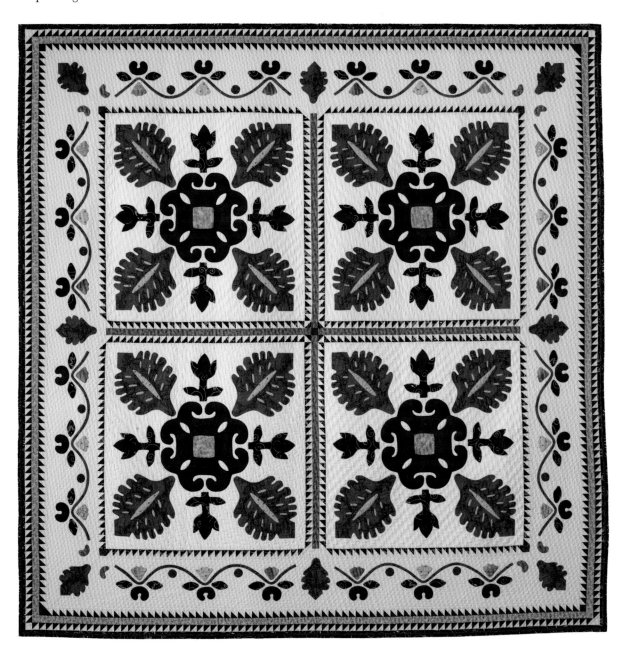

Sitting on the Rock on the Bay

SIZE IN INCHES: 39 × 53

TEXAS LOCATION: Kingwood

MADE BY: Jonna Haerup Poser Graham

STYLE OF QUILT: Art

SOURCE OF DESIGN: Workshop

MATERIALS USED: Cotton, silk, tulle

PRIMARY TECHNIQUES: Appliqué, hand quilting

This award-winning pictorial quilt strongly conveys the quilt-maker's love and affection for the subject—her daughter. Jonna's design captures the girl's youth, health, wholesomeness, and happiness at being exactly where she is—on the Oregon coast. The quiltmaker credits a seminar for helping her get past "blank faces" so that she can now capture expressions.

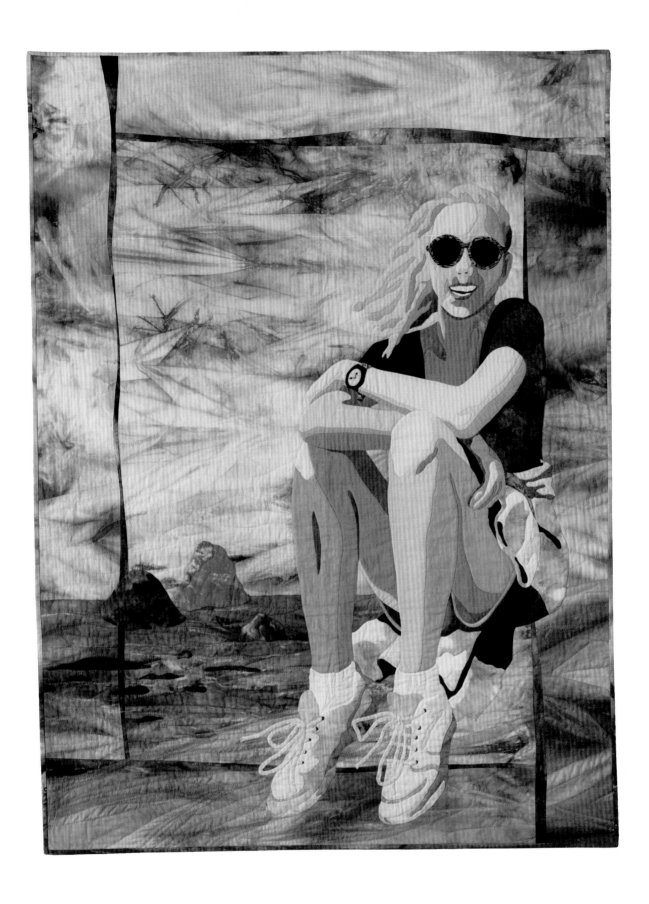

Resolute

SIZE IN INCHES: 31 X 38

TEXAS LOCATION: New Braunfels

MADE BY: Caryl Gaubatz

STYLE OF QUILT: Art

SOURCE OF DESIGN: Original design

MATERIALS USED: Cotton

PRIMARY TECHNIQUES: Hand painting with thickened dye, appliqué, machine quilting

FROM THE COLLECTION OF: Maj. Gen. Vernon B. Lewis (retired)

In 2001, in response to the tragedies of September 11, many quilters made quilts in a catharsis of grief, using their art as a means of working through their sorrow and anger. These quilts were shown six weeks later in Houston at the annual International Quilt Festival. Caryl's quilt was one of the quilts seen in "America: From the Heart." It was included in a silent auction to raise funds for scholarships for the families of the victims and was won by an Army general's daughter, who later gave the quilt to her dad.

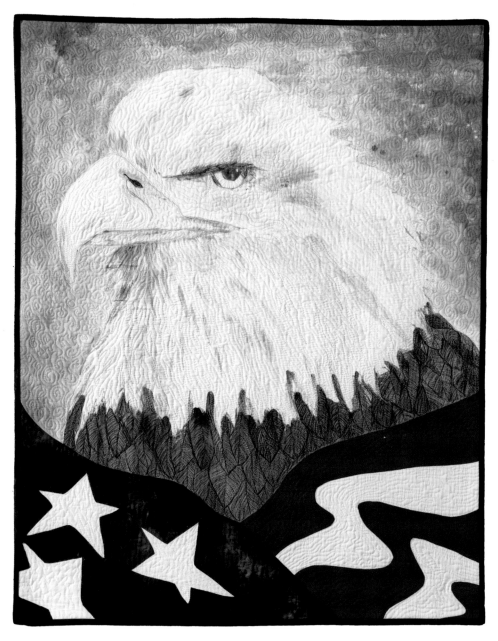

Ladies in Red

SIZE IN INCHES: 26 X 31

TEXAS LOCATION: Austin

MADE BY: Fran Patterson

STYLE OF QUILT: Art

SOURCE OF DESIGN: Original
design

MATERIALS USED: Mixed
fabrics, collaged paper

PRIMARY TECHNIQUES:
embellishing, machine and
hand quilting

The quilt artist says her inspiration for this piece was the playful-
ness in women. At the time, as the mother of a fourteen-year-old
daughter, she estimates that half the quilt was made sitting in
bleachers watching eighteen softball games. "Teenage girls are
an advertiser's best friend when they learn about the 'world of
beauty,'" says Fran. She found it fascinating to see how adolescent
girls grow and change, with one foot still in childhood and the
other eagerly lunging toward adulthood.

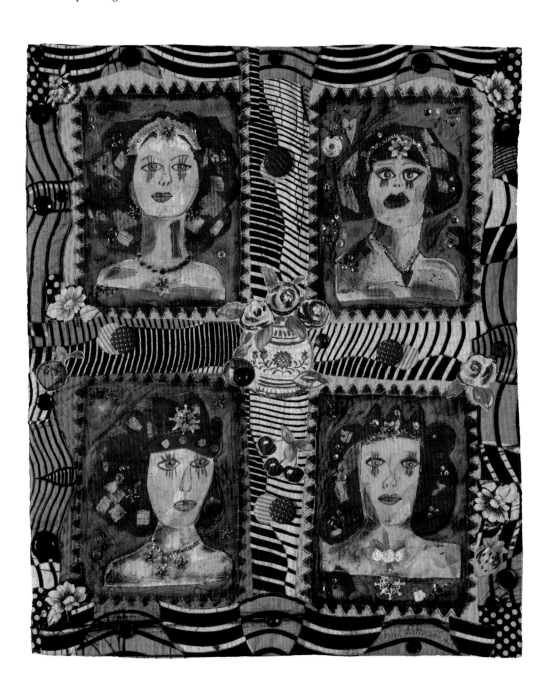

Spirit of America

2001

SIZE IN INCHES: 41 X 30

TEXAS LOCATION: Houston

MADE BY: Christy Johnston

STYLE OF QUILT: Art

SOURCE OF DESIGN: Original design

MATERIALS USED: Cotton

PRIMARY TECHNIQUES: Fused machine appliqué, machine embroidery, machine quilting

FROM THE COLLECTION OF: Robert and Kathy Pepper

A marvelous patriotic quilt, this piece was created as a memorial to the tragedies of September 11. It also serves to remember the victims; to honor the first responders, rescue workers, and members of the armed services who risked their lives that day; and to show the power, dignity, and beauty of the American spirit. Christy also intended the quilt to inspire us all to live our lives reaching for the stars. The quilt was included in the auction to benefit scholarship funds for the victims and their families.

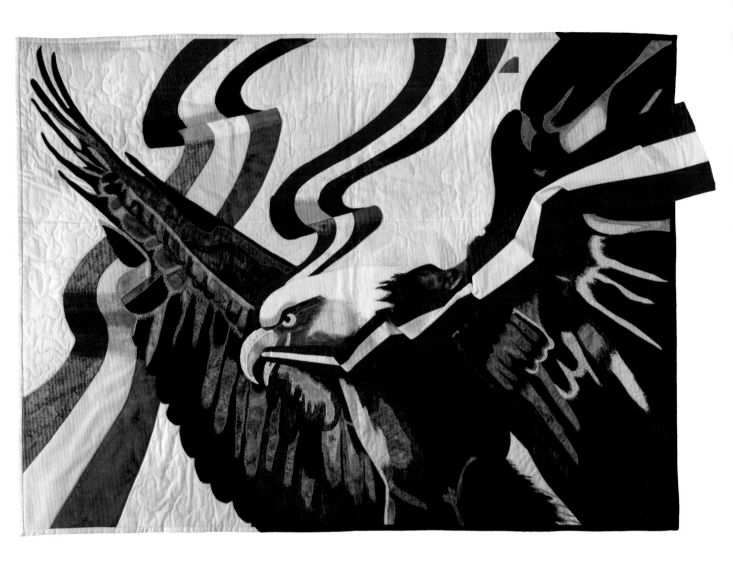

Suburban Sprawl

2001

SIZE IN INCHES: 68 x 68

TEXAS LOCATION: Sugar Land

MADE BY: Valli Schiller

STYLE OF QUILT: Traditional

SOURCE OF DESIGN: Original design based on Schoolhouse pattern

MATERIALS USED: Cotton

PRIMARY TECHNIQUES: Hand and machine appliqué, machine piecing, trapunto, embellishing, machine quilting

The house appliqué motifs were taken from a book on the Schoolhouse pattern, and the flowers were inspired by a photo in a magazine, but the quilt's set, embellishment, and quilting are entirely the design of the quilt artist. The piped petal edge, folky floral border, and use of Yo-Yo rosettes for embellishment effectively soften the otherwise hard edges of this quilt. Says Valli: "Though 'Suburban Sprawl' is my tribute to the 'planned community,' the quilt itself was completely unplanned. Each design decision was spontaneous, based only upon my whim at the moment."

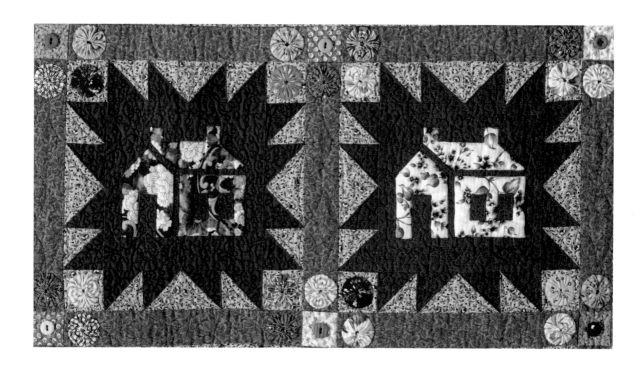

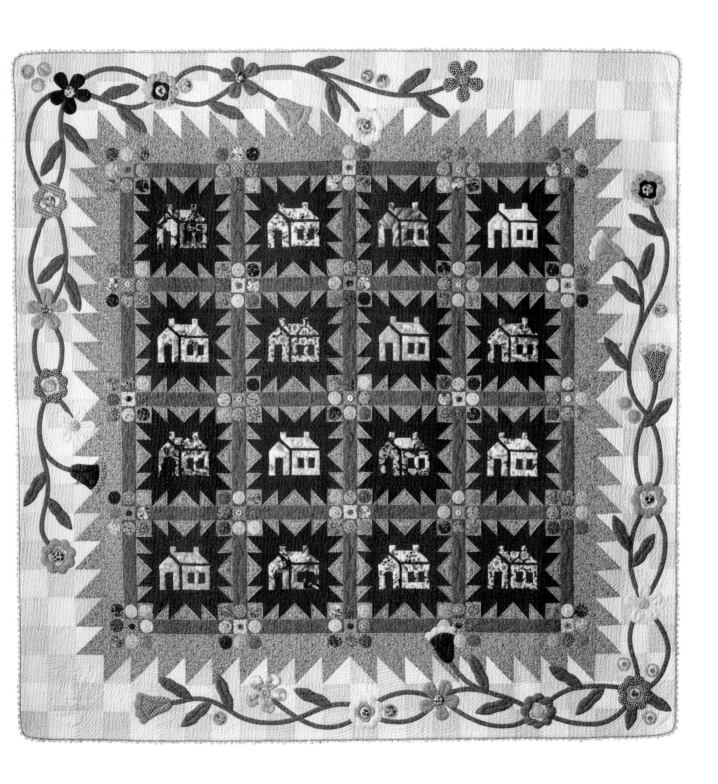

Flora

2001

SIZE IN INCHES: 32 X 52

TEXAS LOCATION: Austin

MADE BY: Judy Coates Perez and the Austin Art Quilt Group

GROUP MEMBERS: Frances Holliday Alford, Vickie Hallmark, Yoshiko Kawasaki, Sherri Lipman McCauley, Judy Coates Perez, Deb Silva, Julie Upshaw

STYLE OF QUILT: Art

SOURCE OF DESIGN: Original design

MATERIALS USED: Hand-dyed cotton

PRIMARY TECHNIQUES: Appliqué, piecing, beading, hand stitching, machine quilting

Seven quilt artists collaborated on the creation of this stunning group quilt, an award-winning design. They used many different techniques to depict the elegance of the colors, lines, shapes, and textures of plants as found in nature. Each of the artists made her own block from start to finish, including the quilting, and then the blocks were put together to form the whole quilt.

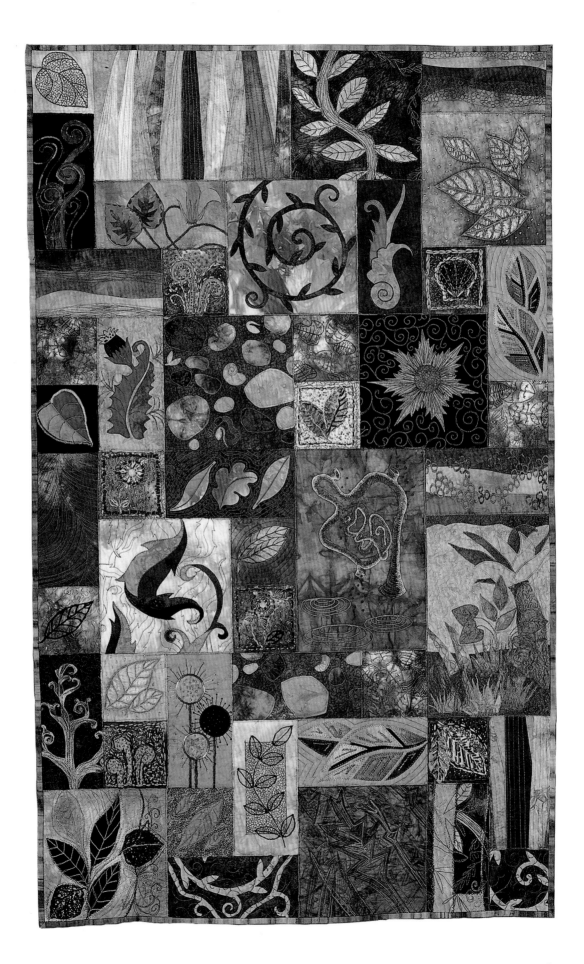

Canning Peaches

2001

SIZE IN INCHES: 45 × 60

TEXAS LOCATION: Beaumont

MADE BY: Sylvia Weir

STYLE OF QUILT: Art

SOURCE OF DESIGN: Original design

MATERIALS USED: Cotton

PRIMARY TECHNIQUES: Piecing, appliqué, threadwork, and machine quilting

Going through old photographs in her parents' estate, the quilt artist, a physician, found this vintage picture of her mother and her grandmother taken the summer before her mother's wedding. She then incorporated the heirloom photo and its family memories into this gentle, evocative piece. "Mom took care in canning peaches, placing the halves just so in the jars, while my grandmother wondered if pretty peaches tasted better," Sylvia remembers. She used a simple four-patch of mostly pastel reproduction fabrics for the background, and along the center axis placed a dye-painted block of peaches. Extensive thread sketching created many of the details in the quilt. The love the two women had for one another is clearly seen. The quilt artist has had work juried into Quilt National.

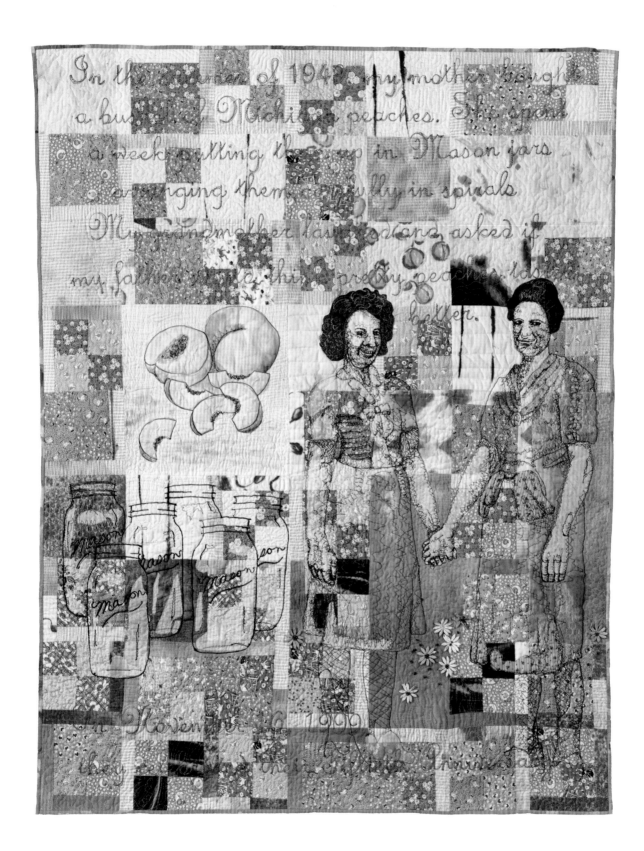

169

Blind Man's Fancy

2002

SIZE IN INCHES: 95 X 95

TEXAS LOCATION: Arlington

MADE BY: Arlene Heintz

QUILTED BY: Karen Roxburgh

STYLE OF QUILT: Traditional

SOURCE OF DESIGN: Museum catalog

MATERIALS USED: Cotton

PRIMARY TECHNIQUES: Machine piecing, machine quilting

A quilt on the cover of a quilt catalog in a Buffalo, New York, museum appealed to Arlene for the carefree spontaneity of its colors and piecing. She decided to recreate the quilt as exactly as possible. She used a magnifying glass to study the photograph and copy each piece of fabric as exactly as possible to the original. She even cut plaids and stripes cross-grain and crooked if the original quilt was cut that way. The quilt, a piecing triumph, has won a Best of Show award.

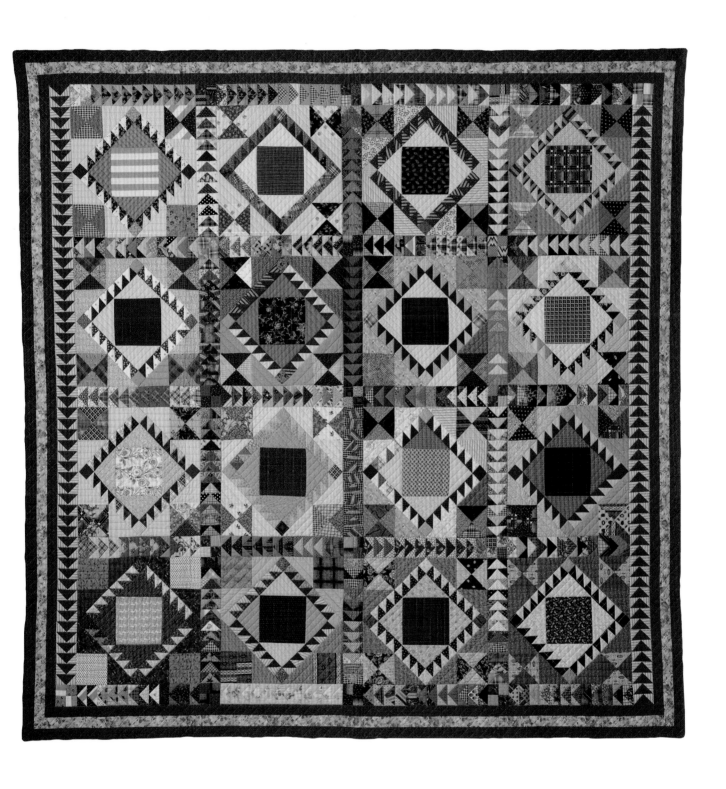

Coastline

2002

SIZE IN INCHES: 70 X 43

TEXAS LOCATION: Houston

MADE BY: Mary Ann Littlejohn

STYLE OF QUILT: Art

SOURCE OF DESIGN: Original
design

MATERIALS USED: 100+ cottons

PRIMARY TECHNIQUES:
Machine piecing, free-
motion machine quilting

FROM THE COLLECTION OF:
Angela Allen

"I wanted to capture the light dancing on the rocks on the shore and the waves in the ocean," says Mary Ann about her quilt. Her color range for the design ranges from sand through peach, rust, and shades of blue, perfect choices for a quilt about the sea. This quilt was based on a photograph of a coastline.

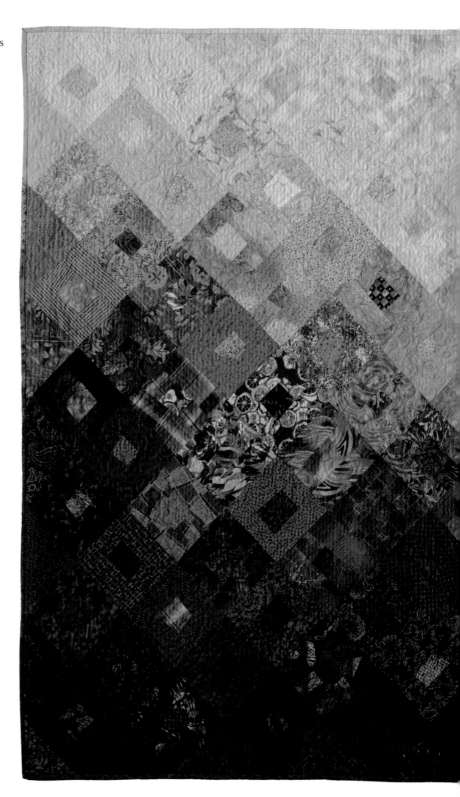

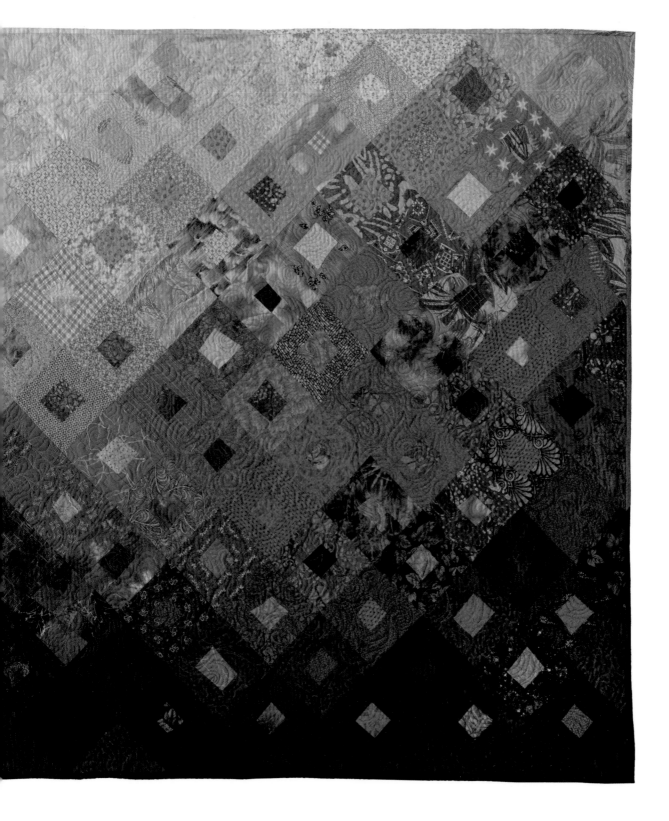

Blossoms in the BA

2002

SIZE IN INCHES: 60 X 73

TEXAS LOCATION: Denton

MADE BY: Lynn Whitson
Carrico

STYLE OF QUILT: Traditional

SOURCE OF DESIGN: Tulip
designs

MATERIALS USED: Cotton

PRIMARY TECHNIQUES:
Machine piecing, hand
appliqué, machine quilting

A beautiful floral appliqué of many different tulips is placed on an unusual black background, adding a bit of mystery to this quilt. But the real mystery is its name: what does BA stand for? Lynn's husband is a professional bowler, and in 2001, he joined the Senior Bowling Tour for five weeks. She went too, and after finding this pattern, she knew that she would spend her time appliquéing in the bowling alleys. As her husband bowled and she appliquéd, "the blocks of this quilt blossomed."

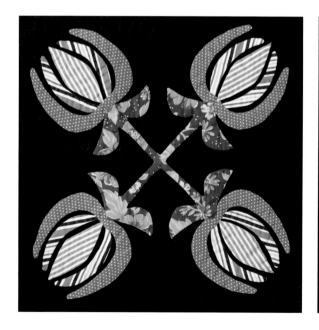
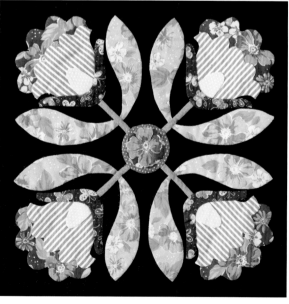

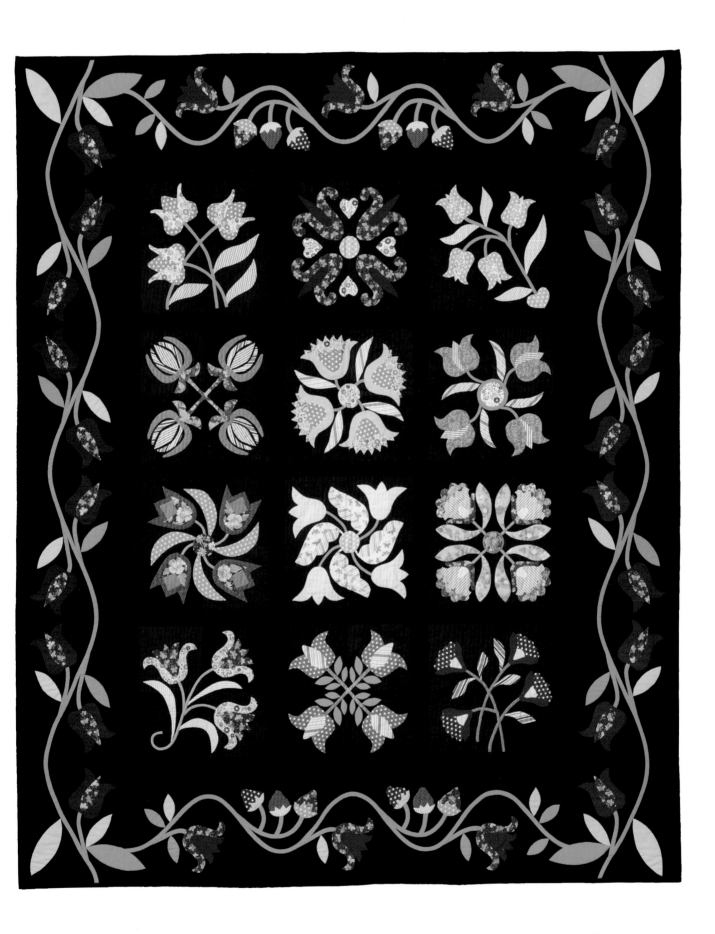

Vase of Roses

2002

SIZE IN INCHES: 78 X 94

TEXAS LOCATION: Houston

MADE BY: Hazel Canny

STYLE OF QUILT: Traditional

SOURCE OF DESIGN: Her
 mother's rose garden

MATERIALS USED: Cotton
 sateen

PRIMARY TECHNIQUES:
 Appliqué, hand quilting

Hazel is a master at appliqué and hand quilting, although she is best known for her whitework, all-quilted quilts. Using an unusual construction method, she first created the top without the appliqué motifs, then quilted the top, and only then did she appliqué the vase and flowers. She states that she "likes the way the back looks" when she works this way. Hazel also loves the way cotton sateen adds luster to her quilts and uses the soft fabric with its subtle sheen whenever possible.

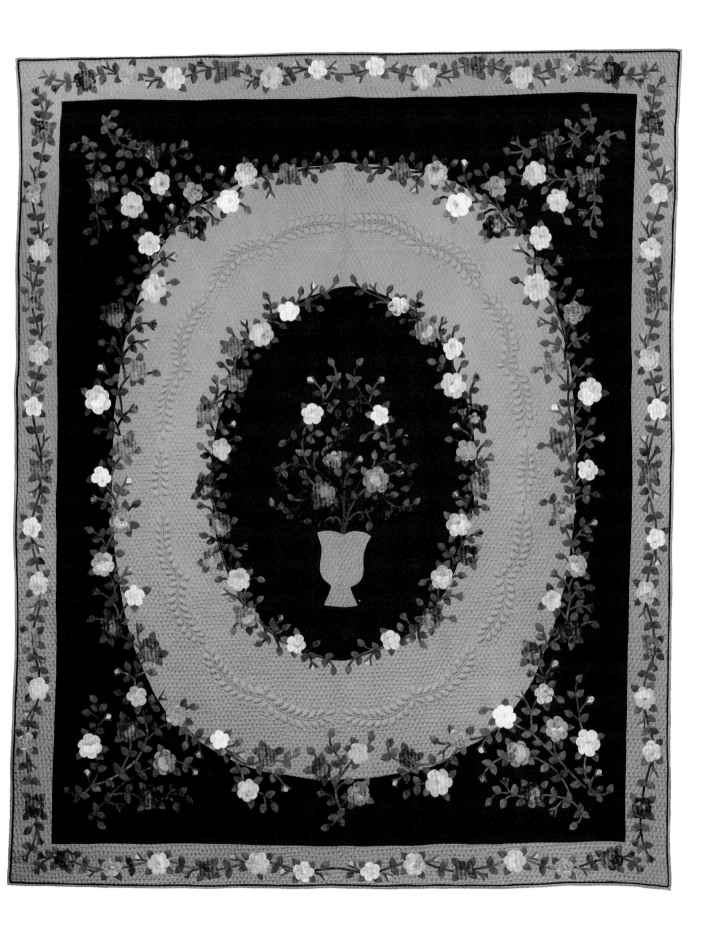

Tailspin

SIZE IN INCHES: 63 x 63

TEXAS LOCATION: Austin

MADE BY: Vickie Hallmark

STYLE OF QUILT: Art

SOURCE OF DESIGN: Golden
 Mean spiral pattern

MATERIALS USED: Cotton

PRIMARY TECHNIQUES:
 Piecing, appliqué, machine
 embroidery, machine
 quilting

"Life throws you curves. Too many curves, too fast, can throw you right into a tailspin!" That's how Vickie describes her double-sided quilt that's as interesting on the reverse as it is on the top side. The copper-hued colors are particularly alluring, and it is not hard to envision waves in motion in this piece. Anyone who believes that quilting doesn't involve mathematics should attempt to understand the Golden Mean spiral that the artist has used as the basis for this quilt. Similar to the Fibonacci spiral, yet different, it is "a logarithmic spiral" that gets wider, or farther from its point of origin, at a certain factor for every quarter turn it makes. Just think of a nautilus shell—you won't be exactly right, but you'll get the general idea of a Golden Mean spiral!

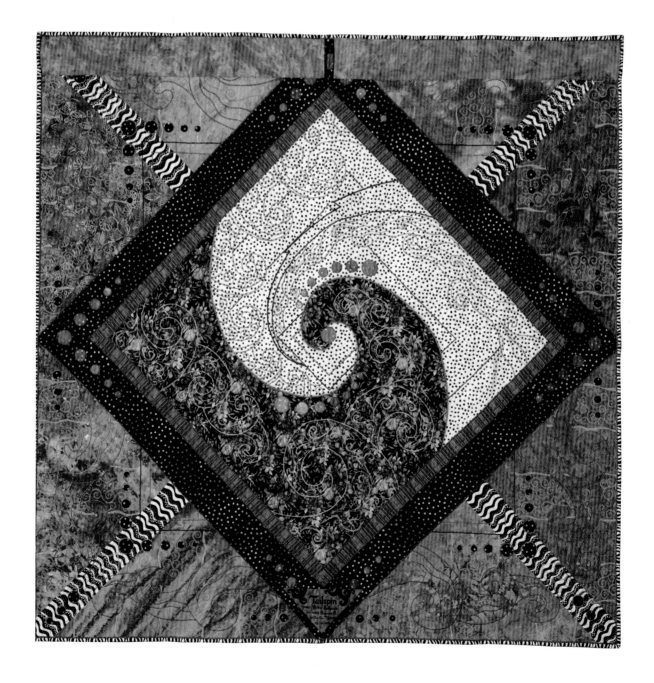

REVERSE

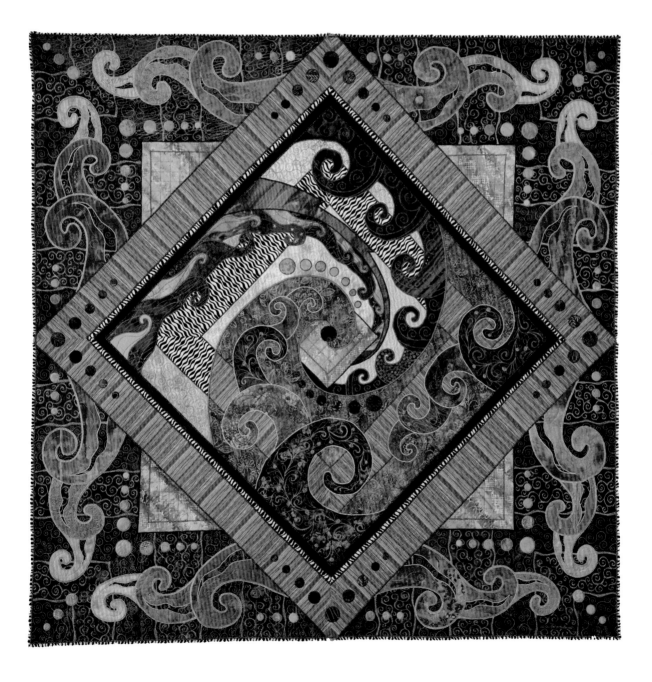

FRONT

Sun Ponies

2002

SIZE IN INCHES: 42 X 37

TEXAS LOCATION: Houston

MADE BY: Kim Ritter

STYLE OF QUILT: Art

SOURCE OF DESIGN: Original
design

MATERIALS USED: Silk, cotton

PRIMARY TECHNIQUES: Hand
printing and painting,
machine appliqué, machine
quilting

Frisky and exuberant, these hand-printed ponies are basking in
the sun and "kicking up their heels." As a child, the quilt art-
ist spent many summer vacations at Pinto Pony Ranch in Okla-
homa, where she learned to love ponies. She was influenced as an
adult to create this work by a visit to the Uffington White Horse,
a Bronze Age chalk drawing in the English countryside. There
a prehistoric hill figure of a highly stylized horse, formed from
deep trenches filled with crushed white chalk, has drawn visitors
for millennia. Kim is one of only two quilt artists in this book to
attain the designation of a Texas Original under the auspices of
the Texas Commission on the Arts, and she has also had work jur-
ied into Quilt National.

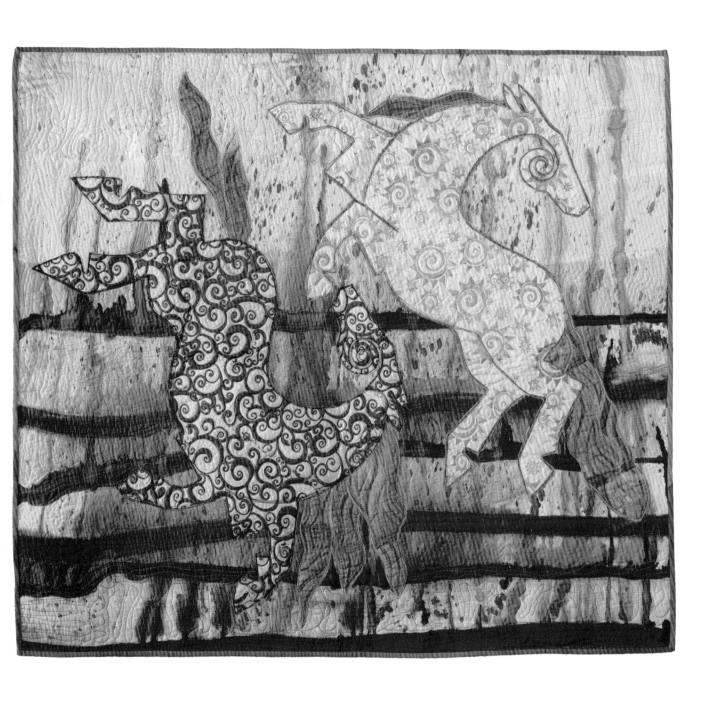

Blue Light Special

2002

SIZE IN INCHES: 82 x 82

TEXAS LOCATION: Beaumont

MADE BY: Joyce Lyon Saia

STYLE OF QUILT: Traditional

SOURCE OF DESIGN: Design
variation from book

MATERIALS USED: Cotton

PRIMARY TECHNIQUES:
Foundation piecing,
machine quilting

"My family wanted to call the quilt *Vertigo*, but I thought it looked electric, hence my title," explains the artist. The design is from a book on foundation quilts but it is a variation not patterned. Blue and white quilts have a universal appeal and are an age-old favorite of both quiltmakers and quilt collectors. The indigo and white quilts of the late nineteenth century are among the most collectible of all. Blue and white quilts often use intricate piecing designs and leave a complex, crisp impression.

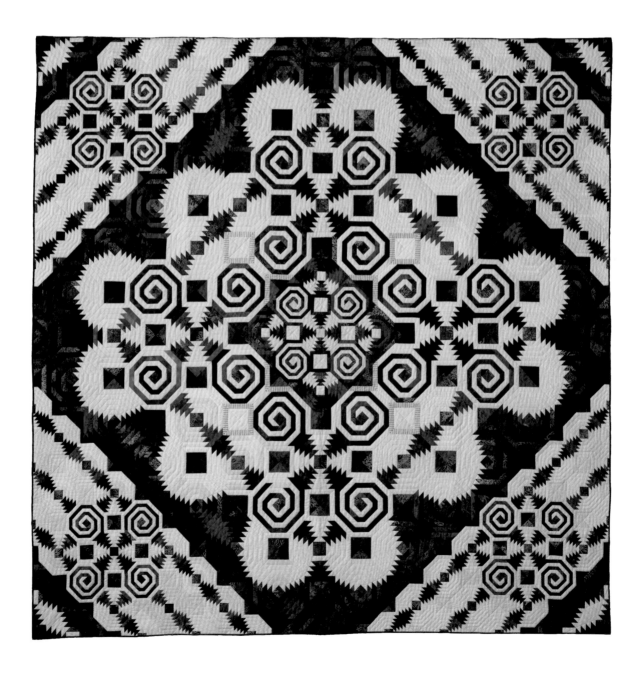

Everyday Best

SIZE IN INCHES: 72 x 72

TEXAS LOCATION: Sherman

MADE BY: Becky Goldsmith

STYLE OF QUILT: Traditional

SOURCE OF DESIGN: Original
 design

MATERIALS USED: Cotton

PRIMARY TECHNIQUES:
 Foundation paper piecing,
 hand appliqué, machine
 quilting

Becky specializes in cheerful quilts of great charm, like this beauty. Vivid colors, a variety of prints, often including dots, and an abundance of energy characterize her designs. She credits her inspiration for this quilt to a rejuvenated antique quilt top and explains that she emphasized the circular motion by using round flowers in the border. This quilt has won awards.

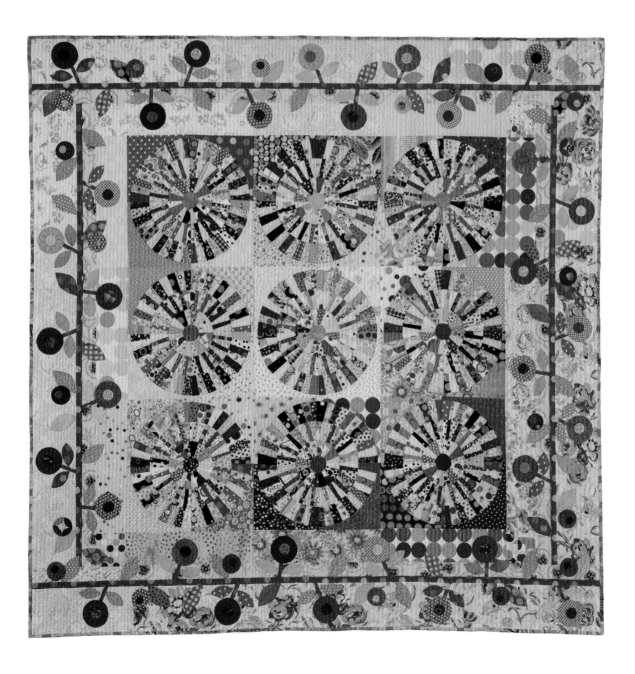

The Barrel Racer

2003

SIZE IN INCHES: 56 x 82

TEXAS LOCATION: Houston

MADE BY: Susan H. Garman

STYLE OF QUILT: Art

SOURCE OF DESIGN: Women in
 rodeo competitions

MATERIALS USED: Cotton

PRIMARY TECHNIQUES:
 Appliqué, hand quilting

The speed, skill, and danger that are involved in rodeo perfor-
mances show clearly in this quilt, which Susan made to look like
a poster "to honor women who compete in barrel racing." She
has used a traditional star design in the background of the poster
design, which adds both depth and richness to the quilt. Note the
realistic appliquéd details on the horse and the dirt being kicked
up in the ring. This quilt has won a Best of Show award.

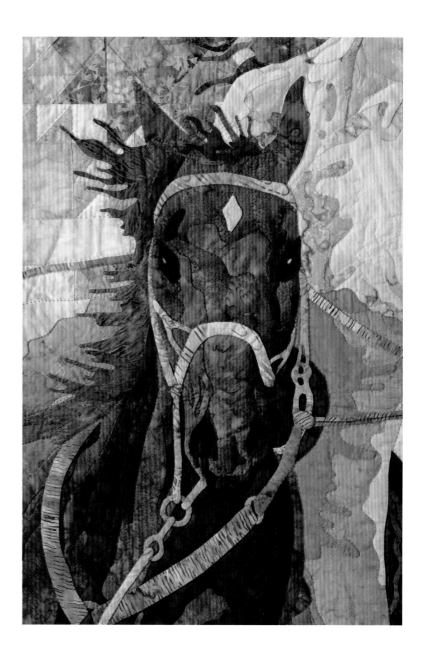

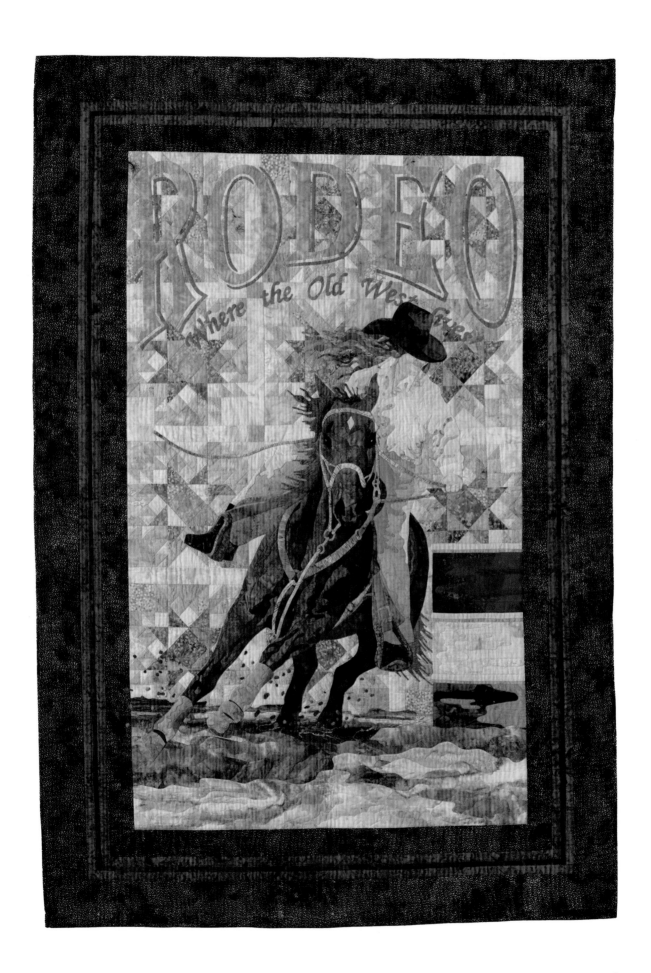

In Texas You Gotta Play Football

SIZE IN INCHES: 75 × 66

TEXAS LOCATION: The
 Woodlands

MADE BY: Lora Kilver Lacey

STYLE OF QUILT: Art

SOURCE OF DESIGN: Sports
 photograph

MATERIALS USED: Cotton

PRIMARY TECHNIQUES:
 Appliqué, hand quilting

Friday night football is a Texas institution, from small towns to big cities. The communities turn out en masse to support their boys—it's a traditional rite of fall all across the state. This pictorial quilt was made to honor Lora's son and "his never-give-up attitude." She says, "His high school football career has given us such joy. We are so proud of him and his team." The quilt design resulted from a sports action photograph (used with permission) and a seminar.

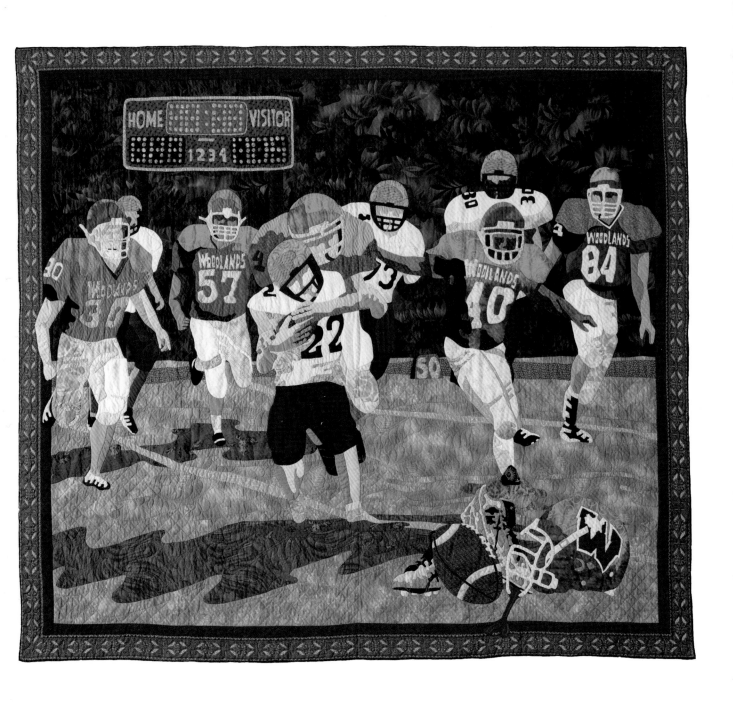

The Quilter

2003

SIZE IN INCHES: 62 X 85

TEXAS LOCATION: Houston

MADE BY: Beth Porter Johnson

STYLE OF QUILT: Art

SOURCE OF DESIGN: Original
design

MATERIALS USED: Cotton,
some overpainted

PRIMARY TECHNIQUES:
Machine piecing, hand
appliqué, machine quilting

What could be more iconic than this patchwork image of a quilter making a quilt? As Beth says, "The quilter revels in the magic of color and pattern. This is her celebration!" Fellow quilter Patricia T. Mayer posed as the model—she has three pieces in this book, also. The quilt has received international attention for its unique image, brilliant manipulation of color, and its expression of the joy of quilting. Some of the fabrics have been overpainted with pastels.

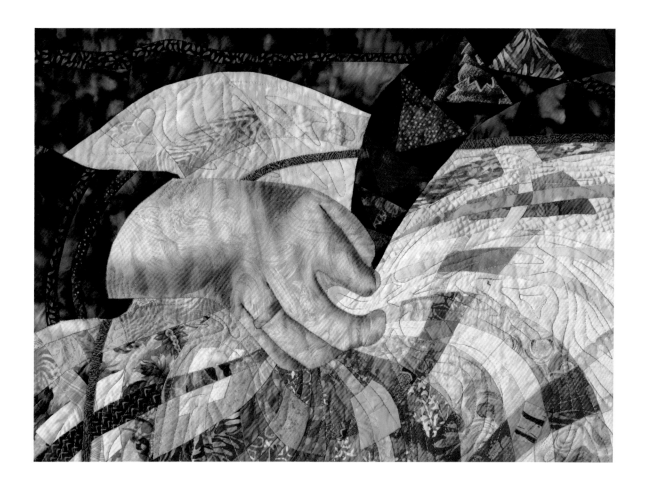

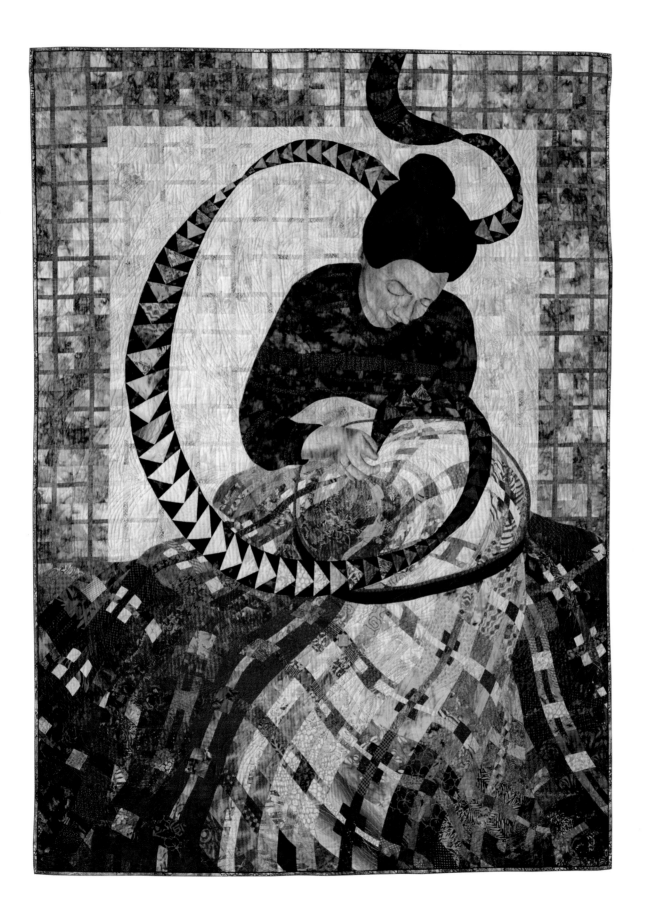

Tree of Life

2003

SIZE IN INCHES: 53 x 61

TEXAS LOCATION: Austin

MADE BY: Judy Coates Perez

STYLE OF QUILT: Art

SOURCE OF DESIGN: Original
design

MATERIALS USED: Cotton

PRIMARY TECHNIQUES:
Painting on wholecloth,
inking, machine quilting

A pictorial art quilt, this piece is wholecloth painted with textile paint, and inks have been used to delineate details. "The universal symbol of the Tree of Life as a recurring theme in many cultures was fascinating to me at a time when our country had invaded Iraq, the Biblical location of the Garden of Eden," explains Judy. "Judeo-Christianity knows the Tree of Life as the giver of knowledge. In other cultures, it is known to bestow immortality, language, spiritual wisdom, or represent a link between heaven and earth," she added. The quilt has won awards and honorable mentions.

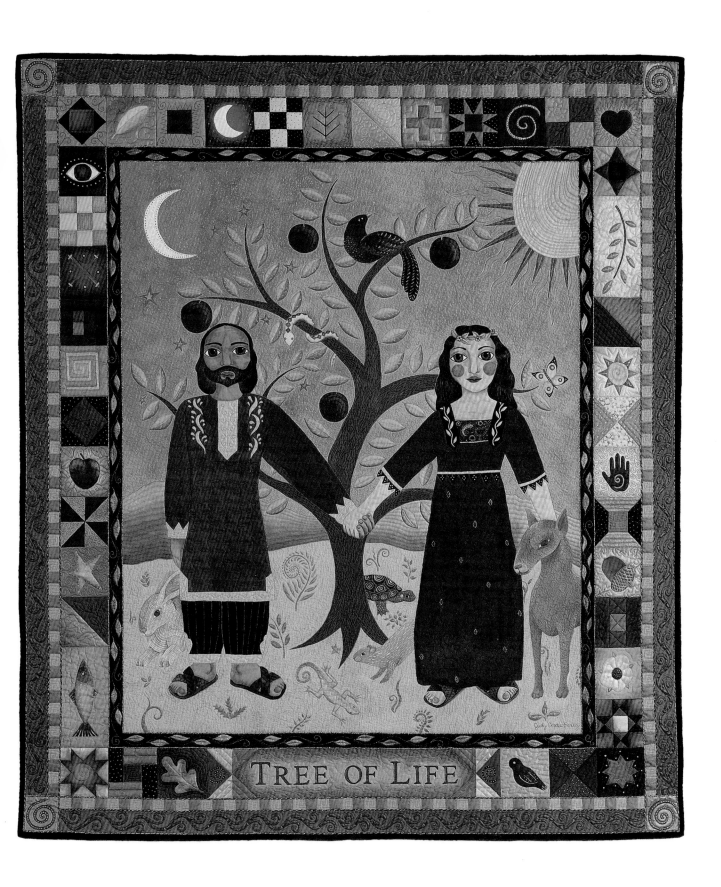

TREE OF LIFE

Windswept

2003

SIZE IN INCHES: 55 x 55

TEXAS LOCATION: Magnolia

MADE BY: Nancy B. Dickey

STYLE OF QUILT: Art

SOURCE OF DESIGN: Original
design

MATERIALS USED: Cotton,
batiks

PRIMARY TECHNIQUES:
Machine appliqué, trapunto,
and quilting

In this evocative piece, the leaves are caught in swirls of motion as
they are blown to the earth, and the rich autumn colors illuminate
the dark indigo of approaching winter. The quilt is the result of
a design class in which the teacher encouraged Nancy to create an
original quilt based on her freestyle drawings of leaves. This quilt
has won several awards.

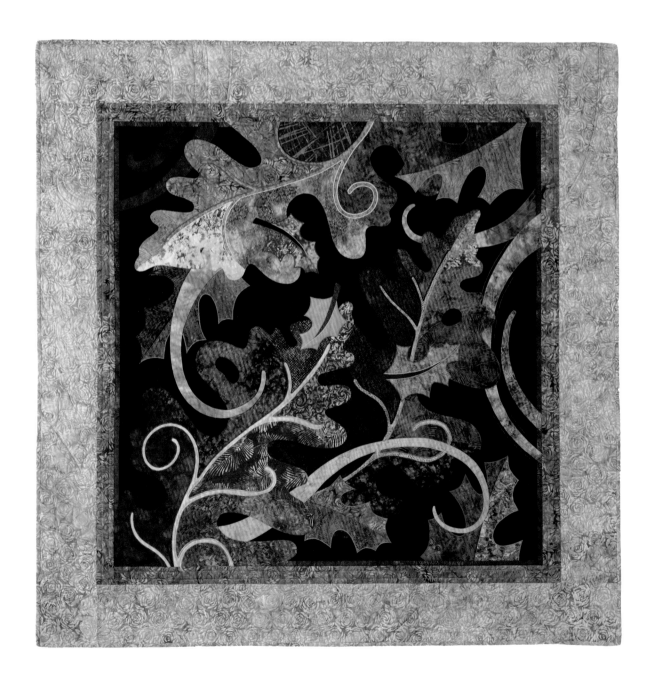

Indy

SIZE IN INCHES: 21 X 30

TEXAS LOCATION: Houston

MADE BY: Patricia T. Mayer

STYLE OF QUILT: Art

SOURCE OF DESIGN: Movie
poster

MATERIALS USED: Cotton

PRIMARY TECHNIQUES:
Appliqué, machine quilting

A versatile quiltmaker who moves with ease and equal effectiveness between traditional quilts and art quilts, Patricia wanted to prove that she could capture a face in fabric because she wanted to teach a portrait class. She had made family portrait quilts but wanted to do one everyone would recognize, hence her choice of Harrison Ford as Indiana Jones. The image was taken from a movie poster and used with permission. Fabric choices, not paint, created this almost uncanny likeness of the famous craggy face that sold millions of movie tickets.

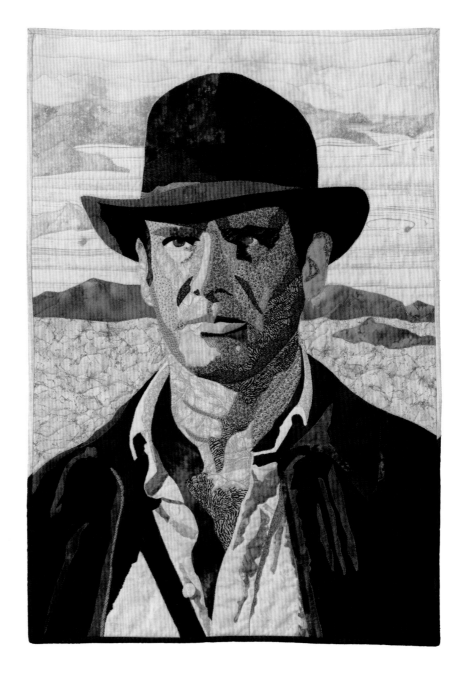

Hot Flashes

2003

SIZE IN INCHES: 78 x 78

TEXAS LOCATION: Kerrville

MADE BY: Sew Be It Bee

GROUP MEMBERS: Anita Crane, Maggie Hoogerheide, Linda Humphrey, Dorothy Johnstone, Patty Mitchell, Helen Ridgway, Marvene Wallace, Anita Wilson

STYLE OF QUILT: Traditional

SOURCE OF DESIGN: Log Cabin pattern variation

MATERIALS USED: Cotton

PRIMARY TECHNIQUES: Paper piecing, machine quilting

Jagged edges and vivid colors explode like fireworks on the black background of this award-winning quilt, and fireworks based on the Pineapple variation of the Log Cabin pattern were the group's inspiration. Helen's bee began this quilt at an annual three-day retreat; they had planned it earlier and brought fabric from their stashes to work on. "We named the quilt 'Hot Flashes' since it seemed there were many of us having problems with that even though we were in the cold of winter!" explains the artist.

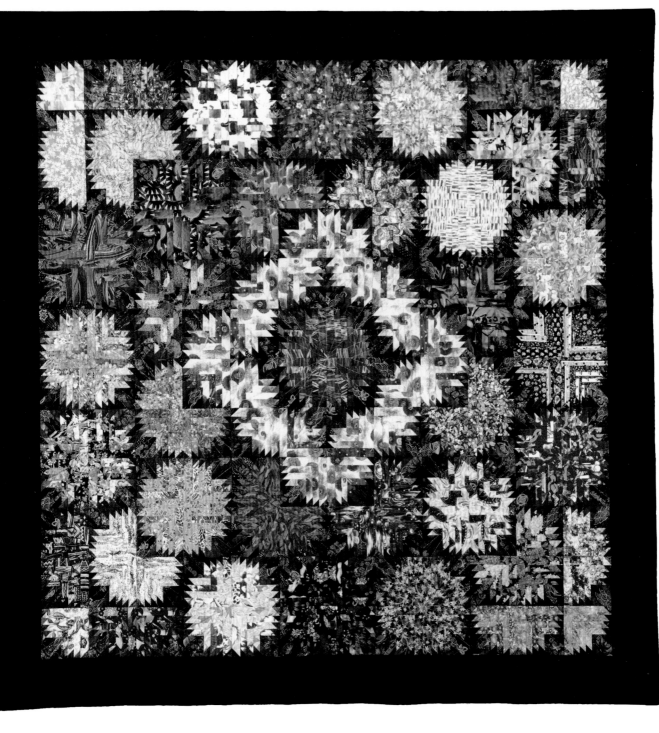

Memorial Mosaic (a la Moda)

2004

SIZE IN INCHES: 57 X 74

TEXAS LOCATION: La Grange

MADE BY: Kathi Babcock

STYLE OF QUILT: Traditional

SOURCE OF DESIGN: Challenge quilt

MATERIALS USED: Cotton

PRIMARY TECHNIQUES: Piecing, appliqué, and machine quilting

Made for a challenge competition sponsored by a Texas company, this quilt is a treasure chest of patriotic symbols, from the eagle and flag to the bluebird of happiness. Some of the elements in the quilt are from patterns, but they have been placed in an original setting. Kathi's quilt won in the local challenge competition and later won a Judge's Choice recognition.

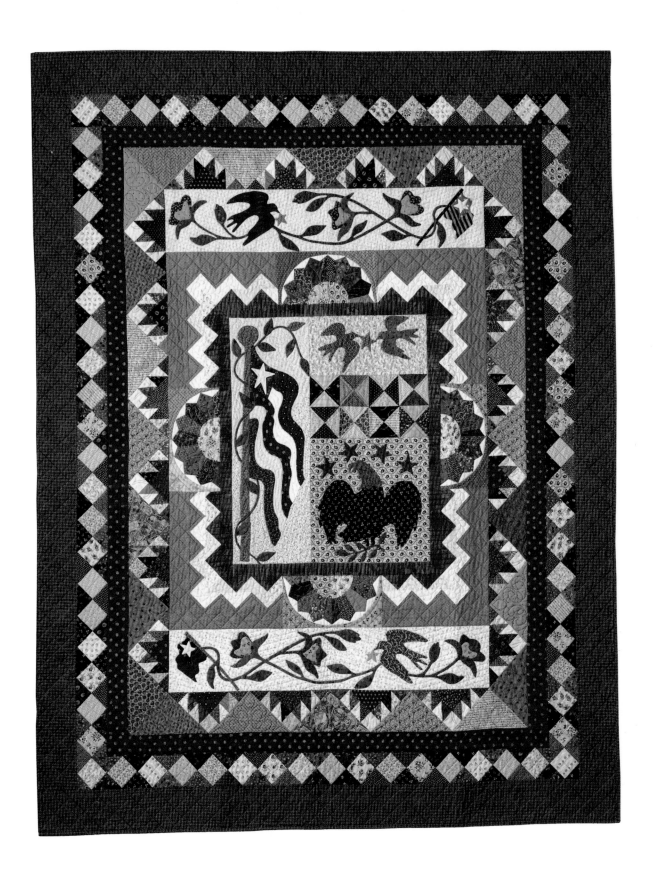

Lone Star Blues

2004

SIZE IN INCHES: 90 x 90

TEXAS LOCATION: Midland

MADE BY: Pat Connally

STYLE OF QUILT: Traditional

SOURCE OF DESIGN: Pattern

MATERIALS USED: Cotton

PRIMARY TECHNIQUES:
Machine piecing and
quilting

The elaborate curving and re-curving machine quilting seen in this piece enhances its visual appeal. Lone Star quilts are always popular in Texas, even though they so often have eight points instead of the traditional five seen on the Texas flag. However, the state's quilters claim the pattern because it produces a lone star, a single star. Pat's color choices in making this pattern are excellent. The quilt has won several awards, including Best of Show.

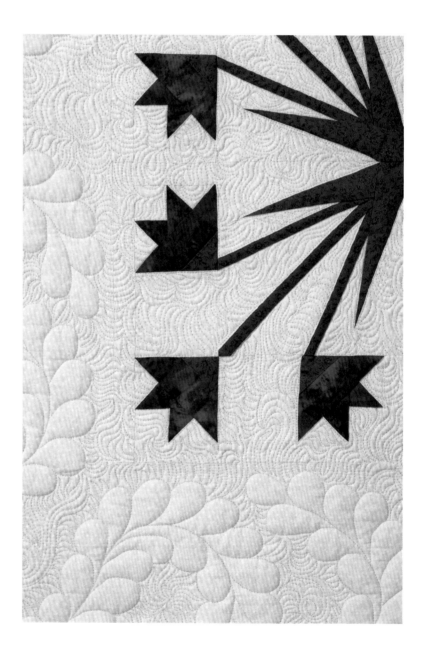

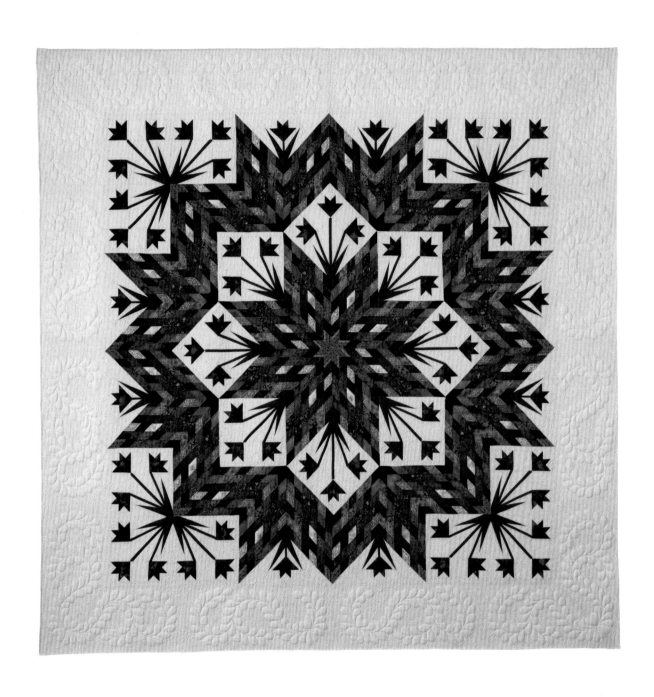

The Forest and the Trees

SIZE IN INCHES: 79 × 82

TEXAS LOCATION: Austin

MADE BY: Barbara Ann Bauer Barrett

STYLE OF QUILT: Traditional

SOURCE OF DESIGN: Tree patterns

MATERIALS USED: Cotton

PRIMARY TECHNIQUES: Machine piecing, hand appliqué, machine and hand quilting

The sixteenth-century proverb—"you cannot see the forest for the trees"—inspired Barbara to make this quilt. It is primarily a study in contrasts between the wildly curving branches, the casual grace of the falling leaves, and the strict geometry of the twelve tree blocks.

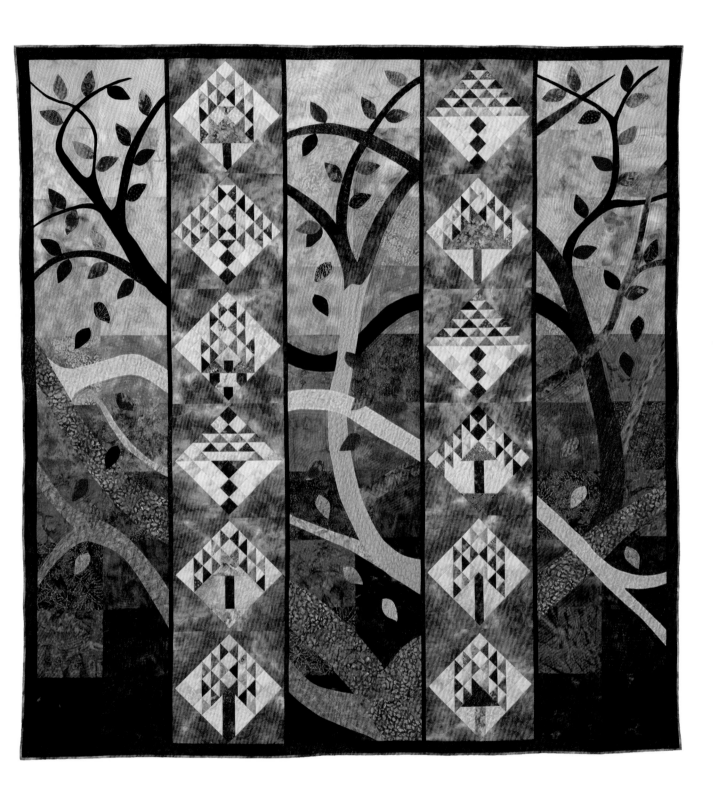

Loada Moda Scraps

2004

SIZE IN INCHES: 86 x 84

TEXAS LOCATION: Cedar Park

MADE BY: Janice Miller Brady

STYLE OF QUILT: Traditional

SOURCE OF DESIGN: Challenge quilt

MATERIALS USED: Cotton

PRIMARY TECHNIQUES: Hand and machine quilting, piecing, hand appliqué

The quiltmaker's first adventure in creating a challenge quilt, this piece contains more than 480 different Moda fabrics, nearly all of which came from her collection. The combination of the flowing border vines contrasting with the geometric stars and geometric flowers emphasize the visual interest of the quilt. Janice has won several first place awards with this quilt.

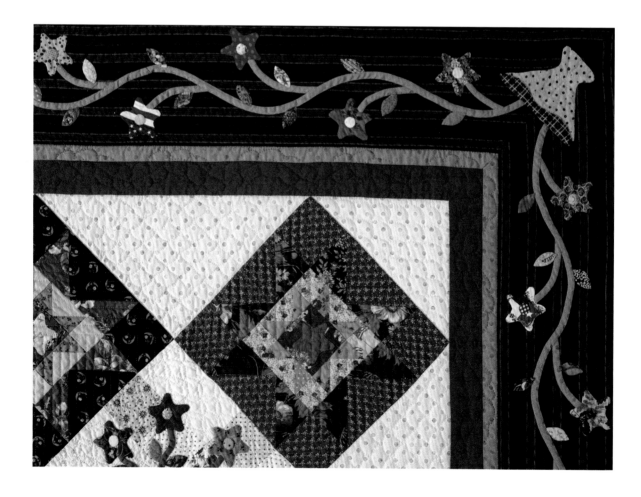

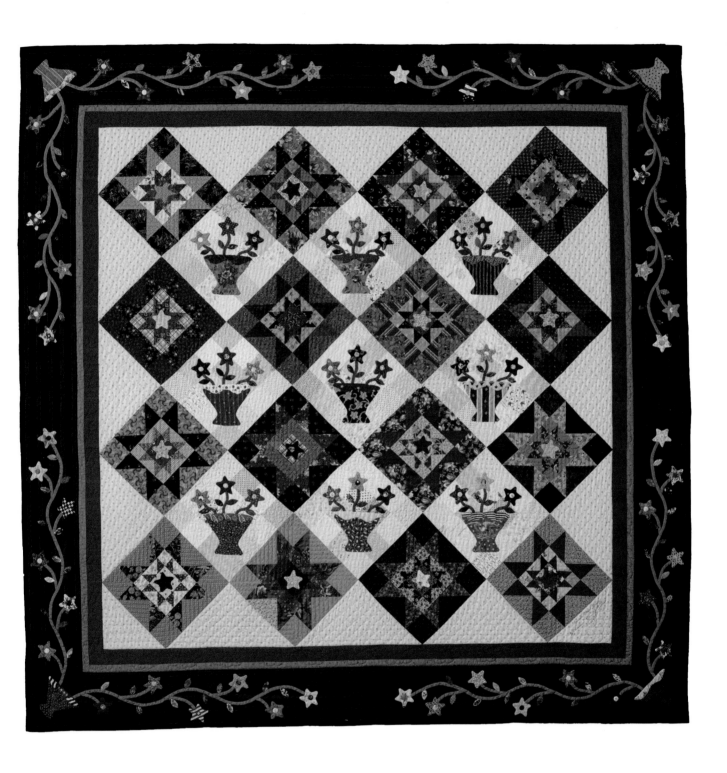

Fugue XI

2004

SIZE IN INCHES: 51 X 31

TEXAS LOCATION: Dallas

MADE BY: Sue Benner

STYLE OF QUILT: Art

SOURCE OF DESIGN: Original
design

MATERIALS USED: Silk, cotton,
polyester

PRIMARY TECHNIQUES: Dyeing,
painting, mono-printing,
fusing, machine quilting

FROM THE COLLECTION OF:
Private collection

This talented quiltmaker is a member of an exclusive group in Texas: art quilters whose work has been accepted in the prestigious Ohio show, Quilt National. Sue's work was juried into the show in eight different years. The quilt's vivid coloration, intriguing surface design, and simple, repetitive geometric shapes overlaid with richly painted designs make it exceptional.

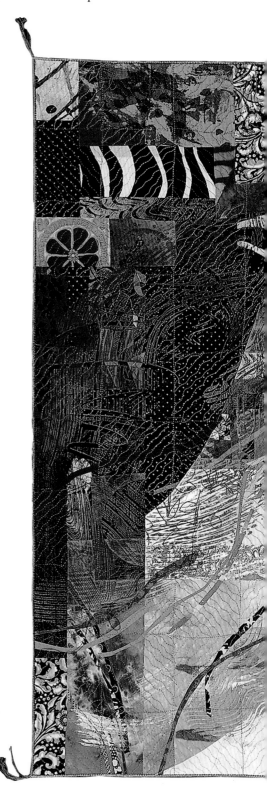

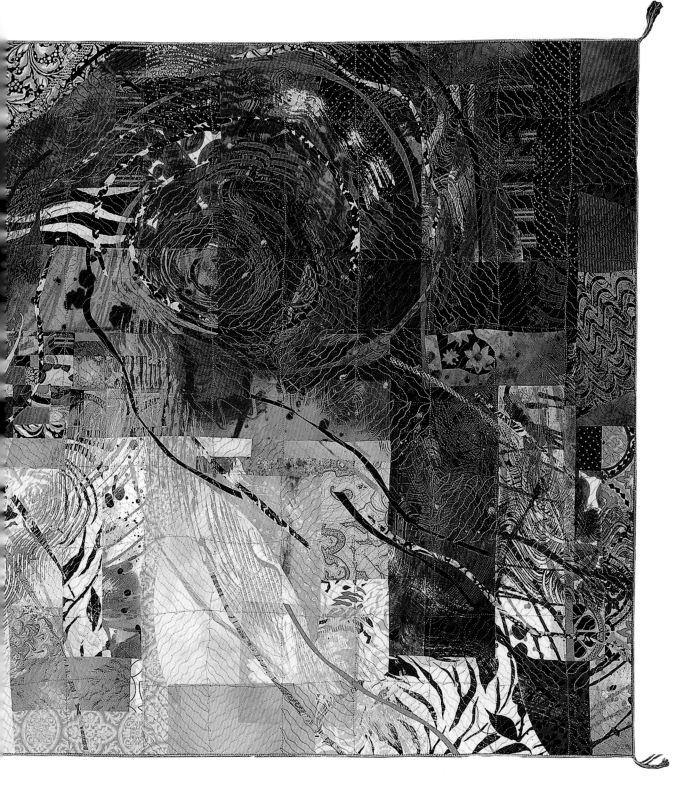

Spring Splendor

SIZE IN INCHES: 35 × 35

TEXAS LOCATION: Humble

MADE BY: Susan Ennis

STYLE OF QUILT: Art

SOURCE OF DESIGN: Original design

MATERIALS USED: Cotton

PRIMARY TECHNIQUES: Fusing, raw-edge appliqué, machine embroidery, machine piecing, machine quilting

A former designer for *Quilters Newsletter Magazine*, Susan has created many beautiful quilts that inspire others to try their hands at quiltmaking. This quilt was planned to evoke the lushness of springtime, when the flowers burst into raucous bloom, spreading their beauty in every direction. The leaves in this piece are so detailed that they rival the blossoms for attention. The quilt has won awards and been featured in a one-woman show in Colorado.

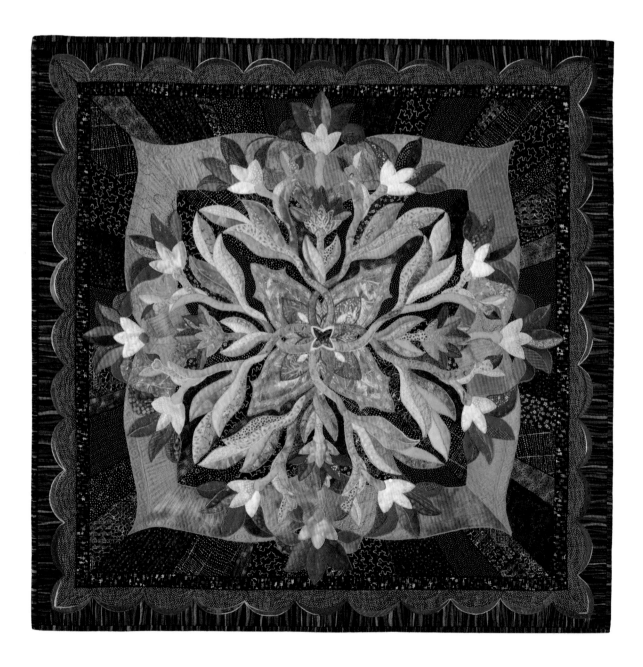

Autumn Splendor

2004

SIZE IN INCHES: 51 x 51

TEXAS LOCATION: Flower Mound

MADE BY: Barbara Oliver Hartman

STYLE OF QUILT: Art

SOURCE OF DESIGN: Original design

MATERIALS USED: Cotton

PRIMARY TECHNIQUES: Hand stitching, appliqué, machine quilting

FROM THE COLLECTION OF: Quilts, Inc.

The artist's favorite season is autumn, and her favorite colors are autumn shades. In this impressionistic landscape quilt, those colors are used to great effect in the forest floor covered in fallen leaves and the golden trees quietly awaiting the next strong breeze to drop their bounty. Many small pieces were applied to the surface and then stitched into place to create the highly textured fallen leaves. This quilt was exhibited internationally. Barbara has had work juried into Quilt National.

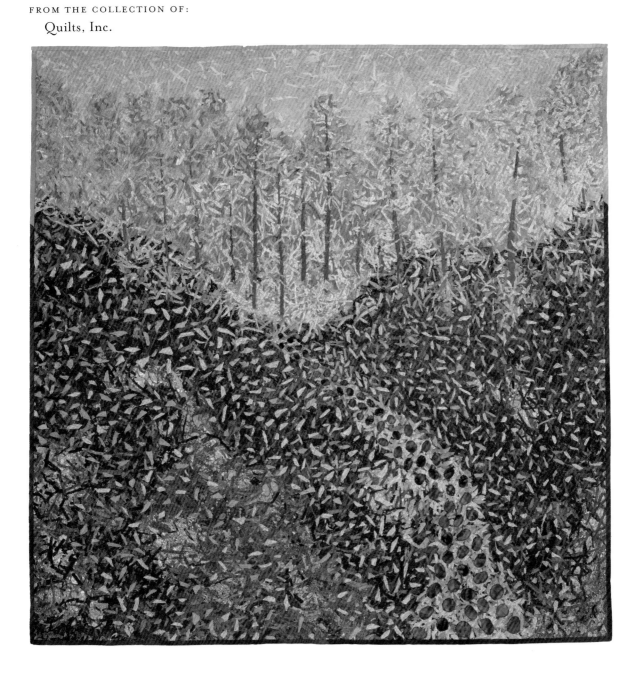

My Monet

SIZE IN INCHES: 44 X 61

TEXAS LOCATION: Dallas

MADE BY: Liz Joe

STYLE OF QUILT: Art

SOURCE OF DESIGN: Original design

MATERIALS USED: Cotton

PRIMARY TECHNIQUES: Design pixilation, fused raw-edge appliqué, machine quilting

Like the French Impressionists' work which requires you to put distance between yourself and the surface of the work to be able to see the picture clearly, this quilt requires distance to come into focus. Having always loved Claude Monet's nature scenes, Liz used special computer software to translate a garden photo into pixels. She used fifty-three different fabrics in twenty-four colors and 6,432 one-inch circles, cut with a die-cut machine, to create this award-winning quilt. It was quilted by sewing through the circles diagonally and leaving loose edges.

America's Flowers

2004

SIZE IN INCHES: 90 x 90

TEXAS LOCATION: Austin

MADE BY: Kathleen Holland McCrady

STYLE OF QUILT: Traditional

SOURCE OF DESIGN: Pattern with original borders

MATERIALS USED: Cotton

PRIMARY TECHNIQUES: Hand piecing, hand appliqué, hand quilting

Baskets of state flowers enliven this beautiful work. Kathleen, who continues a family tradition of quiltmaking, is known throughout the state for the many magnificent traditional quilts she has produced, often taking the extra step that moves past traditional to original. Winner of a Viewer's Choice award, this quilt features fussy cut flowers based on an eight-point star and borders that are an original design with original baskets. Kathleen was one of the artists featured in *Lone Stars II: A Legacy of Texas Quilts, 1936–1986*.

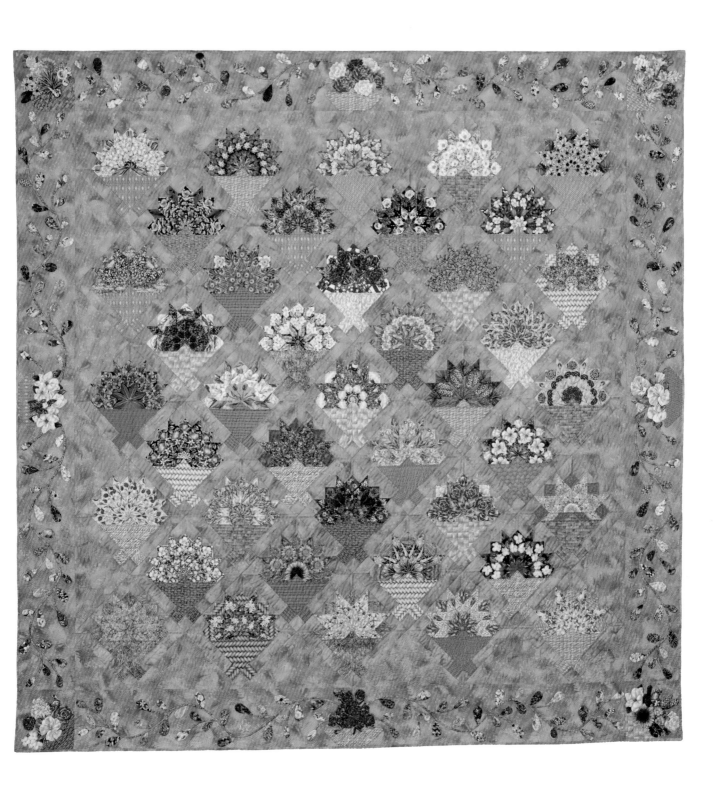

SIZE IN INCHES: 93 × 93

TEXAS LOCATION: Arlington

MADE BY: Kelly Wall Monroe

QUILTED BY: Donna Akins

STYLE OF QUILT: Art

SOURCE OF DESIGN: Original design based on traditional pattern

MATERIALS USED: Cotton

PRIMARY TECHNIQUES: Fusible machine appliqué, longarm machine quilting

Amusing, eccentric, whimsical, fun—all of these could describe this unusual quilt. The bright primary colors and casual shapes informally arranged provide an unexpected contrast to the sophisticated black background. The award-winning quilt was made in 18" blocks, then put together in groups of four, with more leaves and flowers used to hide the seams. According to Kelly, "I wanted to create a quilt that looked like a colorful piece of fabric . . . and was attempting to make it appear that the birds were building the quilt."

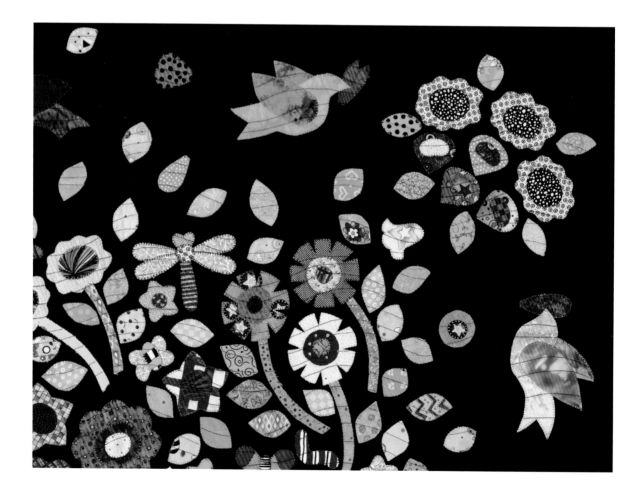

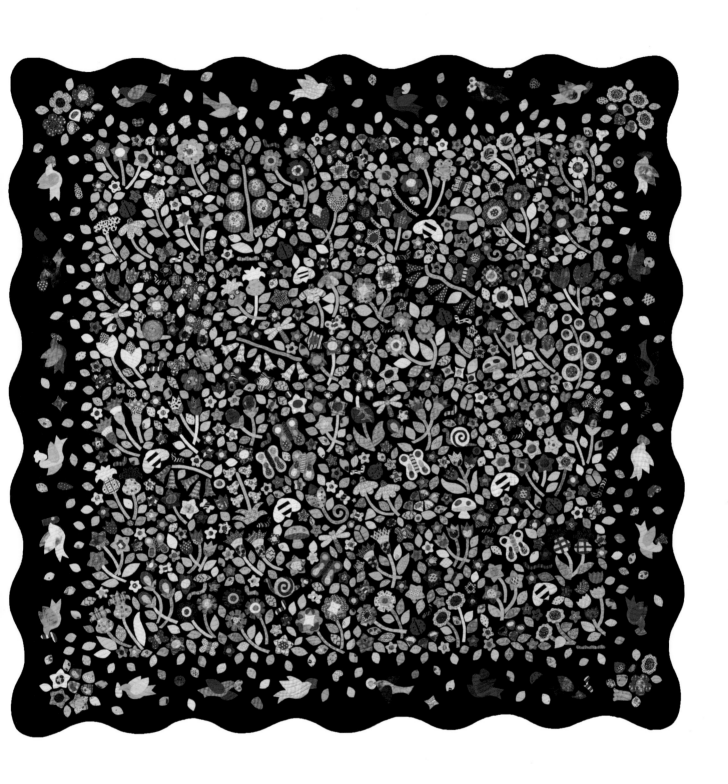

SIZE IN INCHES: 46 X 23

TEXAS LOCATION: Houston

MADE BY: Christy Johnston

STYLE OF QUILT: Art

SOURCE OF DESIGN: Original
design

MATERIALS USED: Cotton

PRIMARY TECHNIQUES: Fused
machine appliqué, machine
embroidery, machine
quilting

Ready to start quilting! That's the exciting time this quilt reveals—
all the materials are gathered together, all the tools are at hand.
"It's just waiting for me to dig in and start sewing," explains
Christy, a Texas quilter who has reluctantly moved out of state
for job reasons and calls the forced move "a bummer!" The quilt
is entirely created with machine work. "There is no paint on this
quilt," Christy emphasizes.

2004

Midnight Garden

2004

SIZE IN INCHES: 63 X 70

TEXAS LOCATION: Mansfield

MADE BY: F. Jolene Welch
Mershon

QUILTED BY: Susan Corbett

STYLE OF QUILT: Combination
of art and traditional

SOURCE OF DESIGN: Hexagon
Stars pattern

MATERIALS USED: Cotton

PRIMARY TECHNIQUES: Piecing,
embellished trapunto, free-
form machine quilting

Fabric is so essential to quilts that it sometimes becomes the actual inspiration itself, such as in this award-winning quilt. "The 'Moonlit Garden' fabric influenced the whole design of this quilt," says Jolene. "Each 'stack-n-whack' block was especially selected for the top, and the use of metallic threads brought a glow like starlit dew. The mood evolved into the midnight garden with the hexagon stars, the night insects in the quilting, and the embellishment of crystal beaded spiders." She made the top in an online seminar.

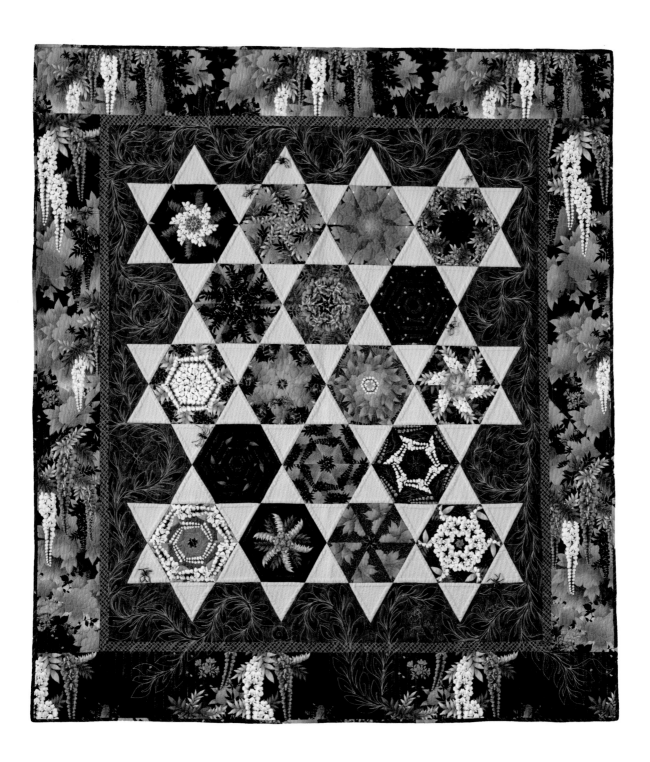

November

2004

SIZE IN INCHES: 70 X 60

TEXAS LOCATION: Watauga

MADE BY: Gabrielle Swain

STYLE OF QUILT: Art

SOURCE OF DESIGN: Original
design

MATERIALS USED: Hand-dyed
cotton

PRIMARY TECHNIQUES:
Piecing, reverse appliqué,
embroidery, embellishing,
hand quilting

Made to pay homage to the quilt artist's favorite time of year,
this quilt celebrates autumn and its changing colors, textures,
and light. The quilt was made with a combination of hand and
machine work and includes reverse appliqué and hand embroi-
dery. This was one of a series of art quilts Gabrielle created
depicting leaves and their variety.

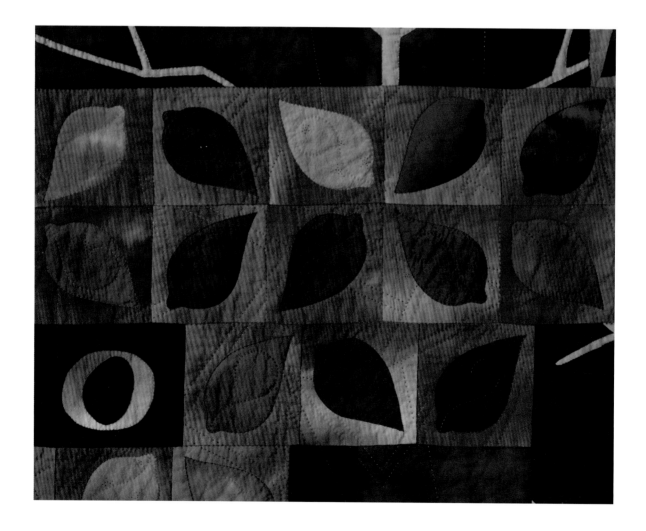

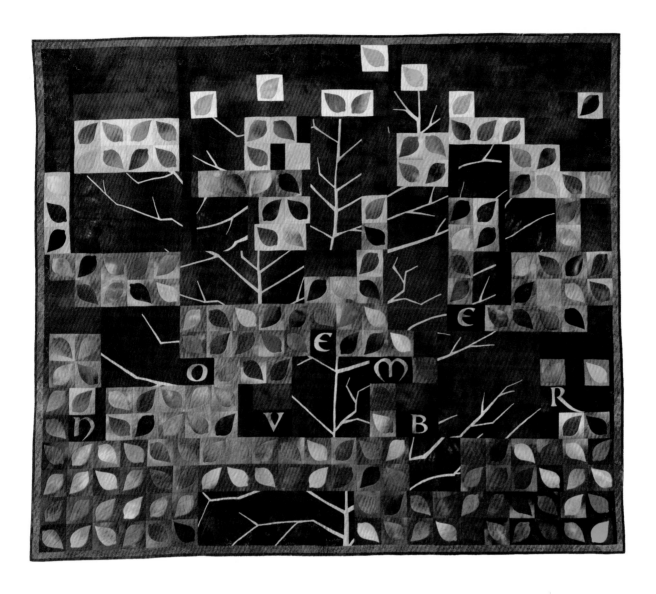

The Fantasy Quilt

SIZE IN INCHES: 77 X 81

TEXAS LOCATION: Pearland

MADE BY: Carolyn Allison

GROUP MEMBERS: Carolyn
Allison, Kris Bryson, Jean
Cloyd, Beth Porter Johnson,
Patricia T. Mayer, Sandra
Greve Thompson

STYLE OF QUILT: Art

SOURCE OF DESIGN: Original
design with border inspired
by *The Faerie Queene*

MATERIALS USED: Cotton

PRIMARY TECHNIQUES:
Appliqué, machine quilting

A round-robin quilt, this piece depicts popular fantasy tales. To do justice to the richly detailed blocks, Carolyn created an imaginative border based on book illustrations of Edmund Spenser's English epic, *The Faerie Queene*. Note the graceful bow with its quiver of arrows, the tiny fairies, the satyr, and the exotic flora and fauna found in the border.

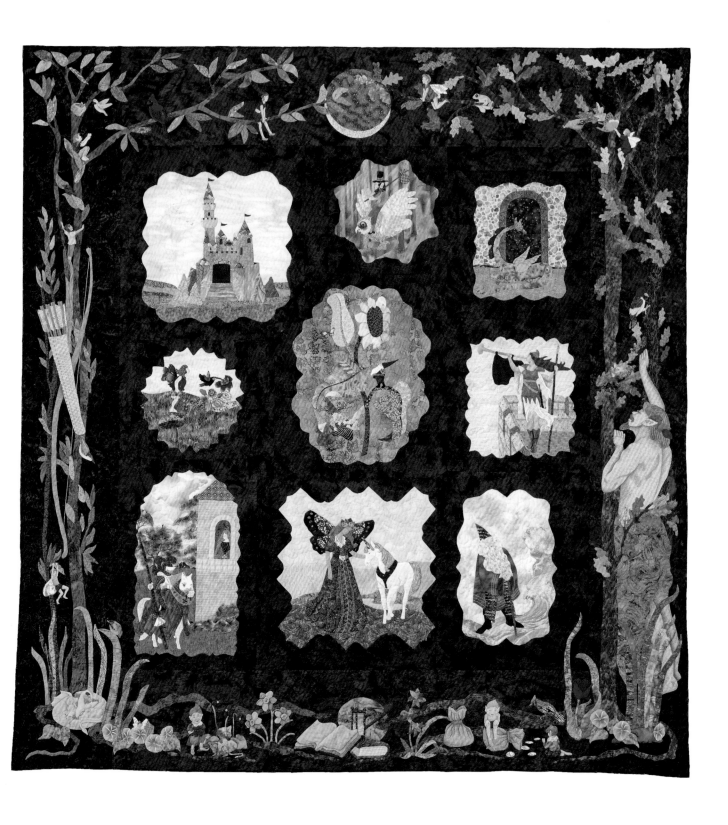

Lapis Vessels

SIZE IN INCHES: 75 X 75

TEXAS LOCATION: Grapeland

MADE BY: Michele Barnes

STYLE OF QUILT: Traditional

SOURCE OF DESIGN: Jacobean
 designs

MATERIALS USED: Cotton

PRIMARY TECHNIQUES:
 Appliqué, piecing, hand
 quilting

This is a quilt of firsts for this quiltmaker; not only was it her first appliqué, but it was also her first scalloped border. In addition, it was only her second hand-quilted piece. Michele was inspired by Dallas quilt artist Pat Campbell's Jacobean designs and accomplished their intricacies perfectly, from the many curved stems and drooping flowers to the unusual shapes of the blue containers. This quilt has won a Best of Show award.

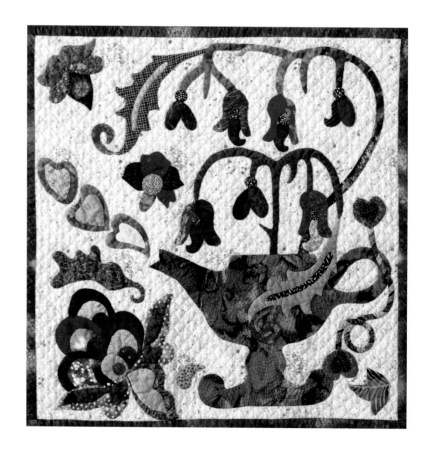

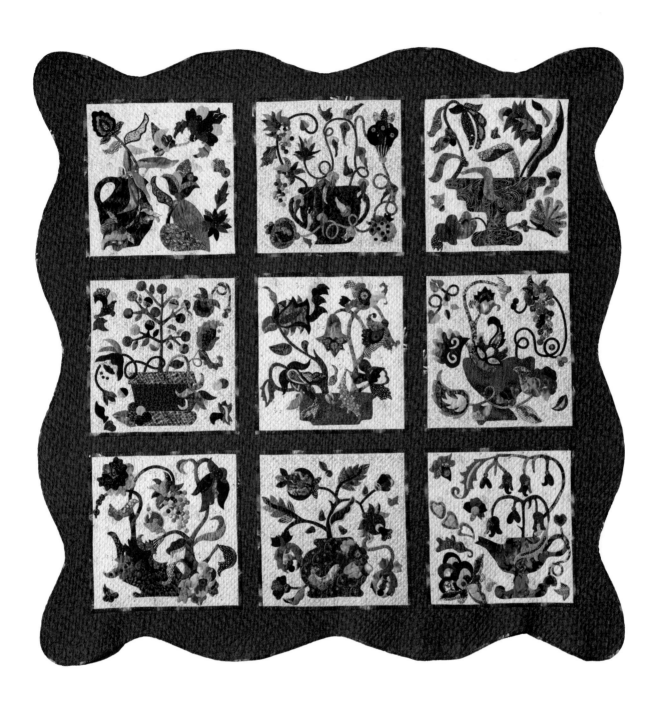

Girlie Swirlies (aka Cosmic Curves)

SIZE IN INCHES: 35 × 35

TEXAS LOCATION: Austin

MADE BY: Austin Art Quilt Group

GROUP MEMBERS: Frances Holliday Alford, Betty Colburn, Connie Hudson, Sherri Lipman McCauley, Susan Lewis Storey, Niki Valentine Vick, Kathy York

STYLE OF QUILT: Art

SOURCE OF DESIGN: Original design

MATERIALS USED: Cotton, metallic, hand painted fabrics, embellishments

PRIMARY TECHNIQUES: Machine piecing and appliqué, reassembly, satin stitching, machine quilting

Group quilts often don't look like planned art pieces. Instead they focus on the individuality of each member of the group. However, the Austin Art Quilt Group enjoys the challenge of producing cohesive work. Taking turns drawing curved lines on paper, they established the shapes, then divided them in half and distributed a top and bottom piece to each artist. The artists stitched and quilted their pieces, which were then re-assembled and satin stitched together. Many embellishments were used, even a swatch of saffron fabric from *The Gates*, the famous art installation in Central Park.

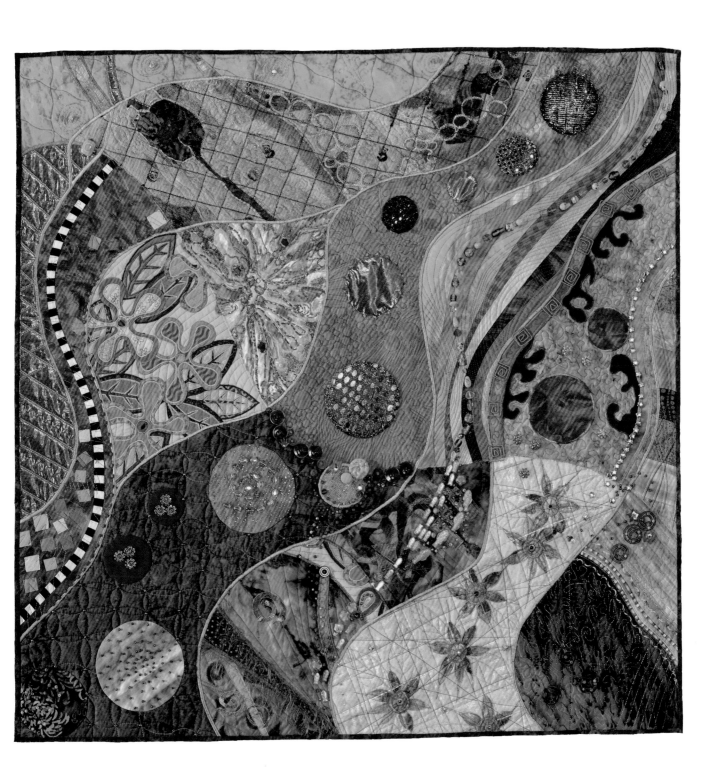

Hummingbird

2005

SIZE IN INCHES: 89 x 95

TEXAS LOCATION: Little Elm

MADE BY: Irena Bluhm

STYLE OF QUILT: Art

SOURCE OF DESIGN: Original
design

MATERIALS USED: Cotton

PRIMARY TECHNIQUES:
Painting, machine quilting

A two-sided design, this quilt is a wholecloth masterpiece on both sides. After it was quilted, the surface of the quilt was painted with colored pencils and textile medium to create the look of an appliquéd piece. Irena often uses double batting to produce the illusion of trapunto. This author of eight books has won sixty awards for her quilts in only five years. Seventeen of those awards were won for this innovative quilt.

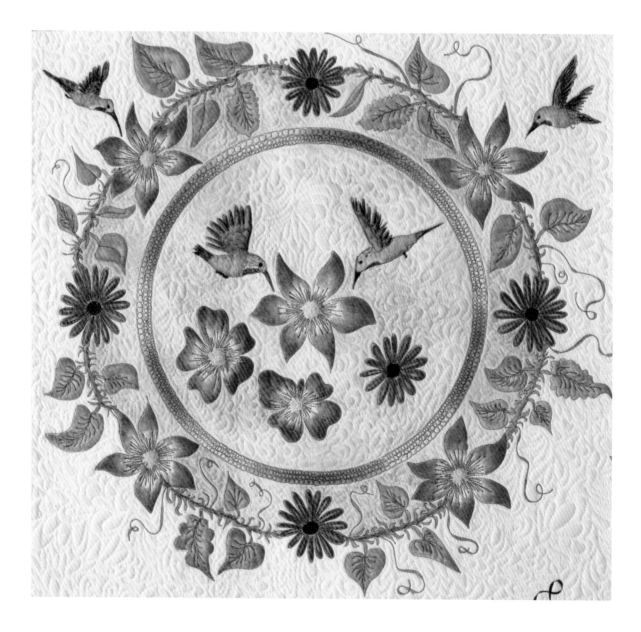

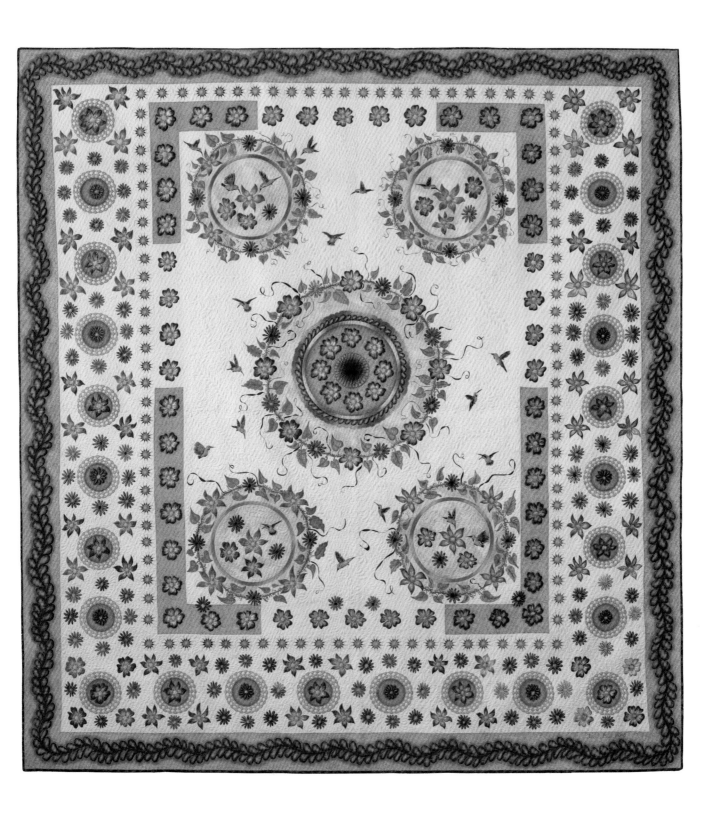

227

White Orchids

SIZE IN INCHES: 74 x 83

TEXAS LOCATION: Houston

MADE BY: Hazel Canny

STYLE OF QUILT: Traditional

SOURCE OF DESIGN: Antique
quilt

MATERIALS USED: Cotton
sateen

PRIMARY TECHNIQUES:
Trapunto, hand quilting

This exquisite all-white trapunto quilt is every bit as fine as the beautiful 1930s pastel quilt by Rose Kretsinger that inspired the quiltmaker. The stitching is a remarkable tour de force, and look at the details created by those stitches. The perfect circles, the vining feathers, the delicate butterflies, the twining petals of the orchids—all are the results of Hazel's artistry. A second-generation quilter, she has been quilting for almost forty years and has won many awards; in that time, she has made more than fifty full-size quilts and ten children's quilts.

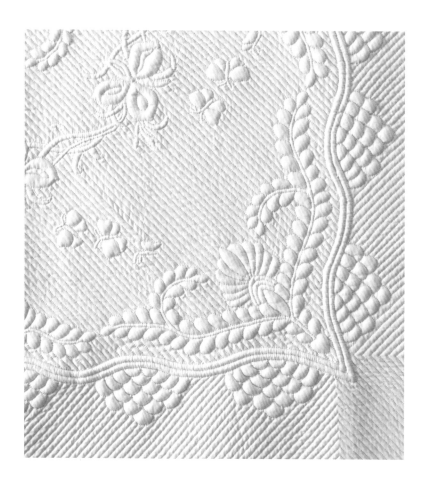

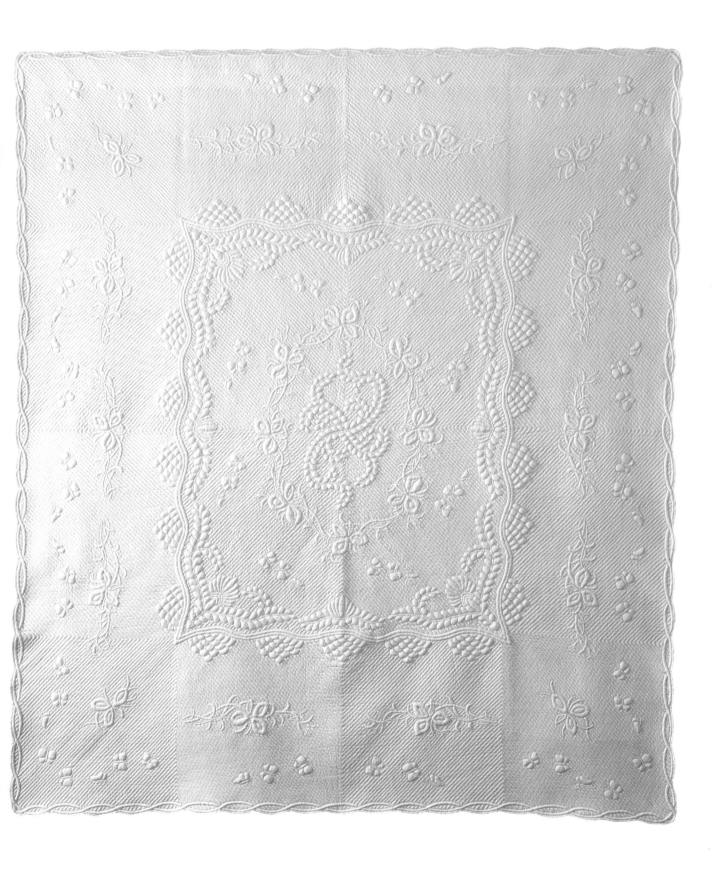

229

Lake Reflections

2005

SIZE IN INCHES: 81 x 91

TEXAS LOCATION: Cedar Park

MADE BY: Lynda Noll

STYLE OF QUILT: Traditional

SOURCE OF DESIGN: Pattern from book

MATERIALS USED: Cotton

PRIMARY TECHNIQUES: Piecing, machine quilting

The masterful use of contrasting and blended colors makes this an especially appealing quilt. It is based on a Blooming Nine Patch pattern seen in a book and is machine pieced and quilted. The Nine Patch is basically a very simple pattern consisting of nine equal squares; it is often used as a beginner's first pattern because it is so simple. However, it can be manipulated, as it has been here, by color saturation and direction to produce very dramatic effects.

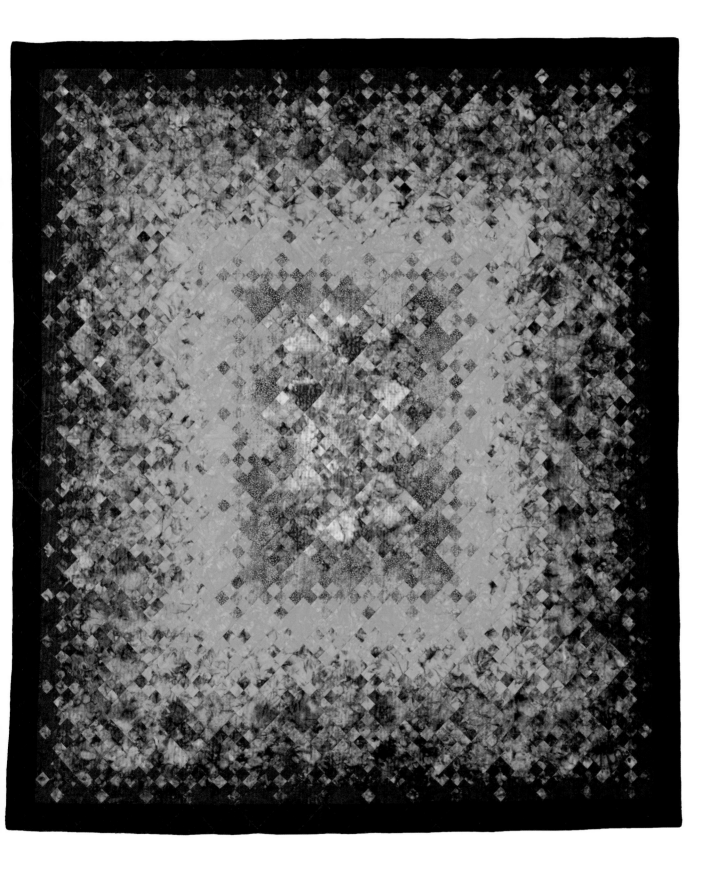

Jon's Big Adventure

2005

SIZE IN INCHES: 40 × 37

TEXAS LOCATION: Denton

MADE BY: Tonya Littmann

STYLE OF QUILT: Art

SOURCE OF DESIGN: Original design

MATERIALS USED: Hand-dyed cotton

PRIMARY TECHNIQUES: Fused appliqué, thread painting, machine quilting

A professional graphic designer, this quiltmaker learned to quilt from her grandmother so she could use her hand-dyed fabrics. She now specializes in pictorial art quilts, like this award-winning piece depicting her husband on a motorcycle trip in Wyoming. Tonya and her husband both have Harleys and enjoy riding in the Texas Hill Country. She says when this quilt hangs in a show, "it's fun to listen to the men pick out the details in the bike!"

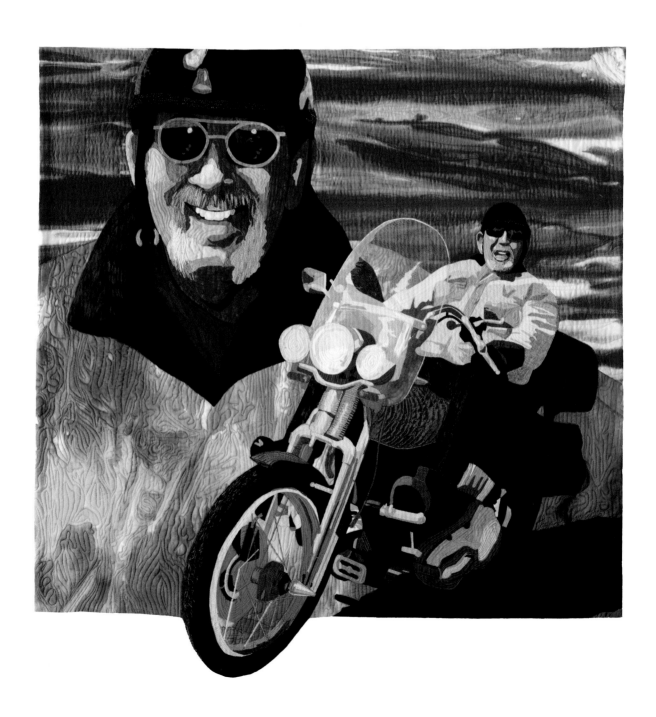

Grannie

SIZE IN INCHES: 28 x 35

TEXAS LOCATION: Austin

MADE BY: Niki Valentine Vick

STYLE OF QUILT: Art

SOURCE OF DESIGN:
Photograph of a drawing

MATERIALS USED: Cotton

PRIMARY TECHNIQUES: Fused
appliqué, machine quilting

The quiltmaker's beloved grandmother is the subject of this heart-warming quilt. Niki says: "She was a gentle soul and always the one I could call on or turn to when I felt things were not going right in my world. Born in 1891, she saw many changes in the twentieth century and died quietly a month past her one hundredth birthday." The artist created this quilt portrait from a photograph taken of a charcoal sketch of the subject when she was eighty.

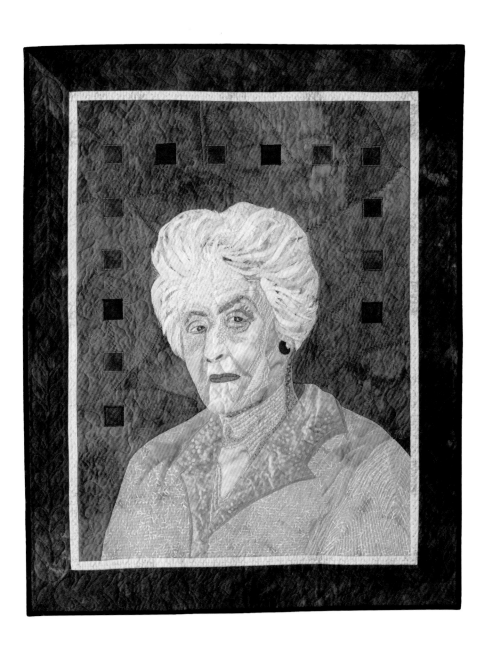

Never Again New York Beauty

SIZE IN INCHES: 84 X 84

TEXAS LOCATION: Wolfe City

MADE BY: Betty Cawthon Day

STYLE OF QUILT: Traditional

SOURCE OF DESIGN: Antique quilt

MATERIALS USED: Cotton

PRIMARY TECHNIQUES: Machine piecing and appliqué, paper piecing, trapunto, hand quilting

A fourth-generation Texas quilter, Betty decided at age fifty to learn how to make lye soap and quilts. She gave up quickly on lye soap ("I couldn't give it away!") but stuck with quilting. In 2004, a tattered family quilt was found between the mattress and the springs of an old bed (this was often done to protect the mattress from the rust resulting from the bare metal springs), and she decided to duplicate the quilt, an 1860s New York Beauty. Her husband, who also makes quilts, drafted the pattern for her. Betty now has the original quilt and a duplicate that another family member made in 1938, which she inherited. This exquisite quilt has won several awards, including a Best of Show.

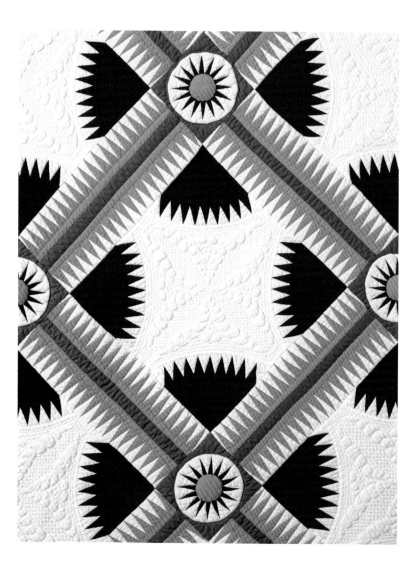

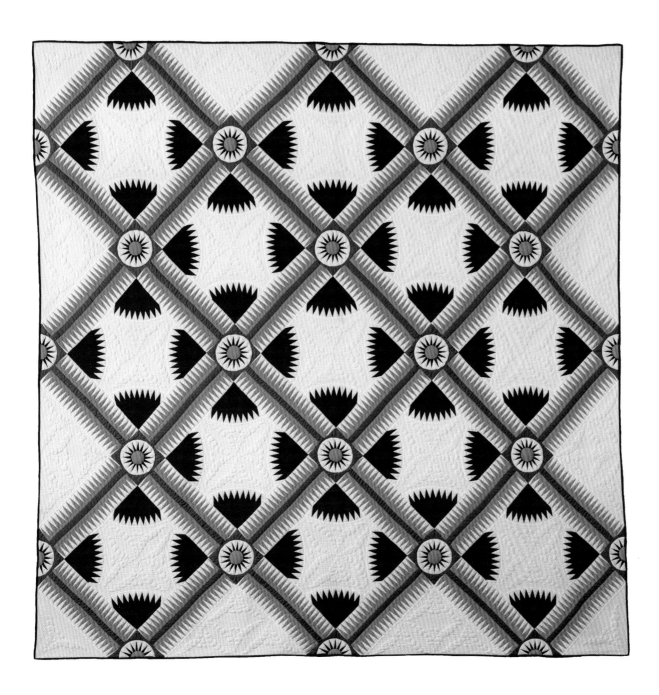

Firewheels

SIZE IN INCHES: 84 x 50

TEXAS LOCATION: Garland

MADE BY: Judy Kriehn

STYLE OF QUILT: Art

SOURCE OF DESIGN: Original design

MATERIALS USED: Cotton (some hand-dyed), batik

PRIMARY TECHNIQUES: Fused appliqué, heavy thread painting, machine quilting

The quilt artist was inspired by an end-of-day fused glass piece she had created earlier. She chose the Gaillardia for her original art quilt because it was a favorite wildflower when she was young. "It had a really long blooming season, and thus it was often available to be picked for bouquets for my mom." The award-winning quilt is heavily thread painted and uses hand-dyed fabrics.

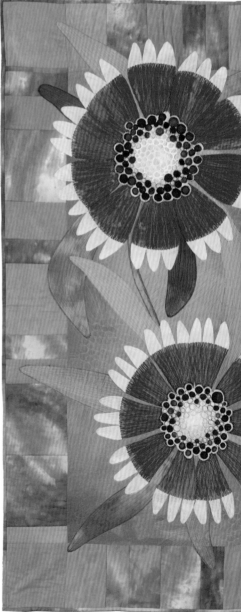

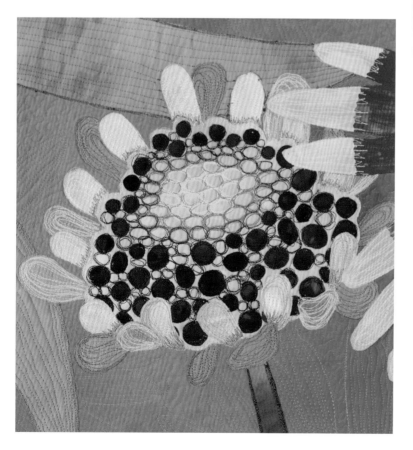

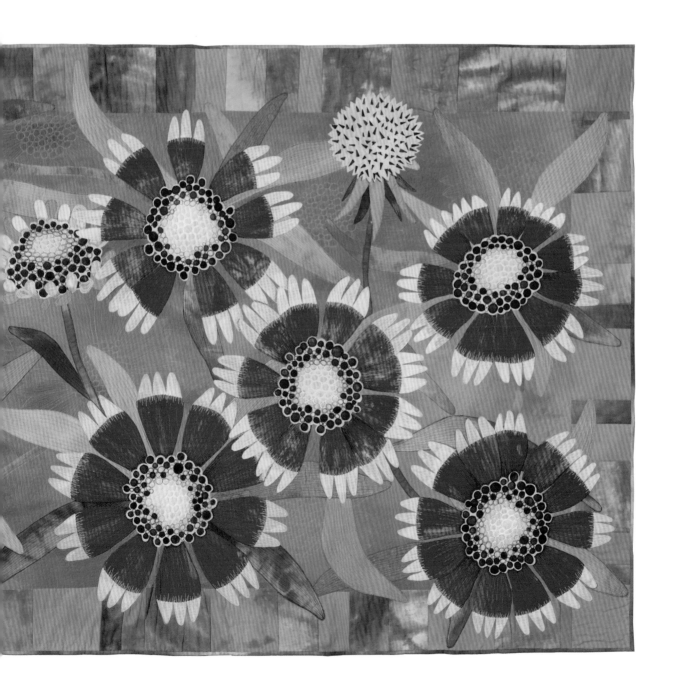

Stars All Around

2006

SIZE IN INCHES: 90 x 90

TEXAS LOCATION: Midland

MADE BY: Pat Connally

STYLE OF QUILT: Traditional

SOURCE OF DESIGN: Feathered
Star pattern

MATERIALS USED: Cotton

PRIMARY TECHNIQUES:
Machine piecing and
quilting

Quilting so lush and rich that it resembles elaborate icing on a wedding cake—that's one of the strong points of this dramatic two-color quilt. Since it was Pat's first attempt at drafting the quilting designs, it's particularly impressive. This quilt was also her first time to draft a pattern for the setting of the quilt, and the circular design with the star points touching is very effective. She chose the Feathered Star pattern because she had read that it was "really hard" and would take "a long time to make." As she says, "the challenge was on!" The quilt has won several awards, including Best of Show.

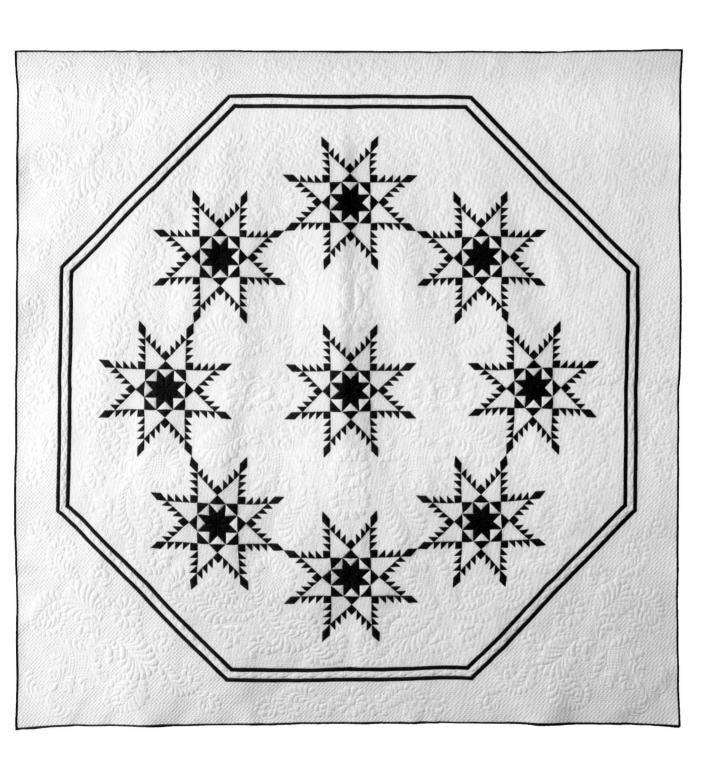

A San Antonio Fiesta

SIZE IN INCHES: 72 × 88

TEXAS LOCATION: San Antonio

MADE BY: Greater San Antonio Quilt Guild

GROUP MEMBERS: Original concept by Janet Miller, original design by Barbara Hodge, Bernie Farris, Melissa Allo, Sherry Allred, Lori Branson, Betty Brister, Janice Frankenberger, Shirley Jones, Sylvia Heck, Geneva Gusman, Maritza Guzman, Ann Larsen, Diane Leclair, Marie McDonald, Janet Miller, Karen Nano, Holly Nelson, Janis Painter, Doris Patterson, Debra Pavelka, Lynn Plunkett, Jean Powell, Sharon Ross, Dea Jae Shore, Barbara Sumlin, Ellie Williams, Barbara Wofford

QUILTED BY: Bernie Farris

STYLE OF QUILT: Art

SOURCE OF DESIGN: Original design

MATERIALS USED: Cotton, metallic bias

PRIMARY TECHNIQUES: Paper piecing, hand appliqué, machine piecing, machine quilting

FROM THE COLLECTION OF: Dale Flashberg

San Antonio, often called the "cradle of Texas liberty," holds an annual ten-day celebration in April—Fiesta San Antonio—to honor those who died at the Alamo and to celebrate San Jacinto Day, when Texas won its independence from Mexico. This raffle quilt, an award winner, with its detailed dancing couple, its flowers, its musical instruments, and even its *cascarones* (eggshells filled with confetti), was inspired by that celebration.

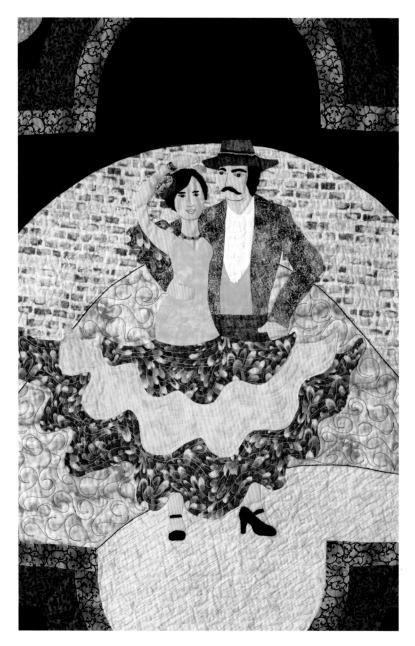

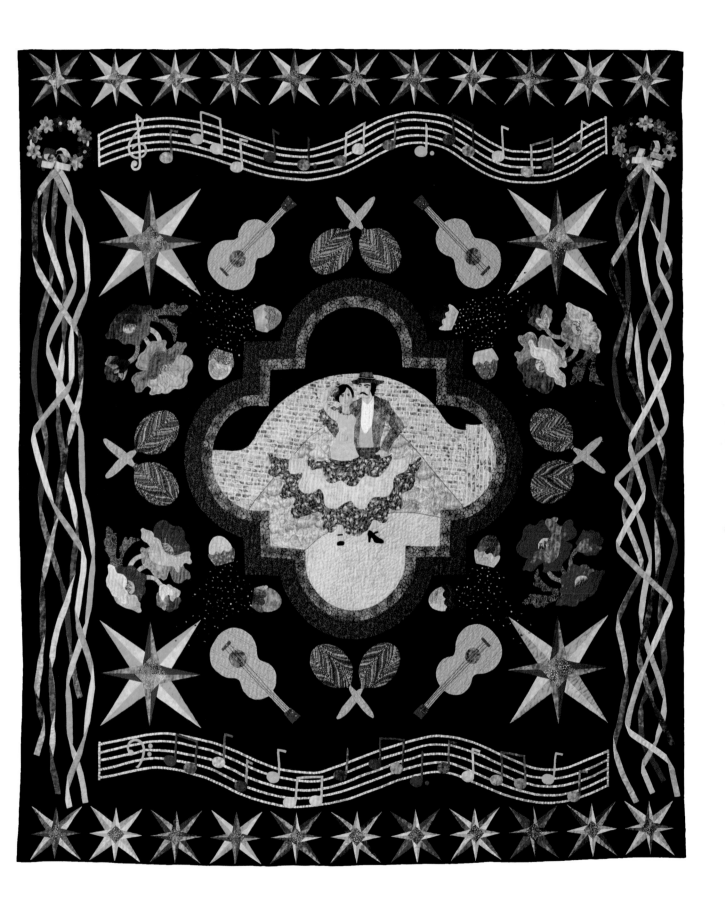

Little Cities

2006

SIZE IN INCHES: 96 x 95

TEXAS LOCATION: Austin

MADE BY: Kathy York

STYLE OF QUILT: Art

SOURCE OF DESIGN: Original design

MATERIALS USED: Cotton

PRIMARY TECHNIQUES: Machine piecing, satin stitching, appliqué, machine quilting

It took several years for the quilt artist to make the 1,600 blocks, based on Log Cabin designs, for this award-winning quilt, but it only took two months to finish. "Ironically, I thought the strip piecing would be a rest from my other quilting work . . . but that was before I decided to start making the small appliquéd circles," Kathy says. "The overall arrangement of the blocks was not apparent from the beginning, but instead was revealed to me over time as I looked for ways of organizing the chaos." The quiltmaker says that the quilt reminds her of a city surrounded by water. "There are resources, roadblocks, and little communities," she explains. "I have always been fascinated by the way people form groups, for the similarities they embrace and the differences they seek out. At what point do the differences become too much and we need to wall ourselves off?"

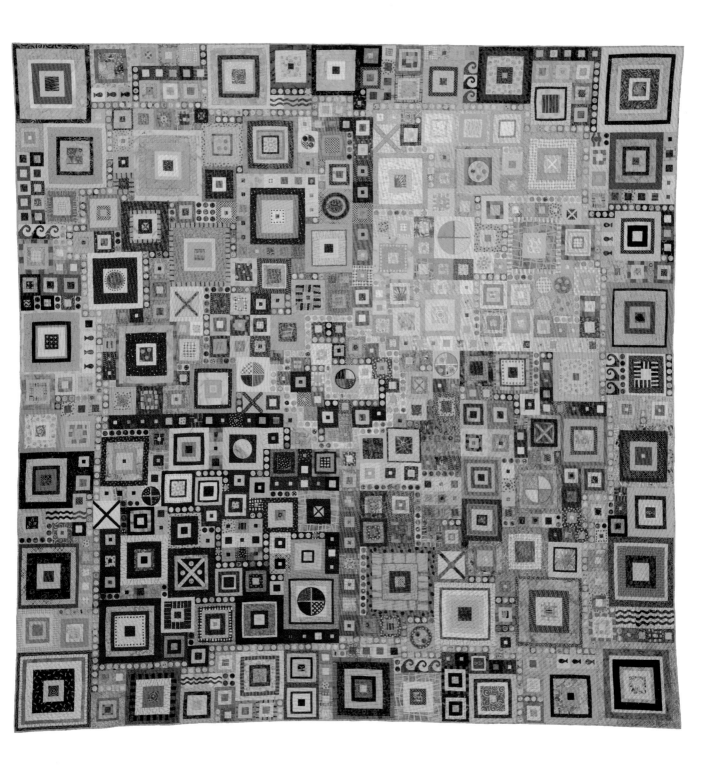

Gerbera

2006

SIZE IN INCHES: 32 × 26

TEXAS LOCATION: Austin

MADE BY: Mandi Ballard

STYLE OF QUILT: Art

SOURCE OF DESIGN: Original design

MATERIALS USED: Hand-dyed cottons

PRIMARY TECHNIQUES: Fusing, appliqué, machine and hand quilting

Quilters are often avid gardeners—no doubt it's something about the vivid colors, the intricate shapes, and the challenge of creating beauty from a patch of dirt. The internal gardener often influences the quilter, which has resulted in so many spectacular floral quilts through the centuries. Here, Mandi has used her own backyard garden as inspiration for this color-saturated design that reflects the many hues found in a blossom touched by the sun.

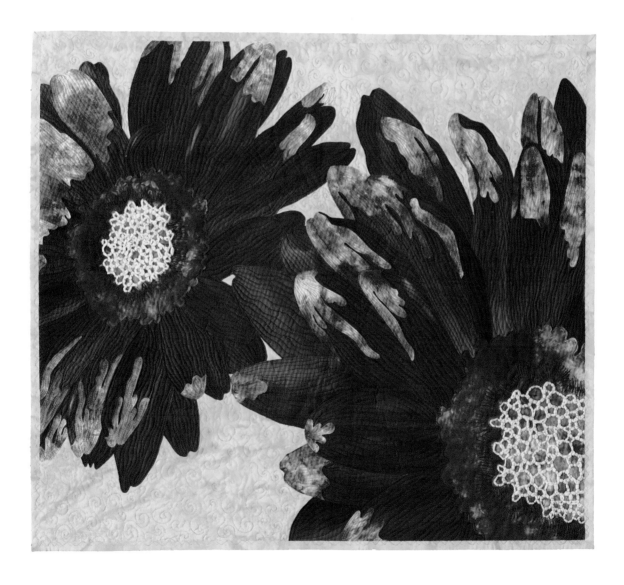

Koi Under the Willow I

SIZE IN INCHES: 26 x 21

TEXAS LOCATION: Kingwood

MADE BY: Ginny Eckley

STYLE OF QUILT: Art

SOURCE OF DESIGN: Original design

MATERIALS USED: Silk, velvet

PRIMARY TECHNIQUES: Inkjet printing, free-motion machine embroidery, machine quilting

Known for her surface design, the quiltmaker has continued her explorations in techniques developed to allow artists to change the very substance of their work. Here, Ginny used silk and velvet to create dimension in this quilt, based on memories of a scene in China, and then overprinted the silk and combined the printing with layers of free-motion embroidery. The ripples in the water are especially realistic. She learned to sew the summer she was eight, taught by her neighbor, and remembers learning about ten different stitches. "It was the best summer of my childhood," she recalls.

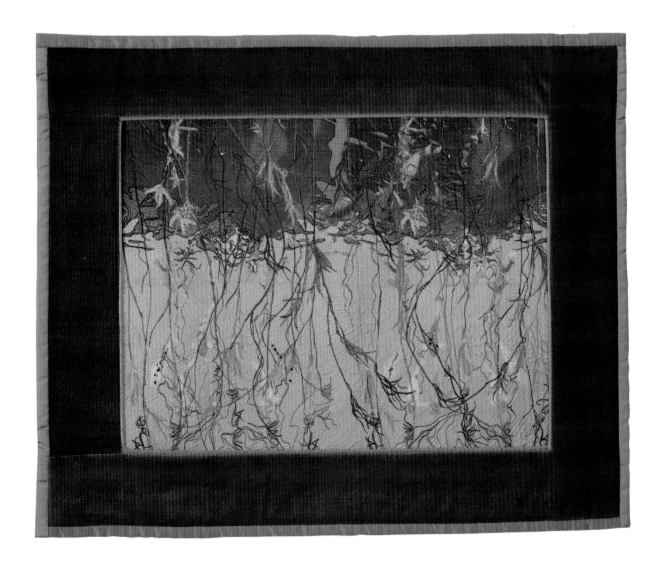

2007

SIZE IN INCHES: 78 x 78

TEXAS LOCATION: Houston

MADE BY: Debbie Brown and the Bunkhouse Buddies

GROUP MEMBERS: Valerie Boessling, Marcia Brenner, Debbie Brown, Melba Drennan, Jo Ann Eubank, Winnie Fleming, Beverly French, Linda Greuter, Ginny Miller, Carol Thelan, Lenel Walsh, Rosyne Wimbish

STYLE OF QUILT: Traditional

SOURCE OF DESIGN: Book on Biblical patterns

MATERIALS USED: Cotton

PRIMARY TECHNIQUES: Piecing, paper piecing, appliqué, machine quilting

Block exchanges are a popular and effective way of using the "divide and conquer" method of easing the workload. Here the quiltmaker's quilt group chose to make blocks from a book on Biblical quilts for their exchange, which produced several quilts Debbie describes as "unique and original."

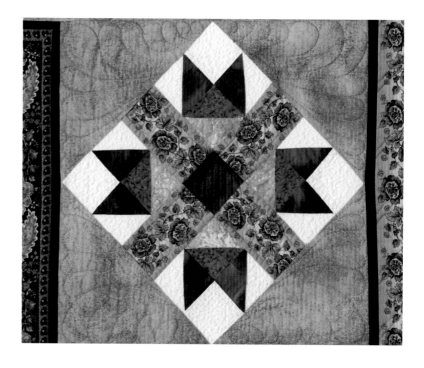

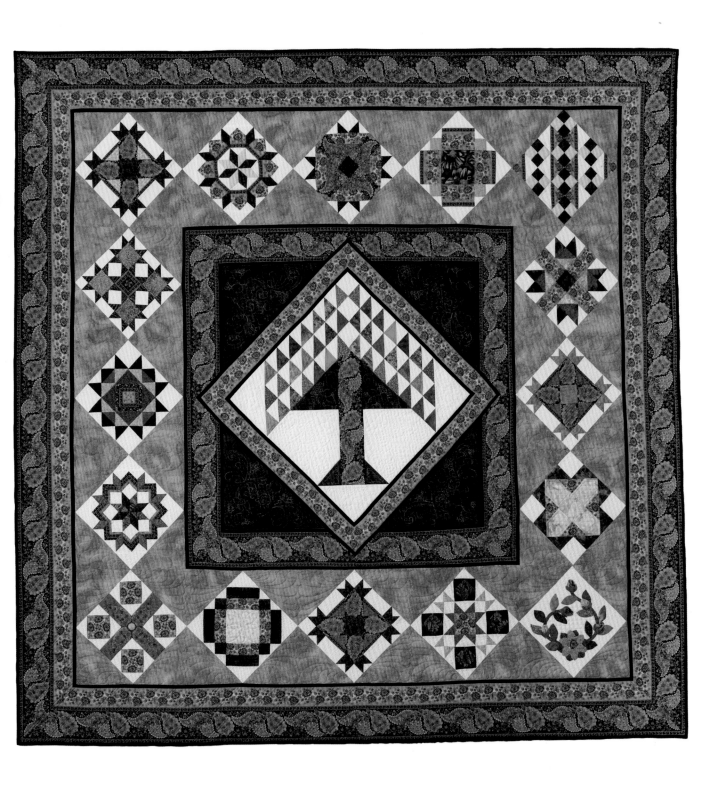

247

Happy Trails

2007

SIZE IN INCHES: 88 X 93

TEXAS LOCATION: LaMarque

MADE BY: Rodeo Committee, Mainland Morning Quilt Guild

GROUP MEMBERS: Ruth Marquez-Sillman, Peggy Mote, Pat Wright

QUILTED BY: Karen Overton

STYLE OF QUILT: Combination art and traditional

SOURCE OF DESIGN: Western theme

MATERIALS USED: Cotton

PRIMARY TECHNIQUES: Machine piecing, redwork embroidery, appliqué, machine quilting

FROM THE COLLECTION OF: Pat Wright

Created for the quilt competition at Houston's Livestock Show and Rodeo, this piece was completed only days before the deadline and still ended up winning first place. Its title was chosen to honor the famous cowboy Roy Rogers and his wife, Dale Evans, whose pictures appear in the quilt, along with Roy's palomino, Trigger. Bucking broncos, sometimes in redwork embroidery, are featured throughout the Western-themed piece, and prickly pear cactus appears in all four corners. The quilt was then raffled, and to the delight of the guild, was won by one of the quilters who worked on the committee to design and make the quilt.

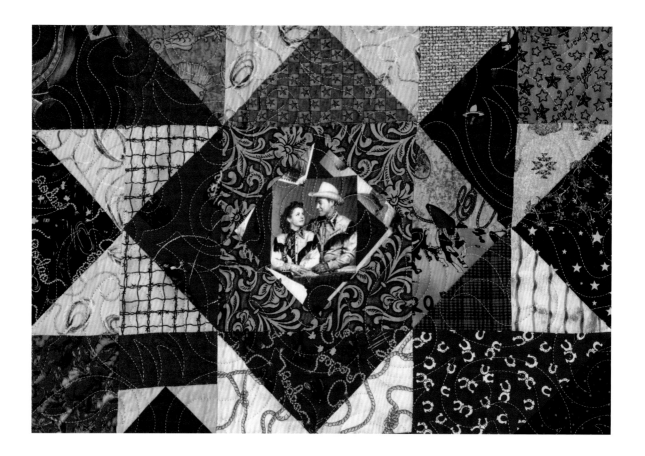

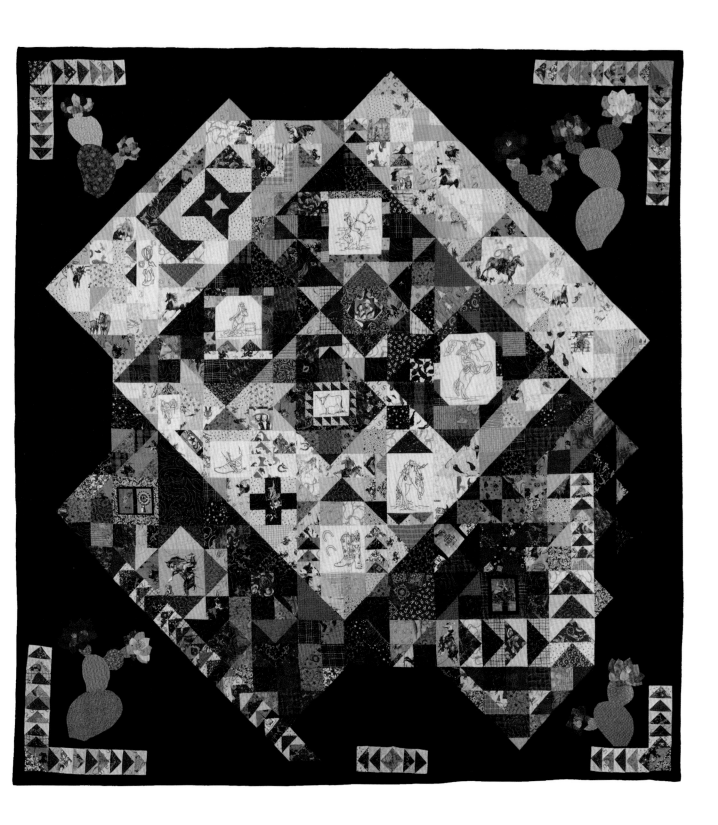

Jewels on the Vine

2007

SIZE IN INCHES: 40 x 50

TEXAS LOCATION: Houston

MADE BY: Beth Porter Johnson

STYLE OF QUILT: Art

SOURCE OF DESIGN: Original
design

MATERIALS USED: Cotton, wool
and silk roving

PRIMARY TECHNIQUES:
Machine piecing, machine
appliqué, machine needle
felting, machine quilting

A guild challenge, "Fruit," resulted in this art quilt of ripe grapes ready for harvest. The challenge offered an ideal opportunity to reinterpret in fabric one of the artist's earlier watercolors. She used freezer paper templates, machine needle-felted wool roving, and highlighted individual grapes. A few years after Beth, a former art teacher, started quilting, she invited her sister to Houston for the big International Quilt Festival—her sister now owns a quilt store in Tennessee!

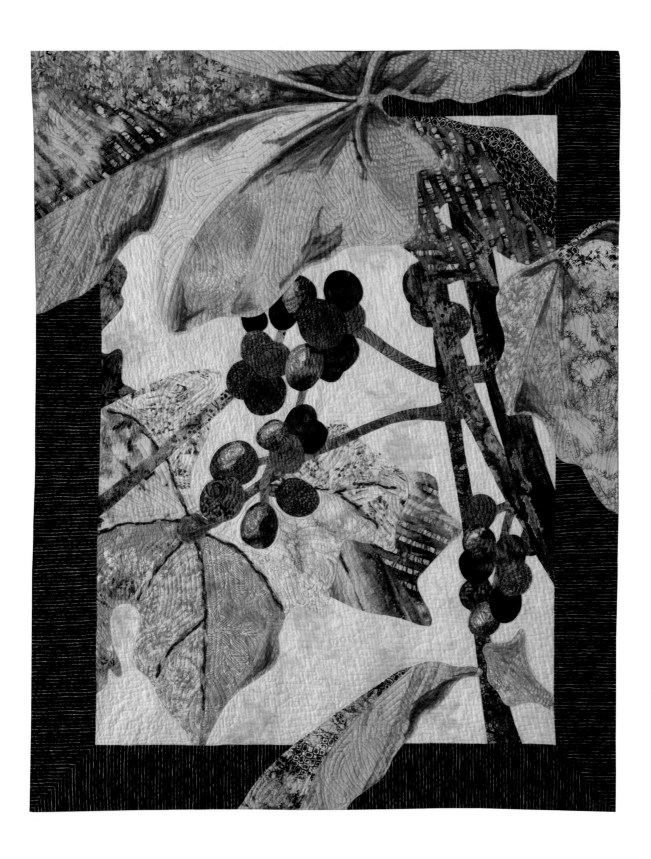

Libellula Saturata, Flame Skimmer

2007

SIZE IN INCHES: 54 × 42

TEXAS LOCATION: Denton

MADE BY: Tonya Littmann

STYLE OF QUILT: Art

SOURCE OF DESIGN: Original
design

MATERIALS USED: Hand-dyed
cotton

PRIMARY TECHNIQUES: Fused
appliqué, thread painting,
machine quilting

A guild challenge to create a quilt with the theme "Under the Magnifying Glass" led to this stunning piece, which has won awards. Tonya knew immediately that she had to do a Flame Skimmer—"Our pond is inhabited by these beautiful red dragon-flies, and they make me smile!" The free-motion stitched wings are satin stitched onto organza to give the transparent effect; shadows were applied with paint sticks.

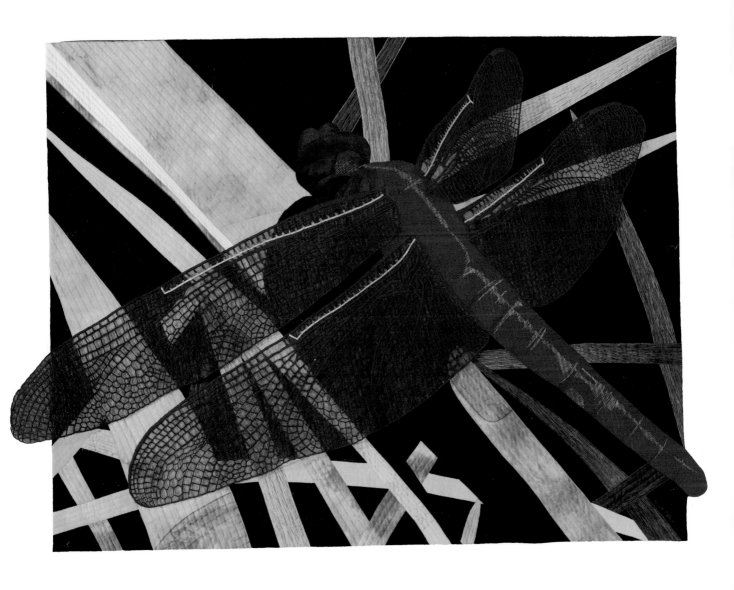

Opposites Attract

2007

SIZE IN INCHES: 54 × 54

TEXAS LOCATION: Houston

MADE BY: Patricia T. Mayer

QUILTED BY: Karen Watts

STYLE OF QUILT: Traditional

SOURCE OF DESIGN: Original design

MATERIALS USED: Cotton, batiks

PRIMARY TECHNIQUES: Hand appliqué, machine quilting

Papercut patterns and many bright batiks combined with black and white add a lively charm to this quilt. Patricia used "echo"-style quilting. This is similar to what was used in Hawaiian quilts, where the quilting stitches move out from the block design; the resulting image resembles the way a stone dropped in a pond creates ripples. The quilt was the result of a self-challenge to design and make a traditional quilt with a modern look.

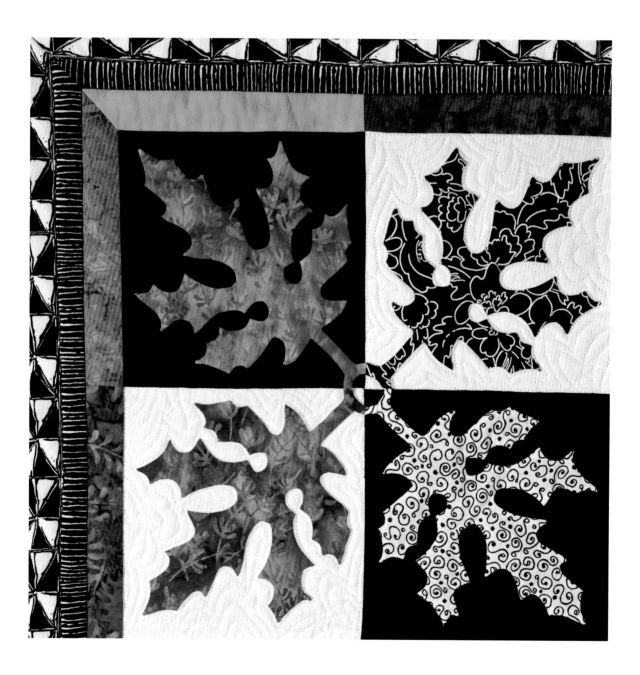

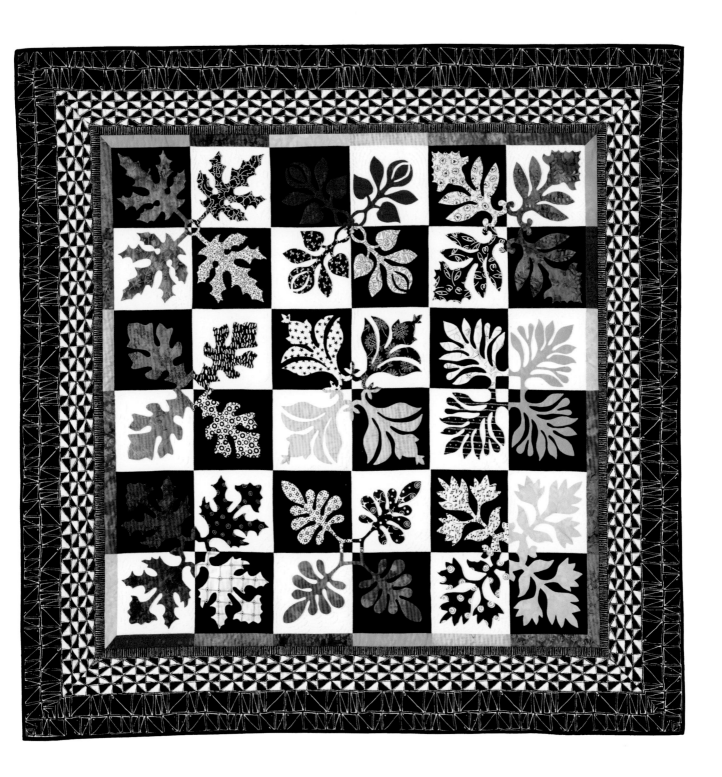

255

Geese and Feathers in the Garden

SIZE IN INCHES: 86 x 101

TEXAS LOCATION: Houston

MADE BY: Sandra Mahaffey McLeod

QUILTED BY: Kathy Colvin

STYLE OF QUILT: Traditional

SOURCE OF DESIGN: Original design borders and patterns

MATERIALS USED: Cotton

PRIMARY TECHNIQUES: Piecing and raw-edge appliqué, machine quilting

The secondary pattern that showed up when the quilt top was finished was a happy surprise to the quiltmaker, who had made the top from fabrics acquired through a fabric exchange with friends. Sandra chose a vine and flower design for the border to contrast with the geometric center, and working with all neutrals, she even pieced the border fabric on which the raw-edge appliqué was done with pearl cotton thread. She selected traditional feather designs and diagonal lines for the quilting.

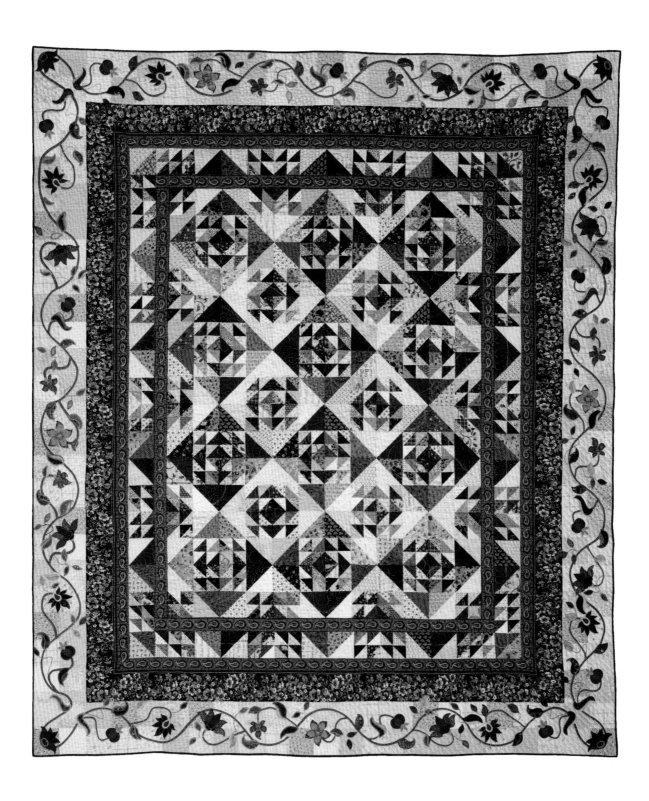

257

Stars in a Garden

2007

SIZE IN INCHES: 75 × 75

TEXAS LOCATION: New Braunfels

MADE BY: Janet Hartnell-Williams

STYLE OF QUILT: Traditional

SOURCE OF DESIGN: Original setting

MATERIALS USED: Cotton

PRIMARY TECHNIQUES: Machine piecing, hand appliqué, hand quilting

Janet likes to build her quilts in an original setting around a traditional pieced block with appliquéd highlights for added interest. Her quilt leads the eye in many directions but uses shades of marigold to confine the activity. Earlier work by this quiltmaker was also featured in *Lone Stars II: A Legacy of Texas Quilts, 1936–1986*.

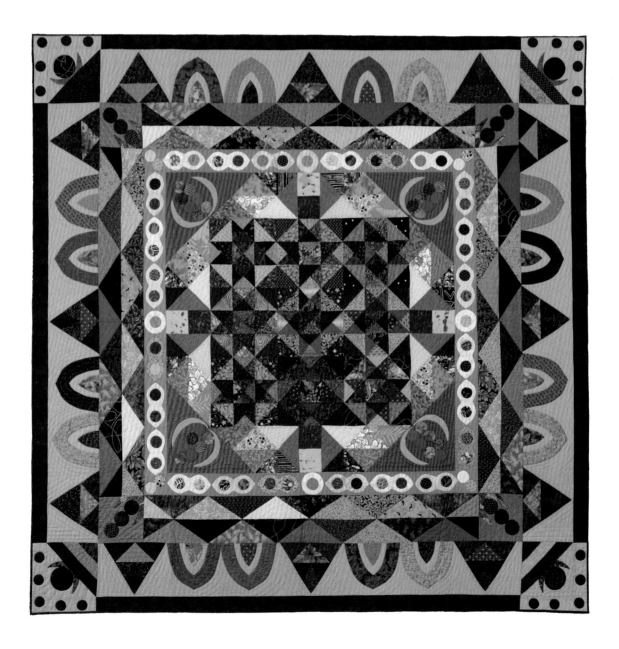

Texas Sunflower

SIZE IN INCHES: 96 x 96

TEXAS LOCATION: Austin

MADE BY: Kathleen Holland McCrady

STYLE OF QUILT: Combination of art and traditional

SOURCE OF DESIGN: Book and original design

MATERIALS USED: Cotton

PRIMARY TECHNIQUES: Hand and machine piecing, hand appliqué, hand quilting

FROM THE COLLECTION OF: Carl Cox

Inspired by a book on medallion quilts, the quilt artist saw this design as an ideal way to use a personal collection of fabrics manufactured in New Braunfels, Texas, at the now defunct Mission Valley Mills, formerly Comal Cottons. "Their wonderful plaids and checks were manufactured there from the cotton bales on the loading docks to the threads for weaving yardage," Kathleen remembers. The authors of this book clearly remember their mothers taking them on annual August trips to Comal Cottons to buy beautiful plaids for their back to school shirtwaist dresses. The huge weaving machines were always running behind an enormous glass window so customers could see what was being produced. Kathleen was one of the artists featured in *Lone Stars II: A Legacy of Texas Quilts, 1936–1986*.

2007

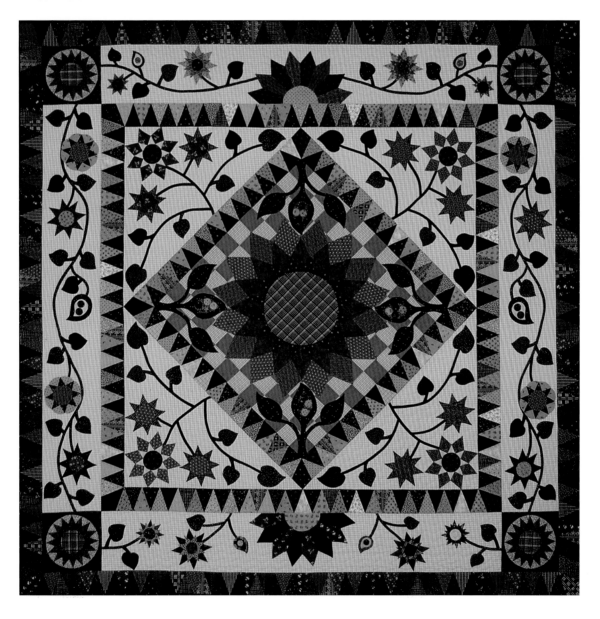

Lily

2007

SIZE IN INCHES: 48 x 36

TEXAS LOCATION: Double Oak

MADE BY: Carol Morrissey

STYLE OF QUILT: Art

SOURCE OF DESIGN: Original
design

MATERIALS USED: Cotton

PRIMARY TECHNIQUES: Hand
painting, machine appliqué,
machine quilting

Carol specializes in quilts based on nature—flowers and animals—
and is known for her oversize renditions that take common every-
day sights and transform them into magnified wonders. Here she
has enlarged the common lily, seen in gardens almost all over the
world, until every tiny aspect of the flower is clearly delineated.
She based the quilt on a photograph she took in Cannero, Italy.
The quilt was included in a one-woman museum show.

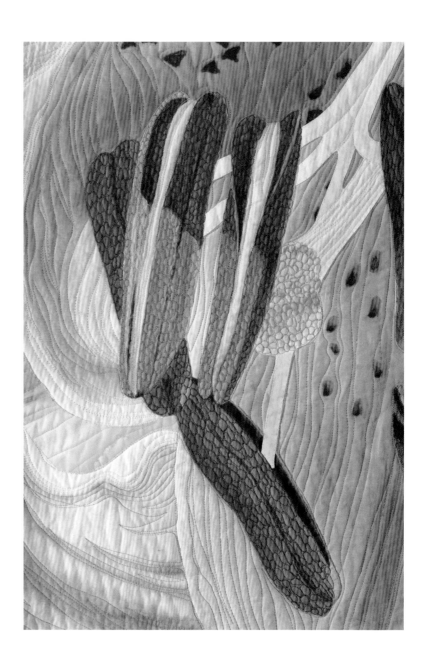

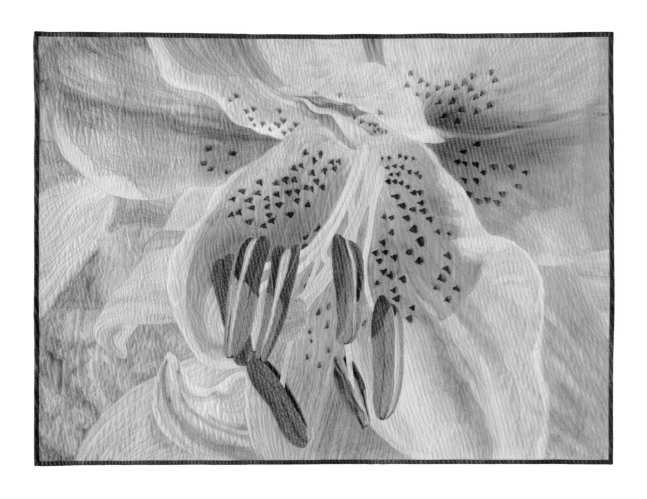

UFO Complete

2007

SIZE IN INCHES: 63 x 87

TEXAS LOCATION: Houston

MADE BY: Betty Rivers and the Block Builders Scrap Bee

GROUP MEMBERS: Lynn Roddy Brown, Jill Danzer, Denise Goodman, Betty Rivers

QUILTED BY: Jane Plisga

STYLE OF QUILT: Traditional

SOURCE OF DESIGN: Original Four Patch design

MATERIALS USED: Cotton

PRIMARY TECHNIQUES: Machine piecing, machine quilting

FROM THE COLLECTION OF: Betty Rivers

This scrappy award winner, a block-swap quilt, is based on the Triple Four-Patch pattern and was so successful that it was used as the cover quilt for a book on this technique. When Betty was initially told about the book, the blocks were in a plastic bag in her stash of unfinished projects. "I unzipped my bag of these blocks, got busy, and made this quilt. That explains the quilt's title!" she says.

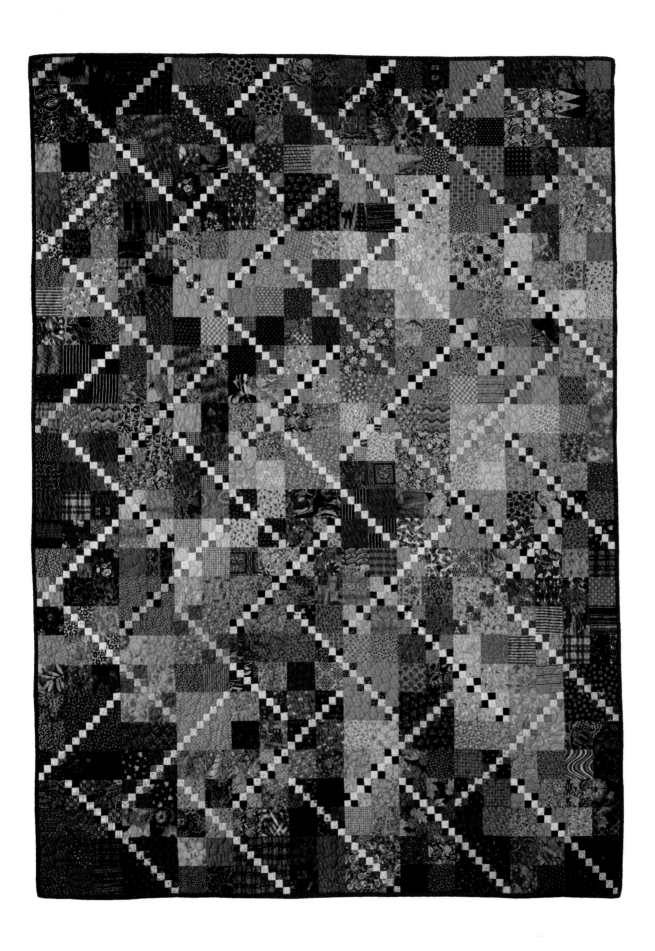

Red Spirals

SIZE IN INCHES: 73 x 73

TEXAS LOCATION: Waco

MADE BY: Connie Watkins

STYLE OF QUILT: Art

SOURCE OF DESIGN: Dutch
 pattern

MATERIALS USED: Cotton

PRIMARY TECHNIQUES:
 Machine piecing, quilting

2007

A Dutch pattern led to the creation of this unusual and striking quilt. "When I first saw it, I wanted to take on the challenge of all the curved piecing," says Connie. The quilt has received international recognition for its excellent color and fabric choice and for the complicated piecing that snakes around the quilt.

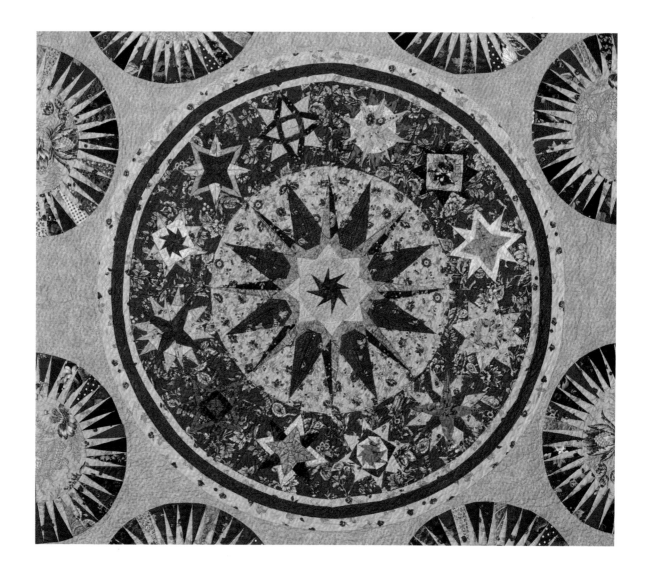

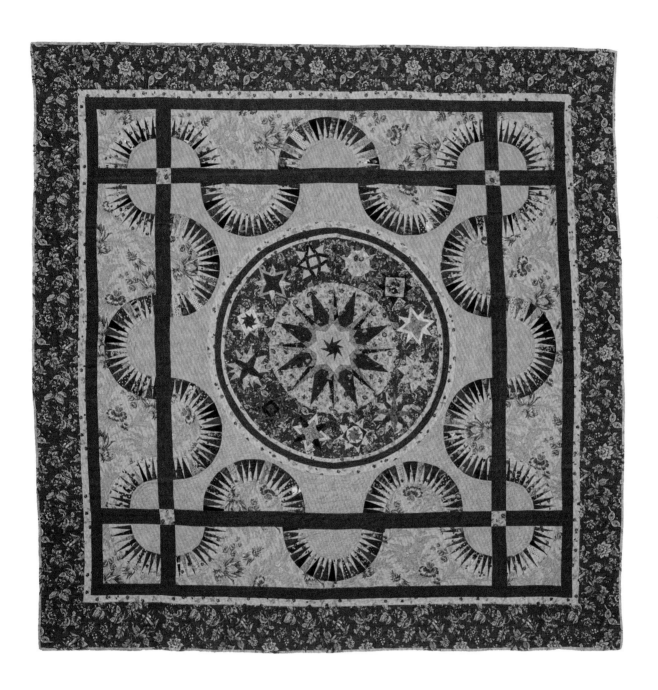

265

Little Red Spot

2008

SIZE IN INCHES: 53 × 54

TEXAS LOCATION: Pflugerville

MADE BY: Naomi S. Adams

STYLE OF QUILT: Art

SOURCE OF DESIGN: Original design

MATERIALS USED: Cotton

PRIMARY TECHNIQUES: Piecing, appliqué, machine quilting

This unusual design was inspired by a gorgeous photo of the Little Red Spot on Jupiter. There is current debate over how red the "Little Red Spot" actually could be today because of changing conditions in the atmosphere. A specific NASA photo of the spot shows the colors that are in the quilt (purple and yellow-green). Naomi's work emphasizes the mystery of space . . . and no, there is no "Little Red Spot" in the quilt! Naomi has had work juried into Quilt National.

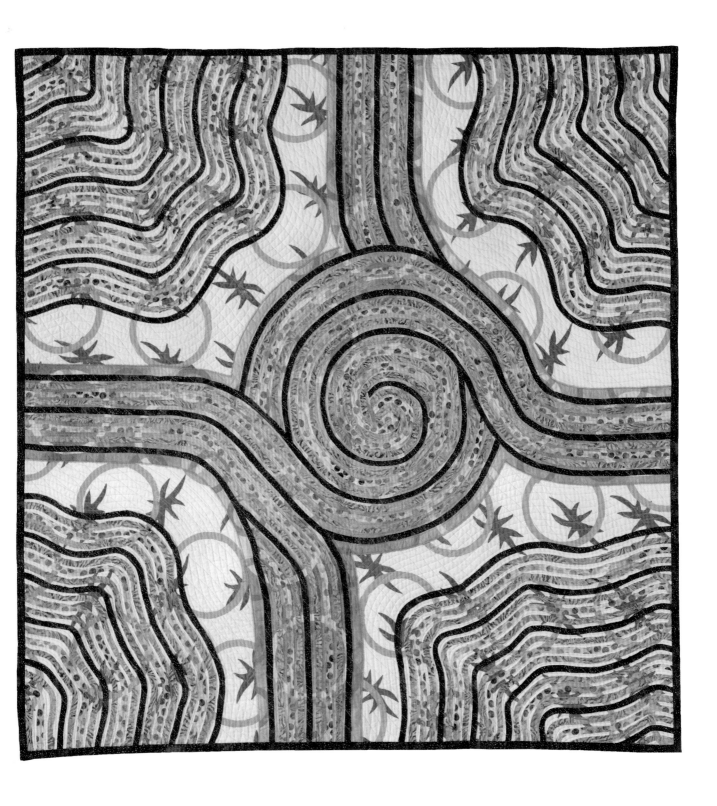

I Sing the Flower Eclectic

SIZE IN INCHES: 47 x 32

TEXAS LOCATION: Austin

MADE BY: Austin Art Quilt Group

GROUP MEMBERS: Frances Holliday Alford, Connie Hudson, Leslie Tucker Jenison, Raewyn Khosla, Sherri Lipman McCauley, Kathy York

STYLE OF QUILT: Art

SOURCE OF DESIGN: Original design

MATERIALS USED: Cotton, hand-dyed silk, batiks

PRIMARY TECHNIQUES: Machine appliqué, free-motion satin stitching, thread painting, hand and machine quilting

FROM THE COLLECTION OF: Frances Holliday Alford

A delightful, vividly colored art quilt, this piece was made by a group exploring the dynamics of combining their individual voices with their group synergy. Each group member made a 16" square floral block using bright colors. The quilted blocks were then cut into 8" quarters, rearranged, and joined to re-create 16" blocks. Each member had to embellish her new block. According to Kathy York, "Many of us had a difficult time adding embellishments. The colors were so bright that many beads seemed to get lost, and if they worked well in one spot, they might disappear in another." The group brainstormed their solutions together, and the result is this lovely and cheerful quilt.

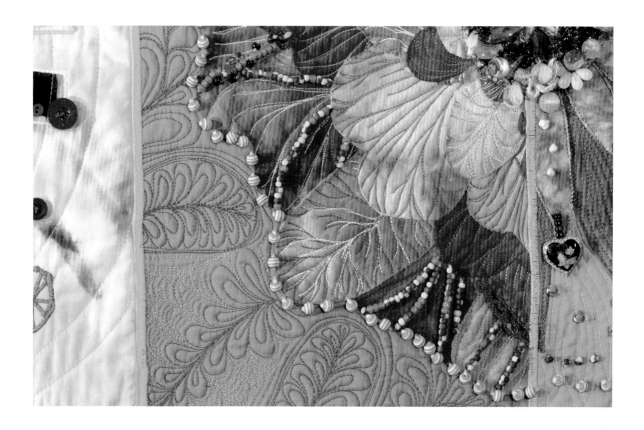

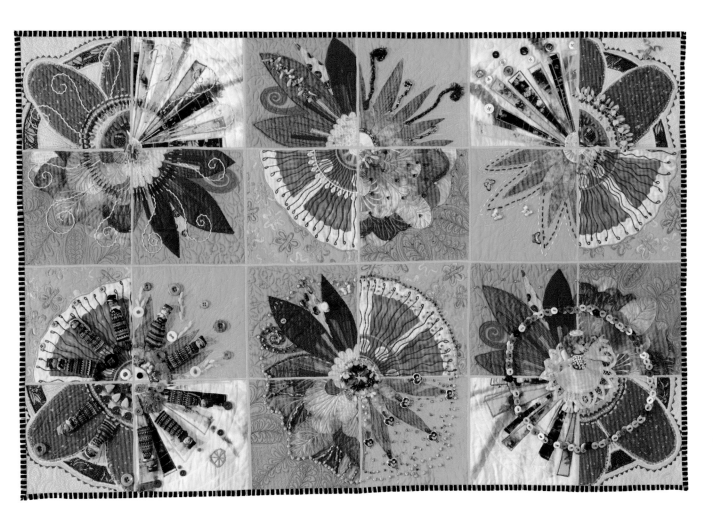

2008

SIZE IN INCHES: 67 × 77

TEXAS LOCATION: Mesquite

MADE BY: Cathy Bradley

STYLE OF QUILT: Traditional

SOURCE OF DESIGN: Original design

MATERIALS USED: Cotton, batiks

PRIMARY TECHNIQUES: Hand appliqué, reverse appliqué, hand embroidery, hand quilting

This unique and heartwarming holiday quilt is based on a collection of family Christmas cards, which were assembled between 1927 and 1929 by the quilter's mother and are now treasured as a reminder of her life. The ten blocks, most of them different sizes, are unified by Cathy's skillful use of frames and small squares. Her attention to detail—note the lace petticoat and the delicate shoes on the girl trimming the tree—is remarkable. The quilt has won multiple awards.

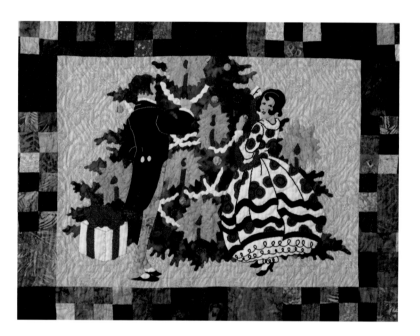

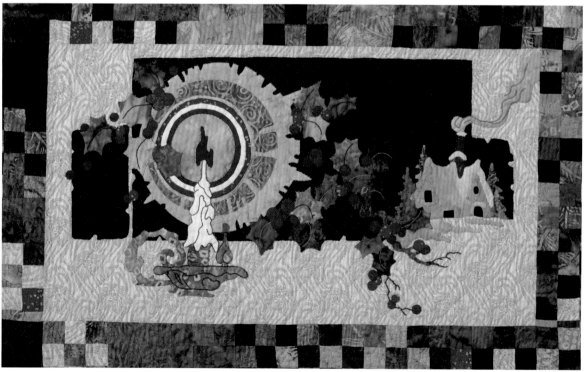

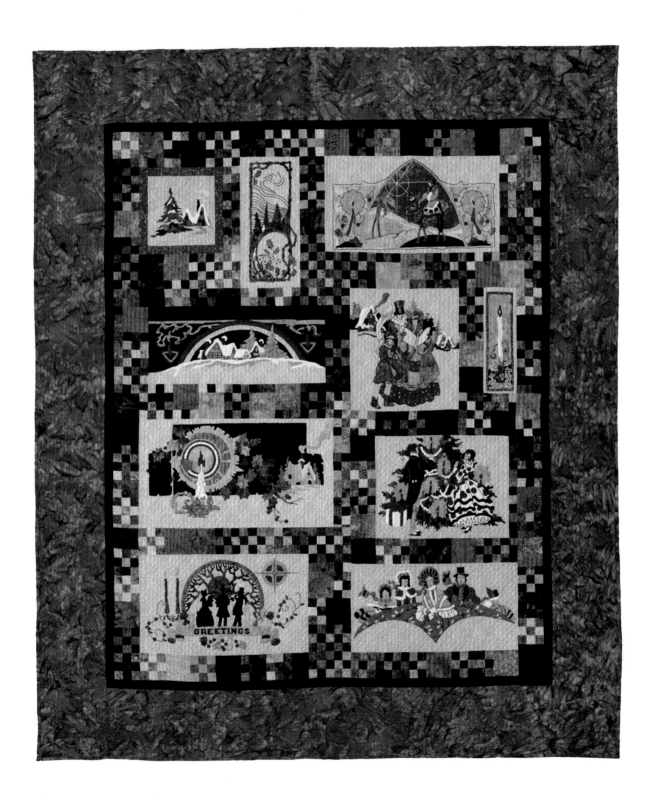

"Houston . . . I Think We Have a Quilter"

2008

SIZE IN INCHES: 73 X 54

TEXAS LOCATION: Katy

MADE BY: Martha DeLeonardis

STYLE OF QUILT: Art

SOURCE OF DESIGN: Original
design

MATERIALS USED: Cotton
(some hand-dyed)

PRIMARY TECHNIQUES:
Machine piecing, curved
machine piecing, turned
edge fabric weaving,
couching, machine quilting

Winner of the international "The Sky's the Limit" competition, Martha's delightful quilt was inspired by a neon-colored photo of Saturn taken with an infrared lens. This made her realize that Saturn need not be earth-toned but could be any color she could imagine . . . a quiltmaker's dream come true, and perhaps a "comfort" to think of an entire patchwork planet!

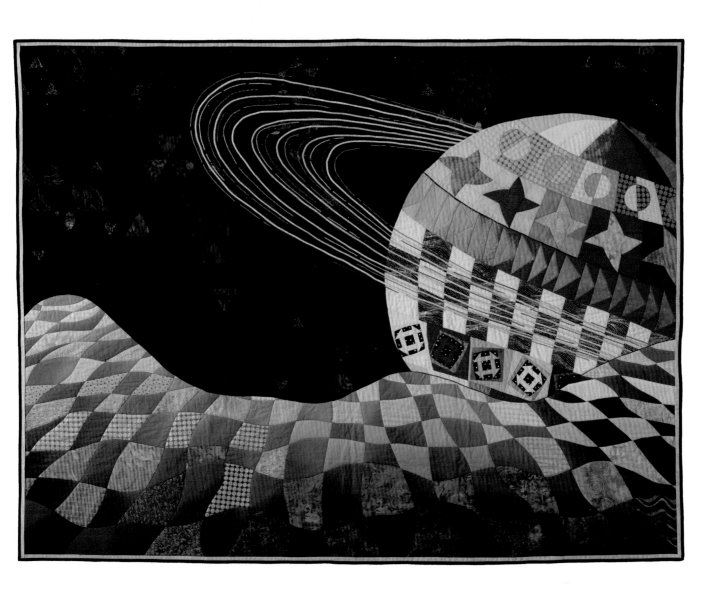

Dragonflies at Sunset

2008

SIZE IN INCHES: 45 × 75

TEXAS LOCATION: Dallas

MADE BY: Jack Brockette

STYLE OF QUILT: Art

SOURCE OF DESIGN: Original
design

MATERIALS USED: 3 layers of
hand-dyed silk organza

PRIMARY TECHNIQUES: Piecing
with ⅛" French seams,
embroidery, machine
quilting

Transparent quilts are seldom seen but are very effective when,
like this one, they use layered colors to create an entirely new hue.
This quilt's primary appeal lies in Jack's imaginative and skilled
creation of the gilded look of a glowing Texas sunset and the
embroidered dragonflies.

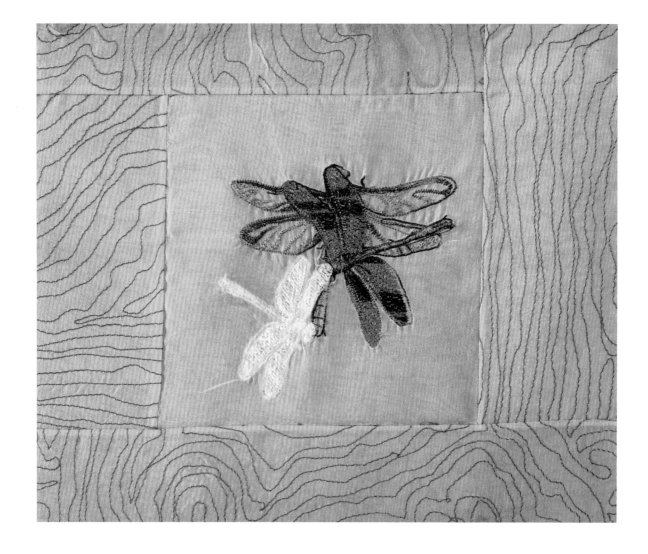

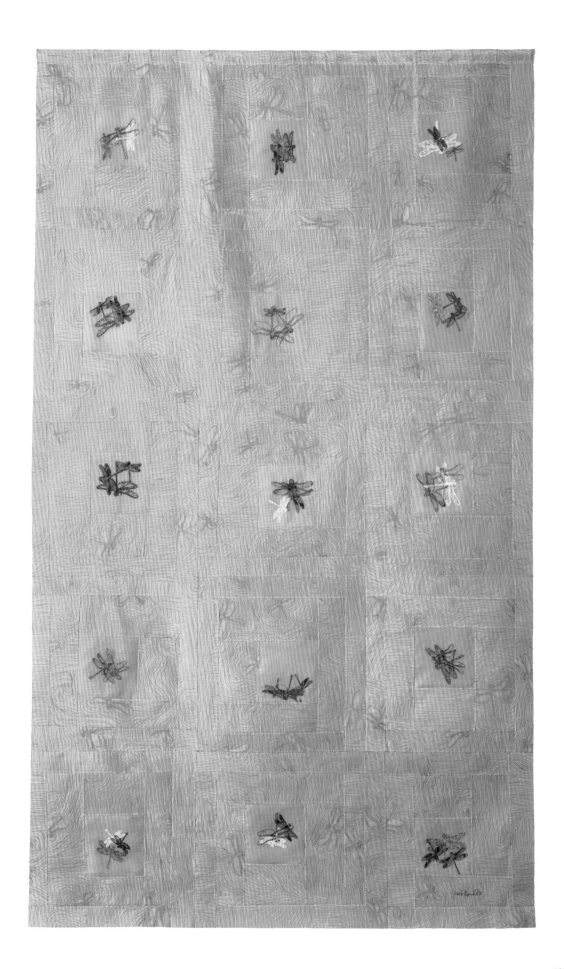

One Fine Day

2008

SIZE IN INCHES: 73 × 65

TEXAS LOCATION: Dickinson

MADE BY: Cynthia Law England

STYLE OF QUILT: Art

SOURCE OF DESIGN: Original design

MATERIALS USED: Cotton, organza, satins

PRIMARY TECHNIQUES: Picture piecing, machine quilting

Based on a photograph the artist took while passing through the Lake Tahoe area, this quilt captures the perfection of the day, especially how the sunlight sparkles off the clear water. The way she has created the texture of the lakeside stones and the transparency of the water near the shore is particularly noteworthy. Cynthia points out: "The longer that I create realistic pictorial quilts, the more I realize you can convert any photograph into fabric. It is up to you how detailed you want your creation to be."

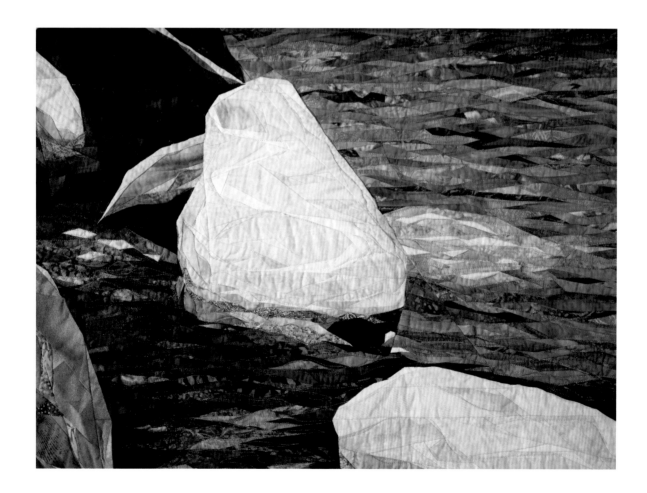

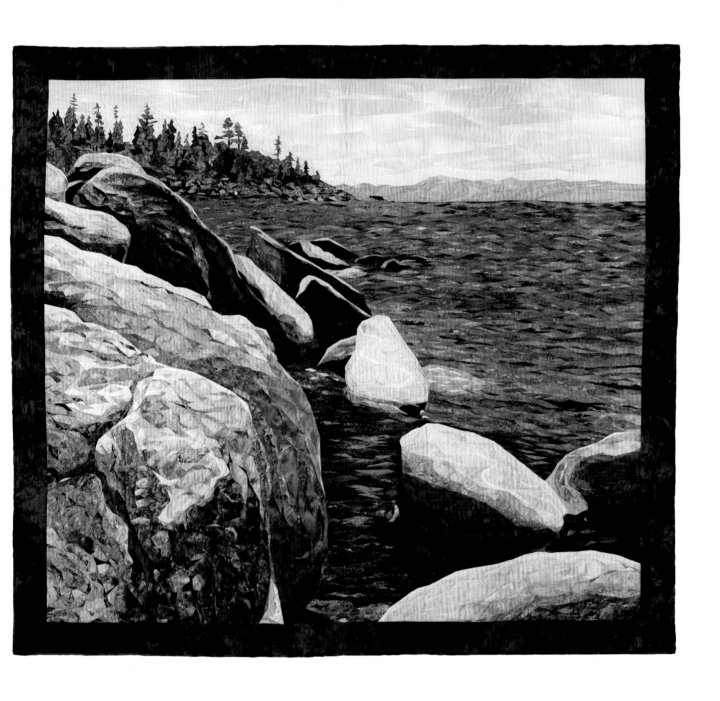

The Winner's Circle

2008

SIZE IN INCHES: 29 × 35

TEXAS LOCATION: Magnolia

MADE BY: Nancy B. Dickey

STYLE OF QUILT: Art

SOURCE OF DESIGN: Original design

MATERIALS USED: Cotton

PRIMARY TECHNIQUES: Machine appliqué, inset cording, fused appliqué, machine piecing and quilting

To simulate the image of the jockey and his horse in the Winner's Circle, Nancy had her husband pose in the sunlight astride a lawn chair holding the dog's leash for reins and waving to the trees as though he were waving to adoring crowds. She studied her neighbor's horses to get just the right expression on the horse's face and consulted a horse trainer to be sure the tack was authentic. She certainly achieved her goal—to portray the final garlanded victory of a race well run—with this quilt.

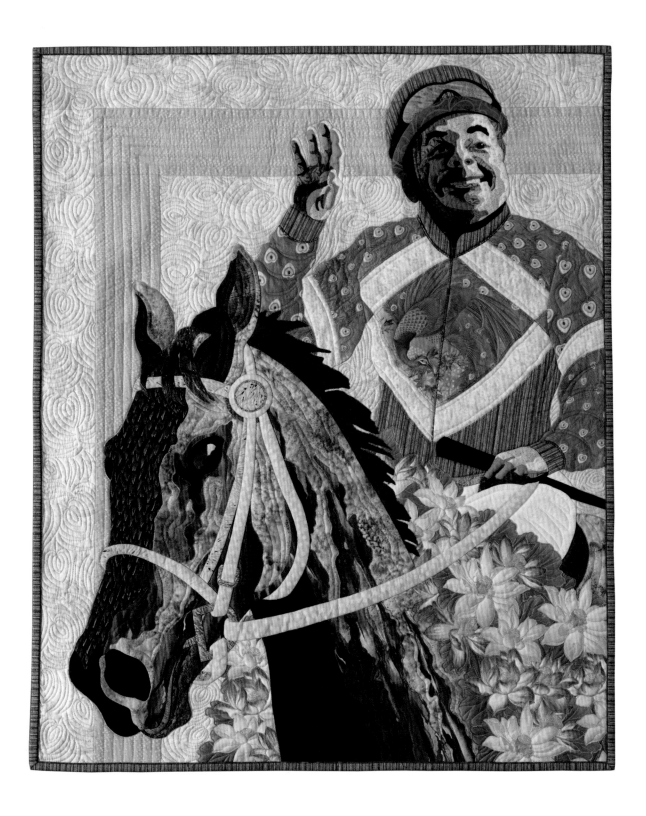

Old Alton Bridge

SIZE IN INCHES: 31 X 33

TEXAS LOCATION: Lantana

MADE BY: Julie (Jules) McKenzie Rushing

STYLE OF QUILT: Art

SOURCE OF DESIGN: Original design

MATERIALS USED: Hand-painted cotton

PRIMARY TECHNIQUES: Making appliqué pattern from enlarged photo, painting to enhance highlights, machine quilting

Working from a personal photograph of this historic old bridge in Denton County, Julie (widely known as Jules) made her appliqué pattern as part of a workshop. Describing her method, she says: "I enlarge photographs to the size quilt I choose to work on either by photocopier or overhead projector. I then trace the enlargement onto freezer paper and use cutouts in the pattern to audition fabric for each piece of the quilt. After all the pieces are selected, cut, and appliquéd, I use textile paint to enhance the highlights and depth of the subject." This art quilt that evokes memories of the past is an award winner.

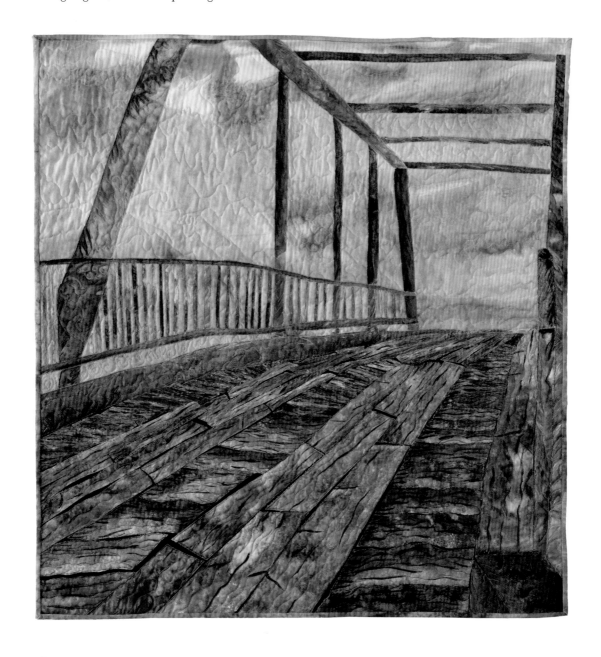

Now

SIZE IN INCHES: 3I X 29

TEXAS LOCATION: San Antonio

MADE BY: Laurie Brainerd

STYLE OF QUILT: Art

SOURCE OF DESIGN: Original
design

MATERIALS USED: Cotton,
recycled garments

PRIMARY TECHNIQUES:
Machine piecing and
quilting

FROM THE COLLECTION OF:
Kathy Harrington, MD

Brilliant, intuitive color combined with strong quilting designs make this a striking piece. Laurie's quilt, a diptych, is comprised of two differently shaped pieces displayed on a separate black background. The shapes represent how life fits together and the circle represents the source.

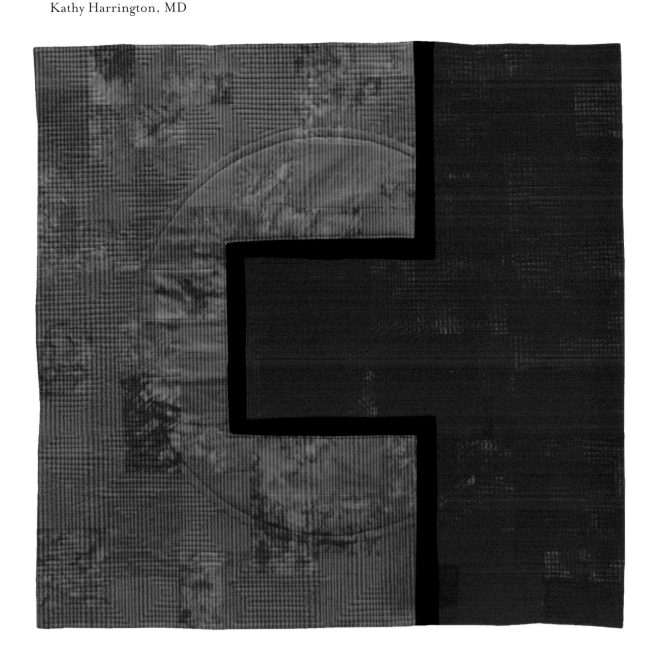

2008

SIZE IN INCHES: 87 x 87

TEXAS LOCATION: Houston

MADE BY: Susan H. Garman

STYLE OF QUILT: Traditional

SOURCE OF DESIGN: Baltimore
style, celebrating historic
sailing ships

MATERIALS USED: Cotton

PRIMARY TECHNIQUES:
Appliqué, hand quilting

The level of detail achieved in this quilt is quite astonishing and results from Susan's diligent research of famous ships over the centuries. She has meticulously reproduced these ships in this piece. "I wanted to design and make a Baltimore-style quilt that celebrated many of the great sailing ships throughout history," she said. "I loved researching the ships to use and matching the wreaths around them with the ship's native country." Among the splendid ships sailing on this counterpane are an eighteenth-century pirate ship and the *Elissa*, a three-masted barque—one of the famous "tall ships"—now docked in Galveston at the Texas Seaport Museum. The border is also an exceptional example of fine appliqué. This quilt has won a Best of Show award.

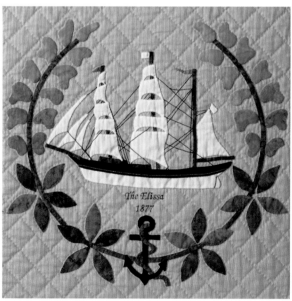

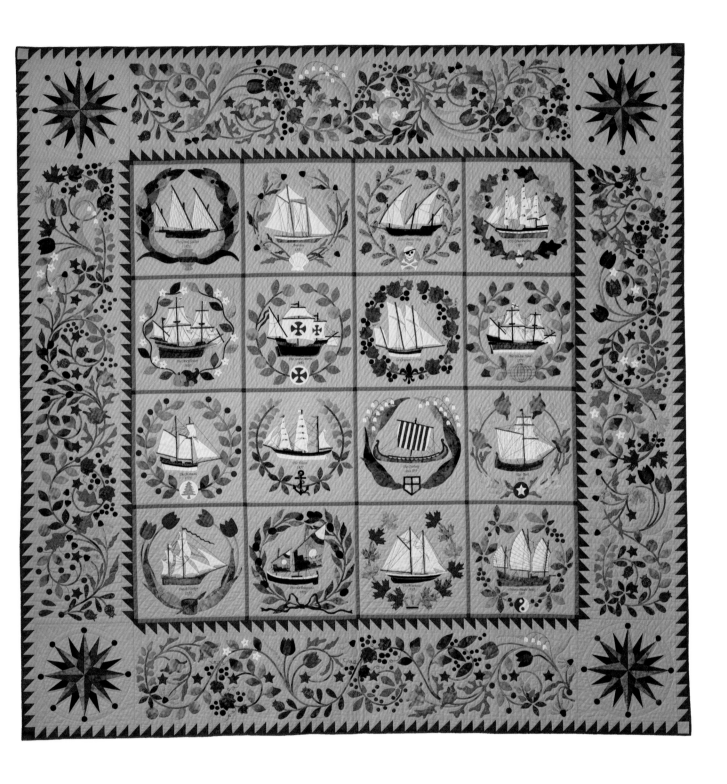

2008

SIZE IN INCHES: 41 x 18

TEXAS LOCATION: Houston

MADE BY: Connie Marie Fahrion

STYLE OF QUILT: Art

SOURCE OF DESIGN: Original design

MATERIALS USED: Thread trash on linen

PRIMARY TECHNIQUES: Free-motion appliqué, free-motion machine quilting

"We all leave behind, we all get left behind, and in between, we just try to stay connected." That old saying was Connie's inspiration for this spirited piece, with its thrifty and imaginative use of "thread trash." A neutral background of linen gave her the freedom to use any and all colors, including subtle colorations in the background itself. She free-motion quilted this piece from the back with rayon thread.

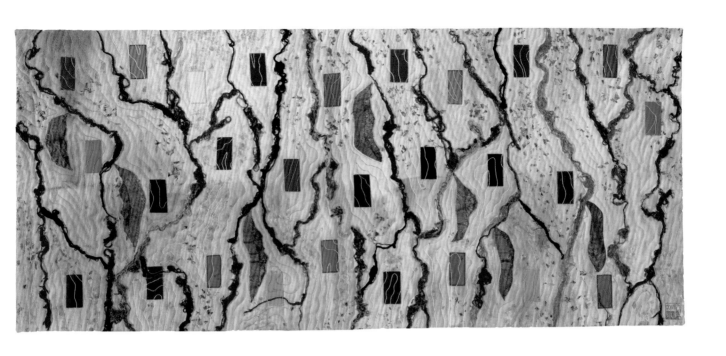

2008

SIZE IN INCHES: 41 X 34

TEXAS LOCATION: Comfort

MADE BY: Mary Ann
Hildebrand

STYLE OF QUILT: Art

SOURCE OF DESIGN: Original
design

MATERIALS USED: Cotton,
batiks

PRIMARY TECHNIQUES: Fused
appliqué, satin stitching,
machine quilting

A local art center's call for quilts based on other art forms resulted in Mary Ann's making this delightful quilt. It is based on a nine-teenth-century woodcut that first appeared in print in the late 1800s in a book on astronomy. Who among us has not at some time wished we had a way to raise the horizon like a curtain and slip into the glory of the star-filled sky? That dream becomes reality in this whimsical quilt, which has won a Best of Show award.

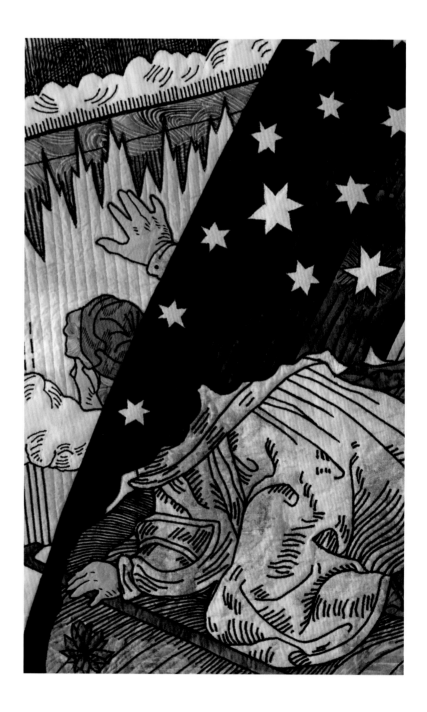

Reclamation: Retro

2008

SIZE IN INCHES: 66 × 82

TEXAS LOCATION: Flower
Mound

MADE BY: Barbara Oliver
Hartman

STYLE OF QUILT: Art

SOURCE OF DESIGN: Original
design

MATERIALS USED: Hand-dyed
and hand-painted cotton

PRIMARY TECHNIQUES:
Machine piecing, machine
quilting

Made from leftover fabrics reclaimed from previous projects, this quilt derives its dramatic visual quality from the color saturation of Barbara's hand-dyed and hand-painted textiles. Note how the center of the quilt appears to be mounted on an old brick wall, entirely created from fabric. The quilt artist was an early recipient of a grant from the International Quilt Association for artistic development.

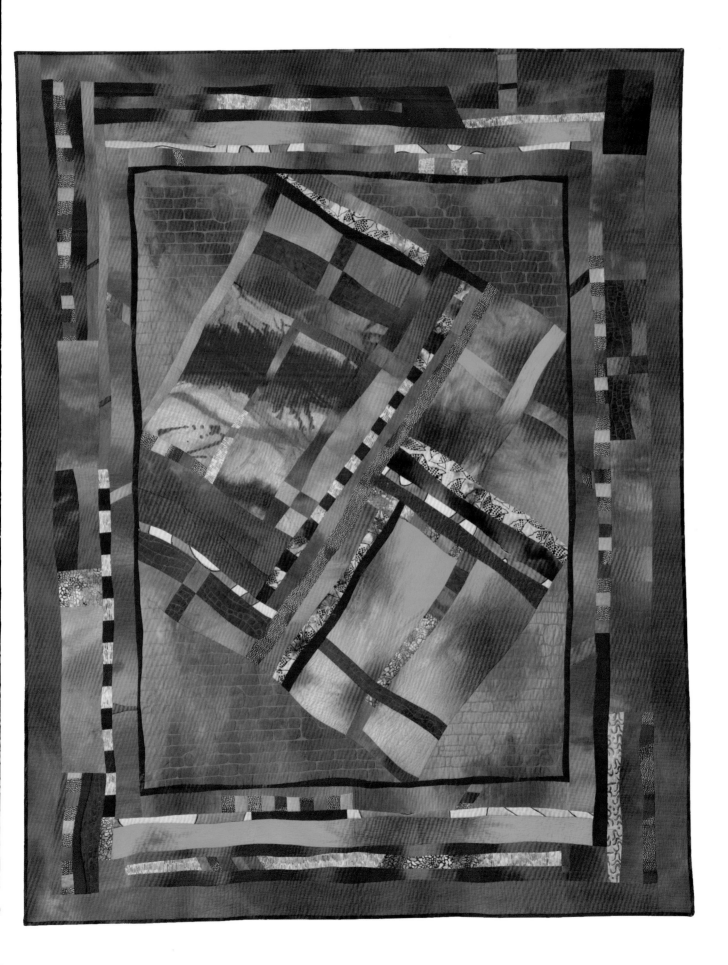

Tree Talk

2008

SIZE IN INCHES: 38 x 25

TEXAS LOCATION: Houston

MADE BY: Beth Porter Johnson

STYLE OF QUILT: Art

SOURCE OF DESIGN: Original
design

MATERIALS USED: Cotton

PRIMARY TECHNIQUES:
Machine piecing, machine
appliqué, machine quilting

The convoluted forms of branches and limbs against a wall of the National Gallery in Washington, D.C., served as the quiltmaker's inspiration for this art quilt. Beth has skillfully captured the stone surface of the building and the rough bark of the trees, and she has paid close attention to the many shades of green, blue, and yellow that create the realistic leaves.

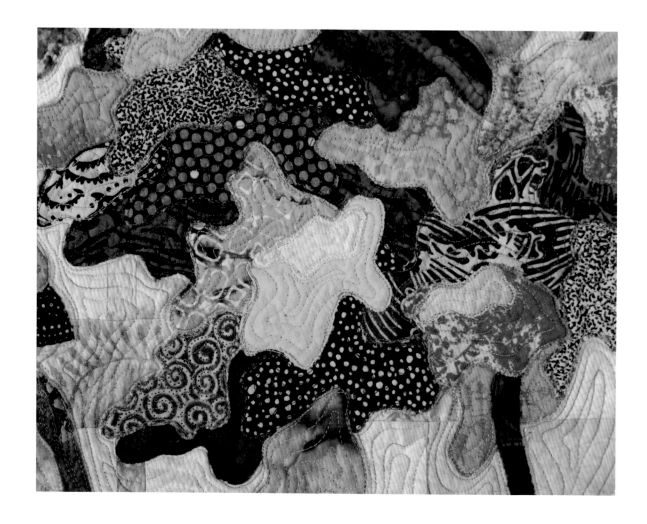

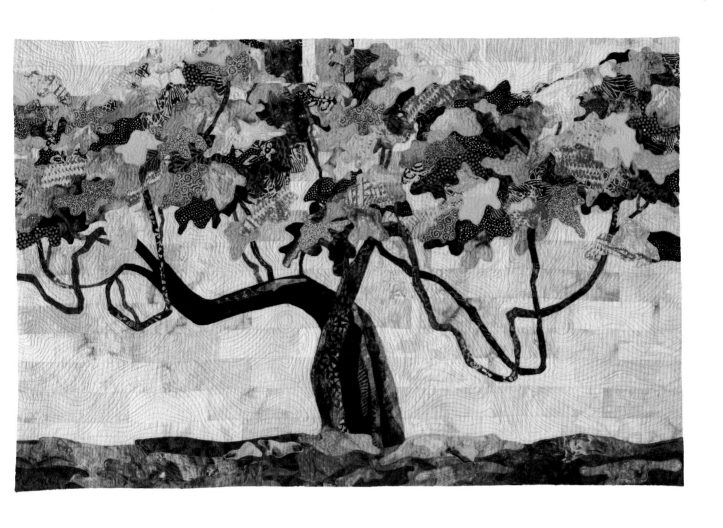

Exiting Eden with Eve Firing Up the Pickup

SIZE IN INCHES: 42 X 53

TEXAS LOCATION: Lubbock and Austin

MADE BY: Ellie Rude Kreneck

STYLE OF QUILT: Art

SOURCE OF DESIGN: Original design

MATERIALS USED: Cotton

PRIMARY TECHNIQUES: Hand painting with dyes, machine piecing, hand appliqué, hand quilting

The immense skies and raw, rugged landscapes of West Texas have influenced this quilt artist, who says that they "invoke a mystical response in me." In her imagination, the region is populated with saints and Biblical figures who have adapted to the vast distances by driving pickup trucks. Ellie says that in this narrative art quilt, the Angel, having interrupted Adam and Eve at tea, is telling a distraught Adam "that he is so out of there. The more pragmatic Eve is already in the pickup and ready to leave."

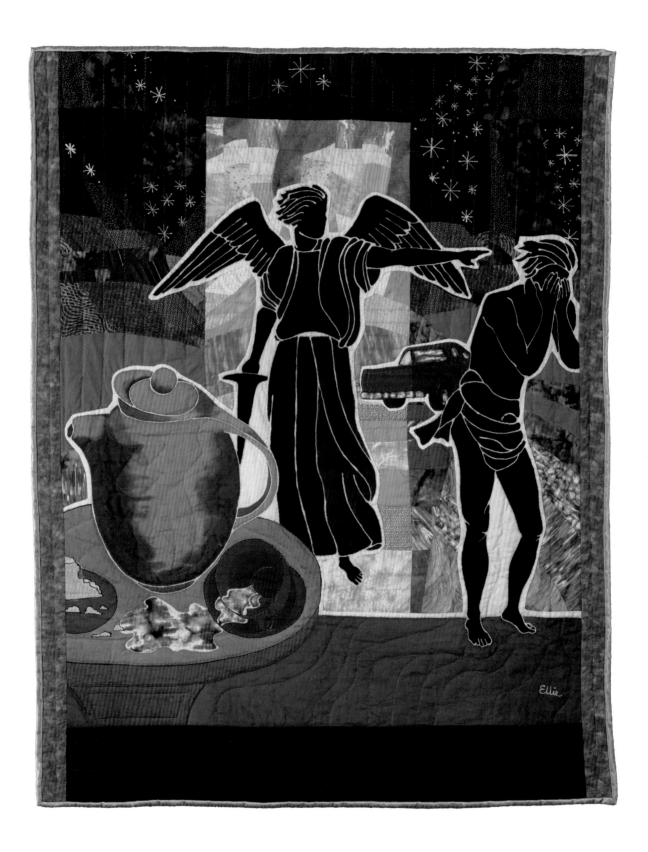

Circle the Date

SIZE IN INCHES: 39 X 39

TEXAS LOCATION: Houston

MADE BY: Libby Lehman

STYLE OF QUILT: Art

SOURCE OF DESIGN: Original
design

MATERIALS USED: Cotton

PRIMARY TECHNIQUES:
Machine embroidery and
appliqué, machine quilting

This impressive art quilt resulted from an amusing lapse of
memory on the quilt artist's part. Libby's story: "When my father
died, a friend told me that I would probably do dumb stuff for
a while. As a true firstborn, I thanked her but knew it wouldn't
apply to me (we firstborns are perfect, of course). Several months
later I went to the airport for a trip I do every year. The confer-
ence books the travel, but the itinerary is always the same. When
I tried to check in, the skycap told me there was a problem. Turns
out, I was at the airport on the right day, but I was a week early. I
schlepped my bags down to baggage claim, got on the same park-
ing shuttle, and went home. With an unplanned free week, I
immediately went to the studio and made this quilt. The title is
in memory of my memory lapse!" The quiltmaker also had work
included in *Lone Stars II: A Legacy of Texas Quilts, 1936–1986*.

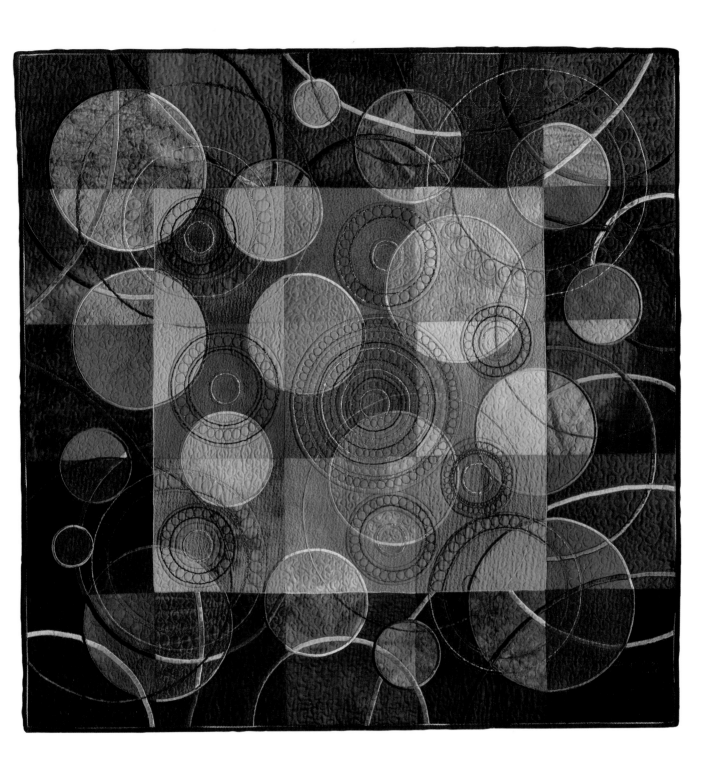

Oh My Gosh!

SIZE IN INCHES: 70 X 88

TEXAS LOCATION: Spring

MADE BY: Diane Tenney

QUILTED BY: Bonnie Portera

STYLE OF QUILT: Traditional

SOURCE OF DESIGN: Pattern

MATERIALS USED: Cotton

PRIMARY TECHNIQUES:
 Machine piecing and
 quilting

Everyone who sees this award-winning quilt exclaims, "Oh my gosh!," so it is obviously well-named. Diane, a member of the Patchwork Divas who specialize in reproducing nineteenth-century quilts, spent about two years completing this quilt between other projects. It took so long because of "its never-ending strip piecing and the pinning of all those seams," she says, explaining that she was determined to finish the quilt in time to move into her new house where she had a wall with an art light to showcase this quilt. The quilt has won Best of Show and other awards.

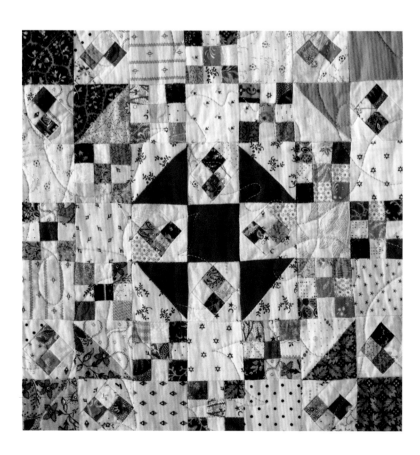

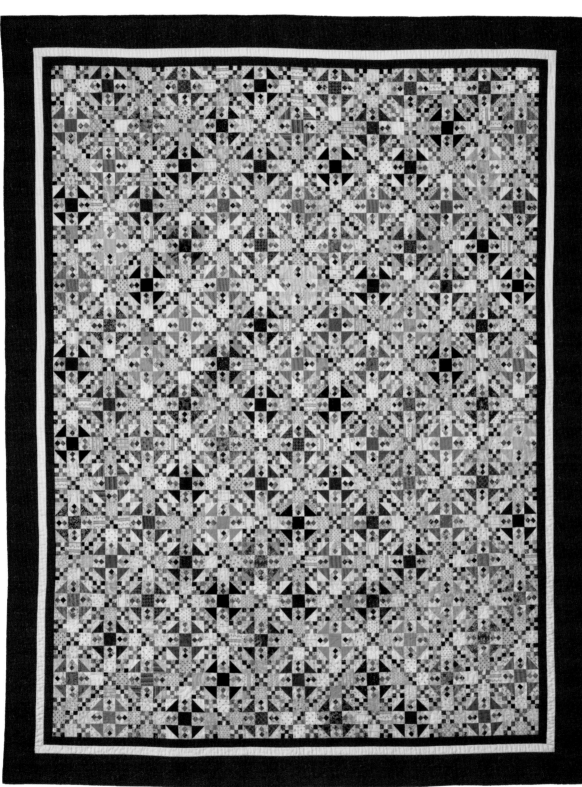

Triple Four Patch

SIZE IN INCHES: 64 x 80

TEXAS LOCATION: Irving

MADE BY: Marilyn Ward Mowry

QUILTED BY: Sheri Mecom

STYLE OF QUILT: Traditional

SOURCE OF DESIGN: Four Patch
pattern

MATERIALS USED: Cotton

PRIMARY TECHNIQUES:
Machine piecing and
quilting

A member of the Nineteenth Century Patchwork Divas block exchange group that recreates quilts from the 1800s using reproduction fabrics, this quilt artist has been involved in twenty-nine exchanges. She particularly liked this one because there were no limitations as to time period or colors, as there were with many of the other exchanges. "I have tried many other crafts, but I have come home with quilting," Marilyn says. "I have made 320 quilts and most of them still live with me. I am also a first-generation quilter who taught her mother to quilt!"

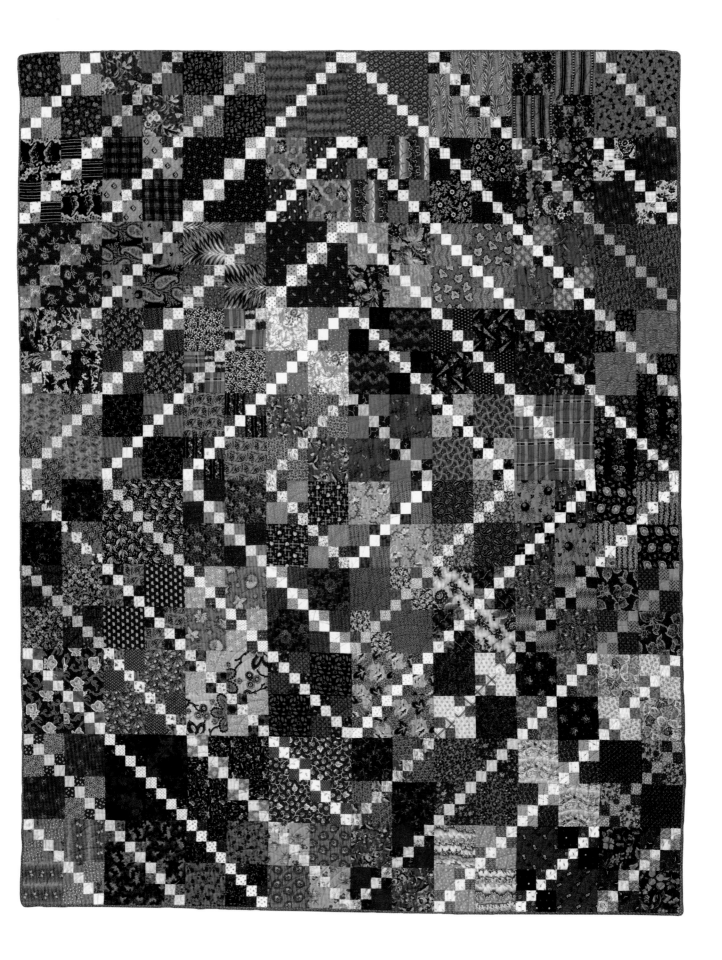

Just Sing . . . Sing a Song

2008

SIZE IN INCHES: 63 × 33

TEXAS LOCATION: Katy

MADE BY: Tom Russell

STYLE OF QUILT: Art

SOURCE OF DESIGN: Original design

MATERIALS USED: Cotton

PRIMARY TECHNIQUES: Hand appliqué, machine piecing, embellishing, machine quilting

An ode to embellishment, this cheerful, cheeky, charming quilt with its chubby birds perched on long skinny legs demands a smile from the viewer. It is an exuberant piece that features embroidery, couching, beading, and the use of ribbons, buttons, and sequins. Tom let his imagination run wild in creating this amusing design with its extravagantly looped branches and fantasy flowers, not to mention the birds that have no equal in real life! The award-winning quilt is the result of a challenge that involved forty-nine quilters contributing fabric that had to be used for the entries. "The challenge encouraged participants to stretch their creativity and learn to work with what they are given," says the artist.

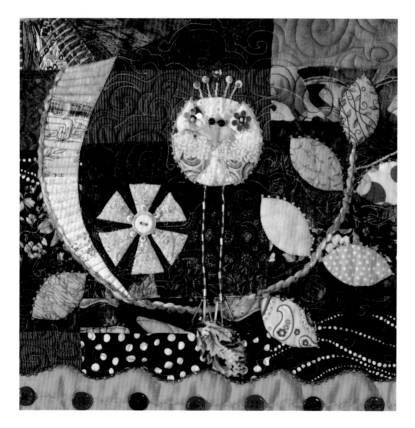

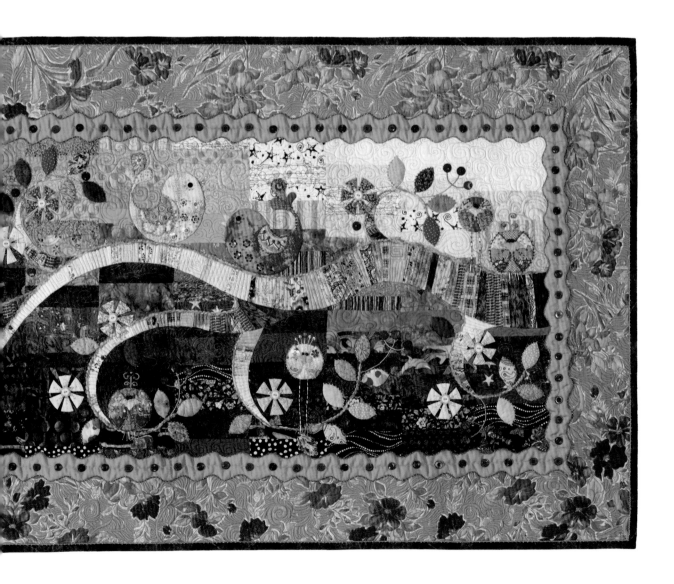

Cubist's Edge

2009

SIZE IN INCHES: 36 × 48

TEXAS LOCATION: Austin

MADE BY: Frances Holliday Alford

STYLE OF QUILT: Art

SOURCE OF DESIGN: Original design

MATERIALS USED: Cotton

PRIMARY TECHNIQUES: Raw-edge appliqué, satin stitching, photo transfer, needle felting, hand and machine quilting

The vase of flowers is an icon in art, appearing over and over throughout the centuries. Here, drawing on her own imagination, Frances took the iconic image and cut it into four squares. When reassembled, the edges met in new positions to create a new image. Each of the twelve original squares used a different technique: embellishing, machine felting, satin stitching with variegated thread, overlays, photo transfer, hand stitching, and painting.

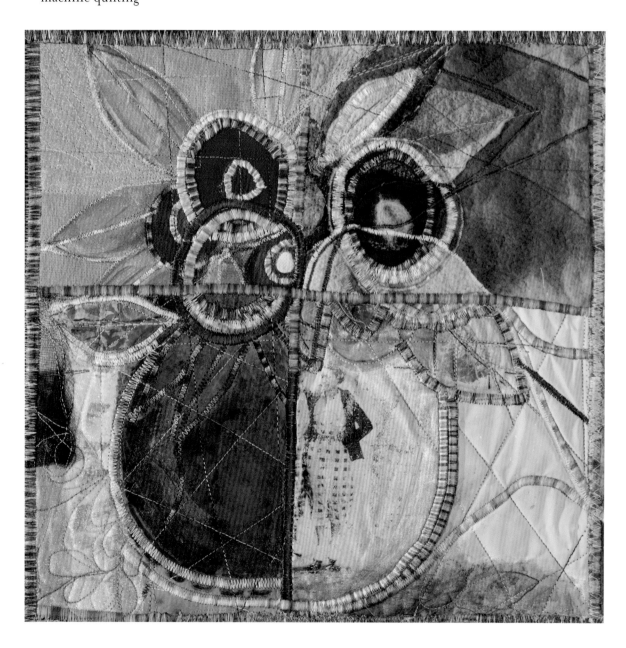

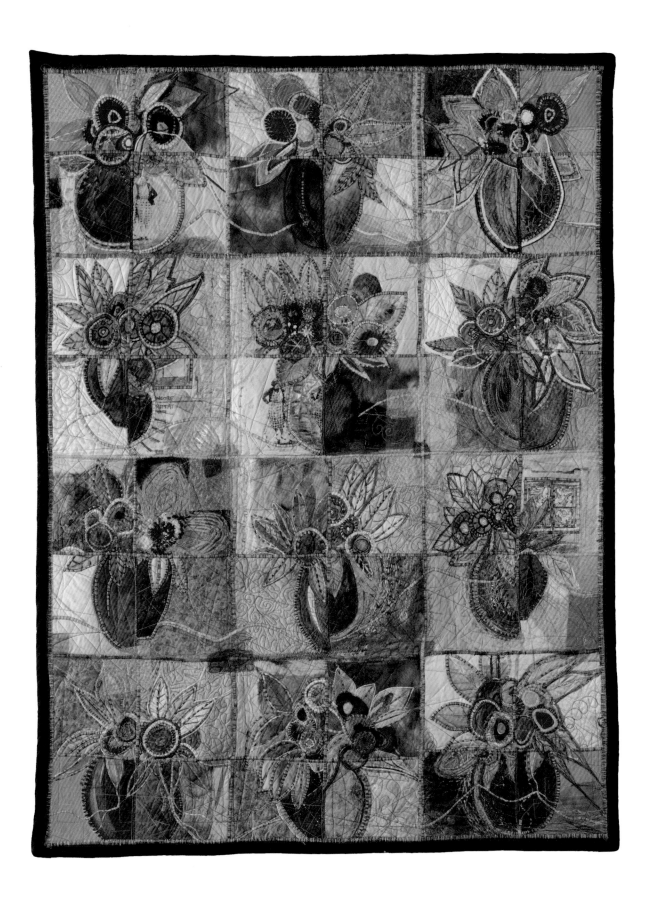

Group Conversations

SIZE IN INCHES: 63 x 40

TEXAS LOCATION: Austin

MADE BY: Austin Art Quilt
Group

GROUP MEMBERS: Frances
Holliday Alford, Jean
Dahlgren, Barb Forrister,
Pearl Gonzalez, Connie
Hudson, Leslie Tucker
Jenison, Sheri Lipman
McCauley, Diane Sandlin,
Kathy York

STYLE OF QUILT: Art

SOURCE OF DESIGN: Original
design

MATERIALS USED: Hand-
dyed, screen-printed, and
commercial fabrics; batiks

PRIMARY TECHNIQUES:
Machine piecing, fusing,
embellishing, satin stitching,
machine quilting

A creation of the prolific Austin Art Quilt Group, this quilt
depends on the repeated earth-tone colors, accented with red
and turquoise, to unify the varying styles of each quilt artist.
The blocks are all multiples of 4", and each block was made and
quilted before being joined together with satin stitching. Embel-
lishment is one of the group's favorite techniques, and here but-
tons, in particular, are used to great advantage. Repetitive geo-
metric shapes such as circles, triangles, and squares also unify
this piece.

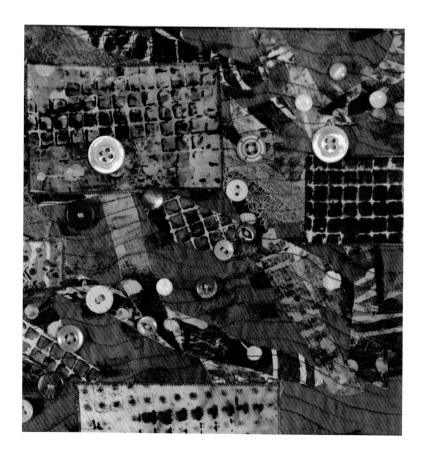

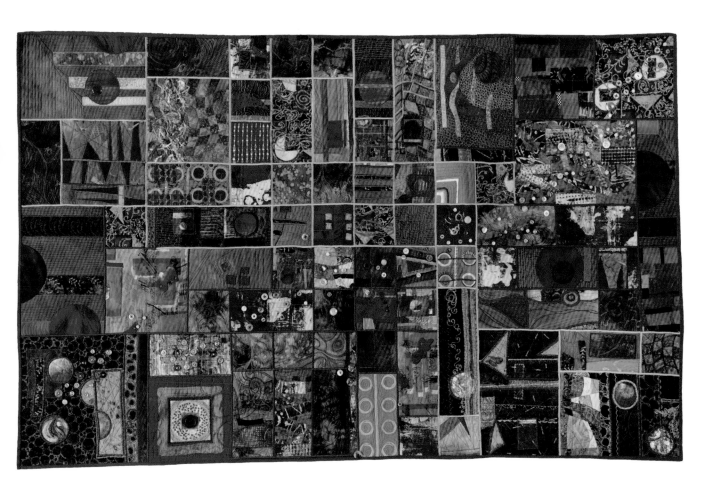

Wyoming Prairie Winters

SIZE IN INCHES: 83 x 89

TEXAS LOCATION: The Woodlands

MADE BY: Venetta Morger

STYLE OF QUILT: Traditional

SOURCE OF DESIGN: Feathered Star pattern

MATERIALS USED: Cotton

PRIMARY TECHNIQUES: Machine piecing with hand-drawn templates, machine quilting

If you're fighting winter cold and snow on a Wyoming prairie, the beautiful spring colors of this quilt would be a dream come true. Venetta based this quilt that sings of spring on a workshop she took eighteen years earlier. She quilted it on her home sewing machine, and the excellence of the quilting is an integral part of the appeal of this award-winning quilt.

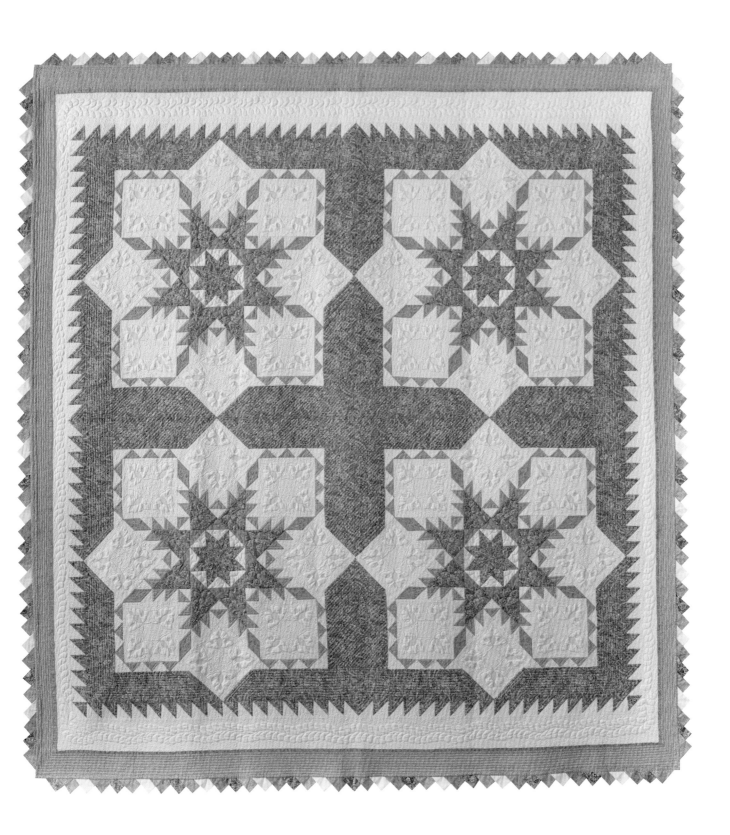

Texas Hay Rake

2009

SIZE IN INCHES: 94 X 94

TEXAS LOCATION: Grapeland

MADE BY: Michele Barnes

STYLE OF QUILT: Traditional

SOURCE OF DESIGN: Flowers
and grapes in a Sawtooth
Wheel as seen in a book

MATERIALS USED: Cotton

PRIMARY TECHNIQUES: Pattern
drafting, appliqué, hand
quilting

Any Texan with a passing knowledge of farming or ranching can understand why Michele would look at this nineteenth-century quilt in the collection of the International Quilt Study Center in Nebraska and make the unlikely transition to an essential farm implement from the past. The modern version is often seen at work in East Texas today. The feeling of movement is almost overwhelming—the wheels are rolling, the tines are raking the hay into piles for baling. Even the color is reminiscent of the harvest season. Her quilting designs are also very unusual. The quilt has won a Best of Show award.

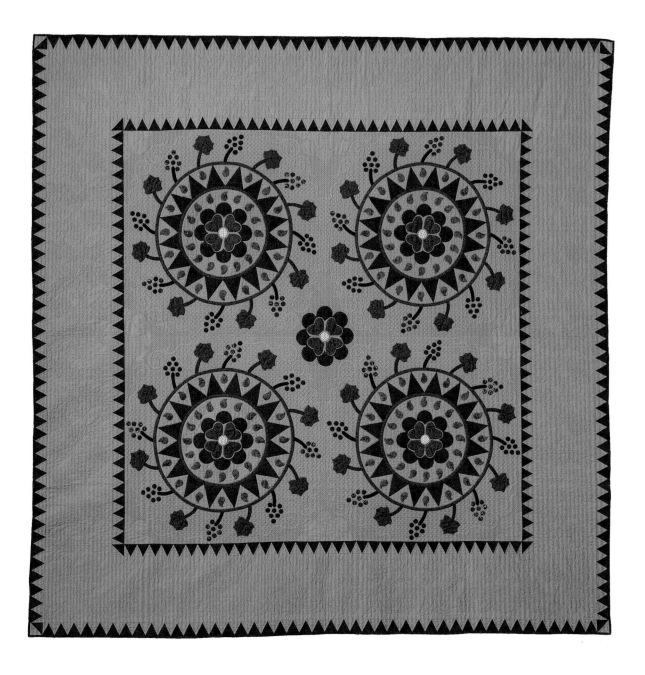

Borders All Around

2009

SIZE IN INCHES: 88 x 88

TEXAS LOCATION: Houston

MADE BY: Debbie Brown

STYLE OF QUILT: Traditional

SOURCE OF DESIGN: Design-as-
you-go class

MATERIALS USED: Cotton

PRIMARY TECHNIQUES: Piecing
and machine quilting

Curious Texas quilters seldom shy away from taking classes to expand their skills, and this quilt is the result of a class teaching formulas for quilt design and the importance of precision piecing. Debbie evidently learned her lessons well, because her stylish medallion quilt has won several Best of Show awards. The artist's beautiful feather quilting is an especially impressive accomplishment.

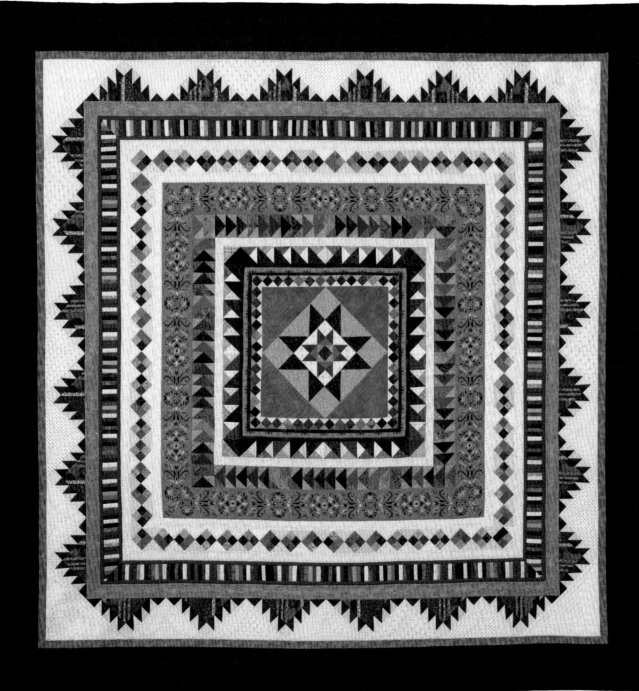

Hospital Rising

2009

SIZE IN INCHES: 41 X 41

TEXAS LOCATION: Kingwood

MADE BY: Ginny Eckley

STYLE OF QUILT: Art

SOURCE OF DESIGN: Original
design

MATERIALS USED: Silk

PRIMARY TECHNIQUES: Dyeing,
silk screening, painting,
free-motion embroidery,
machine quilting

What inspires artists is often a mystery to others. Who could look at a common construction scene and see an art quilt in the making? Ginny could, and then carried that inspiration forward to apply the surface design techniques such as dyeing and silk screening that create this image. Even the birds seem to demonstrate excitement and impatience as the massive hospital goes up floor by floor. This quilt has won awards and been accepted to prestigious art quilt venues.

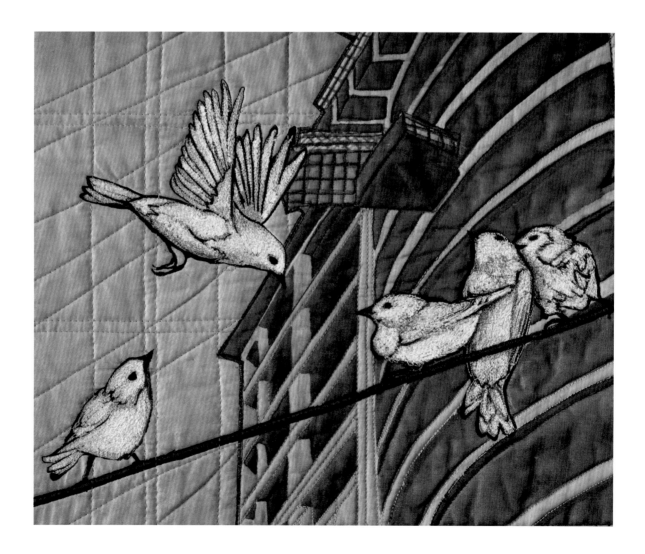

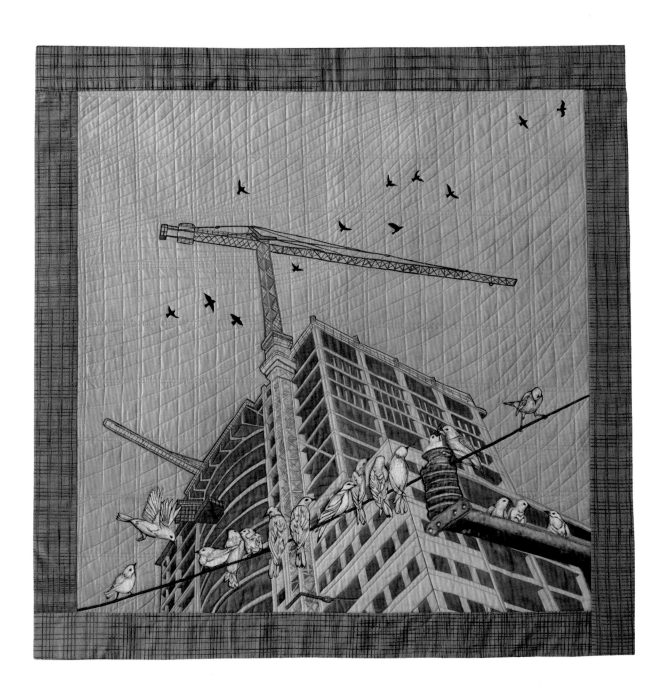

Chocolate & Cherries

2009

SIZE IN INCHES: 80 x 80

TEXAS LOCATION:
Friendswood/Pearland

MADE BY: Winnie Blair
Fleming and the Round
Robin group

GROUP MEMBERS: Marcia
Brenner, Melba Drennan,
Pamela Fernandez, Winnie
Fleming, Beverly French

QUILTED BY: Denise Green

STYLE OF QUILT: Traditional

SOURCE OF DESIGN: Borders
exchange

MATERIALS USED: Cotton

PRIMARY TECHNIQUES: Piecing
and appliqué, machine
quilting

Medallion quilts have always been popular with quiltmakers. They depend on successive rows of borders to create visual interest. This quilt's borders, the result of a Round Robin borders exchange, are unusual in their intricacy. Note the tiny stars inside the small blocks, the bargello-like curving border, the triangles inside triangles. To complete this piece, Winnie has used some of the recent reproduction "conversation prints" that originally date back to the late nineteenth century.

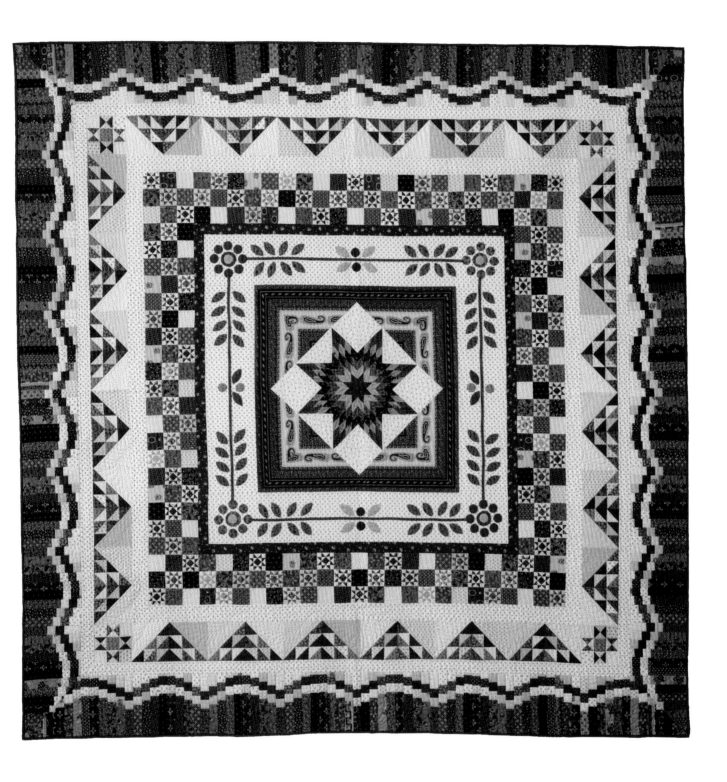

315

Life's a Beach

2009

SIZE IN INCHES: 30 x 26

TEXAS LOCATION: Austin

MADE BY: Barb Forrister

STYLE OF QUILT: Art

SOURCE OF DESIGN: Original design

MATERIALS USED: Cotton (some hand-dyed and painted)

PRIMARY TECHNIQUES: Painting, dyeing, heat distressing, machine piecing, appliqué, and quilting

This original art quilt is inspired by a photo of the quilt artist's youngest daughter with her father, taken at the age when she loved to have tea parties and pretend to talk on the phone. At a family outing on the beach, Barb caught her when she was distracted and started pouring water in her dad's lap, which was "a cold and unexpected surprise for him!"

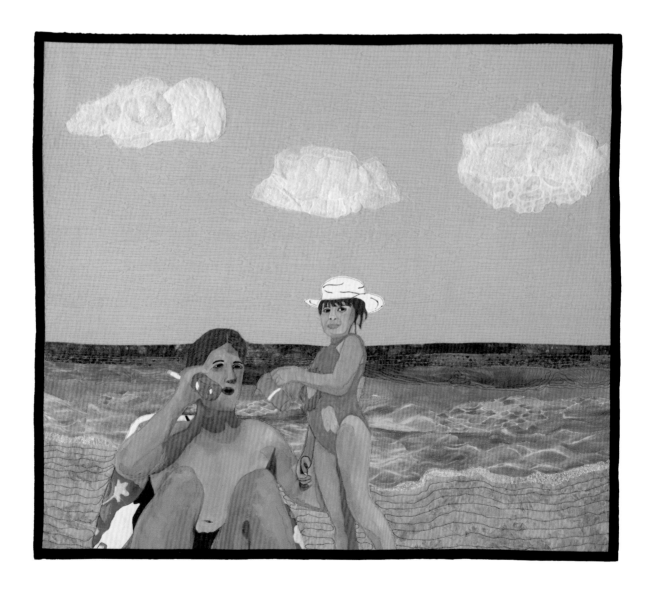

Among the Ancestors

SIZE IN INCHES: 31 X 28

TEXAS LOCATION: Garden Ridge

MADE BY: Caryl Gaubatz

STYLE OF QUILT: Art

SOURCE OF DESIGN: Original design

MATERIALS USED: Cotton, printed silk organza

PRIMARY TECHNIQUES: Hand painting with thickened dye, flour paste resist on background, degumming, overdyeing, appliqué, machine quilting

In this quilt, stoic horses rest against a background of ancient cave-dwellers' art. The pictographs could have come from many prehistoric sites, including the famous one in the Dordogne area of France. There, to protect the walls and their priceless paintings from damage caused by the breathing of the enormous number of visitors each year, a nearby cave was created with exact duplicates of the famous paintings, and the original cave placed off limits to visitors. The horses in Caryl's memorable quilt are based on a friend's photograph.

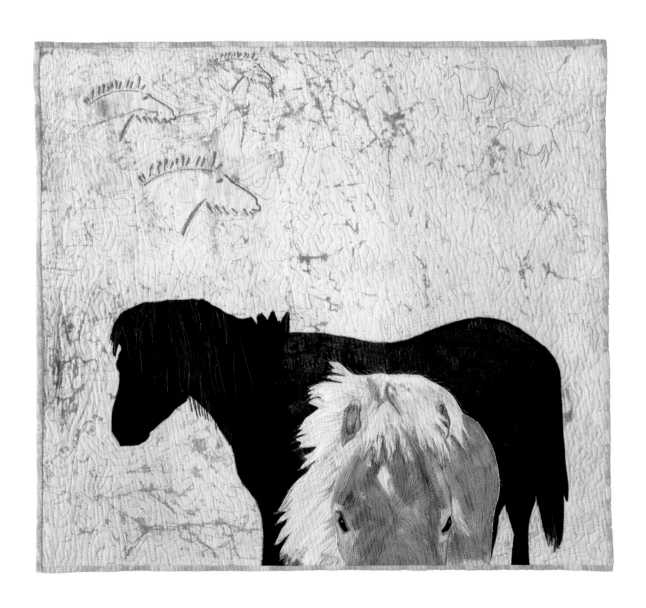

2009

SIZE IN INCHES: 48 × 48

TEXAS LOCATION: Benbrook

MADE BY: Susan Garay

STYLE OF QUILT: Traditional

SOURCE OF DESIGN: Log Cabin and Tumbling Blocks patterns

MATERIALS USED: Cotton, batiks

PRIMARY TECHNIQUES: Individually designed and hand-drafted paper piecing, machine quilting with a small amount of hand quilting

Based on a combination of the Log Cabin and Tumbling Blocks patterns, this quilt is an intriguing combination of traditional designs and art elements. The Tumbling Blocks pattern is often used to create optical illusions, as the artist has done here. The way Susan has created other designs within designs on the different surfaces of each block adds depth and motion to the quilt.

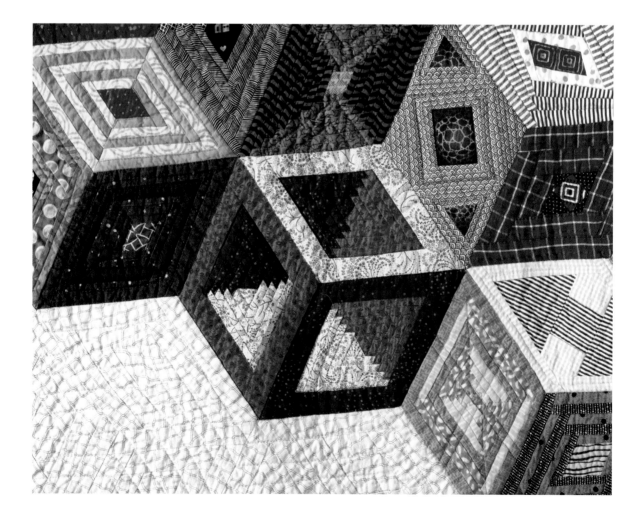

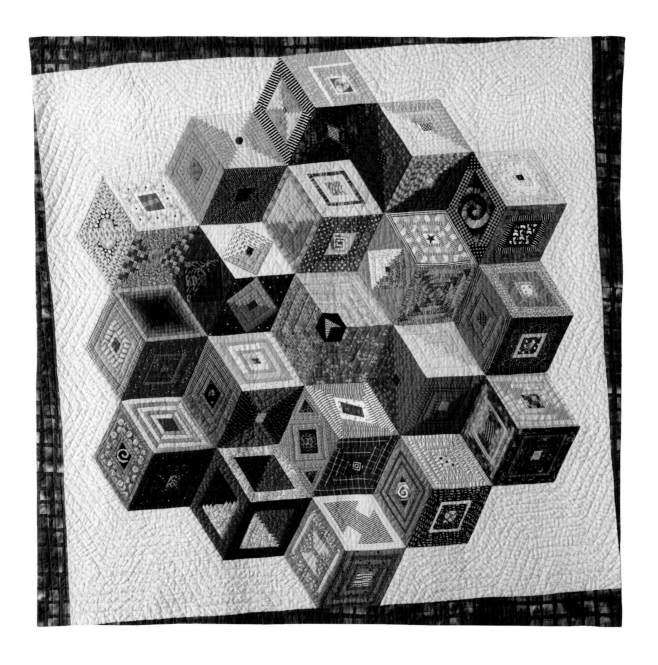

2009

SIZE IN INCHES: 29 X 41

TEXAS LOCATION: San Antonio and Austin

MADE BY: Leslie Tucker Jenison and Frances Holliday Alford

STYLE OF QUILT: Art

SOURCE OF DESIGN: Original design

MATERIALS USED: Cotton, silk, paper, stamps, foil

PRIMARY TECHNIQUES: Mixed-media postcards mailed repeatedly, machine appliqué and quilting

Two friends, both quilt artists, discovered that both of them wrote and mailed mixed-media postcards to themselves while traveling, and thus the idea for this imaginative cloth and paper art quilt was born. For over a year, Leslie and Frances created postcards from post-consumer ephemera, including postage stamps, foil, gold leaf, even recycled plastic "green" batting. Many of the layers were applied using gel medium to secure the collage elements, but sometimes nothing more than a postage stamp or sticker was used. The cards were mailed back and forth, allowing the postal service cancellations and the subsequent wear and tear to add to the developing patina the artists loved. As Frances explains, by requesting "hand cancel," they were usually able to avoid the postal service's rough machinery. "Frances and I were pretty happy when the cards got a little 'beat up,'" says Leslie. "It made it seem like the cards were on a little adventure of their own!"

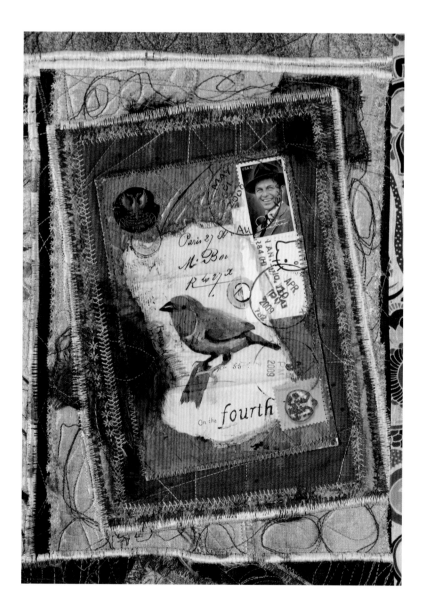

John Lennon—Requiem

2009

SIZE IN INCHES: 81 x 91

TEXAS LOCATION: Conroe

MADE BY: Bob Mosier

QUILTED BY: Mary Jane Plisga

STYLE OF QUILT: Art

SOURCE OF DESIGN: Original design

MATERIALS USED: Cotton

PRIMARY TECHNIQUES: Piecing and appliqué, machine quilting

FROM THE COLLECTION OF: Steve & Stacey Bourque

An artist's tribute to another artist—that's the basis for this quilt honoring a rock and roll legend. Bob is Artist in Residence at the John Cooper School, and when his students chose rock and roll for their annual gala, they asked if he could use T-shirts to make a raffle quilt. He used the T-shirts for the border and the back of this piece and appliquéd the facial features, glasses, and hair. The quilt brought in $20,000 for the school. According to Bob, "My first quilts were actually kites. In a small kite club, all of us created duplicates of traditional quilt patterns in ripstop nylon. My largest piece was a Tumbling Blocks pattern that was 58' long and had over 7000 pieces. Because we had all used quilt patterns, and because quilts are recognized as the only art to originate in North America, we were invited to China as the U.S. delegation to a World Invitational Kite Festival." Bob also says he's never met an art media he didn't like, but now he is fascinated by exploring the use of fabrics and is encouraging his students to do the same.

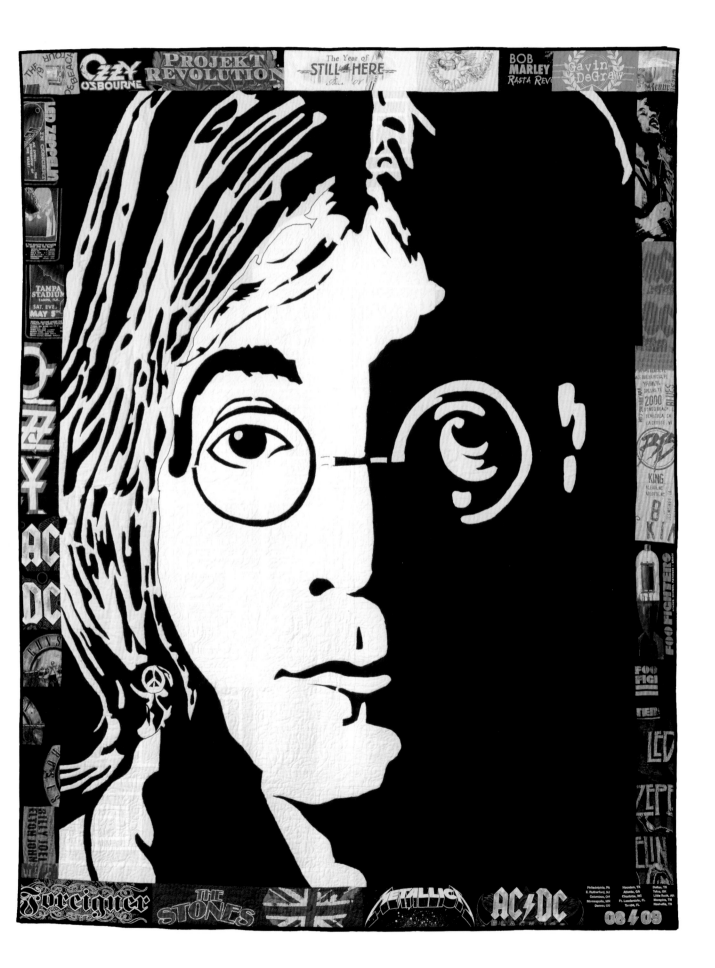

323

Broken Star

2009

SIZE IN INCHES: 70 X 70

TEXAS LOCATION: Brenham

MADE BY: Cynthia Kay Henneke

STYLE OF QUILT: Art

SOURCE OF DESIGN: Original design

MATERIALS USED: Cotton

PRIMARY TECHNIQUES: Fussy cutting, machine quilting

The design for this award-winning quilt began as a way to surround a Feathered Star block. Each block had twenty pieces, and the symmetrical mirror image required templates and fussy cutting of the 480 pieces. After months of work, the concept was finished . . . but the Feathered Star had disappeared from the final quilt! A sixth-generation quilter, Cindy was originally inspired by her childhood love of kaleidoscopes with their changing colors and patterns.

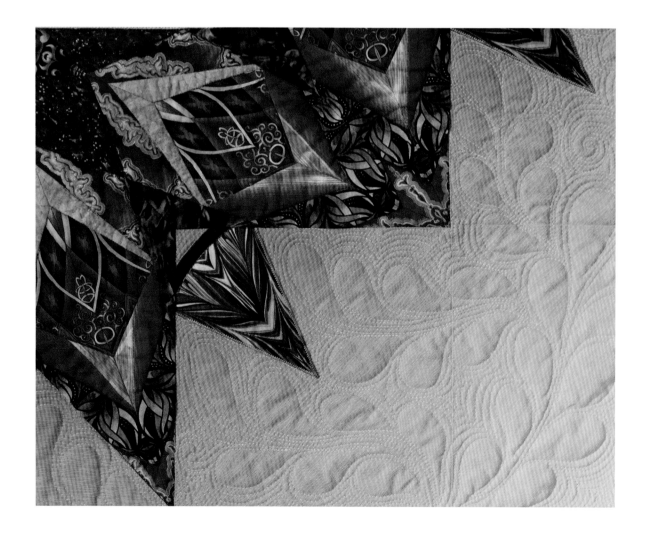

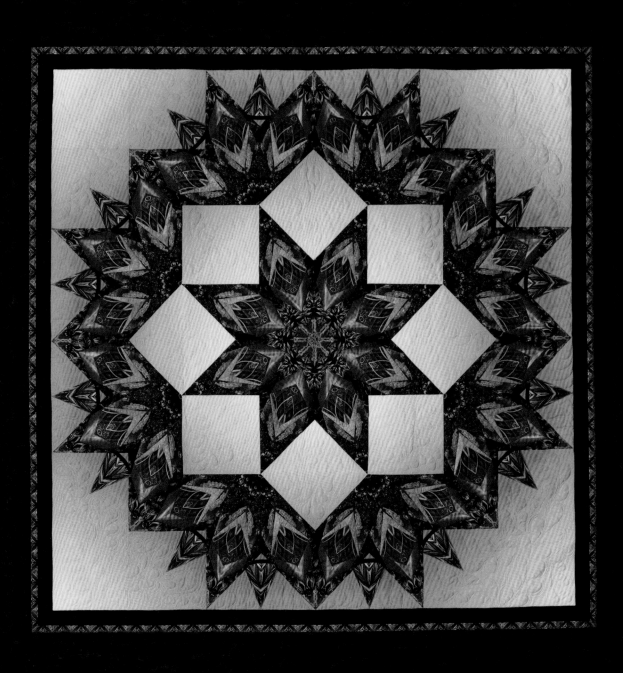

Tribute to Jane

2009

SIZE IN INCHES: 82 x 82

TEXAS LOCATION: Houston

MADE BY: Patricia T. Mayer

QUILTED BY: Karen Watts

STYLE OF QUILT: Traditional

SOURCE OF DESIGN: Book

MATERIALS USED: Cotton

PRIMARY TECHNIQUES:
Machine and hand piecing,
reverse appliqué, hand
appliqué, trapunto, machine
quilting

The "Dear Jane" quilts created a phenomenon all their own with the publication of the book which provided drawings for the many small pieced and appliquéd blocks in Jane Stickle's famous quilt, c. 1863. Since the book did not provide directions, Patricia spent nine months finding a way to make each little block with the most suitable fabric and technique. She recreated the 169 blocks out of Civil War reproduction fabrics for authenticity. She then chose to execute the distinctive border, usually seen as pieced tree designs, in all whitework with trapunto, a very unusual technique that is most effective in this award-winning quilt.

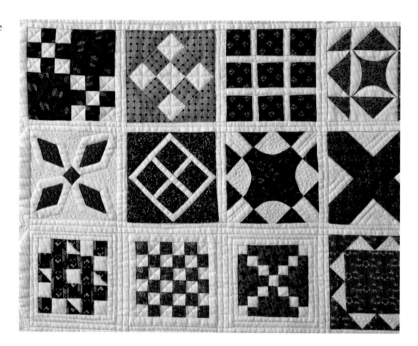

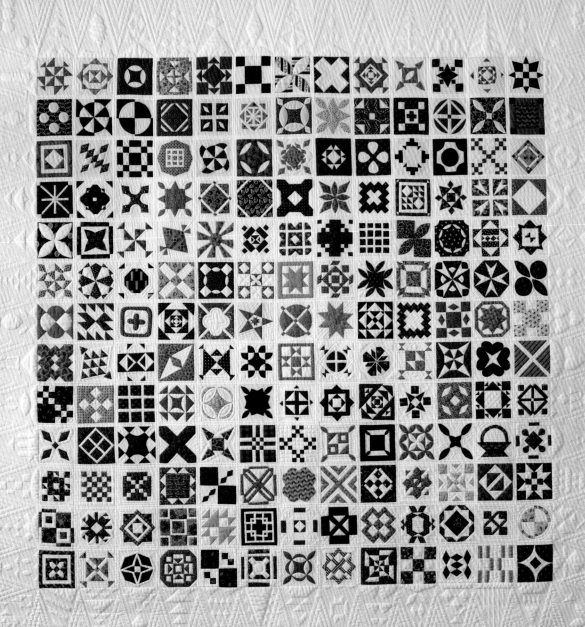

327

Breakfast in the Garden (Flowers of the Field Series)

2009

SIZE IN INCHES: 18 x 31

TEXAS LOCATION: Lufkin

MADE BY: Jeanelle McCall

STYLE OF QUILT: Art

SOURCE OF DESIGN: Original design

MATERIALS USED: Cotton and linen

PRIMARY TECHNIQUES: Thread painting, hand embroidery, needle felting, combination of hand and machine quilting

Jeanelle, a commercial artist, has the distinction of being one of the only two quiltmakers in this book who have been selected as a Texas Original Artist by the Texas Commission on the Arts. She drew upon the imagery of the birds and flowers in her own garden, where sunflowers and zinnias create cover for hidden conversations. In this award-winning quilt, her thread painting is exceptional, especially in the way she conveys the innocent determination of the birds.

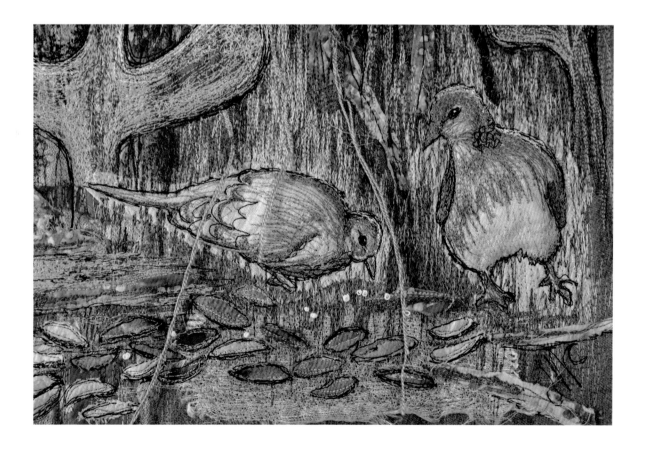

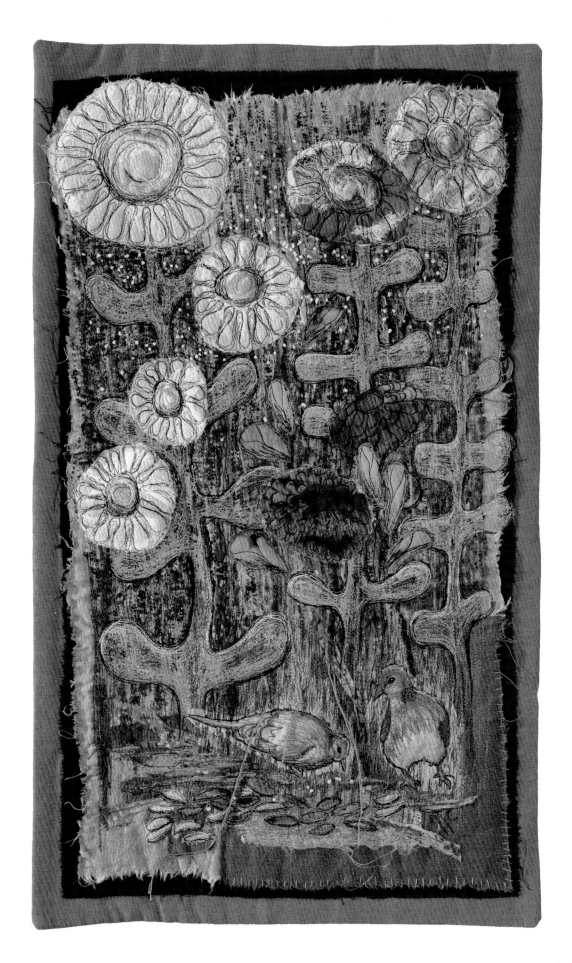

Iguana

2009

SIZE IN INCHES: 54 X 42

TEXAS LOCATION: Double Oak

MADE BY: Carol Morrissey

STYLE OF QUILT: Art

SOURCE OF DESIGN: Original design

MATERIALS USED: Cotton

PRIMARY TECHNIQUES: Painting on wholecloth, inking, machine quilting

FROM THE COLLECTION OF: Jill Glanville

"A colorful iguana seemed happy to pose for me while I took his photograph. He was very still except for a blink of his eyes when the camera would click. I couldn't wait to finish painting him because I was anxious to begin painting his scales, but once I started quilting them, they seemed to multiply!" Carol recalls. This wholecloth quilt was achieved with ink and paint and was longarm quilted at a sit-down machine. The iguana was created with ink, and the background was painted. A close look at the scales and you will understand why the artist felt they were multiplying! Carol, a fifth-generation quilter, won a major award with this piece.

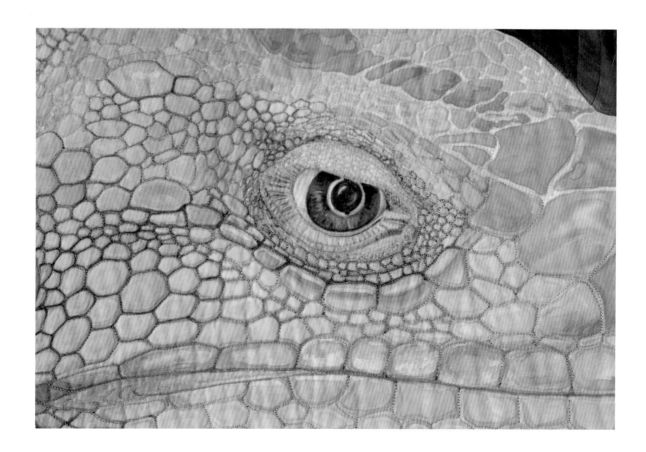

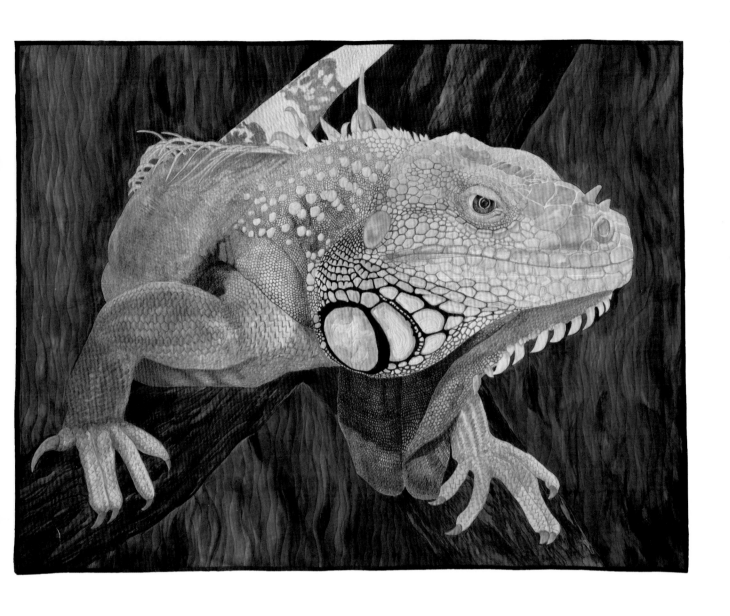

Starry Night

2009

SIZE IN INCHES: 50 X 62

TEXAS LOCATION: Sherman

MADE BY: Shirley Fowlkes Stevenson

STYLE OF QUILT: Art

SOURCE OF DESIGN: Original design

MATERIALS USED: Cotton, batiks

PRIMARY TECHNIQUES: Paper piecing, machine and hand piecing, hand appliqué, machine quilting

Twelve different Mariner's Compass blocks are presented to stunning effect in this award-winning quilt, which is a combination of machine paper piecing and hand appliqué. The brilliant jewel-tone colors transform this piece, and when used with so much black, they create a vision of the night sky. Shirley was inspired by "happy memories of spreading quilts on the lawn on cool summer nights, gazing at the stars with my sisters, and asking our parents questions about the stars they couldn't answer!" Earlier work by this artist was included in *Lone Stars II: A Legacy of Texas Quilts, 1936–1986*.

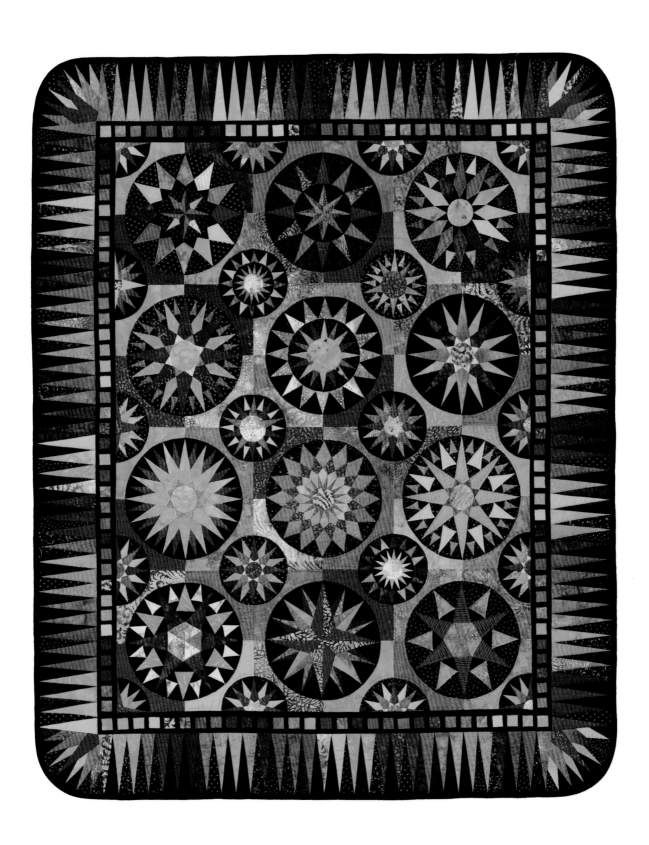

Starr Light

2009

SIZE IN INCHES: 84 × 84

TEXAS LOCATION: Conroe

MADE BY: Patti Nethery-Starr

QUILTED BY: JoAnn Wood

STYLE OF QUILT: Traditional

SOURCE OF DESIGN: Pattern

MATERIALS USED: Cotton, batiks

PRIMARY TECHNIQUES: Paper piecing, machine piecing, machine quilting

Based on a pattern called Prairie Flower or Hawaiian Star, this quilt was paper pieced by machine and then custom quilted on a longarm machine to enhance the design. The quiltmaker's mastery of precision piecing is evident from the many sharp points featured in this quilt, and her color sense is excellent. Patti's quilt has won Best of Show.

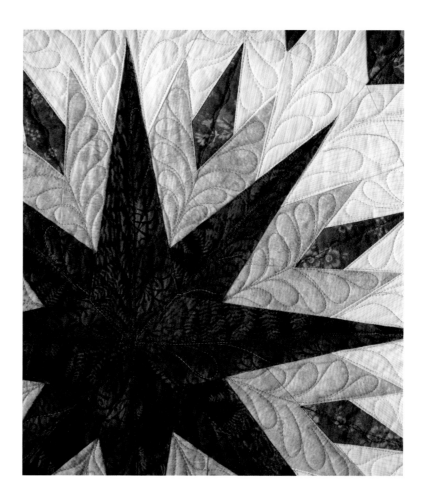

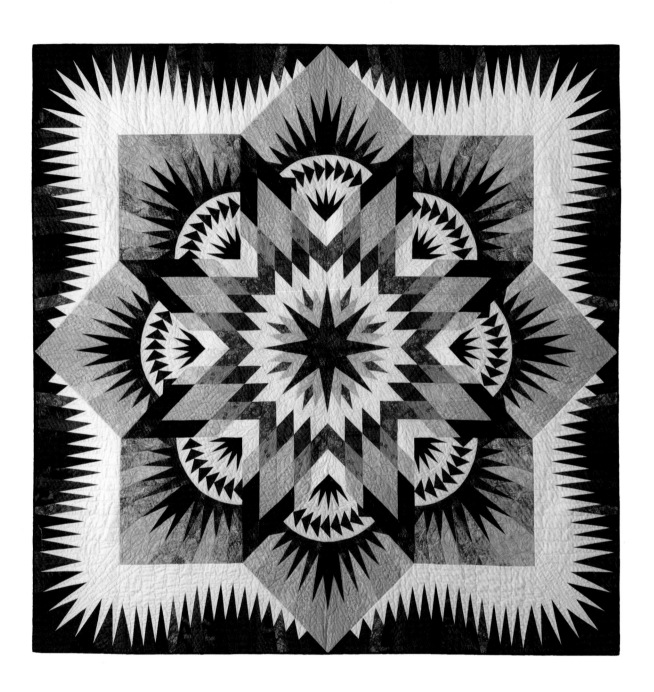

Oh, For Henna's Sake

2009

SIZE IN INCHES: 74 X 74

TEXAS LOCATION: Hallettsville

MADE BY: Michelle Reasoner

STYLE OF QUILT: Traditional

SOURCE OF DESIGN: Original design

MATERIALS USED: Cotton, Swarovski crystals

PRIMARY TECHNIQUES: Machine piecing, embellishing, machine quilting

"Henna is an ancient form of temporary body art that dates back as far as 5,000 years. This quilt depicts motifs from North Africa, the Middle East, and India. It includes stylized feathers and peacocks, which are often used as a symbol of love," says the quilt artist. She explains that henna art is usually intricate with tightly spaced designs, which she depicted with Swarovski crystals in place of the dots so often used. The award-winning quilt, based on the Drunkard's Path pattern, started with a Christmas scrap bag of small pieces of hand-painted batiks from Malaysia. Michelle used twenty-six vivid threads in quilting and machine stitched circles smaller than a pencil's eraser.

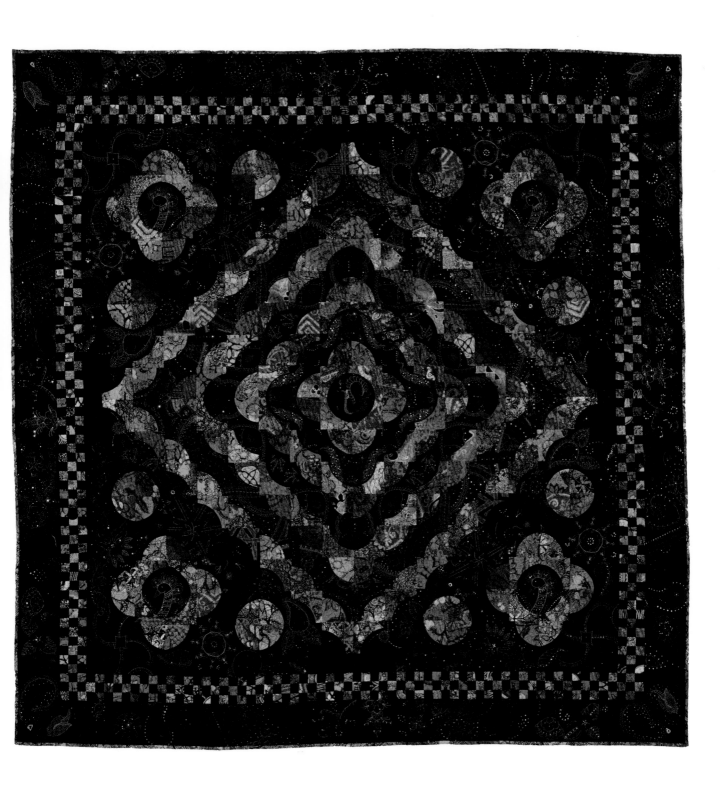

Buttercream

2009

SIZE IN INCHES: 63 x 83

TEXAS LOCATION: Houston

MADE BY: Minay Sirois

STYLE OF QUILT: Traditional

SOURCE OF DESIGN: Welsh and
 Amish designs

MATERIALS USED: Cotton

PRIMARY TECHNIQUES:
 Machine piecing, hand
 embroidery on back, hand
 quilting

Harking back to the ancient Welsh "strippy" quilts, where wide strips of solid fabric are joined to create a place to show off fine hand quilting, this piece is a tribute to the beauty that excellent hand stitching can add to simple designs. The quilted vining feather, cable, and floral are the only design elements in this piece, but Minay has executed the stitching so masterfully on the soft color palette of cream, butter yellow, and corn yellow that nothing else is needed. (For the sake of future quilt researchers, let the record reflect that Minay was originally named Debra!)

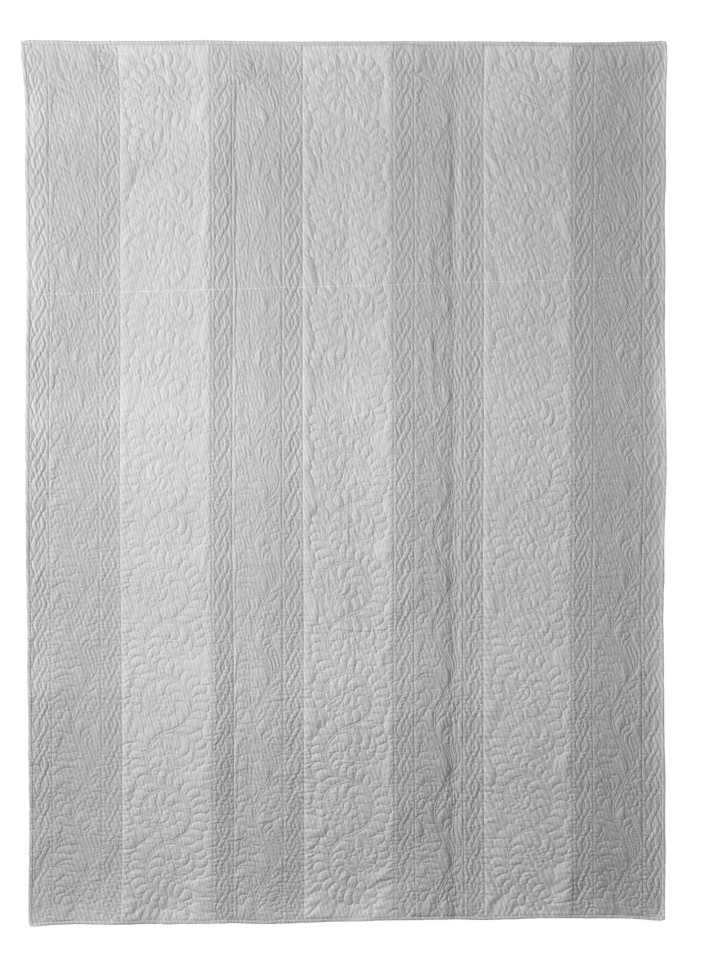

339

Headwaters

2009

SIZE IN INCHES: 56 × 57

TEXAS LOCATION: Tottsboro

MADE BY: Gay Young Ousley

STYLE OF QUILT: Art

SOURCE OF DESIGN: Original
design

MATERIALS USED: Hand-dyed
cotton

PRIMARY TECHNIQUES: Dyeing,
machine appliqué, machine
quilting

"Beginnings intrigue me," says the quilt artist. "This quilt was inspired by the headwaters of the Rio Grande near Creed, Colorado. Our mighty river begins as trickles of snowmelt high in the Rockies!" Gay's art quilt makes good use of dyed fabrics, particularly in the sky, which is a single piece of hand-dyed fabric. However, instead of being painted, as so many landscape quilts are today, she has used appliqué to create this tranquil mountainous scene. The only painting appears in the sky.

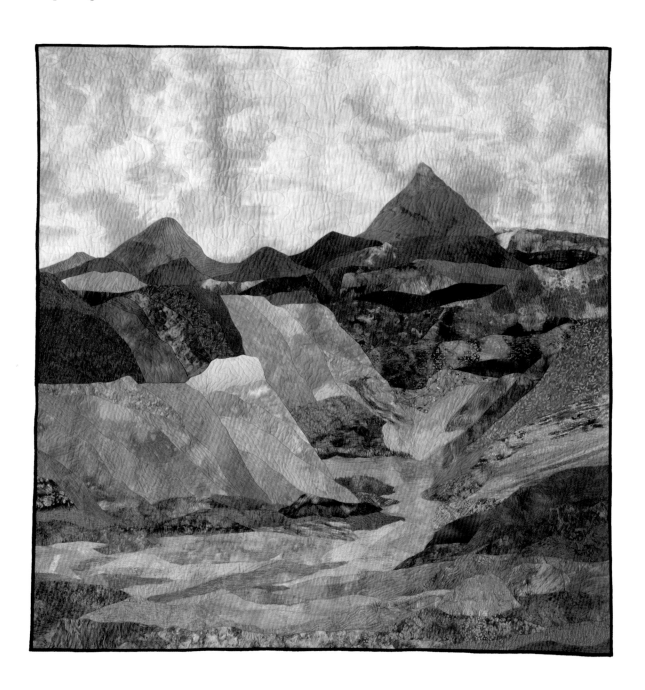

Clam Session

SIZE IN INCHES: 61 x 61

TEXAS LOCATION: Beaumont

MADE BY: Karen Stone

STYLE OF QUILT: Art

SOURCE OF DESIGN: Original improvisational design

MATERIALS USED: Cotton, silk

PRIMARY TECHNIQUES: Hand and machine appliqué, machine piecing with some paper piecing, machine quilting

According to the artist, this quilt "is a decorative one-patch quilt, in that the block shape is a traditional Clamshell, with the content therein mere ornamentation. As in traditional jazz, improvisation flourishes within a familiar structure." Karen often takes a familiar pattern and with unusual color choices, deliberate skewing of the set, and surface manipulation, transforms the familiar into something new and exotic. Her quilts frequently win awards, and one received the prestigious People's Choice award in Quilt National.

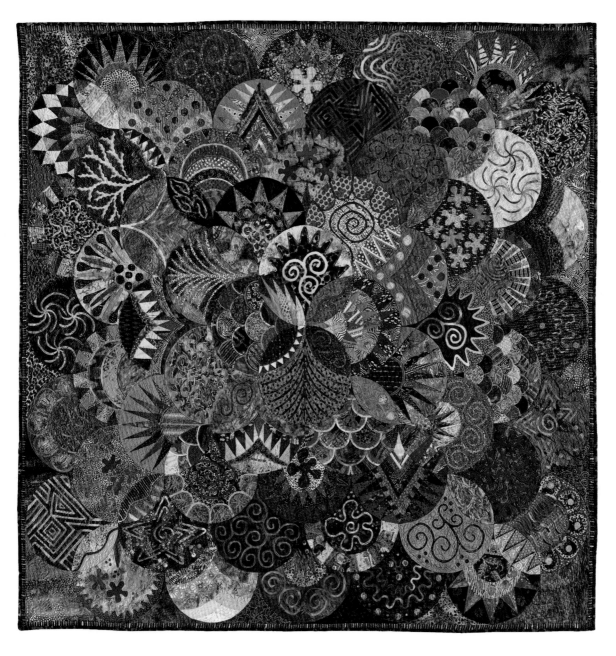

Big on Texas

2009

SIZE IN INCHES: 48 x 65

TEXAS LOCATION: Austin

MADE BY: Martha Murillo
Tsihlas and Paloma Tsihlas

STYLE OF QUILT: Art

SOURCE OF DESIGN: Original
design

MATERIALS USED: Hand-dyed
cotton, batiks

PRIMARY TECHNIQUES: Piecing,
appliqué, free-motion
machine quilting

FROM THE COLLECTION OF:
Carol Ikard

Nothing identifies a Texan more than a pair of boots . . . and what a pair of boots these are! This mother-daughter team has created the quintessential Texas boot, full of symbolism from oil derricks to windmills, from the Alamo to the Capitol, from armadillos to longhorns, from wagon wheels to cowboy hats, and of course, the classic image of a cowboy on a horse. The artists have named Texas cities all around the outer edge of the quilt and appliquéd a riot of bluebonnets behind the boots. "Western boots are an integral part of Texas history," says Martha. "I decided to use the boots and Texas landmarks as inspiration." The quilt has won several awards.

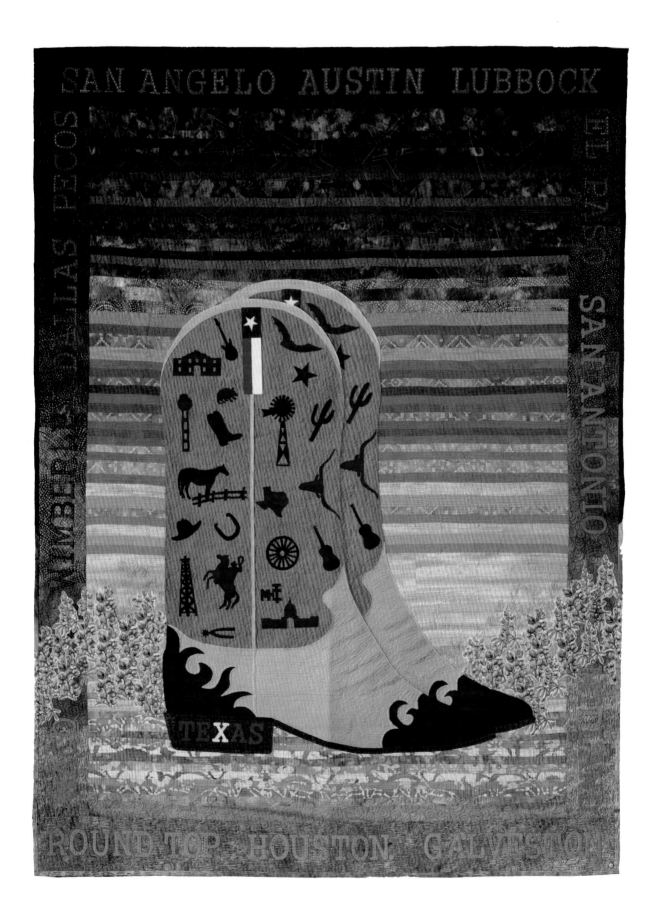

Coneflower

2009

SIZE IN INCHES: 32 × 36

TEXAS LOCATION: Austin

MADE BY: Mary Ann Vaca-
Lambert

STYLE OF QUILT: Art

SOURCE OF DESIGN: Original
design

MATERIALS USED: Cotton,
batiks

PRIMARY TECHNIQUES: Raw-
edge appliqué, thread
painting, beading, free-
motion quilting with
meandering, machine
quilting

A magnified image of a popular Texas wildflower sometimes called Mexican hat for its resemblance to the sombrero, this award-winning quilt has a surprise in the many glass and wooden beads that stand on end to emphasize the flower center or cone. According to Mary Ann, "Coneflowers are one of my favorite flowers. I made a small piece for a local museum and liked it so much that I had to make a larger piece."

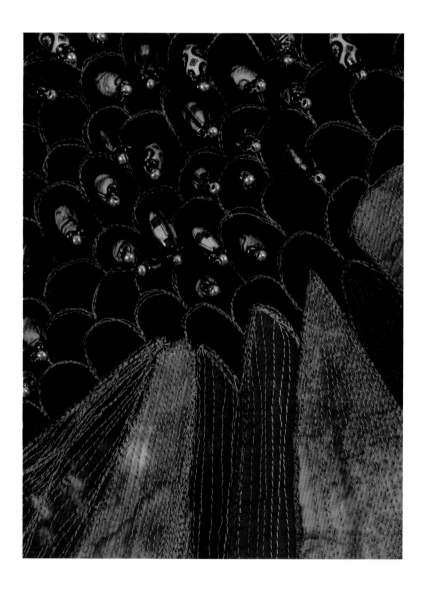

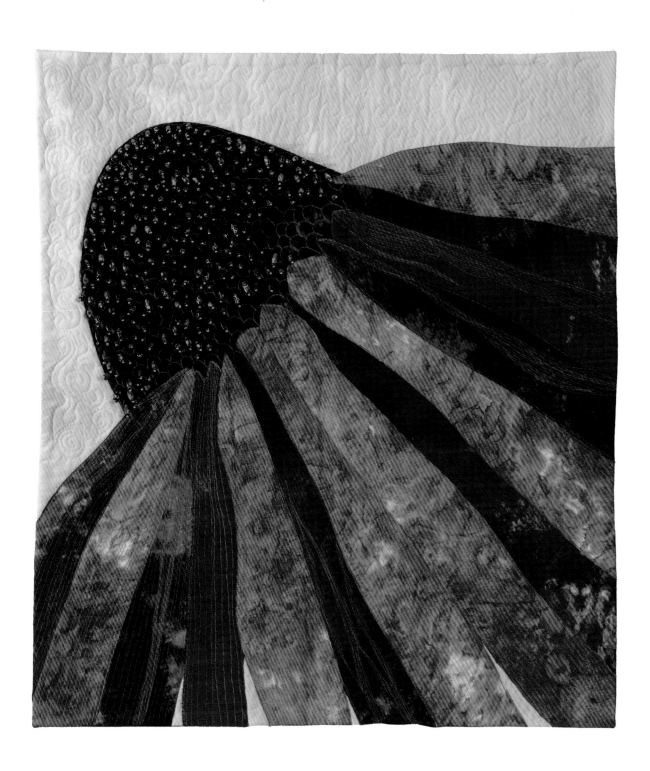

SIZE IN INCHES: 36 × 48

TEXAS LOCATION: Austin

MADE BY: Kathy York

STYLE OF QUILT: Art

SOURCE OF DESIGN: Original design

MATERIALS USED: Cotton

PRIMARY TECHNIQUES: Multiple layer batik and dyeing, bleach discharging, inking, machine quilting

Inspired by a climb the artist did at Enchanted Rock State Park, this wholeclth quilt successfully shows the overwhelming size of the rock as compared to the size of a climber and captures details splendidly. Look at the way one toe has slipped into the crack for stability, the way the muscles in the climber's arm are delineated, and the powerful grip her wrapped hands have on the rock. "I find something very compelling about a beautiful line, in this case, a rock crack," says Kathy. "It looks impossible to climb, brutal yet elegant. There is comfort and security in a well-defined edge." This quilt is an award winner, and the quilt artist has had her work juried into Quilt National.

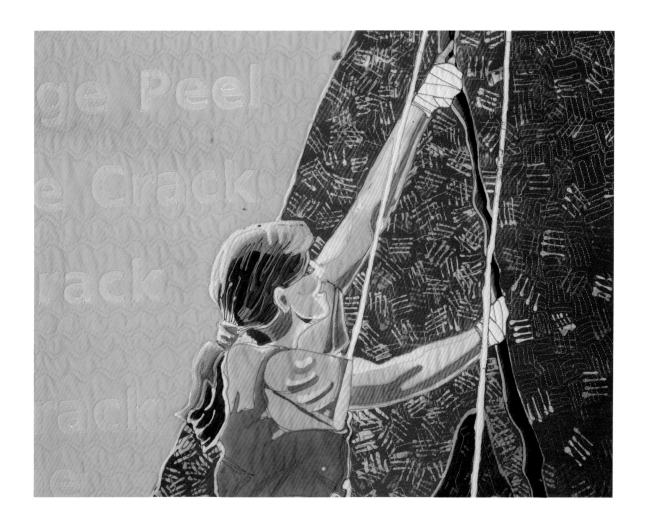

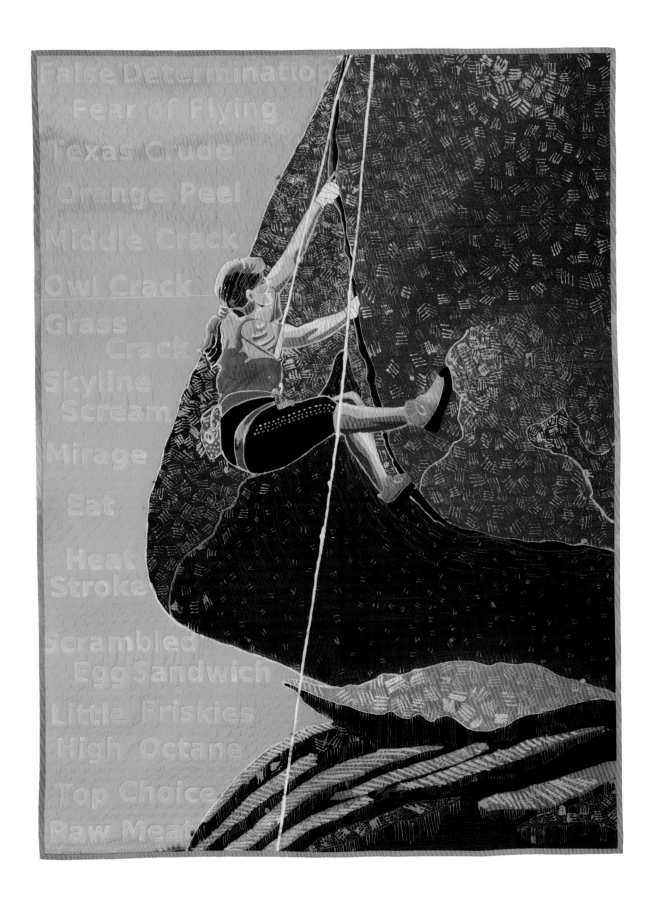

Curiosity

SIZE IN INCHES: 54 × 46

TEXAS LOCATION: Killeen

MADE BY: Pauline Barrett

STYLE OF QUILT: Art

SOURCE OF DESIGN: Original
design

MATERIALS USED: Cotton

PRIMARY TECHNIQUES: Fusible
appliqué, machine appliqué,
machine quilting

Dogs are curious creatures, and this quilt resulted from Pauline's repeated encounters with two of them, which she combined into this design. Her fabric choices are excellent—the grain of the wood fence; the shadows on the concrete walk; the furry, stitched texture for the white dog; the elegance of the butterflies.

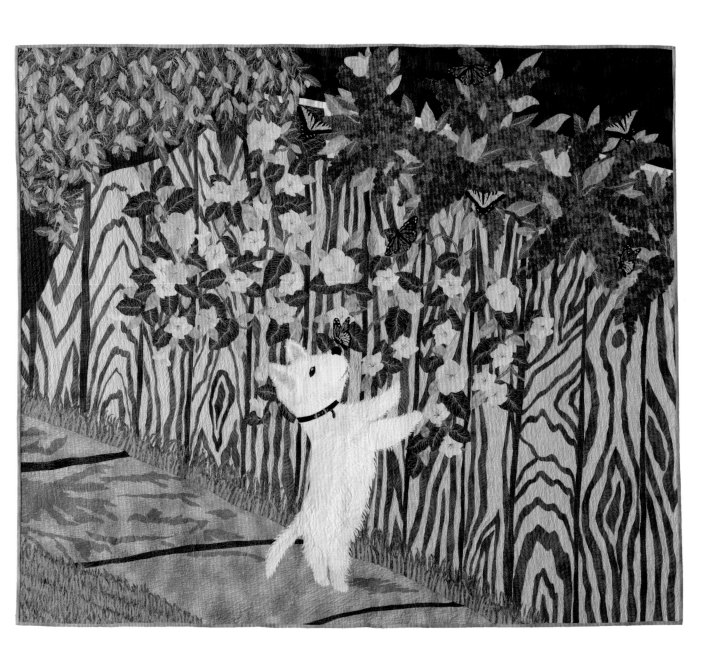

2010

SIZE IN INCHES: 92 X 92

TEXAS LOCATION: Bandera

MADE BY: Betty L. Brister

STYLE OF QUILT: Traditional

SOURCE OF DESIGN: Stars patterns and Jacobean designs

MATERIALS USED: Cotton

PRIMARY TECHNIQUES: Machine piecing, hand appliqué, hand quilting

Incorporating three patterns—Feathered Star, Stars of the Orient, and Jacobean appliqué designs—this quilt is visually exciting and technically challenging. Betty combined fabric selection, color choice, multi-layer appliqué, delicate stems, and perfect circles to create the perception of a stylized medallion quilt.

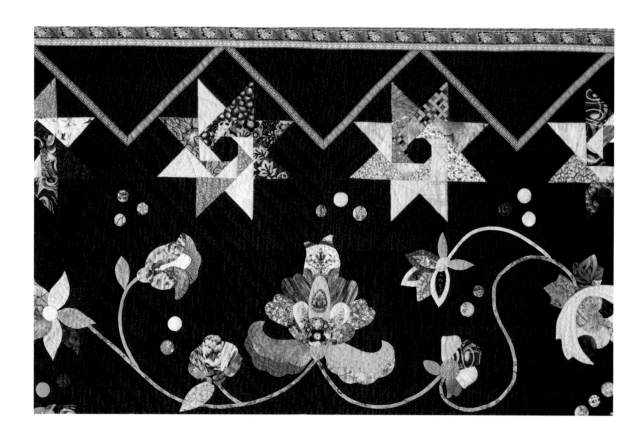

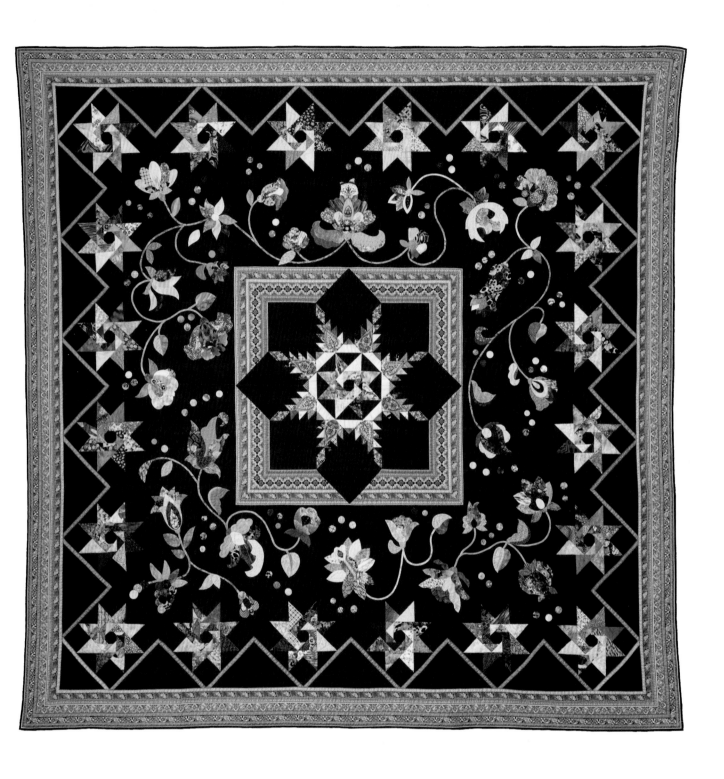

Last Chance, Last Dance

SIZE IN INCHES: 72 x 72

TEXAS LOCATION: Houston

MADE BY: Moira Cannata
(deceased)

STYLE OF QUILT: Traditional

SOURCE OF DESIGN: Log Cabin
Courthouse Steps pattern

MATERIALS USED: Cotton, satin

PRIMARY TECHNIQUES:
Machine piecing, longarm
machine quilting, paper
piecing

FROM THE COLLECTION OF:
Fred Cannata

The last quilt completed before the quilt artist's untimely death in 2010, this remarkable design uses 22,932 small pieces arranged in variations of the Log Cabin Courthouse Steps pattern. Moira wrote that her friends had held an intervention with her for having too much fabric, and so she created this tribute to old-fashioned Charm quilts in which one pattern is repeated in different ways. "This was the last chance these scraps would dance through my sewing machine," she explained.

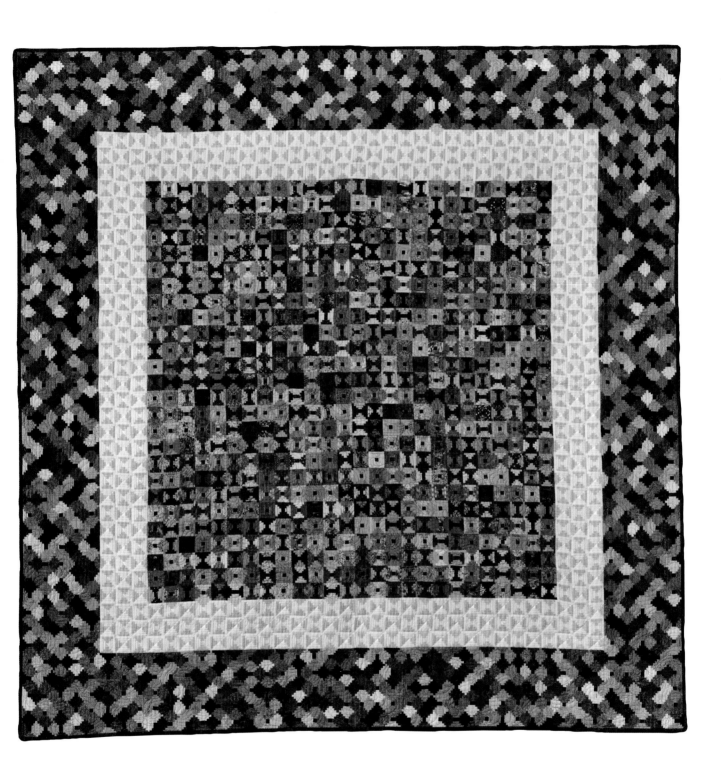

A Secret Garden Discovered

2010

SIZE IN INCHES: 30 x 43

TEXAS LOCATION: Round Rock

MADE BY: Andrea M. Wold
Brokenshire

STYLE OF QUILT: Art

SOURCE OF DESIGN: Original
design

MATERIALS USED: Silk, cotton

PRIMARY TECHNIQUES: Painting
on wholecloth, free-motion
embroidery, machine quilting

FROM THE COLLECTION OF:
Cheryl Kubic

The color-saturated, painted surface of this silk quilt is enhanced by the quiltmaker's artistic use of free-motion machine embroidery to add depth and dimension to the flowers in their rustic setting. The hidden iris garden was discovered after a long hike around Lake Georgetown. Andrea captured the beauty of the flowers growing along a stream that then cascaded into a creek below.

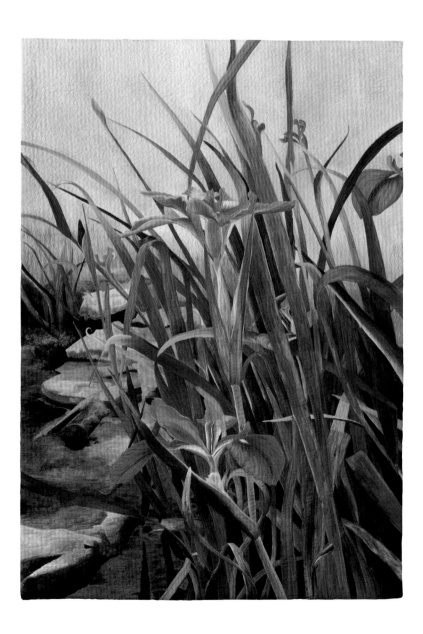

Three's Company

2010

SIZE IN INCHES: 36 × 46

TEXAS LOCATION: Round Rock

MADE BY: Andrea M. Wold
Brokenshire

STYLE OF QUILT: Art

SOURCE OF DESIGN: Original
design

MATERIALS USED: Hand-dyed
cotton, batiks, silk

PRIMARY TECHNIQUES: Fusing,
hand-painted appliqué,
confetti piecing, free-motion
embroidery, machine quilting

Texas summers see the sunflowers reach for the sky, a sky this quilt artist has captured beautifully with confetti piecing. This method uses tiny, randomly cut pieces of fabric to create a textured surface. The pieces almost seem to be faceted and skillfully convey the changing colors of a summertime sky bright with dancing light. Fused appliqué of the hand-painted sunflowers and their oblivious bee, intent on gathering pollen, complete Andrea's outstanding quilt, which she intended to convey the concept of summer's bounty.

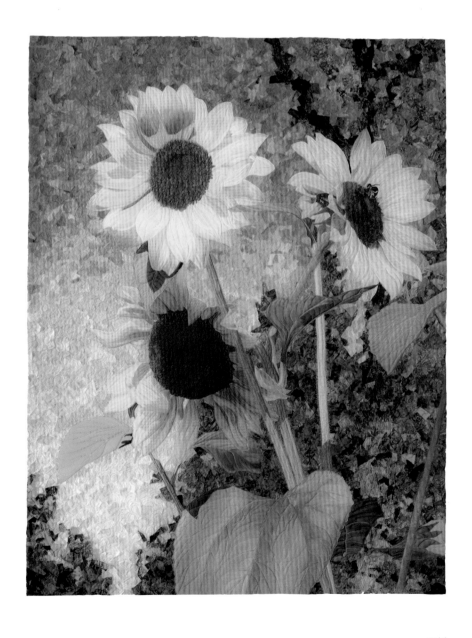

2010

SIZE IN INCHES: 77 X 77

TEXAS LOCATION: Sherman

MADE BY: Becky Goldsmith

STYLE OF QUILT: Traditional

SOURCE OF DESIGN: Original
design

MATERIALS USED: Cotton

PRIMARY TECHNIQUES: Hand
appliqué, machine quilting

"I love the energy of circles," states Becky, who hopes that the blocks and surrounding borders of this quilt will successfully convey that sense of energy to the viewer. More than 464 circles show up on this piece, not counting the ones in the border. Her clever use of dotted fabrics adds to the complexity of this design.

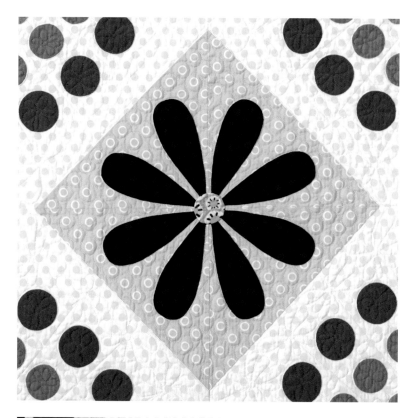

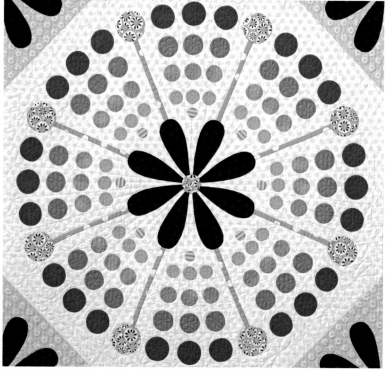

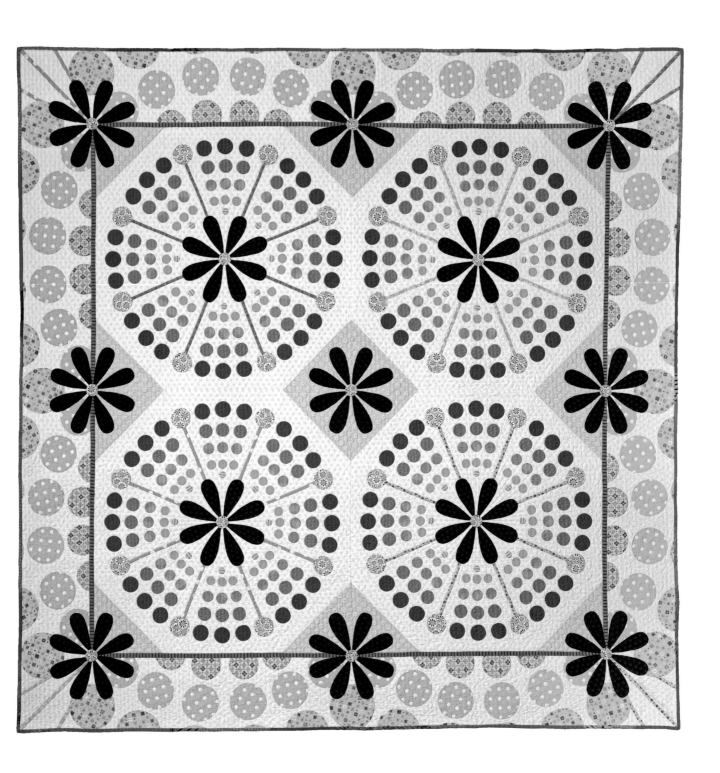

The Right Time

SIZE IN INCHES: 47 x 50

TEXAS LOCATION: Houston

MADE BY: Carolyn Crump

STYLE OF QUILT: Art

SOURCE OF DESIGN: Original design

MATERIALS USED: Cotton

PRIMARY TECHNIQUES: Hand and thread painting, fabric pattern transferral

A love of jazz, which is often considered one of America's two indigenous art forms (quilts being the other), inspired this quilt-maker, along with an opportunity for the piece to be shown in a Costa Rica exhibition, "Visions of Jazz in Fiber." Carolyn's thread painted and appliquéd quilt captures the energy of the musicians, the originality of their music, and the unmistakable atmosphere of a jazz club.

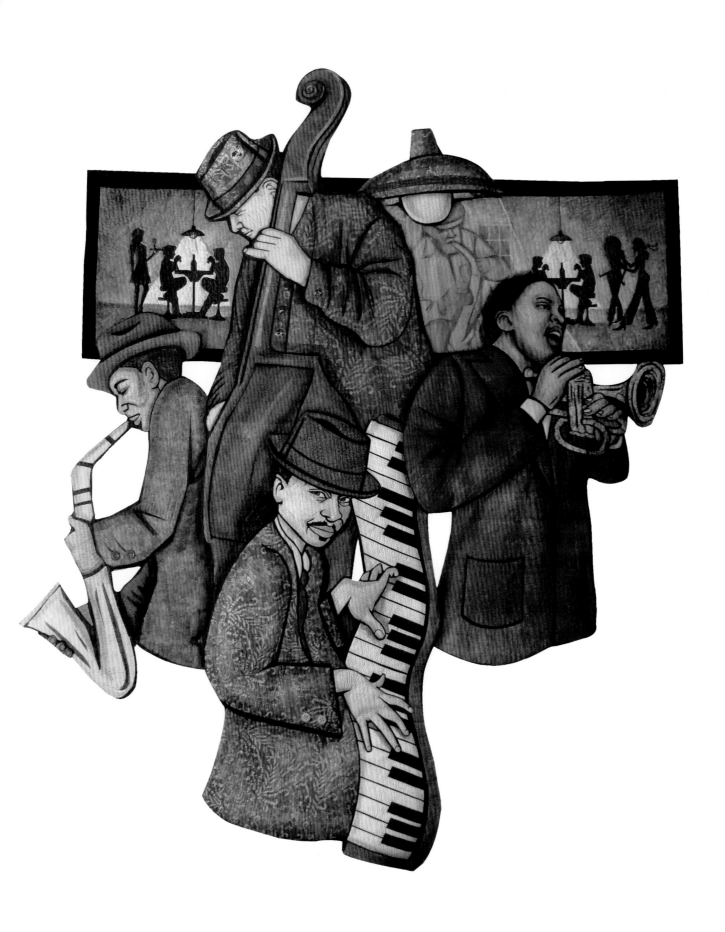

359

Gold Rush

2010

SIZE IN INCHES: 82 x 82

TEXAS LOCATION: Sulphur Springs

MADE BY: Bettie Graves Hammock

QUILTED BY: Jackie Brown

STYLE OF QUILT: Traditional

SOURCE OF DESIGN: Pattern

MATERIALS USED: Cotton

PRIMARY TECHNIQUES: Piecing, machine quilting

Nine hundred pieces went into the making of this stunning, precisely pieced quilt. Based on a diamond variation of the Log Cabin pattern, this design has an American Indian feel to it. The rich jewel-tone colors are set off perfectly by the excellent feathered machine quilting.

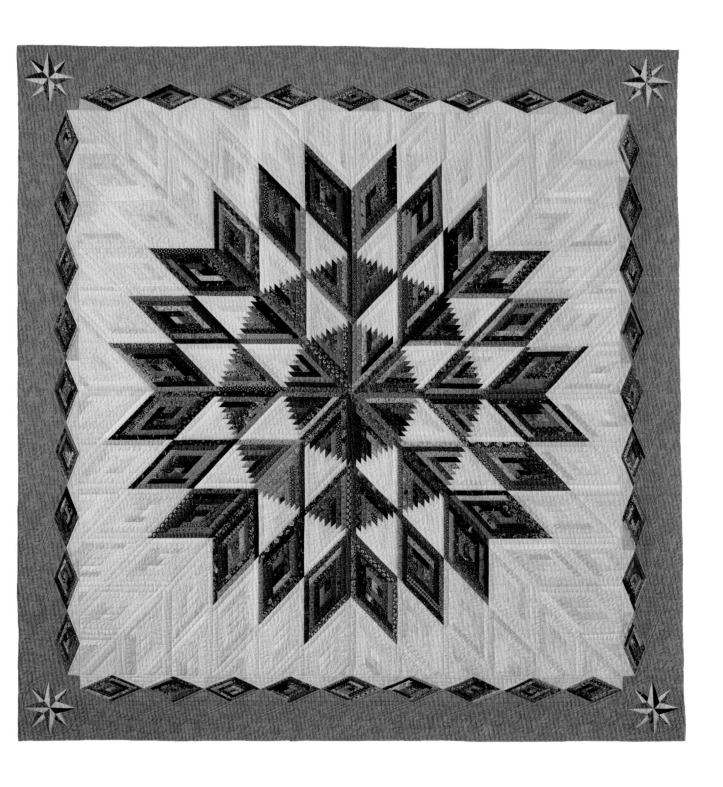

Fireworks in the Midnight Sky

2010

SIZE IN INCHES: 88 X 93

TEXAS LOCATION: Plano

MADE BY: Joan C. Wilson

QUILTED BY: Richard Larson

STYLE OF QUILT: Art

SOURCE OF DESIGN: Original design

MATERIALS USED: Hand-dyed cotton, batiks

PRIMARY TECHNIQUES: Freeform piecing with zigzag stitching, machine quilting

FROM THE COLLECTION OF: Dr. Elizabeth Kerner

This quilt, designed to be an abstract representation of fireworks, was to be displayed as a second-story wall hanging in a large open entry with double doors. The artist used freeform piecing and appliqué to create the bold image needed for the theme and for the hanging space. Joan says: "A paper-piecing design for the stars was developed to allow resizing the individual dimensions of each star. It was necessary to use this process as the stars were being formed into circles using templates. A standard star block would not have worked." It is interesting to note that the fabric shapes were pieced together using a zigzag stitch rather than being pieced to a background or foundation.

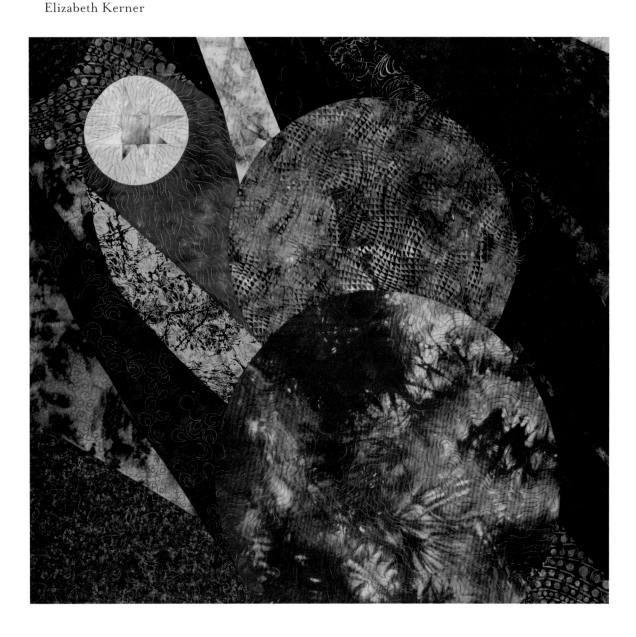

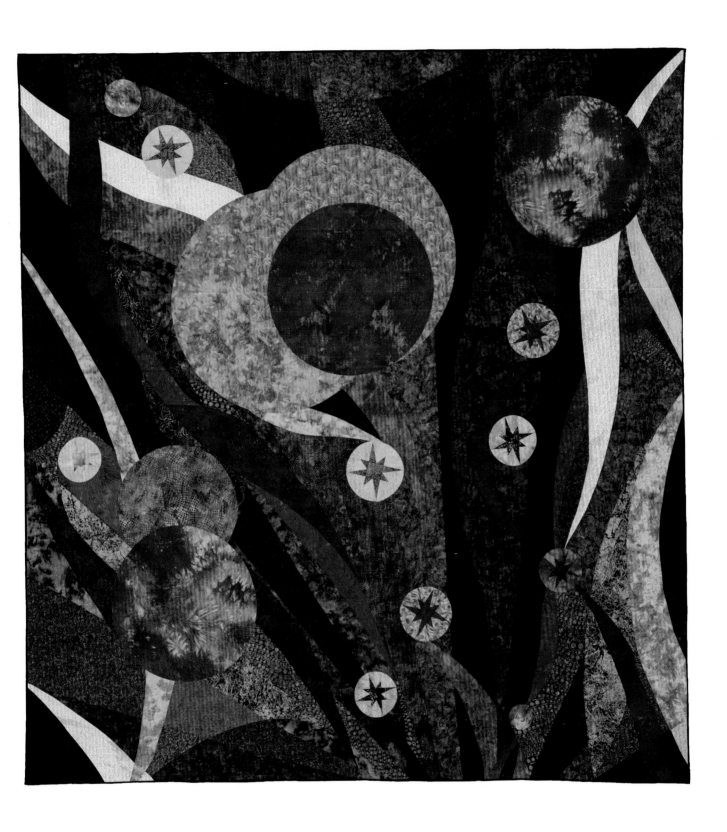

Façade

2010

SIZE IN INCHES: 42 X 52

TEXAS LOCATION: Richardson

MADE BY: Melissa Sobotka

STYLE OF QUILT: Art

SOURCE OF DESIGN: Original
design

MATERIALS USED: Cotton,
batiks

PRIMARY TECHNIQUES:
Appliqué, machine quilting

Italian ruins have inspired many artists through the centuries—something about the light, the color of the surroundings, the texture of the stones has always appealed to artists. This quilt is no exception, being based on a photo the artist took of a crumbling façade in the spa town of Montecatini, Italy. Melissa's appliqué work in creating the disintegrating surface of the stone and brick, the damage to the Ionic columns, and the faded paint is exceptional. A pictorial art quilt, this piece has won several awards.

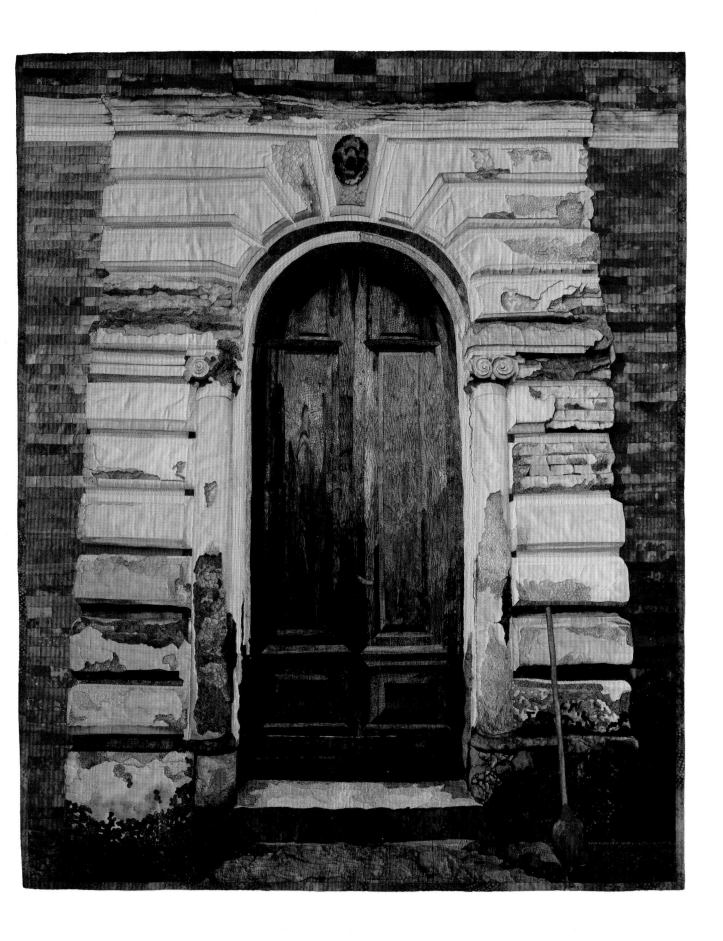

Think Green

2010

SIZE IN INCHES: 27 x 38

TEXAS LOCATION: Houston

MADE BY: Carolyn Crump

STYLE OF QUILT: Art

SOURCE OF DESIGN: Original design

MATERIALS USED: Cotton

PRIMARY TECHNIQUES: Hand and thread painting, fabric pattern transferral, appliqué

Endangered species, recycling, global warming, the burning of the rain forests, and even "tree huggers," as environmental activists are sometimes called—all of these topics related to current environmental concerns can be seen in Carolyn's quilt. The elephant's eye and the designs seen on the man's face are particularly interesting; it is almost as though green plants are beginning to grow on his skin, indicating that we are one with the world and its problems.

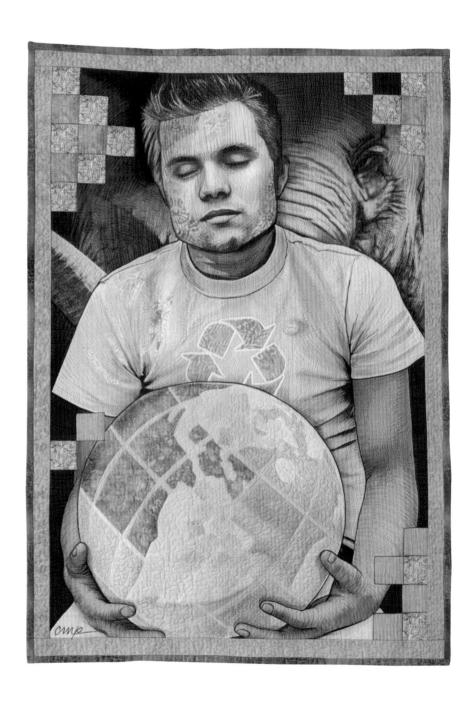

Sentinel in the Gulf

SIZE IN INCHES: 35 × 39

TEXAS LOCATION: La Grange

MADE BY: Kay Giese Marburger

STYLE OF QUILT: Art

SOURCE OF DESIGN: Original design for son who works on oil rigs in Gulf

MATERIALS USED: Cotton (some hand-dyed), nylon tulle

PRIMARY TECHNIQUES: Raw-edge machine appliqué, drawing, machine quilting

Made for her son who works on oil rigs in the Gulf of Mexico, this quilt is especially timely in view of the blowout that spilled so many millions of gallons of oil into the Gulf of Mexico in the summer of 2010. With careful attention to detail, Kay has captured the solitary beauty of these huge constructions. She used hand-dyed nylon tulle to create the shading and shadows that are so effective in this award-winning piece, and skillfully drew on the details of the oil rig.

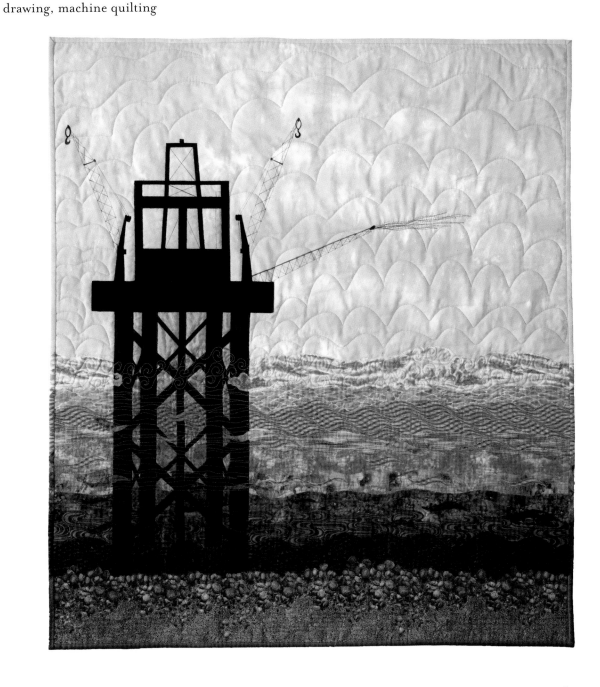

Texas DNA

2010

SIZE IN INCHES: 55 × 55

TEXAS LOCATION: Austin

MADE BY: Martha Murillo Tsihlas

STYLE OF QUILT: Art

SOURCE OF DESIGN: Original design

MATERIALS USED: Hand-dyed cotton, batiks

PRIMARY TECHNIQUES: Piecing, appliqué with both raw-edge and needle-turn appliqué, free-motion machine quilting

A quilt full of Texas symbolism, the time line of Texas history silhouetted around the border is fascinating to study. Starting at the top are the earliest Texas images of discovery: Indians and teepees, a Catholic friar and missions, a Spanish conquistador. In the right border are seen settlement images: a farmer, a covered wagon, a cowboy driving longhorns, and a homestead with a pioneer woman and the family graveyard. The bottom border continues Texas' growth with the steam railway, the Pony Express, cotton and shipping, the Capitol, and the oil boom. On the right border you see the most current history: man's landing on the moon, the battleship *Texas* from World War II, a wind farm, and finally a big city with its vital airline transportation. "Texas' culture is the result of different ethnic groups," says Martha. "The flags on the quilt represent these groups. The colorful circle is the blending of cultures, all to become one, as shown by the star of Texas." This quilt has won several awards.

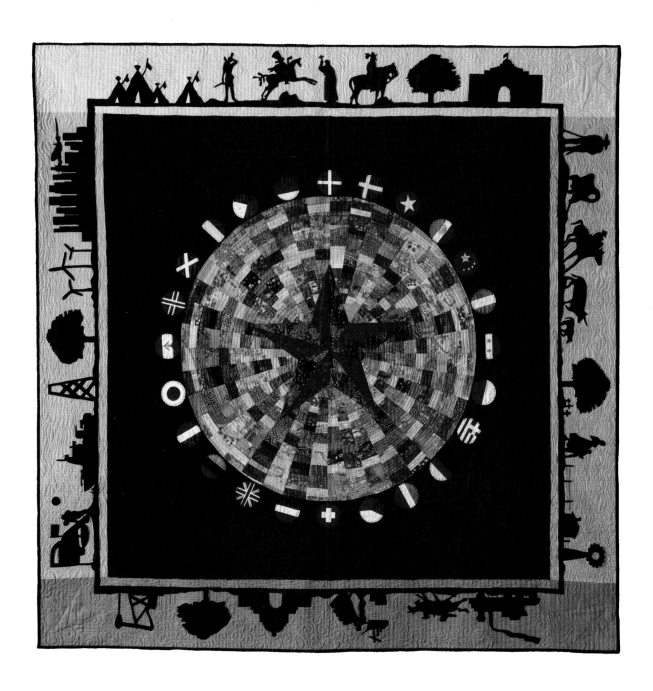

2010

SIZE IN INCHES: 84 × 74

TEXAS LOCATION: Kingwood

MADE BY: Margery O. Hedges

STYLE OF QUILT: Art

SOURCE OF DESIGN: Original design

MATERIALS USED: Cotton, silk

PRIMARY TECHNIQUES: Free-motion embroidery, machine appliqué, fusible appliqué, machine piecing, painting, thread painting, machine quilting

An enchanting quilt, this whimsical piece celebrates childhood fairytales in textile form. "Goldilocks and the Three Bears," "Little Red Riding Hood," "Snow White and the Seven Dwarves," even "Rapunzel" and "Jack and the Bean Stalk" show up in Margery's testimony to the memory and power of beloved fairytales. Many of the details are painted.

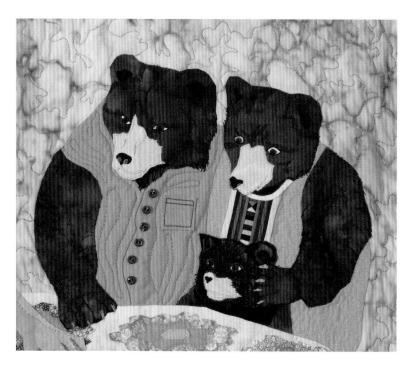

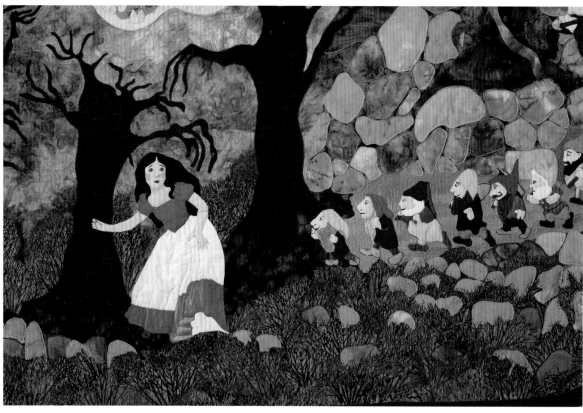

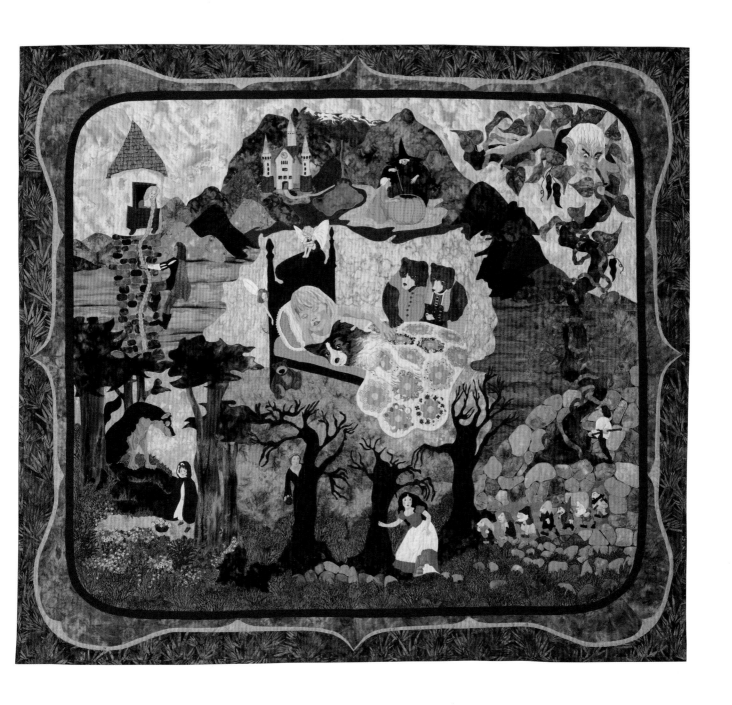

Ripple Effect

2011

SIZE IN INCHES: 52 X 40

TEXAS LOCATION: Houston

MADE BY: Libby Lehman

STYLE OF QUILT: Art

SOURCE OF DESIGN: Original
design

MATERIALS USED: Cotton

PRIMARY TECHNIQUES:
Machine embroidery and
appliqué, machine quilting

Libby looks on her quilts as experimental projects that allow her to try new ways of machine stitching and quilting. Curves and layers have always intrigued her, and her machine work has set the bar for excellence. Unusual threads, metallic threads, textured threads—all have added their shimmer and gleam to her work. This quilt was made to capture a particular effect, Libby explains: "I've always been fascinated watching the ripples on water as they travel outward. I admire people who can skip stones—mine sink immediately!" The quiltmaker also had work included in *Lone Stars II: A Legacy of Texas Quilts, 1936–1986,* and has been juried into Quilt National several times.

Glossary

appliqué: Derived from French verb *appliquer*, meaning to apply or lay one thing on another; cutout shapes of fabric are "applied" to a larger background fabric and held down with a blind stitch, whip stitch, buttonhole stitch, ladder stitch, or embroidery. Appliqué techniques include turned edge, raw-edge, or fusible appliqué, traditional needle-turn appliqué, or invisible appliqué. Some types of appliqué are done by hand; others can be done by hand or machine.

art quilt, art quilter: Generally, an art quilt is one that doesn't look like a traditional quilt, nor is it ever intended to be used on a bed. It is often wall sized, to be hung as art; it may even be very small, but is not to be confused with a miniature quilt. It is not bound by any rules other than ones the maker chooses to follow. It may employ many printing, dyeing, painting, marbling, embellishing, and manipulating techniques. It is a means by which a quilter expresses her creativity. Many art quilters are unconcerned with traditional quilting techniques and do not choose to follow any accepted "rules" about quiltmaking.

Artist Trading Cards: Miniature art "quilts," usually a standard business card size, that are often traded by quilt artists or used as a business card. Most often made of fabric covering a foundation, such as an index card or cardboard, which is then embellished in various ways. Sometimes abbreviated as ATC.

Baltimore Album: A particular type of fancy appliquéd sampler quilt, generally on a white or cream background fabric, and consisting of a number of individual blocks featuring motifs such as baskets, cornucopias of fruit, flowers, flags, shields, other patriotic items, landmarks, ships, birds, etc. This stylized type of quilt has long been thought to have originated in Baltimore in the mid-1800s. Such Album quilts employed many fine fabrics, not scraps, and often incorporated inking in the blocks, sometimes autographs of the maker. They were not "everyday" quilts, but ones always saved for "best," and showed off the skill of the quiltmaker or makers. These quilts have enjoyed a popularity surge from about 1990 to present.

basting: Long stitches used to hold the "quilt sandwich," or top, batting, and backing, together for quilting. Popular substitutes for basting include pinning with straight or safety pins, tacking with a tacking gun, or using spray adhesive.

batik: Cloth created by wax-resist dyeing. A design is painted onto fabric with melted wax so subsequent dyeing will not "take" in that area, thus creating a design that is in contrast to surrounding fabric. Batik prints are often incorporated into modern quilts.

batting: The filling of a quilt, originally cotton or wool, also called wadding or inner lining; the middle layer of the "quilt sandwich." Many other types of batting are available to quilters now: organic cotton, cotton-silk, silk, cotton-wool, bonded, polyester, polyester-cotton, bonded polyester, needle punched, fusible, high loft, low loft, medium loft, and other types.

beading, hand beading: Methods of embellishing a quilt.

bearding: When batting fibers migrate through the top or back of a quilt, they form what look like "pills" on a sweater. This is not as big a problem as it used to be, since more closely woven fabrics and improved batting, such as bonded and needle punched varieties, have become available.

binding: Finishing the raw edges of an otherwise completed quilt, or the finished edge itself.

block printing: An old method of making designs on fabric that is being used by some contemporary art quilters to create their fabric. The two most common methods are woodcuts or linocuts. In woodcuts, a wood block is prepared with sections that are to be either white or a base color carved out, leaving those in high relief to carry the ink or dye that is applied before the block is pressed onto fabric. Linocuts are prepared the same way, using linoleum blocks instead of wood blocks. The image that is printed onto the cloth has a corresponding mirror image where the uninked or undyed area that was cut away remains. To achieve a colored print, a block is needed for each color.

Broderie perse: Literally "Persian embroidery." A very old quiltmaking technique that imitated the look of what was then expensive chintz fabric. It involved cutting out motifs and appliquéing them onto a base

fabric, usually muslin or another solid color. Modern-day quilters use the method to achieve very different looks than the traditional patterns. If making art quilts, they may use a fusible product to hold the cutout design onto the base fabric.

burning or searing: Some art quilters like to burn or sear fabric to incorporate into their quilts. Often it is done with silk or a synthetic that has been fused to a heat-bonding product and the design drawn onto the resulting bonded fabric. The edges can be seared with a heat gun, soldering iron, or woodburning tool, each producing a slightly different result. For instance, a heat gun generally shrinks and draws fabrics up a bit. Different fabrics respond differently to the process: silk may curl and synthetics often melt, edges may look singed or textured. This technique can be used on pieces to add to a quilt top, or it can be done after the top is pieced. The process requires care, as the heat can cause serious burns. Many quilters use a painter's mask if burning synthetics indoors due to vapors. Others conduct such projects outdoors.

by the piece: Quilting around each edge of each piece in a quilt.

conversation prints: Very small designs that in nineteenth-century quilts were said to offer subjects for conversation. They can include anything from hunting horns, to feathers, foxes, dogs, horses and other animals, suns, moons, stars, etc. Today they are often called novelty prints.

corners, to turn: Planning borders and quilting designs to curve around corners with no broken line. This practice stems from an old superstition that a broken line in the border foretells a broken life. Quilts are often judged on how well they "turn the corners."

couching, hand or machine: When thicker threads forming a design on a surface are held down by hand or machine zigzag stitching.

counterpane, whitework, boutis, Marseilles spread: All are types of wholecloth quilts usually, but not always, made of white cotton quilted with white thread in elaborate overall designs. They show off intricate and expert quilting. Counterpane or whitework quilts are usually not padded; when they are they are frequently referred to as stuffed work or trapunto quilts. Boutis, a type of quilt with two layers, originated in Provence, France, in the 1600s. A boutis, or special tool, was originally used to insert cording that created the raised design; other specialized tools, or improvised ones, are used today now that boutis are enjoying a revival. Marseilles cloth or spreads made on jacquard looms and simulating hand quilting originated in Provence in the 1700s, taking the name of the French port city.

crazy quilts: Quilts made from irregularly shaped pieces, often of costly fabrics such as silks, satins, or velvets to form blocks, or an overall top. Individual pieces were heavily decorated with elaborate embroidery stitches, souvenir ribbons, scarves, laces, painted motifs, etc. They were especially popular during Queen Victoria's reign and were often used as throws or decorations. They were never quilted or intended to be used on a bed. From time to time, there is a resurgence of popularity in crazy quilting.

design wall: A large piece of quilt batting, felt, or flannel attached to a wall that allows the quilter to "stick up" her pieces of fabric to try several combinations of colors or fabrics as a design evolves.

echo quilting: Also called outline quilting. A quilting design that follows, or echoes, the outer edges of an appliquéd design on the quilt top. Typically seen in Hawaiian quilts.

embellishment methods: Overdyeing, inking, fabric painting, fabric marking, beading (hand or machine), disperse dyeing, fiber-reactive dyeing, stenciling, foiling, silk fusion, faux felting, immersion dyeing, dye painting, discharge dyeing, dye printing, stamping, embroidery, all are types of embellishment used by art quilters and others.

English paper piecing: An old, and very accurate, method of piecing quilt blocks, or "making patchwork," in which fabric is basted over a paper template, pressed, and joined up with other blocks. It is almost always done by hand, and is a method favored for fussy cutting and for complex and hard to piece shapes, such as diamonds with sharp points.

fabrics for quilting: Fabrics favored by quilters of old used to be cotton calico, chintz, wool, muslin (also called unbleached domestic), or even homespun. Today's quilters are using all of those, except for homespun, along with cotton sateen, silk, synthetics, large-scale batiks, and upholstery fabrics, as well as making their own fabrics by manipulating commercial fabric, or by actually creating fabric from fusible threads and other fusible products.

fat quarter: A quarter yard of fabric that is cut 18"x 22" rather than the standard 9" x 44" that would normally be cut from a yard of fabric. Fat quarters are often rolled and displayed in color families for sale to quilters.

foundation paper piecing: An old piecing technique currently enjoying a revival in which very small fabric pieces are sewed to paper, making them easier to handle.

foundation piecing: Sewing fabric pieces to muslin or other fabric to create quilt blocks.

free-motion machine stitching, free-motion machine quilting, free-motion machine embroidery: All methods by which a quilter can control the fabric, thread, and movement of the needle by dropping or covering the feed dogs on her sewing machine, using it to embellish the surface of a quilt with threadwork

or to quilt the layers of a "fabric sandwich" together to make a quilt.

fused appliqué, fusible appliqué: Appliqué that uses fusing to apply the designs to the base fabric.

fusibles: Fusible products used in quilts include fusible batting, fusible fleece, fusible freezer paper, fusible fibers, fusible interlining, fusible sprays, fusible webbing, and others. Some fusibles hold quilt pieces in place while the top is being completed, then they are removed; some are intended to remain in the quilt or quilted garment. Most, except for sprays and glue sticks, are heat-set using an iron. Examples of some popular fusibles are Angelina, fast2fuse, Lutradur, Mistyfuse, Pellon, and Timtex.

fussy cut, fussy cutting: Isolating and meticulously cutting a design from a printed fabric and centering it in the middle of a quilt block or piece of fabric when making a quilt. The design motif might be a flower, a star, an animal, or similar motifs, often cut from conversation prints or novelty prints. A template is usually used to make a number of fussy cuts for a quilt.

greige goods: The raw base fabric before processing in commercial textile production. It is pronounced "gray" goods.

hand-guided machine quilting: See **longarm quilting**.

Hawaiian quilts, quilting: Hawaiian quilts seem to have developed from needle skills taught by missionaries in the early 1800s, although some aspects of the typical Hawaiian design were already appearing in a type of bed covering made from beaten vegetable fibers. Typically, Hawaiian quilts are made from two large pieces of cloth, each a different color. One is used as the background; the second color is cut into an overall symmetrical design similar to cutting folded paper snowflakes, Mexican *papel picado*, or German *scherenschnitte*, and appliquéd onto the base fabric. The quilt is then "echo" or outline quilted, a method in which the quilting follows the outer edges of the design.

in the ditch: Quilting stitches just beside or actually in the seam.

jelly rolls: 2.5" x 44" strips of pre-cut color-related fabrics rolled to resemble "jelly rolls" and tied with ribbon. When used in a quilt, it becomes known as a "jelly roll" quilt.

journal quilts: Small quilts, usually the size of an 8.5" x 11" page, called a Quilt Page, that chronicle a quilt artist's creative journey or record her personal growth, a means by which she explores new design directions or inspirations, colors, imagery, techniques, and materials.

laidwork or laid work: Additional terms for appliqué, somewhat out-of-date.

layer cakes: Ten inch square packages of usually forty related fabrics stacked in layers and tied for use in quilts, often called "layer cake quilts."

longarm quilting: Originally commercial quilting done on very large and expensive specialty machines using programmed designs. Today, some quilters are interested in making more quilts and making them faster and have either become longarm quilters themselves, or are paying to have quilt tops quilted by individual longarm quilters, who create their own hand-guided quilting designs. Such longarm quilters have created a thriving cottage industry, and have helped to transform the perception of longarm machine quilting.

machine appliqué, machine piecing, machine quilting: Processes for creating quilts using home sewing machines rather than hand appliqué, hand piecing, and hand quilting.

machine embroidery: A type of machine stitching that can be machine guided, which relies on purchased patterns, or free motion, which allows the quilter to create her own patterns and designs.

machine thread painting, threadwork, thread embellishment: A method of embellishing quilts with thread using a sewing machine. See **free-motion machine stitching**.

marbling: Immersion dyeing or painting with dyes to achieve a unique piece of fabric resembling marbled paper for use in quilts.

miniature, or mini, quilt: Small version of a large quilt design, not a quilt block, but an actual miniaturized version of a full-sized quilt.

molas: See **reverse appliqué**.

needlepunched batting: A commercial process by which quilt batting is punched multiple times by needles resulting in the batting being more stationary, thus reducing bearding.

paste resist: Some art quilters are creating fabric to incorporate into their quilts by experimenting with a flour-water paste resist process, brushing the paste onto fabric and allowing it to dry. Next, with various utensils, combs, or a stylus, they draw designs or write words or characters in the paste. Then a permanent dye or ink is applied and the fabric can be "scrunched" or not. After drying, the paste is washed out of the fabric, and a design is left.

paper foundation piecing: Often used in making mini quilts or complicated designs, it is a method of piecing a quilt block onto paper for easier handling.

patchwork: Sewing small pieces of fabric together to form either individual blocks which can be combined into a quilt, or which can form the larger design themselves. Sometimes called piecework, or pieced work.

PFD or "prepared for dyeing": Cotton fabric available by the yard for use in dyeing or painting. It does not

have to be prepared by bleaches, brighteners, or fabric sizing, and is used by quilters who want to create their own fabric for use in quilts.

photo transfer: Any of several methods of printing a photograph onto fabric for incorporation into a quilt. Some photo-transfer quilts include groups of blocks made from special family photographs by individual family members to present to an honoree at a celebration such as an anniversary or a birthday. Photo transfer techniques may also be used to produce abstract designs on fabric for use in art quilts.

piecing: To sew small patches of fabric together with narrow seams to form a quilt block, top, or backing. Pieced work, or piecework, is the result.

prairie points: Triangles made by folded squares of fabric, which are used to finish the edge of a quilt or are sometimes used in borders within the quilt.

printing methods: Silk screening, digital manipulation, inkjet printing, laser printing, thermo-screening, computer printing, and block printing are all methods by which quilt artists are using special techniques to create or alter fabric for use in their quilts.

puff paints: These are three-dimensional paints in tubes. Quilters use them directly from the tube to create freehand designs or apply them by means of a template to get high-relief colors. Puff-painted fabrics can be washed but should not be put into a dryer. Such decorated fabrics are another means of embellishment for quilts and quilted wearables.

quilt: A fabric "sandwich" consisting of three layers: top, batting or filling, and back; derived from French *cuilte*, which was derived from Latin *culcita*, a stuffed mattress or cushion.

quilting: Simple running stitches, preferably small and even, holding all three layers of a quilt together; stitches often follow fancy designs that have been marked on a quilt using templates. Some quilters mark their own freehand designs to follow in quilting. A method little used now is "laying on," in which a quilter draws a design with the point of her needle, then quilts it while the impression remains, as no lasting mark is left to follow.

quilt labels: The means by which a quilter identifies her quilt and gives its provenance. It is usually a piece of fabric, which can be plain muslin, fabric from the quilt top, or any other material inked with permanent ink, painted, typed, stitched, dyed, or embroidered with the name of the quilt or quilt design, name of quilter, size of quilt, year completed, and sometimes where it was made and for what occasion, if any. If made for someone else, that individual may also be identified on the label. If needed, the label is heat set before being sewn or fused to the quilt back. Occasionally, if the provenance is lengthy, a fabric pocket is attached to the quilt and sheets of paper with the information are inserted into it.

quilt sandwich: A description for a quilt consisting of a top layer which has the quilt design, a center layer or "filling," which is the quilt batting, and a bottom layer, which is the quilt back. See **quilt.**

quilt top: The top side of the fabric "sandwich" that shows on the bed or wall and carries the main design; usually used to refer to the completed pieced or appliquéd design before it is quilted.

raffle quilt, donation quilt, opportunity quilt: All are terms for quilts made by individuals or groups as a money-making effort, usually by a non-profit organization or entity which sells tickets for a chance to win the quilt.

raw-edge appliqué, raw-edge collage, raw-edge machine appliqué: Hand or machine stitching or fusing fabric to a base fabric in which the raw edge of the fabric being applied has not been turned under or otherwise hidden.

redwork: Fabric blocks stamped with a design which, when embroidered in red embroidery thread or floss, can be combined to form redwork quilts.

reverse appliqué: Method of appliqué whereby part of the background fabric is removed in a desired shape and another fabric added from underneath to fill the area; known also as inlaid appliqué. This method was popularized by the molas of the San Blas Indians.

rotary cutter: A very sharp round blade with a handle, similar in looks to a pizza cutter. Used to cut through many layers of stacked fabric at one time. Use of the rotary cutter and mat have greatly speeded up the cutting of fabrics for quilting.

rotary mat: A special "self-healing" mat marked in a grid to facilitate cutting with a rotary cutter.

roving: Can be wool, silk, or cotton and is used for hair in dollmaking and also when art quilters feature people in their quilts. In addition, it can be used in different ways as embellishment in art quilts. Roving is combed, bundled up, sometimes dyed, and twisted into ropelike cords that are available commercially. A little lasts a long time when used for dolls and quilts.

sashiko: An early Japanese quilting technique that uses a decorative running stitch, generally with white thread, and two layers of fabric, with or without batting between them, to produce designs, most often on indigo-dyed cotton.

sashing: Strips used to separate blocks in a quilt; also called stripping.

set: To sew the finished blocks together to form the quilt top. It also refers to the arrangement of the blocks; often, varying secondary designs are produced by altering the set of the blocks.

shibori: A cloth-resist dyeing method developed at least as early as eighth-century Japan to make patterns on fabric. There are several techniques typically used. Two commonly recognized by Westerners are *kanoko*

shibori, which involves binding or tying fabric, usually with thread, before dyeing (what is often called tie-dyeing), and *arashi shibori*, in which fabric is wrapped diagonally around a pole and "scrunched" to achieve a pleated effect. Quilters who like to make their own cloth sometimes use these techniques.

sleeve: A fabric tube sewn to the quilt back to accommodate a wooden, metal, or other supporting device that allows a quilt to be hung on a wall for display.

specialty threads: Modern threads include many used in traditional and art quilting, depending on the desired effects. They include metallics, heat fusibles, water solubles, trilobal polyesters, and any number of other special types.

spi: Stitches per inch, counted on one side of a quilt only. This measure of a quilter's ability to take many small stitches in hand quilting her quilt is often seen as a test of her overall quiltmaking ability; it does not apply to machine quilting, and even many hand quilters today do not feel compelled to strive for a high spi.

stash: A quilter's stash is her supply of fabrics, often bought and added to frequently with no particular project in mind; hoarded fabrics.

stipple: Stipple quilting utilizes very tiny, very close quilting stitches that form no discernible pattern but are used to flatten the background of the quilt; often used in combination with trapunto or padded appliqué so that the stuffed areas rise in relief.

stitching in the ditch: To quilt along the seam lines in a quilt top.

string piecing: Sewing tiny scraps of fabric to a foundation, often newspapers, letters, or old catalog pages that have been cut to form a pattern; once the scraps are sewn down, the foundation can be torn away, and the finished piece is ready to be used in piecing the quilt top; a type of foundation piecing.

strip piecing: Creating new fabric by sewing together narrow strips of other fabrics; once the new fabric is created, designs are cut out and pieced into the finished quilt.

stuffed work: Produced when a quilter stitches the design outlines in a fine running stitch and then from the back carefully eases cotton, wool, or polyester batting through small holes in the backing fabric to pad the outlined areas.

Swarovski crystals: Brand name of a popular product used in embellishing quilts.

template: A design, typically cut from plastic, that is used to create multiple pieces of the same shape or design for use in quilts. Earlier quilters used cardboard, cereal boxes, cups, glasses, leaves, etc., to make templates.

thread embroidery: See **free-motion machine stitching**.

trapunto: A term applied in the nineteenth century to American and English stuffed and corded work, but currently used to describe all forms of stuffed work.

UFOs: The unfinished objects or projects that a quilter has; some UFOs collect for years.

wall quilts: Smaller-sized quilts made to be hung on a wall as decoration rather than being used as bed coverings.

watercolor quilts: Quilters use many very small pieces of patchwork, often incorporating small prints like those from Liberty of London, to create a quilt top that looks like an Impressionist painting when completed. Also known as colorwash quilts or Impressionist quilts.

water-soluble fabric: Fabric that disappears when exposed to water, leaving the stitches that were applied to it.

water-soluble stabilizers, water-soluble marking pens: Water-soluble stabilizers make it easier to handle slippery, thin fabrics while working with them. They then dissolve when immersed in water. Water-soluble pens are used in marking quilting designs, then disappear when the fabric is wet.

wearable art: Quilters refer to garments made by incorporating a variety of quilting and other sewing techniques as wearable art, or art-to-wear. Many "wear their art" when attending quilt shows.

Selected Reading List

There are more options for acquiring good books on a wide range of quilt-related topics than ever before because there are many publishers now who specialize in the quilting industry, bringing out an array of new titles each year. Other specialty publishers include quilt books on their craft lists. In addition, general interest publishers sometimes offer quilt or quilt-related books. Almost all of these books are stocked at quilt shops and bookstores, and are also often available online from the publisher if they are unavailable locally. A number of historic or popular titles have been reprinted fairly recently. Some books and magazines can be found only online, and there are also useful options in on-demand publishing on some quilt or quilting websites. Further, websites such as AbeBooks, Alibris, Amazon, and Bookfinder and secondhand bookstores offer many out-of-print selections that previously were unavailable. We have listed some selections that we feel have special merit, including some older publications that we still find inspiring or which fill an otherwise unmet need, but this list is by no means complete.

History of Quilts and Quilting

Austin, Mary Leman, ed. *The Twentieth Century's Best American Quilts: Celebrating 100 Years of the Art of Quiltmaking*. Golden, CO: Primedia, 1999.

Berenson, Kathryn. *Quilts of Provence: The Art and Craft of French Quiltmaking* (revised). New York: Potter Craft, 2007.

Brackman, Barbara. *America's Printed Fabrics, 1770–1890*. Lafayette, CA: C & T Publishing, 2004.

———. *Clues in the Calico: A Guide to Identifying and Dating Antique Quilts*. McLean, VA: EPM Publications, 1989.

———. *Making History: Quilts and Fabrics from 1890–1976*. Lafayette, CA: C & T Publishing, 2008.

Bresenhan, Karey Patterson, curator. *America from the Heart: Quilters Remember September 11, 2001*. Lafayette, CA: C & T Publishing, 2002.

Bresenhan, Karey Patterson, and Nancy O'Bryant Puentes. *Celebrate Great Quilts! circa 1825–1940: The International Quilt Festival Collection*. Lafayette, CA: C & T Publishing, 2004.

Cooper, Patricia J. and Norma Bradley Allen. *The Quilters: Women and Domestic Art*. Lubbock, TX: Texas Tech University Press, 1999.

Finley, Ruth E. *Old Patchwork Quilts and the Women Who Made Them*. McLean, VA: EPM Publications, 1992.

Hall, Carrie A. and Rose G. Kretsinger. *The Romance of the Patchwork Quilt in America*. New York: Dover Press, 1988.

Lipsett, Linda Otto. *Eliza Roseberry Mitchell's Graveyard Quilt: An American Pioneer Saga*. Dayton, OH: Halstead and Meadows Publications, 1995.

———. *Remember Me: Women and Their Friendship Quilts*. San Francisco: Quilt Digest Press, 1985.

Moonen, An. *Quilts, the Dutch Tradition*. Arnhem, the Netherlands: Nederlands Openluctmuseum, 1992.

Orlofsky, Patsy and Myron. *Quilts in America* (reprint edition). New York: Abbeville Press, 1992.

Prichard, Sue, ed. *Quilts 1700–2010: Hidden Histories, Untold Stories*. London: V&A Publishing, Victoria and Albert Museum, 2010.

Ramsey, Bets and Merikay Waldvogel. *Southern Quilts: Surviving Relics of the Civil War*. Nashville, TN: Rutledge Hill Press, 1998.

Swan, Susan Burrows. *Plain and Fancy, American Women and Their Needlework, 1700–1850*. New York: Holt, Rinehart and Winston, 1977.

Waldvogel, Merikay. *Soft Covers for Hard Times*. Nashville, TN: Rutledge Hill Press, 1990.

Waldvogel, Merikay and Barbara Brackman. *Patchwork Souvenirs of the 1933 World's Fair*. Nashville, TN: Rutledge Hill Press, 1993.

Woodard, Thomas K. and Blanche Greenstein. *Twentieth-Century Quilts, 1900–1950*. New York: E. P. Dutton, 1988.

Texas Quilts and Quilting

Bresenhan, Karey Patterson and Nancy O'Bryant Puentes. *Lone Stars: A Legacy of Texas Quilts, 1836-1936*. Austin: The University of Texas Press, 1986.

———. *Lone Stars II: A Legacy of Texas Quilts, 1936–1986*. Austin: The University of Texas Press, 1990.

Kaylakie, Marcia. *Texas Quilts and Quilters: A Lone Star Legacy*. Lubbock, TX: Texas Tech University Press, 2007.

Texas Heritage Quilt Society. *Texas Quilts, Texas Treasures.* Paducah, KY: American Quilter's Society, 1986.

Yabsley, Suzanne. *Texas Quilts, Texas Women.* College Station, Texas: Texas A&M University Press, 1984.

Quilt Pattern Identification

Brackman, Barbara. *Encyclopedia of Appliqué.* McLean, VA: EPM Publications, 1993.

———. *Encyclopedia of Pieced Quilt Patterns.* Paducah, KY: American Quilter's Society, 1993.

Malone, Maggie. *5,500 Quilt Block Designs.* New York: Sterling Publishing, 2003.

Rehmel, Judy. *The Quilt I.D. Book: 4,000 Illustrated and Indexed Patterns.* New York: Prentice Hall Press, 1986.

Art Quilts and Quilting

Bresenhan, Karey Patterson, Juror and Editor. *500 Art Quilts.* New York: Lark Books, 2010.

Dunnewold, Jane. *Art Cloth: A Guide to Surface Design for Fabric.* Loveland, CO: Interweave Press, 2010.

———. *Complex Cloth: A Comprehensive Guide to Surface Design.* Bothell, WA: Fiber Studio Press, 1996.

Fahl, Ann. *Coloring with Thread: A No-Drawing Approach to Free-Motion Embroidery.* Lafayette, CA: C & T Publishing, 2005.

Hargrave, Harriet. *From Fiber to Fabric: The Essential Guide to Quiltmaking Textiles.* Lafayette, CA: C & T Publishing, 1997.

Johnston, Ann. *Color by Accident: Low-Water Immersion Dyeing.* Lake Oswego, OR: Ann Johnston, 1997.

———. *Color by Design: Paint and Print with Dye.* Lake Oswego, OR: Ann Johnston, 2001.

Love, Gladys. *Embellishing with Anything: Fiber Art Techniques for Quilts—ATCs, Postcards, Wallhangings, and More.* Lafayette, CA: C & T Publishing, 2009.

McMorris, Penny and Michael Kile. *The Art Quilt.* Lincolnwood, IL: Quilt Digest Press, 1996.

Noble, Elin. *Dyes and Paints: A Hands-On Guide to Coloring Fabric.* Bothell, WA: Fiber Studio Press, 1998.

Noble, Maurine and Elizabeth Hendricks. *Machine Quilting with Decorative Threads.* Bothell, WA: That Patchwork Place, 1998.

Torrence, Lorraine and Jean B. Mills. *Fearless Design for Every Quilter.* Lafayette, CA: C & T Publishing, 2009.

Creativity

Bresenhan, Karey Patterson, ed. *Creative Quilting: The Journal Quilt Project.* Stow, MA: Quilting Arts, LLC, 2006.

———. *I Remember Mama: A Book of Love About Mothers, Daughters, and Quilts.* Golden, CO: Primedia, 2005.

Martin, Nancy J. *At Home with Quilts.* Bothell, WA: That Patchwork Place, 1996.

———. *Decorate with Quilts.* Bothell, WA: That Patchwork Place, 1996.

Studios. Special interest publication from Quilting Arts, LLC. Stow, MA.

Where Women Create. Quarterly publication from Stampington and Company, Laguna Hills, CA.

How to Quilt

Anderson, Alex. *Beautifully Quilted with Alex Anderson: How to Choose or Create the Best Designs for Your Quilt.* Lafayette, CA: C & T Publishing, 2003.

———. *Finish It with Alex Anderson.* Lafayette, CA: C & T Publishing, 2004.

———. *Hand Quilting with Alex Anderson.* Lafayette, CA: C & T Publishing, 1998.

———. *Paper Piecing with Alex Anderson.* Lafayette, CA: C & T Publishing, 2010.

———. *Start Quilting,* 3rd edition. C & T Publishing, Lafayette, CA: C & T Publishing, 2009.

Beyer, Jinny. *A Quilter's Album of Blocks and Borders: 4044 Pieced Designs for Quilters.* Elmhurst, IL: Breckling Press, 2009.

———. *Quiltmaking by Hand: Simple Stitches, Exquisite Quilts.* Elmhurst, Illinois: Breckling Press, 2004.

———. *Soft-Edge Piecing.* Lafayette, CA: C & T Publishing, 1995.

Ferrier, Beth. *More! Hand Appliqué by Machine: 9 Quilt Projects, Updated Techniques, Needle-Turn Results Without Handwork.* Lafayette, CA: C & T Publishing, 2009.

Fons, Marianne & Liz Porter. *Quilter's Complete Guide.* Birmingham, AL: Oxmoor House, 1993.

———. *Quilts from America's Heartland: Step-by-Step Directions for 35 Traditional Quilts.* Emmaus, PA: Rodale Press (St. Martin's Press), 1994.

Hall, Jane. *The Experts' Guide to Foundation Piecing.* Lafayette, CA: C & T Publishing, 2006.

Hargrave, Harriet. *Heirloom Machine Quilting.* Lafayette, CA: C & T Publishing, 2004.

———. *Mastering Machine Appliqué.* Lafayette, CA: C & T Publishing, 2001.

Hargrave, Harriet, and Carrie Hargrave. *Quilter's Academy.* Lafayette, CA: C & T Publishing, 2009.

Hargrave, Harriet, and Sharyn Craig. *The Art of Classic Quiltmaking.* Lafayette, CA: C & T Publishing, 2000.

Hargrave, Harriet, Sharyn Craig, Alex Anderson, Liz Aneloski. *All-in-One Quilter's Reference Tool.* Lafayette, CA: C & T Publishing, 2004.

Hopkins, Judy. *501 Rotary-Cut Quilt Blocks.* Woodinville, WA: Martingale & Co., 2008.

Hopkins, Judy, and Nancy J. Martin. *101 Fabulous Rotary-Cut Quilts.* Bothell, WA: Martingale & Company, 1998.

———. *Rotary Riot: 40 Fast & Fabulous Quilts.* Bothell, WA: That Patchwork Place, 1991.

McClun, Diana and Laura Nownes. *Quilts! Quilts!! Quilts!!! The Complete Guide to Quiltmaking.* Lincolnwood, IL: Quilt Digest Press, 1997.

Michell, Marti. *Quilting for People Who STILL Don't Have Time to*

Quilt. San Marcos, CA: American School of Needle-work, 1998.

Montano, Judith Baker. *Fiberart Montage.* Worthington, OH: Dragon Threads, 2005–2008.

——. *Crazy Quilt Handbook* (revised 2nd edition). Lafayette, CA: C&T Publishing, 2009.

Noble, Maurine. *Machine Quilting Made Easy.* Bothell, WA: That Patchwork Place, 1994.

Pahl, Ellen, ed. *The Quilter's Ultimate Visual Guide: From A to Z.* Emmaus, PA: Rodale Press, 1997.

Quilter's Newsletter. All About Quilting from A to Z. Lafayette, CA: C & T Publishing, 2002.

Reynolds, Bethany S. *Stack-n-Whack-pedia.* Paducah, KY: American Quilter's Society, 2008.

——. *Stack-n-Whackier Quilts.* Paducah, KY: American Quilter's Society, 2001.

——. *Magic Stack-n-Whack Quilts.* Paducah, KY: American Quilter's Society, 1998.

Sienkiewicz, Elly. *Baltimore Album Revival! Historic Quilts in the Making.* Lafayette, CA: C & T Publishing, 1994.

——. *Baltimore Album Legacy.* Concord, CA: C & T Publishing, 1998.

——. *Baltimore Elegance: A New Approach to Classic Album Quilts.* Lafayette, CA: C & T Publishing, 2006.

——. *Best of Baltimore Beauties: 95 Patterns for Album Blocks and Borders.* Lafayette, CA: C & T Publishing, 2000.

Sienkiewicz, Elly with Mary K. Tozer. *Elly Sienkiewicz's Beloved Baltimore Album Quilts: 25 Blocks, 12 Quilts, Embellishment Techniques.* Lafayette, CA: C & T Publishing, 2010.

Quilt Care

Caring for Your Treasures: Textiles—A Guide for Cleaning, Storing, Displaying, Handling, and Protecting Your Personal Heritage. Washington, D.C.: American Institute for Conservation of Historic and Artistic Works. No publication date given.

Commoner, L. A. "Warning Signs: When Textiles Need Conservation." *Conservation Concerns: A Guide for Collectors and Curators.* Washington, D.C.: Smithsonian Institution Press, 1992.

Crews, Patricia and Shirley Niemeyer. *To Protect and Preserve: Caring for Family Quilts in the Home.* Lincoln, NB: International Quilt Study Center and Museum, University of Nebraska-Lincoln, 2005.

Guidelines for the Care of Textiles. Washington, D.C.: The Textile Museum, 2001.

Knutson, T. "Handling and Storage of Textiles and Costume Artifacts." *Technical Bulletin for Museum Professionals.* Denver, CO: Rocky Mountain Conservation Center, 1996.

Mailand, Harold and Dorothy Stites Alig. *Preserving Textiles: A Guide for the Non-Specialist.* Indianapolis, IN: Indianapolis Museum of Art, 1999.

Niemeyer, Shirley and Patricia Cox Crews. *Care and Conservation of Heirloom Textiles.* NebGuide Publication. Lincoln, NE: Extension, Institute of Agriculture and Natural Resources, the University of Nebraska-Lincoln, 2006.

"Preserving Quilts in Your Home." *Artifact Care Series #1.* Tallahassee, FL: Museum of Florida History, 2010.

Puentes, Nancy O'Bryant. *First Aid for Family Quilts.* Wheatridge, CO: Leman Publications, 1986.

Worrall, Mary, Beth Donaldson and Lynn Swanson. *Quilt Care* (revised). East Lansing, MI: Great Lakes Quilt Center, Michigan State University Museum, 2003.

Quilt Software

BlockBase (Barbara Brackman's *Encyclopedia of Pieced Quilt Patterns* as software) from Electric Quilt Company.

Electric Quilt 5, 6, and *7* (quilt design software) from Electric Quilt Company.

Sew Precise (foundation piecing software) from Electric Quilt Company.

STASH (virtual fabric) from Electric Quilt Company.

Wearable Art

Murrah, Judy. *Dress Daze: Countless Ideas for Comfortable Dresses.* Bothell, WA: That Patchwork Place, 1993.

——. *Jacket Jazz: Five Great Looks—Over 30 Patchwork Techniques.* Bothell, WA: That Patchwork Place, 1993.

——. *Jacket Jazz Encore: Six More Great Looks—Over 30 Patchwork Techniques.* Bothell, WA: That Patchwork Place, 1994.

——. *Jazz It Up: 101 Stitching & Embellishing Techniques.* Bothell, WA: That Patchwork Place, 1998.

——. *Judy Murrah's Jacket Jackpot.* Woodinville, WA: Martingale & Co., 2003.

——. *More Jazz: New Shapes and Great Ideas for Wonderful Wearable Art.* Bothell, WA: That Patchwork Place, 1996.

Quilt- and Sewing-Related Magazines

American Patchwork & Quilting

American Quilter (publication of the American Quilter's Society)

Art You Wear Newsletter

Artist Trading Cards

Beadwork

Belle Armoire

Cloth Doll Magazine

Cloth Paper Scissors

Doll Crafter

Creative Quilting Magazine

Fabric Trends

Fiberarts

Fons & Porter's For the Love of Quilting

International Quilt Festival Quilt Scene

McCall's Quilting

Patchwork & Quilting (England)

Piecework

Quilt

The Quilter

Quilter's Home
Quilter's Newsletter
Quilter's Quarterly (publication of the National Quilting Association)
Quilter's World
Quilting Arts
Quiltmaker
Quiltmania (France)
Quilts . . . A World of Beauty (publication of the International Quilt Association)
Sew News
Sew Somerset
Somerset Digital Studio
Somerset Studio
Stitch
Studios
Threads

Quilt Television Shows and Videos

Various local public broadcasting stations (PBS affiliates) and cable channels offer quilt- and sewing-related shows such as those listed below. Videos and DVDs, too, offer many options for viewing programs, or for learning techniques.

America Quilts Creatively
America Sews with Sue Hausmann
Fons and Porter's Love of Quilting
Kaye's Quilting Friends
Martha's Sewing Room
Quilt Central
Quilt in a Day
Quilting Arts
Sewing with Nancy

Quilts and Quilting on the Internet

There are countless quilt-related websites, online quilt magazines, how-to-quilt videos and DVDs, and quilter-written blogs available on the Internet. Numerous quilt suppliers and quilt shops make shopping for products on the Internet a possibility, also. A quick query to a favorite search engine will produce numerous entries to explore.

Index